GREAT ARTISTS

A TREASURY OF PAINTINGS
BY THE MASTERS

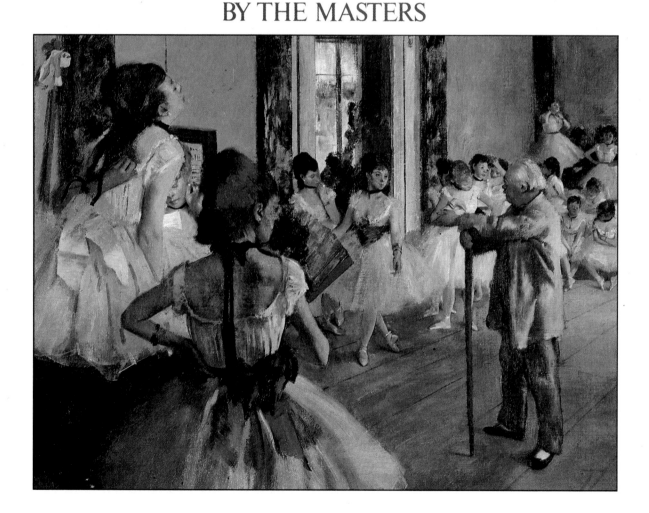

Exeter Books

NEW YORK

FOREWORD

"And how should I begin?"

This line from T. S. Eliot's 'The Love Song of J. Alfred Prufrock' comes to haunt those of us who want to find out but do not know where to look. If you want to know about painters, *Great Artists* provides a map, a compass, and the certain promise of buried treasure. Here is where you can begin. And where you can refer.

Today more people than in any previous age visit galleries, queue up for specialized exhibitions, see the work of artists on television and want to know more. This surge of interest is not only a consequence of greater leisure. It is nourished by the increasing realization – previously the prerogative of the few – that artists richly repay attention. The closer the attention, the finer the rewards. What are needed – not only at the beginning, but all along the way – are clear, unpretentious guides. The best art historians and philosophers – such as Professor Sir Ernst Gombrich – advocate this, as do painters themselves. One of David Hockney's favourite ways to get to know a new painter, for instance, is to buy a bunch of postcard reproductions!

Why are artists thought to be ever more valuable – the evidence ranging from the bewildering and distasteful millions which pass across the auction room to the millions who pass through the turnstiles? What is the draw?

We are attracted for many different reasons – the brilliant imagination of the individual painter, the skill, the charm, the ideas, the knowledge, the boldness, the passion – but we persist for one we share in common: a belief in the artists' uniqueness and integrity.

Oh, we know that court painters bowed the knee to princes and society painters tugged the forelock to patrons: we understood that a well-placed dimple and a straightened nose on a portrait of a lady would result in another commission, another lady; another day, another dimple. But even there, the great artists – as represented here – soar above it. They find ways. They switch their energy to the clothes their sitters wear; they put in messages coded for later generations to decipher; they may be chameleons but they are always aware that they work in public and – the greatest of them – do not break their trust. They keep their heads when all around are losing theirs. And they are, uniquely, as they are because they glorify the freedom of their individual gift. They remain their own men.

Copyright © Marshall Cavendish Limited 1987

First published in USA 1987
by Exeter Books
Distributed by Bookthrift
Exeter is a trademark of Bookthrift Marketing, Inc.
Bookthrift is a registered trademark of Bookthrift Marketing
New York, New York

All rights reserved.

ISBN 0-671-08650-2

Printed in Spain by Cronion S.A., Barcelona

Here we have some of the greatest of European painters from the Renaissance (1445-1576) from Flemish Art (1450-1890), the Romantics (1746-1867) and the Impressionists (1832-1926).

The range of information given about each artist runs from the plain useful – where to see the paintings; further reading – to a connoisseur's view of one distinguishing aspect of the technique. The greatest emphasis, though, is on the artist's life, his work, comparisons with the work of others and the historical context. And the greatest space – rightly – is given over to well-captioned reproductions. It is all done with brevity and yet it draws on a wide range of sources. It is not only the place at which you can begin, it is also a place to which you can return.

Few of us would question that it is helpful to know about a painter's technique: even fewer, I guess, would doubt the benefit of knowing about the period in which the artist lived. Not only for the superficial (but often crucial) matters of fashion in dress, entertainment and manners, but also to have some inkling of the painter's relationship with the deeper, more public, dramatic and historical events and currents of the time. No one can avoid being part of their times. Artists often define them.

Finally, there is 'The Artist's Life'. There will always be an argument over this. The fact that we know so little of so many great artists does not make their work less valuable. On the other hand, the fact that we know a lot about some artists does not make *their* work any less valuable either. There is the view of Yeats, that the artist is not that "bundle of accidents and incoherence that sits down to breakfast": fair enough. However, I would go along with the cautious opinion of a later poet, Wallace Stevens, that "reality is only the base. But it *is* the base."

This book provides a base for all who want to confirm and extend their interest in and passion for great artists.

Melvyn Bragg

CONTENTS

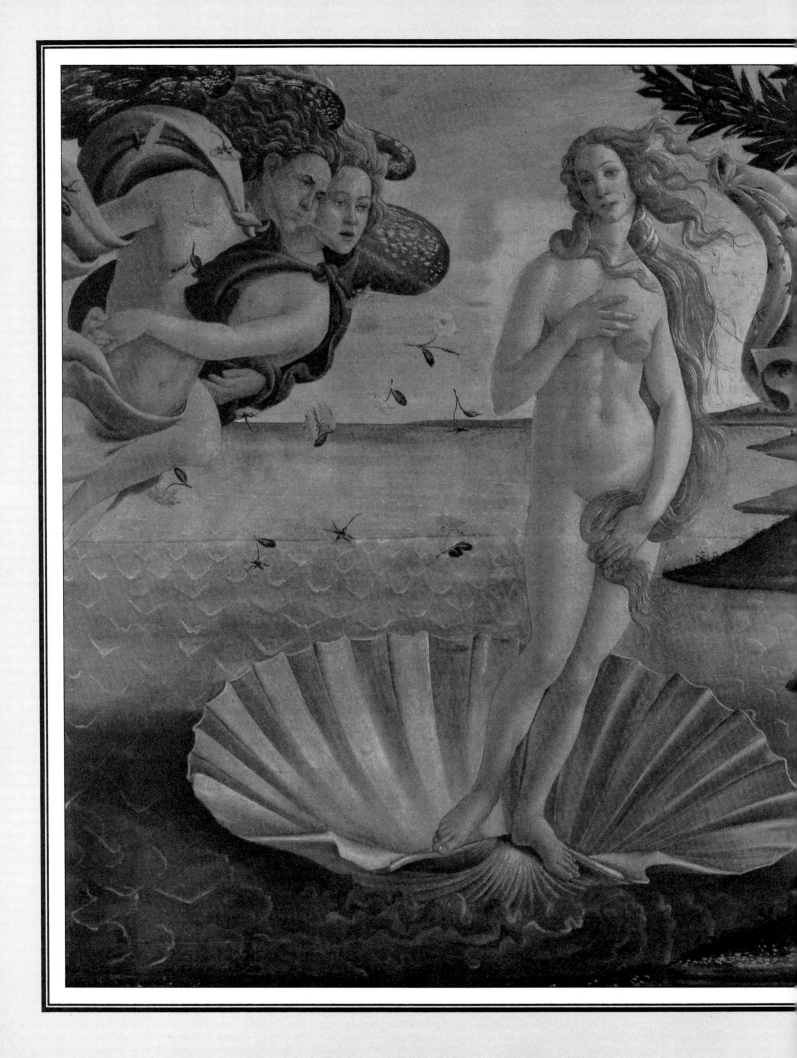

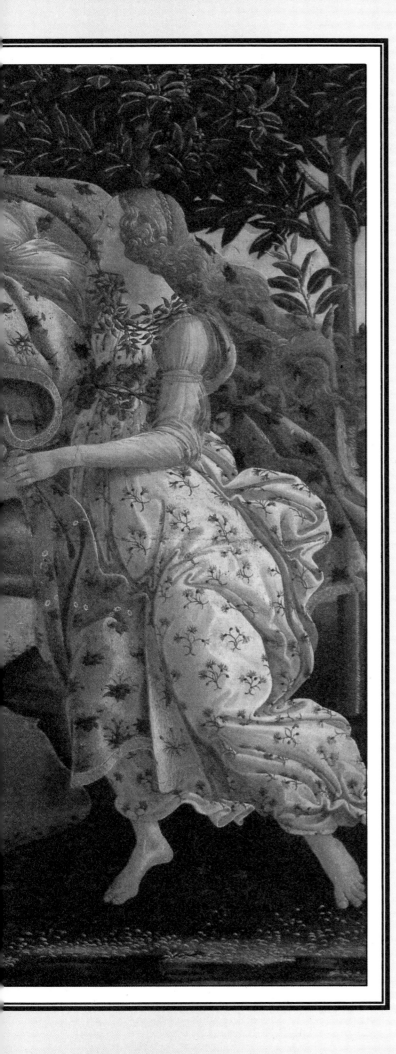

The Birth of Venus *c.1485*
by Botticelli
67¾″ × 109½″ Uffizi, Florence

Introduction

The period known as the Renaissance was characterised by a dedicated pursuit of knowledge. It began in Italy in the 14th century as an intellectual movement and stretched across the schools of painting, sculpture and architecture, reaching its peak two hundred years later in what is often referred to as the High Renaissance. Botticelli, Leonardo da Vinci, Michelangelo, Raphael and Titian are some of the greatest Renaissance artists whose work has become famous the world over.

Inspired in Florence, Rome and Venice, these artists moved away from existing styles of painting by developing perspective and drawing from live models. They sought to combine accurate representation with an enthusiasm for classical design. Man became their centre of focus, in an elevated position, with nature taking second place. Traditional religious subjects, particularly the theme of 'Madonna and Child' were their most common subject matter; these biblical themes were fashionable and frequently commissioned by patrons.

Botticelli, the most sought-after painter in Florence, became famous for his religious paintings but is now best remembered for *The Birth of Venus* (frontispiece) and *Primavera* (p.90), both mythological in subject. After achieving fame in the 1480's his work fell out of favour as it came to be considered old-fashioned. Also, Botticelli was intrigued by the fanatical monk Savonarola. The painter may have been affected by Savonarola's influence as his later paintings reveal a spiritual intensity not found in his earlier work.

Leonardo da Vinci was more than a successful painter; he was a multi-talented genius who remained distanced from his contemporaries in order to immerse himself in scientific research. He was obsessed by his own work and his drawings show his many scientific inventions, while his paintings show perfection of line and colour. His most famous painting, *Mona Lisa* (p.96) and *The Virgin and Child with Saint Anne* (p.97) emanate a calmness and grace also found in *The Annunciation* (p.94).

Michelangelo is heralded as the greatest Renaissance sculptor.

He was trained at Lorenzo de Medici's 'sculpture school' and produced astonishing marble sculptures *Pietà* (p.98) and *David* (p.99). However, his talents were by no means limited to this medium alone; he also become respected as an architect and Pope Julius II commissioned him to paint the ceiling of the Sistine Chapel in the Vatican. Michelangelo began this momentous task in 1508, and four years later his work was unveiled. The Sistine Chapel ceiling represents the high point of the Renaissance and its decoration sums up the spirit of Renaissance art. The story of the creation covers the central ceiling, while prophets and pagan sibyls adorn the corners. Recently restored, the artist's original choice of bright colours is revealed once more.

While Michelangelo was painting the Sistine ceiling, Raphael was decorating the Pope's apartments. *The School of Athens* (p.106) is one of a series of breathtaking frescoes painted in true Renaissance style – a mastery of proportion, representing classical beauty and ancient learning. *The Liberation of Saint Peter* (p.88) shows the saint freed by an angel, and is one of Raphael's greatest works. Raphael was the supreme master of compositional symmetry. In *The Triumph of Galatea* (p.49), Galatea is the central figure around which the other nymphs and sea gods rotate, creating the perfect balance.

In contrast to this, Titian developed a style that was freer, warmer, and full of sensual colour, which is clearly shown in the famous nude *Venus of Urbino* (p.78) and the earlier *Sacred and Profane Love* (p.76). Awarded the highest praise of any Venetian painter, Titian's fame easily rivalled that of the other great Renaissance artists. He completed a vast range of secular and religious pictures and his work had enormous influence on future schools of art.

Throughout the Renaissance, Italy experienced an era of incomparable artistic achievements. The scope for painting, sculpture and architecture resulted in prolific creativity, often amidst political turmoil. The masterpieces produced were to be an inspiration to future painters for centuries.

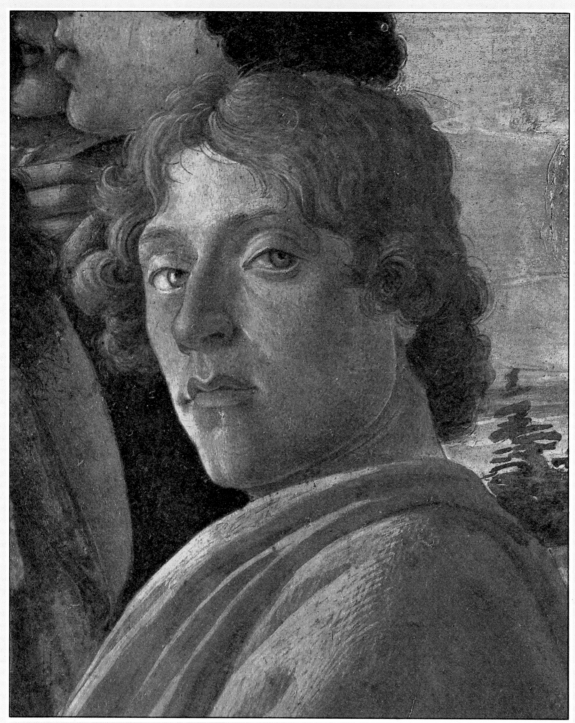

Self-Portrait from *The Adoration of the Magi*/Uffizi, Florence

Botticelli
1445-1510

Sandro Botticelli, one of the most popular artists of the Renaissance, spent almost all his life in his native Florence. At the peak of his career, Botticelli was the most sought-after painter in the city and head of a thriving workshop. His only important journey outside Florence was made when he was one of the artists chosen to decorate the Sistine Chapel in Rome – the most prestigious commission of the day.

Late in Botticelli's career, his work gained a new emotional intensity, and it is possible that he was affected by the disturbing atmosphere in Florence when the ascetic monk Savonarola was virtual ruler of the city. His work fell out of favour to such an extent that he was almost forgotten for centuries, and it was only in the late 19th century that he was 'rediscovered' and recognized as one of the greatest artists of his age.

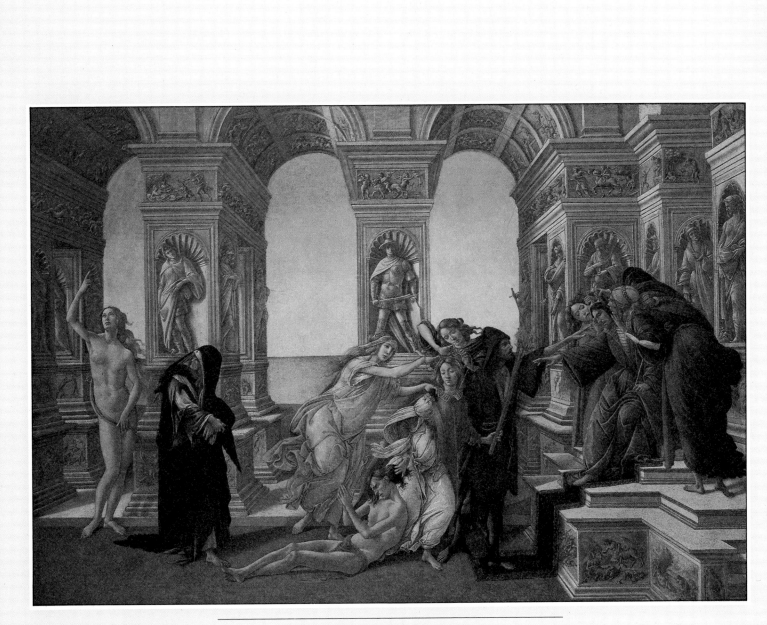

The Calumny of Apelles *c.1496-97*
24½″ × 36″ Uffizi, Florence

The Forgotten Florentine

Botticelli is now one of the most popular artists of the Italian Renaissance. But his work suffered centuries of neglect before it was rediscovered by the Victorians.

Key Dates

1445 born in Florence

c.1461 joins Filippo Lippi's workshop

c.1470 establishes own workshop

1470 receives first documented commission

1478 Pazzi conspiracy against the Medici family; Botticelli paints effigies of the dead conspirators

1481 summoned to Rome to paint frescoes for the Sistine Chapel

1482 returns to Florence

1494 Florence under threat of invasion; the monk Savonarola comes to power

1498 Savonarola executed

1500 paints the *Mystic Nativity*

1510 dies in Florence

A sought-after painter
At the peak of his career, Botticelli was in demand both for religious works and secular paintings like this wedding picture.

Alessandro di Mariano di Vanni Filipepi was born in 1445, the youngest son of a Florentine tanner called Mariano Filipepi. The Florentines were remarkably fond of nicknames, and Alessandro's eldest brother, Giovanni, was known as 'Il Botticello', meaning 'little barrel', presumably on account of his rounded shape. Alessandro (shortened to Sandro for convenience) assumed the nickname some time before 1470, and it eventually became the family surname.

Mariano Filipepi was a humble artisan who lived in the Ognissanti quarter of Florence; it was a relatively poor, working-class area of tanners and weavers, but the cloths woven there were the pride of Florence and were in great demand all over northern Europe. In spite of Botticelli's own success, he never deserted the area, and the house which his father bought in the Via Nuova in 1464 remained a lifelong family home, which he shared with his brothers.

THE WEAVING DISTRICT

These premises in Florence's weaving district also housed Botticelli's workshop from about 1470, a fact which had amusing repercussions: the 16th-century biographer, Giorgio Vasari, relates how Botticelli's next-door neighbour set up eight massive looms, whose thunderous noise and vibration so distracted the painter that he could not work. Botticeli begged his neighbour to be more considerate, but to no avail. So in desperation, he balanced an enormous stone 'big enough to fill a wagon' on the wall dividing their houses, which threatened to topple and destroy the weaver's property at the slightest disturbance. Botticelli's ingenuity won the argument.

A lifelong home
(below) Botticelli always remained loyal to the Ognissanti quarter of Florence – the working-class, weaving district where he was born. Even at the height of his success he lived and worked at the family home.

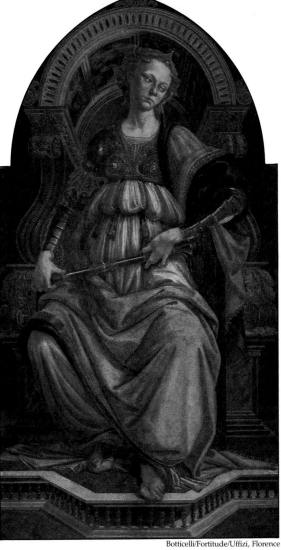

Botticelli/Fortitude/Uffizi, Florence

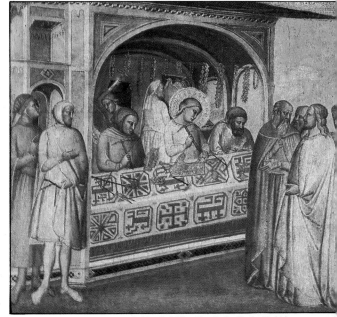

Taddeo Gaddi/San Eloy Orefice/Prado, Madrid

The first commission
(left) This painting of Fortitude is Botticelli's first documented work. He was commissioned through a well-connected patron soon after he set up his workshop.

A goldsmith's training
(above) This Florentine painting shows St Eloi, the patron saint of goldsmiths. Botticelli's brother was a goldsmith, and the artist was probably apprenticed too.

Few facts are known about Botticelli's early years, but it seems probable that at 13 he was apprenticed to a goldsmith. He soon decided, however, that he wanted to paint, and about 1461 or 1462 his father sent him to the workshop of Filippo Lippi, a renowned Florentine master who was then working on a fresco cycle in the cathedral of Prato just outside Florence.

Lippi, who specialized in religious paintings of graceful piety and sweet-faced Madonnas, was also notorious as the seducer of the nun Lucrezia Buti. The product of their unholy alliance was a son, Filippino Lippi, who in turn became Botticelli's pupil after Filippo's death in 1469.

It was at about this time that Botticelli set up on his own, and in 1470 he received his first

documented commission. This was for a figure of *Fortitude* (this page), one of the seven *Virtues* commissioned by the Merchants' Guild for their Council Chamber. The commission had originally been given to the painter Piero del Pollaiuolo, who had already completed some of the figures. But *Fortitude* was taken from him and given to Botticelli at the intervention of an influential patron with Medici connections.

By 1472 Botticelli had become a member of the Compagnia di San Luca, a charitable confraternity for artists. And by the end of 1473, his reputation had reached Pisa, where he was summoned to paint a fresco in the Cathedral. This project was later aborted but, back in Florence, he continued to consolidate his reputation with such masterpieces as *The Adoration of the Magi* (p.10) painted c.1475 for Sta Maria Novella and commissioned by the banker Zanobi del Lama. He had also won the patronage of Lorenzo de' Medici's wealthy cousin, Lorenzo di Pierfrancesco de' Medici, for whom he may have painted *Primavera* (p.90-91) in about 1478.

The Medici link had been forged in good time. In 1478, political events swept Botticelli into the limelight. Under the guidance of Lorenzo de' Medici – known as 'the Magnificent' – Florence was both a thriving and influential centre of

The reluctant traveller
(left) Botticelli rarely left his native Florence, but in 1473 he travelled to Pisa to fulfil a commission. When the project was cancelled, he soon returned home.

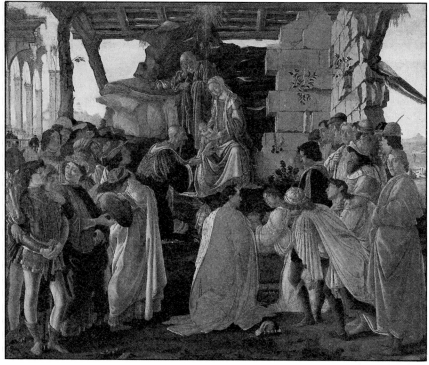

Botticelli/Adoration of the Magi/Uffizi, Florence

An early masterpiece
(above) The Adoration
of the Magi *(c.1475) is
one of Botticelli's finest
works. Commissioned by
a wealthy banker for the
church of Sta Maria
Novella in Florence, it
helped to consolidate the
artist's reputation among
the important patrons of
the city. The painting
supposedly contains
portraits of members of
Florence's ruling family –
the Medici. The man
standing in the foreground
on the extreme right of the
painting is thought to be
Botticelli himself (see
page 6).*

international business and politics. But there were
warring factions and rival families jealous for
positions of power within the city itself. On 26
April, during the celebration of High Mass in the
Cathedral, conspirators employed by one such
rival family – the Pazzi – attacked Lorenzo and
Giuliano de' Medici, with the approval of Pope
Sixtus IV. Giuliano died, but Lorenzo escaped and
the Pazzi attempts to rally support for their cause
floundered. The conspirators were captured and
hanged from the windows of the Palazzo Vecchio.

In the event, Botticelli profited from the
occasion, as he was asked to paint the effigies of
the dead men. It was a macabre, but highly
prestigious commission, and no doubt it helped to
secure for him what every artist dreamed of – a
summons to Rome to work for the Pope.

PAINTING FOR THE POPE

Pope Sixtus (whose part in the Pazzi conspiracy
was judiciously forgotten) was assembling the
greatest artists of the day to decorate the newly
built Sistine Chapel in the Vatican with portraits of
previous popes, and scenes from the lives of
Moses and Christ. Botticelli arrived in Rome in the
summer of 1481 and executed three frescoes in the
Chapel for which he was handsomely paid.

While Botticelli was away, his father died, and
after only one year in Rome, the artist returned to
Florence and to the home which his brother
Giovanni had inherited. Botticelli was now at the
height of his powers, and demands flooded in for
paintings of religious and secular subjects,
banners, wedding chests, and portraits. His
Madonna and Child paintings were particularly
popular, and many imitators – as well as his own
workshop – were churning out copies.

The Sistine Chapel

Pope Sixtus IV, who was in office from 1471 to
1484, was one of the most dynamic of the art-
loving popes of the Renaissance. During his
pontificate, many of Rome's splendid buildings
were erected and numerous churches repaired.
The most magnificent monument to Pope
Sixtus is the chapel named after him in the
Vatican palace – the Sistine Chapel, constructed
between 1475 and 1481. On completion of the
chapel, Sixtus summoned together the leading
Italian artists of the day – Botticelli, Perugino,
Cosimo Rosselli, Domenico Ghirlandaio and,
later, Luca Signorelli – to decorate the walls
with a series of frescoes such as *Punishment of
the Rebels* on the facing page.

The new chapel
*This reconstruction shows the appearance of the
Sistine Chapel before Michelangelo painted the
chapel's ceiling, but with the wall frescoes.*

He employed three assistants at this time, and
there was plenty of work to keep the workshop
fully occupied. However, one rather acerbic
contemporary described his workshop as 'an
academy for idlers with nothing better to do', and
on his father's tax return of 1481, Giovanni wrote
of Botticelli – 'he works in the house when he has a
will'. Botticelli certainly encouraged a genial
atmosphere in the workshop, and even enjoyed
practical jokes at the expense of his assistants.

Vasari relates how he arranged the sale of a
painting of the Madonna surrounded by angels,
which was a copy of one of his own compositions

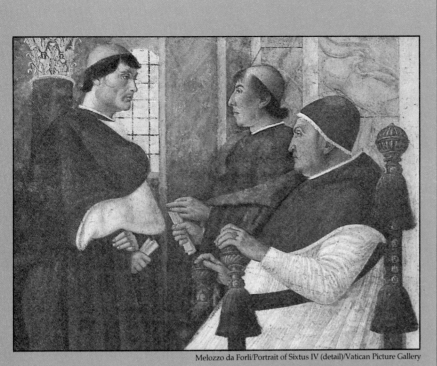

Melozzo da Forli/Portrait of Sixtus IV (detail)/Vatican Picture Gallery

The warrior-pope
(above) Sixtus IV (on the right) was a politician and warmonger as well as a patron of the arts.

The Punishment of the Rebels
(below) This is one of the three frescoes which Botticelli executed for the Sistine Chapel.

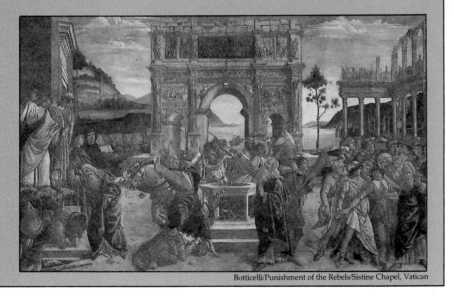

Botticelli/Punishment of the Rebels/Sistine Chapel, Vatican

paper hats. The poor pupil was persuaded that his vision had been an aberration of the mind.

In the 1480s, Botticelli's reputation was at its peak. So when the Duke of Milan requested an account of the most prestigious painters of the day from his agent in Florence, Botticelli topped the list as 'A most excellent painter, both on panel and wall. His works have a virile air and are done with the best judgement and perfect proportion'. He had few serious rivals in Florence at this time: Leonardo had left for Milan, the Pollaiuolo brothers were working in Rome, and Verrocchio had gone to Venice to execute the equestrian statue, the *Colleoni Monument*.

During the 1490s the fortunes of Florence changed. The explosive Prior of San Marco, Girolamo Savonarola, had been delivering sermons in heady rhetoric which denounced the corruption of the city and foretold its imminent destruction. In 1492, Lorenzo the Magnificent died, and his son, Piero, took over the government of the city, but proved to be politically inept.

Charles VIII of France was threatening an invasion to claim the Kingdom of Naples, and when he actually landed in Italy, and moved south

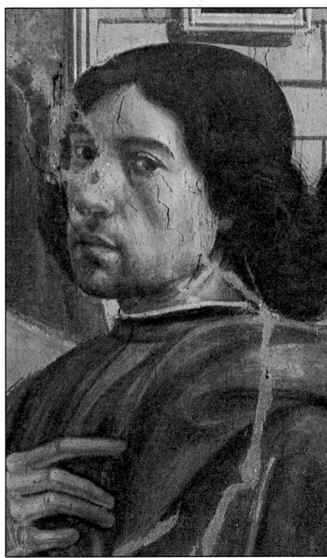

Ghirlandaio/Joachim's Offer Rejected (detail)/Santa Maria Novella, Florence

by a pupil called Biagio. Having told Biagio to hang the painting in good light for the perusal of the prospective buyer, Botticelli then made some red paper hats, of the type worn by the councillors of Florence, and stuck them onto the angels' heads with wax. Having fetched the buyer, the bemused Biagio was on the point of exploding with rage at the sight of his 'Madonna and councillors' when he realized that the buyer (whom Botticelli had informed of the joke) had apparently noticed nothing strange and was happy to conclude the deal. Biagio left with him to fetch the money, and by the time he returned, Botticelli had removed the

A gifted contemporary
Domenico Ghirlandaio (1449-94) was one of Botticelli's greatest Florentine contemporaries. They worked alongside one another in the Sistine Chapel and also in Ognissanti in Florence.

Botticelli's Star Pupil

One of the finest draughtsmen of the 15th century, Filippino Lippi (c.1457-1504) was the son of Botticelli's master, the artist-monk Filippo Lippi, and the nun Lucrezia Buti. After his father's death, the young Filippino entered Botticelli's workshop as an apprentice. Like his father and his master, his works are characterized by sweetness and grace, though his colours tend to be stronger and his forms more angular. Filippino's name is not widely known today, but he enjoyed a great reputation in his lifetime: Lorenzo de' Medici described him as 'superior to Apelles' – supposedly the greatest artist of the ancient world.

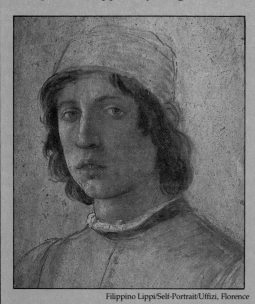

Filippino Lippi
(left) This self-portrait of the artist as a young man is a detail taken from a fragment of a fresco.

The Vision of St Bernard
(below) Painted around 1480, this is one of Filippino's first major paintings. The close affinities with Botticelli's style are obvious, but there is an excited, vigorous quality which is Filippino's own.

Filippino Lippi/Self-Portrait/Uffizi, Florence

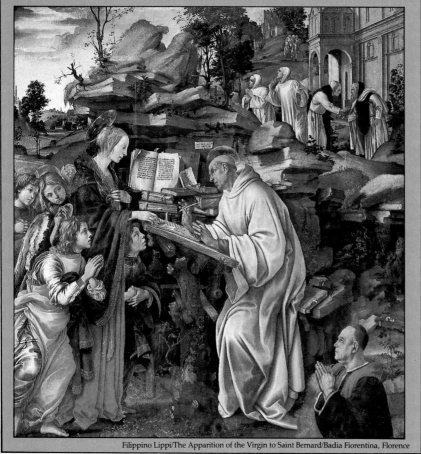

Filippino Lippi/The Apparition of the Virgin to Saint Bernard/Badia Fiorentina, Florence

in the autumn of 1494, Piero ceded to him the port of Pisa and other vital Florentine strongholds. The city was enraged, and Piero was forced to flee. For Savonarola, the invasion of Charles VIII could fortuitously be interpreted as the Divine Retribution he had prophesied, and when Charles VIII camped outside Florence, Savonarola was sent to mediate and prevent the city's destruction. This accomplished, he was heralded as a Saviour, and established a theocracy in Florence.

Botticelli, whose life embraced little outside of Florence, could not fail to be shaken by these events. He was reputedly a keen follower of Savonarola's sermons, and his work certainly changed stylistically during this period. It became far more emotionally charged, and imbued with a sort of religious angst.

DECADES OF DECLINE

To add to his many personal worries, Botticelli's brother Giovanni died in 1493, and in 1497, Botticelli's lifelong benefactor, Lorenzo di Pierfrancesco was forced to leave Florence for political reasons. Botticelli had been working on a set of drawings to illustrate Dante's *Divine Comedy* for Lorenzo, but the series was never finished, and there were to be no more Medici commissions.

Savonarola's fanatical dictatorship could not last. By 1498, he had made many enemies in Florence, and was excommunicated by Pope

An unmarked grave
(left) Botticelli was buried in his parish church – the Church of Ognissanti. He died an old and forgotten man, and no sign of his grave remains.

Alexander VI. Eventually he was tried by the Signoria, the councillors of Florence, for being a false prophet. On 23 May 1498 he was executed.

After Savonarola's death, his followers known as 'piagnoni' (snivellers) had to meet in secret; Botticelli's brother, Simone, was one of these piagnoni and claimed in his diary that he was using Botticelli's workshop as a secret meeting place. It is not known whether this is true, or whether, in fact, Botticelli himself was a piagnone.

During the next decade, Botticelli's personal fortunes declined still further. 1502 was a particularly bad year. Isabella Gonzaga had been seeking the services of a painter, and Botticelli was recommended to her as the other famous Florentine artists were 'too busy', but Isabella was not interested. And in November, the artist was denounced for sodomy (as Leonardo had been over 20 years previously). Although sodomy was a grave offence, punishable in theory and sometimes in practice by burning at the stake, it was not a rare occurrence – particularly in Renaissance Florence, a city noted for its gaily dressed, slender young men. In any case, the charge against Botticelli was dropped, and it is still a matter of conjecture whether or not he was a homosexual: certainly he never married.

In 1503-5, he could not afford to pay his dues to the Compagnia di San Luca, but he was still working, and managed to pay off these debts in October 1505. He was not in demand as he had been two decades before, though in 1504 he was still considered sufficiently important to be on the committee deciding the site for Michelangelo's *David*. However, this was an honorary position. In artistic matters, Florence had moved on to the progressive ideas and attitudes of Leonardo – who had returned from Milan in 1500 – and of Michelangelo himself.

Botticelli was out of sympathy with the new approach to antiquity; even when he had stayed in Rome in 1481-2 he had remained curiously unaffected by his surroundings. What he absorbed from antiquity was the romance of its myth. He had mastered perspective and anatomy, but he had no desire to study either as sciences, and could not share Leonardo's attitude to reality. In fact, in his late works he retreated into a more archaic and medieval manner of painting.

Vasari describes Botticelli in his last years as 'old and useless, unable to stand upright and moving about with the help of crutches'. And by the time he died, aged 65, in May 1510, he was both out of date and neglected. When he was buried in the churchyard of the Ognissanti, near to the family home, his reputation was buried with him. He was not 'rediscovered' until the 19th century, when the artists of the Pre-Raphaelite movement found in him a kindred spirit.

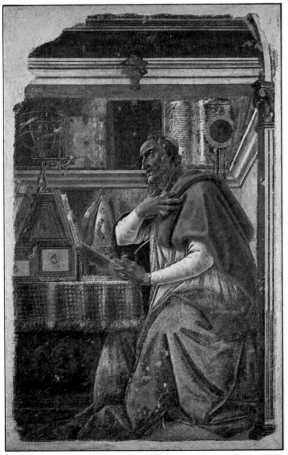

Botticelli/The Divine Comedy: Hell/Staatliche Museen, Kupferstichkabinett, Berlin

A painted memorial
(left) Botticelli painted this fresco of St Augustine for the monk's choir in the Church of Ognissanti, but it has since been moved to the refectory of the monastery – where it remains as a memorial to the artist.

The last Medici commission
(above) In the late 1490s, Lorenzo di Pierfrancesco de' Medici commissioned Botticelli to execute a set of drawings illustrating Dante's Divine Comedy. *But Lorenzo's exile brought an end to this – and all – Medici commissions.*

Botticelli/Saint Augustine/Ognissanti, Florence

Master of Mythology

Botticelli was the first Renaissance artist to paint mythologies with the seriousness traditionally reserved for religious themes. His classical goddesses are as grand and beautiful as his Madonnas.

By the standards of his time Botticelli was both a versatile and a prolific artist. As with virtually all his contemporaries, the greater part of his output consisted of religious works, but he also painted portraits, allegories, mythologies and literary themes. Catalogues of his work list about 150 surviving paintings (plus many more from his studio), which is an exceptionally large number for a 15th century artist. Most of his paintings were on panel, but he was also a master of fresco and, unusually for the time, he made drawings as works of art in their own right.

A BUSY WORKSHOP

Botticelli signed and dated only one of his many paintings – *The Mystic Nativity* (p.93) – and relatively few of his pictures are documented. Consequently there is often great scholarly dispute about the authenticity and dating of his works. His busy studio (and imitators outside it) produced numerous copies and variants of his originals, and the degree of Botticelli's personal participation in a painting no doubt depended on the importance of

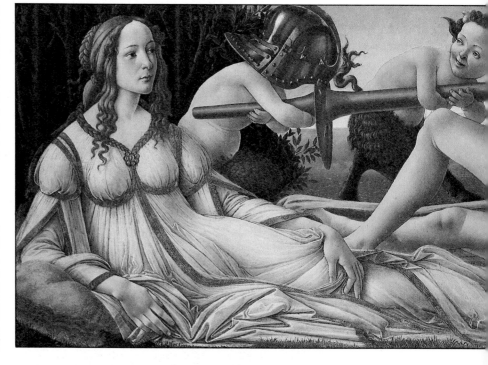

Abundance
(left) This is Botticelli's most beautiful surviving drawing. It probably alludes to the season of autumn.

Enigmatic frescoes
(below) In 1873, three frescoes by Botticelli were discovered in a villa near Florence. Their subjects are obscure.

Mars and Venus
(above) This masterpiece was probably painted to decorate a bed – an appropriate position for its erotic subject.

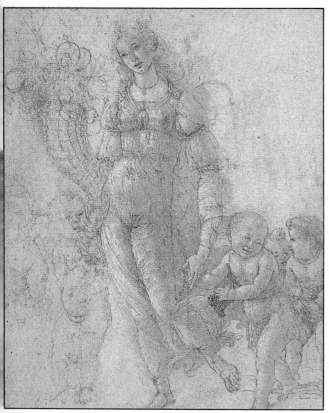

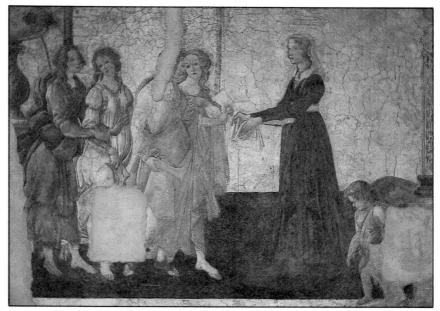

British Museum, London

Venus and the Graces/Louvre, Paris

the commission. Some of his Madonna and Child designs were so popular that they may have been bought 'off the peg' from his workshop.

Although little is known of Botticelli's life and there is much controversy about individual pictures, it is clear that at the peak of his career he was the most sought-after painter in Florence. He must already have had a considerable reputation by 1481 when he was called to Rome to help decorate the Sistine Chapel, and when he returned

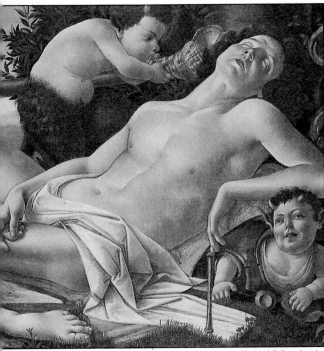

National Gallery, London

to his native city in the following year, the departure of Leonardo da Vinci for Milan had cleared the path for his advancement. Botticelli's clientele was numerous and varied, including the greatest families in Florence, civic authorities and some of the city's finest churches.

The most remarkable of Botticelli's paintings – and now the most famous – are his mythologies, for he was the first artist since antiquity to paint mythological scenes on a large scale. Previously, such subjects had been of minor importance, most often featuring as furniture decorations. They were particularly popular as paintings on *cassoni* – the chests that were given as wedding presents or used for containing a bride's dowry. Botticelli himself painted *cassone* panels, and his *Mars and Venus* was probably also originally part of a piece of furniture – very likely a headboard for a bed. His two most famous mythologies – *Primavera* (p.90) and *The Birth of Venus* (frontispiece) – are much more ambitious in scale than these paintings: *Primavera* is more than ten feet wide and *The Birth of Venus* is not much smaller.

Botticelli's mythologies were painted for a different kind of audience to that of his religious pictures. His altarpieces were public works and had to be instantly comprehensible to a large number of people, and although his smaller

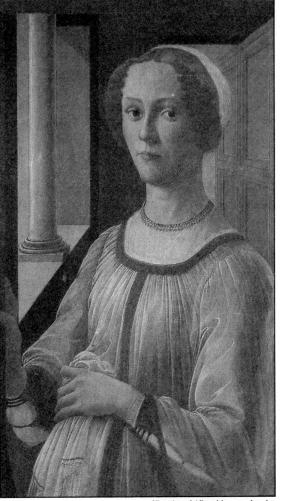

Victoria and Albert Museum, London

A master portraitist
Botticelli was one of the finest portraitists of his time, his firm, vigorous lines giving a feeling of incisive characterization. This early work, in which the sitter is Smeralda Bandinelli, grandmother of the sculptor Baccio Bandinelli, was owned by Dante Gabriel Rossetti, one of the Pre-Raphaelite 'discoverers' of Botticelli.

A favourite subject
(below) Botticelli painted The Adoration of the Magi *several times. This version, probably done fairly early in his career, shows his skill in fitting the composition into the 'tondo' (circular) format.*

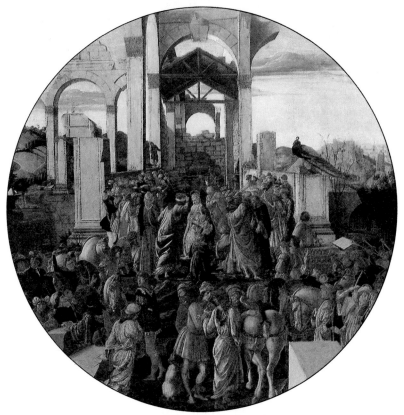

National Gallery, London

The Madonna of the Book
(right and detail above) The Virgin and Child is the most common theme in Christian art and Botticelli is one of the few artists who found continually fresh inspiration in the subject and never became hackneyed in his treatment of it. The Madonna of the Book is one of his most tender portrayals of the subject and also shows his superb technical skills, for this is a luxury product, entirely from the master's own hand. His treatment of the halo (above) is particularly delicate.

devotional pictures might be kept in private houses, they all followed traditional Christian formulae. The mythologies, on the other hand, were painted for the private delectation of highly sophisticated literary-minded patrons, which explains why their symbolism can be so difficult to unravel. A patron would tell the painter exactly what he wanted in the picture, and as there was no fixed pattern of thought in mythological symbolism as there was in orthodox Christian belief, critics and historians have had wide scope for interpretation.

ILLUSTRATING DANTE

Although the 'content' of his portrayals of various subjects differed greatly, Botticelli did not show any clear divergence of style in treating religious and mythological themes. He may have revived antique subjects, but he did not, unlike some of his contemporaries, try to depict them through authentically antique forms. Indeed it is often pointed out that his pagan goddesses are from the same mould as his Madonnas – they have the same sad, sweet beauty and the same exquisite gracefulness.

This gracefulness was a characteristic that Botticelli inherited from his master Filippo Lippi, but he brought sensitivity to line to new heights of expressiveness, making it the most distinctive feature of his style. It characterizes almost all his mature work, but is seen at its purest in his drawings illustrating Dante's *Divine Comedy* (p.13). At this time printed books were still regarded by many connoisseurs as inferior to manuscripts and Botticelli's illustrations were for a deluxe handwritten edition of the poem done for his greatest patron, Lorenzo di Pierfrancesco de' Medici, who may have commissioned *Primavera*

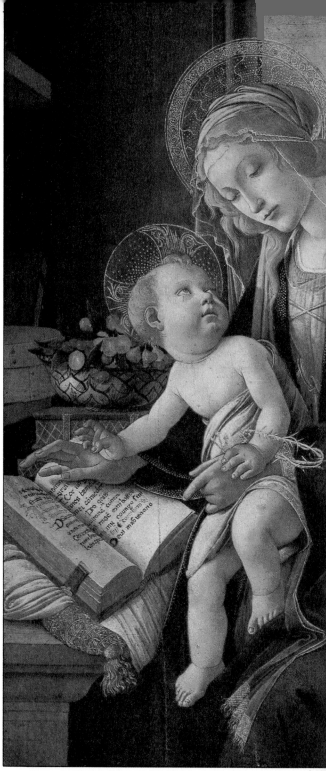

Ornate Haloes

and *The Birth of Venus*. The drawings are now divided among three museums, but originally each opening of the manuscript featured a full-page drawing facing the portion of the text it illustrated. Some of the drawings are unfinished and some are coloured, but the majority are pen-and-ink drawings of great subtlety and refinement. They are unique for their time.

The extreme linearity of Botticelli's style made his work seem increasingly old-fashioned and the last decade of his life was spent in comparative obscurity. It is not true, as his 16th-century biographer Giorgio Vasari asserted, that he gave up painting under the influence of Savonarola, but after Leonardo's return to Florence in 1500 he must have seemed rather out-dated. He had no interest in the scientific investigation of the human body or the modelling through light and shade that characterized Leonardo's work, and his late masterpiece, *The Mystic Nativity*, shows an extraordinary indifference to all the advances in naturalistic representation that Italian – and particularly Florentine – artists had achieved in the course of the 15th century; he has even used the archaic artistic device of showing the Virgin as much bigger in scale than the accompanying adoring shepherds.

The eclipse of Botticelli's reputation was for centuries almost total. He was never completely forgotten because his biography was in Vasari's *Lives* and his largest paintings were in the Sistine Chapel, although then as now few of the tourists who went to gaze reverently at Michelangelo's ceiling paid much attention to the frescoes on the walls. It was only in the second half of the 19th century that there was a renewed appreciation of Botticelli's genius. Two of the foremost critics of the age – John Ruskin and Walter Pater – led the way, and as late as 1870 Pater referred to Botticelli as 'still a comparatively unknown painter'. Since then Botticelli's reputation has increased apace and few Renaissance painters now have such widespread appeal. The Uffizi in Florence houses the world's greatest collection of Italian paintings, but even in competition with a galaxy of masterpieces it is usually the room containing *Primavera* and *The Birth of Venus* that is the most crowded in the museum.

Poldi Pezzoli Museum, Milan

Botticelli is highly varied in his treatment of haloes. Sometimes he uses simple rays of golden light, but more often he uses the halo as an excuse to display his exquisite brushwork in a delicate mesh of gold.

COMPARISONS

Masters of Line

The most distinctive feature of Botticelli's style is its graceful linearity. All his forms are clearly outlined and he makes little use of light and shade to create an effect of three dimensions. His master, Filippo Lippi, had similar tastes and his *Feast of Herod* perfectly illustrates what the critic Sir David Piper has called 'the seductive charm of his flowing line'. When interest in Botticelli revived in the 19th century, Burne-Jones was among the artists most captivated by his work. The beautiful, wan figures in *The Golden Stairs* are indebted to the Renaissance master.

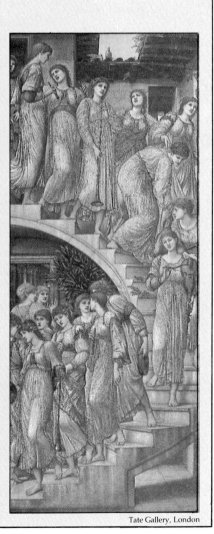

Cathedral, Prato

Filippo Lippi (c.1406-69) **The Feast of Herod** (detail) *(above) Botticelli was Lippi's pupil when he painted this fresco.*

Sir Edward Burne-Jones (1833-98) **The Golden Stairs** *(right) Burne-Jones's picture is without apparent subject – it is a romantic dream.*

Tate Gallery, London

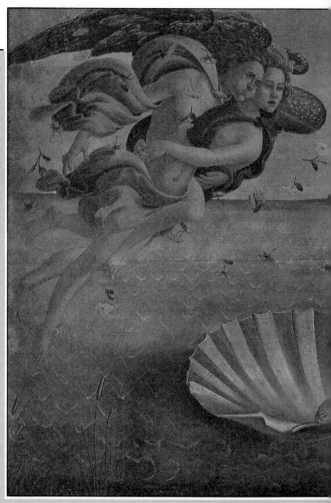

The Birth of Venus

The Birth of Venus may have been painted for Botticelli's patron, Lorenzo di Pierfrancesco de' Medici. Botticelli may also have painted *Primavera* for him but the pictures were not necessarily intended to form a pair – *The Birth of Venus* is smaller than *Primavera* and it is painted on canvas, whereas *Primavera* is on panel. Although *The Birth of Venus* makes sense as a straightforward representation of a classical myth, it is unthinkable – given the learned tastes of the patron – that it does not have some deeper meaning. In humanist thought, Venus was not an erotic symbol, but an embodiment of beauty who could be the inspiration of noble thoughts. To Plato – the Greek philosopher most revered in Lorenzo's circle – beauty was identical with truth.

Lorenzo's villa
Botticelli's patron bought the Villa Castello in 1477. The Birth of Venus *and* Primavera *hung here.*

Zephyr
(below) Venus is blown ashore by Zephyr, the west wind, whose sweet breath begets flowers.

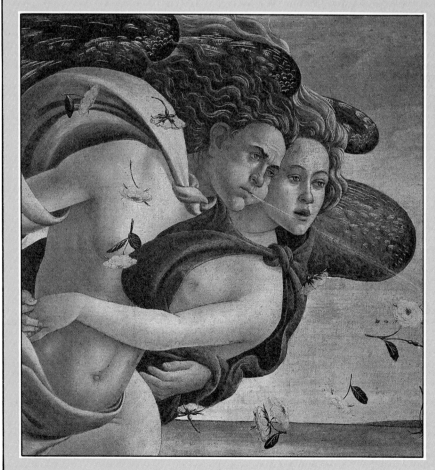

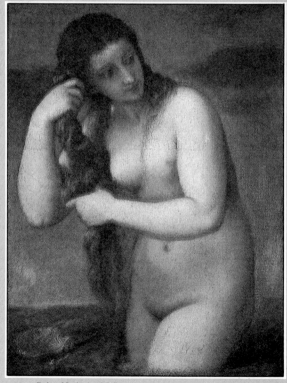

The story of Venus
Strictly speaking, Botticelli's painting does not represent Venus' birth, but her advent into the world. Titian's picture (above) shows her being born from the sea.

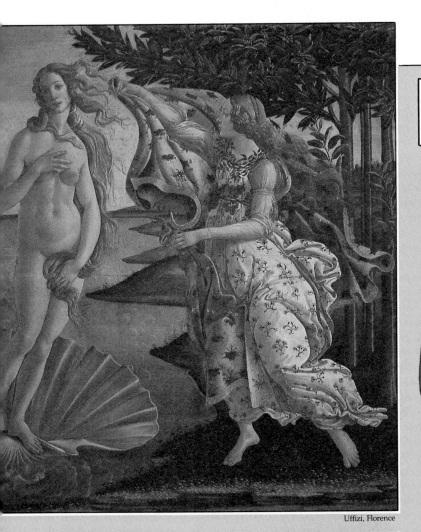

Uffizi, Florence

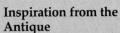

'The greatest artist of linear design that Europe has ever had'
Bernard Berenson

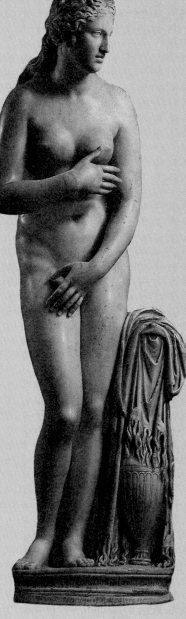

Inspiration from the Antique
(left) Botticelli based the pose of his Venus on an ancient prototype shown in this statue. The pose is known as the 'Venus pudica' (modest Venus) because of the position of her hands, and was common in ancient representations of the goddess. Botticelli's proportions, however, are very different from those of classical statues.

A learned patron
(below) Lorenzo di Pierfrancesco de' Medici (1463-1503) is known by his full name to distinguish him from his more famous cousin Lorenzo the Magnificent. He was very young when he first commissioned Botticelli, but already learned in humanistic culture.

Flora
(left) The goddess of flowers stands on the island of Cyprus, where Venus landed, preparing to cover her naked body with a richly patterned robe.

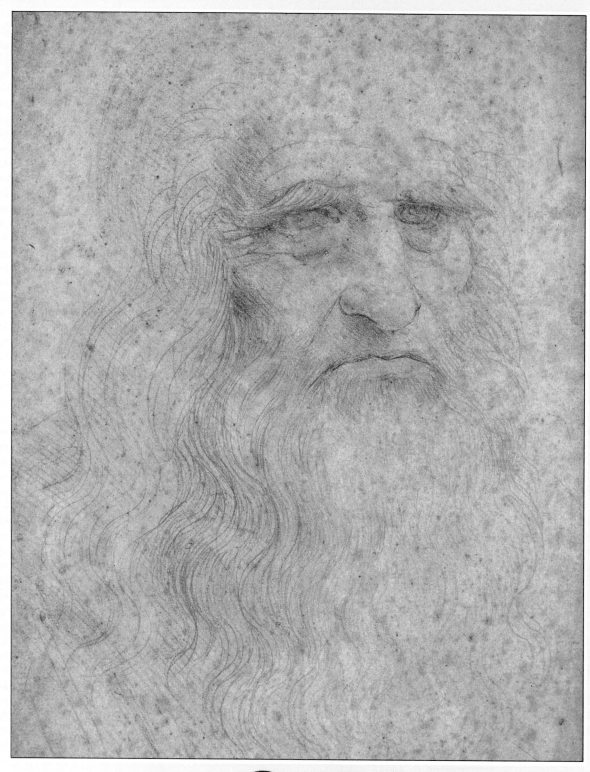

Leonardo Da Vinci

1452-1519

Leonardo da Vinci was not only one of the greatest artists of the Renaissance, but also perhaps the most versatile genius who ever lived. His interests embraced virtually every field of study then known; anatomy and geology were two of his passions, and his great dream was man-powered flight. However, his perfectionism meant that he finished comparatively few major paintings.

Leonardo was born near Florence, but the scene of his most ambitious artistic undertakings was Milan. He spent his last years in France as the guest of King Francis I, revered as no previous artist had been. Although so many of his projects were unfulfilled, his marvellous drawings are eloquent testimony to the power of his incomparably inventive mind.

The Adoration of the Magi (unfinished) *1481-82*
96¾″ × 95½″ Uffizi, Florence

The Universal Man

**Leonardo characterizes the spirit of the Renaissance: he spent his life
in the pursuit of knowledge, and was as revered for his vast intellect
as he was for his astonishing skill as an artist.**

Leonardo da Vinci was born on 15 April 1452 in or near the little town of Vinci, nestling against the slopes of Monte Albano and a day's journey from the glittering city of Florence. He was the illegitimate son of a rising Florentine legal official, Ser Piero da Vinci. Although little is known of Leonardo's mother, Caterina, the boy was acknowledged cheerfully by Ser Piero and was brought up by him and Leonardo's step-mother.

Virtually nothing is known of Leonardo's childhood, though biographers have speculated on the theme of the young Leonardo in the green Tuscan countryside, acquiring his lifelong fascination with nature. Certainly he began drawing and painting at an early age. According to the 16th century artist and art historian Giorgio Vasari, Leonardo's work so impressed his father that he took samples into Florence to show his friend Andrea del Verrocchio, one of the leading

Key Dates

1452 born in or near Vinci, Italy

c.1469 apprenticed to Verrocchio in Florence

1476 accused of sodomy

c.1482 moves to Milan

1483 commissioned for *Virgin of the Rocks*

1493 completes clay model of *The Great Horse* for Ludovico Sforza, Duke of Milan

1495 begins *The Last Supper*

1499 Milan invaded by the French; Leonardo leaves for Venice and Florence

1502-3 works as a military engineer for Cesare Borgia, then returns to Florence

1506 returns to Milan

1512-13 French expelled from Milan; moves to Rome

1516-17 'retires' to Amboise in France

1519 dies in France

The young Leonardo?
(below) It is thought that the figure of St Michael from Tobias and the Archangels, *attributed to Francesco Botticini (1445-97), is a likeness of Leonardo, who would have been about 18 when the picture was painted.*

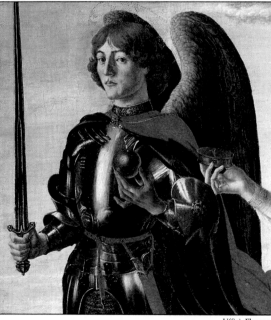

Uffizi, Florence

artists of the day. Verrocchio was also enthusiastic, and Ser Piero enrolled his teenage son in the master's busy workshop.

Verrocchio's workshop, like that of other major artists, was something of a cross between an art school and a design studio. Apprentices such as Leonardo worked their way up from sweeping floors to mixing colours to helping out in the production of commissioned paintings. Leonardo had reached this stage by the age of 20, when Verrocchio gave him responsibility for painting one of the angels in *The Baptism of Christ* (c.1472).

Leonardo's angel radiated his youthful genius. Vasari wrote that Verrocchio 'never touched colours again, he was so ashamed that the boy understood their use better than he did'. Leonardo had 'graduated', and became a master of the painters' Guild of St Luke, which allowed him to set up as an independent painter. However, he remained based at Verrocchio's until the late 1470s.

Leonardo had learned a good deal, in the years that he spent at his master's studio, and not all of it

Arno Landscape (1473)
(right) This pen drawing of the Arno valley is dated 1473 – or rather ƐϹ⅄Ɩ – in Leonardo's customary mirror-writing. The artist's first dated work, it was executed when he was 21 and working in Florence.

Uffizi, Florence

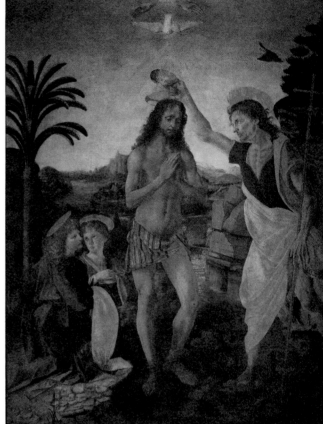

Uffizi, Florence

from Verrocchio. Florence in the 15th century was one of the great cultural centres of the world, and Leonardo would have come into contact with many of the scholars whose new ideas and learning were shaping the intellectual climate of Renaissance Italy. Most importantly of all, he would have known the renowned mathematician, geographer and astronomer Paolo Toscanelli. As Florence's most celebrated scholar, Toscanelli was sure to include among his house guests the best and brightest passing through the city.

A DISTRUST OF SOCIETY

Somewhere about this time, Leonardo became a vegetarian. It was one of many ways in which he seemed to distance himself from his contemporaries. Not that he was a recluse – according to Vasari, 'Leonardo's disposition was so lovable that he commanded everyone's affection', and there are many other accounts of his good looks and charm, as well as his quirky sense of humour that gave him a lifelong taste for practical jokes. Yet he always had a deep distrust of human society: 'Alone you are all yourself,' he wrote, 'with a companion you are half yourself.'

The first years of Leonardo's life as a fully-fledged artist coincided with the rise of supreme power in Florence of Lorenzo de' Medici – 'il Magnifico'. He ruled the prosperous city-state

Leonardo's angel
(above) Leonardo painted the left-hand angel in Verrocchio's Baptism of Christ while he was still an apprentice. The young artist's brilliance so astounded Verrocchio that – according to Vasari – he gave up painting.

The Bridges of Florence
(below) The Ponte Vecchio in the foreground was the first bridge to span the river Arno which runs through Florence and provided the source of energy for the profitable cloth industry.

The towers of Vinci
(above) Leonardo spent his childhood in the quiet hill town of Vinci, amid the rolling Tuscan countryside less than 20 miles from Florence. Two towers dominate the little town: that on the right belongs to the church where – according to local tradition – Leonardo was baptized; that on the left now houses a Leonardo museum.

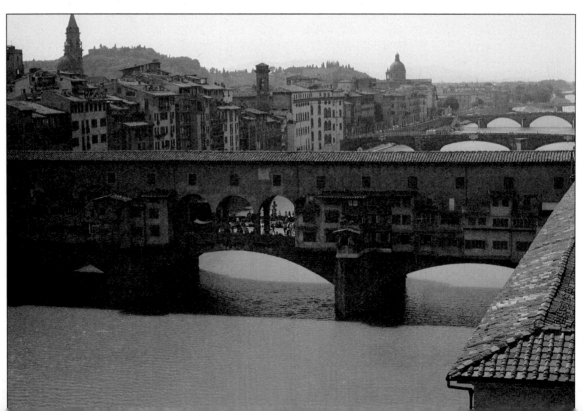

Leonardo's Master

Although the fame of Andrea del Verrocchio (1435-88) has been overshadowed by that of his most brilliant pupil, Leonardo, he was a major artist in his own right. At the time when Leonardo entered his busy workshop, Verrocchio was the principal sculptor in Florence, and one of the most sought after artists in all Italy.

Trained as a goldsmith, Verrocchio's work is marked by its exquisite craftsmanship. And though he practised mainly as a sculptor, he also excelled in metalwork and painting. His reputation attracted some of the most promising young artists to his studio, including Pietro Perugino who later became the master of the great painter Raphael.

Portrait of Verrocchio
(left) This portrait of the master has been attributed to one of his pupils, Lorenzo di Credi. Though Verrocchio's real surname was di Cione, the name by which he is known means 'true eye' – a reflection of his esteemed reputation as an artist.

The Sforza Altarpiece (detail)/Brera, Milan

Uffizi, Florence

Bargello, Florence

The virile and the effeminate
(above and left) These two sculptures by Verrocchio show the two different 'types' of men which also appear in Leonardo's art. In The Colleoni Monument, *the feeling of brute power and restrained energy which emanates from the statue is topped by the rider's sneering face with its deep-cut lines and furrowed brow. A completely different feeling characterizes the figure of David (detail, left) – with his delicate features and enigmatic half-smile.*

with shrewd self-interest, and like many members of his family had cultivated tastes. Yet Leonardo received little of the lavish patronage which abounded in Florence at the time: though he sketched obsessively, in the years he remained in Florence after leaving Verrocchio's studio, he executed – as far as is known – only a handful of paintings. The most important of these, *The Adoration of the Magi*, was left unfinished.

Part of the reason for this surprising lack of official work was that Leonardo, talented though he was, had probably already gained a reputation for not delivering his commissions. Once he had solved the problem of a composition, he tended to lose interest and was ready to move on to the next intellectual puzzle.

But he also had more wordly things on his mind. In 1476, he was twice accused of the crime of sodomy, though both charges were dismissed through lack of evidence. It may well be that he was homosexual – he never married, and later in life usually contrived to have a young man or two about him – but it seems more likely that there was little room in his life for sexual relationships with

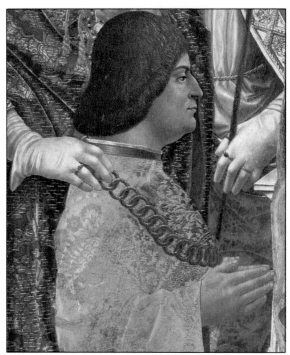

The Sforza Altarpiece (detail)/Brera, Milan

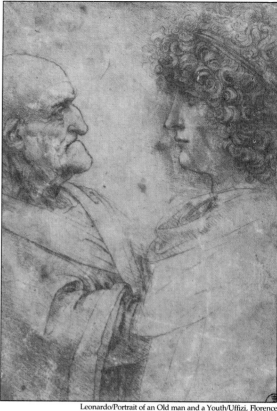

Leonardo/Portrait of an Old man and a Youth/Uffizi, Florence

The city of Milan

(above) Leonardo spent over 20 years of his life in Milan in northern Italy just south of the Alps. Although it boasted the largest cathedral in the country, Milan lagged far behind Florence in both architecture and culture. But it was immensely rich – with thriving textile and arms industries.

either men or women. He distrusted passion of any sort other than intellectual.

And Leonardo's intellectual pursuits were widespread to say the least. Although he despised the violent politics of Medici's Florence, he spent a fair amount of his time in the late 1470s designing a whole armoury of murderous engines, including a primitive machine gun. He was soon to use his ingenuity in this field in an attempt to gain favour – and employment – from one of Medici's rivals, Ludovico Sforza, the ruthless Duke of Milan. Around 1482, Leonardo left Florence, and travelled to this northern city in search of work.

The lovely Salai

(above) This curly haired young man is thought to be Leonardo's friend Salai. The grotesque features of the old man opposite him emphasize Salai's youthful beauty.

His Milanese career got off to a slow start, but in 1483 he received an important commission from the Church of San Francesco Grande. The church's prior may have heard of Leonardo's reluctance to complete a piece of work for he drew up a lengthy contract which specified a seven-month deadline. He could have saved himself the trouble as the painting – *The Virgin of the Rocks* – was not delivered for another 25 years.

A STATUE FOR THE DUKE

While work was beginning on *The Virgin of the Rocks*, Leonardo was already thinking about another – as yet only imagined – work of art. He knew that Duke Ludovico intended to honour his brigand father with a massive equestrian statue, and was determined to gain the commission. He sent the Duke an extraordinary letter in which he outlined his prowess as a military inventor and engineer. Among other startling claims, he declared that he could make bridges that were 'indestructible by fire and battle', and 'chariots, safe and unassailable'. Almost as an afterthought, he offered his services as an architect, a sculptor and a painter.

Leonardo's opportunism had the desired effect. In 1483, he was allowed to begin work on the Great Horse. His projected statue was an immense undertaking. Innovative as always, Leonardo was unwilling to produce the usual static sculpture: he set himself the seemingly impossible task of creating a 26 feet high rearing

Duke Ludovico Sforza

(far left) Ludovico Sforza, the despotic ruler of Milan was nicknamed 'Il Moro' (The Moor) because of his dark complexion. He was a vain and boastful man who ruled his glittering court with an iron hand.

The Duke's child bride

(left) When Il Moro was 39, he married the 15-year-old Beatrice d'Este, whose family ruled the neighbouring city-state of Ferrara. The young duchess delighted in her extravagant life-style, and bore her husband a son when she was 17. But she died in childbirth a few years later.

The Sforza Altarpiece (detail)/Brera, Milan

25

horse. Such a feat had never been achieved before, and much time was needed to solve the problem.

But Ludovico Sforza was not a patient man, and by 1489 he was writing to Florence in search of another sculptor who could get the work done more quickly. Meanwhile, Leonardo made himself a king of Master of Revels at the Duke's court, designing stage machinery and amusing mechanical toys. When no sculptor could be found to take on the Great Horse project, Leonardo was authorized to resume work on it. By November 1493, the full-sized clay model was complete. All that was needed was for Sforza to assemble the 90-odd tons of bronze required for its casting.

While he was waiting for the bronze, Leonardo began work on a huge mural of *The Last Supper* for the nearby monastery church of Santa Maria delle Grazie. Its brilliance was indisputable, and even before it was finished, it drew many admiring pilgrims to the monastery. But Leonardo had used a disastrously experimental technique and within a few years his masterpiece was peeling off the damp wall of the monastery's refectory.

SUCCESS AND ADMIRATION

At the time though, neither Leonardo nor his contemporaries knew what lay in store. At 42, he was at the peak of his career, admired and respected by all. He had his own school of apprentices, and had never been busier. Perhaps he fretted when he heard that Ludovico had sent the bronze once destined for the Great Horse to his embattled brother-in-law to make cannons. But there were brighter things to think of.

He had acquired a protégé – a young boy 'with lovely hair and lovely curls and well-shaped eyes and mouth', known as Salai. And he was writing his *Treatise on Painting*, a huge work which was to influence artists for centuries to come.

Leonardo's notebooks were filling rapidly, crammed with sketches and comments written in his precise, left-to-right, mirror-image hand. He could see nothing without wanting to study it: birds, plants, the movement of water. Above all, he became passionately interested in human anatomy, and increasingly involved with the grim but fascinating business of dissection. And what did not exist to observe, he could imagine. During these years came the first flood of inventions – a submarine, a tank, even a helicopter.

Leonardo continued to shower his patron with grandiose proposals for great works of architecture and civil engineering. He took up town planning, and produced a massive scheme for the rebuilding of all Milan, with airy boulevards and an impeccable sewage system. But Ludovico was rarely interested: by the end of the century, he was struggling to keep control of the city. In 1499, Milan fell to Louis XII of France.

With Ludovico and his court gone, there was nothing to keep Leonardo in Milan, and he left the city. But he had stayed just long enough to see the entry of Louis's army, and the destruction of a

Leonardo's Drawings

Leonardo made hundreds of sheets of drawings, which display the universal nature of his interests. He used them primarily as an aid to scientific research, although their preoccupations are often reflected in his paintings. They were usually accompanied by observations in his famous mirror writing.

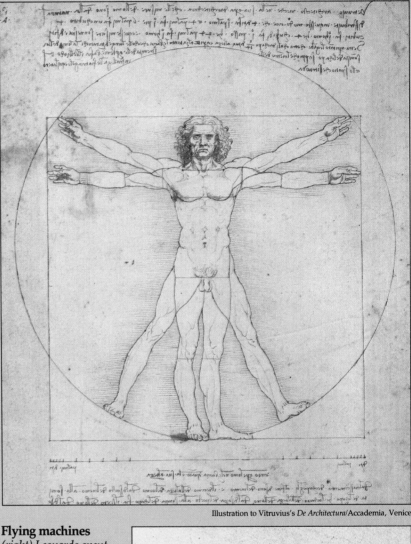

Illustration to Vitruvius's *De Architectura*/Accademia, Venice

Flying machines
(right) Leonardo spent more than 20 years of his life trying to devise a way for man to fly. He studied the flight of birds, bats and even insects, and invented a variety of ingenious machines. One of his most incredible contraptions was the 'aerial screw' – or helicopter – based on contemporary whirligig toys.

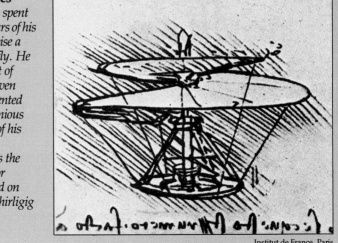

Institut de France, Paris

The Proportions of the Human Figure (c.1492)
(left) This famous drawing illustrates a passage from a Roman treatise on architecture, in which man is shown to be 'the measure of all things'.

Botanical drawings
(below) This study of crowfoot, star of Bethlehem, wood-anemone and leafy-branched spurge may have been connected with the lost painting of Leda.

Ideal architecture
(right) Leonardo made several drawings of ideal churches – none of which were ever built. He clearly delighted in playing elaborate games with geometric shapes.

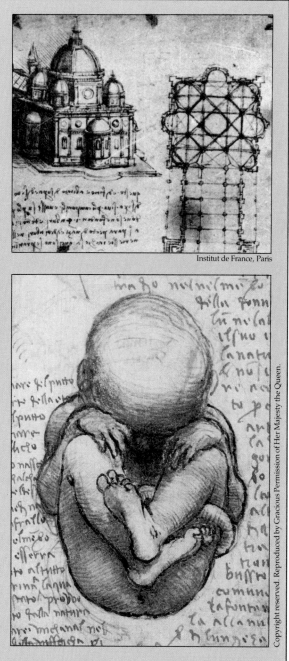

Institut de France, Paris

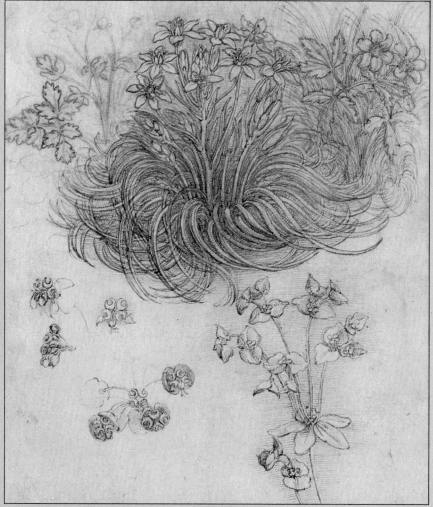

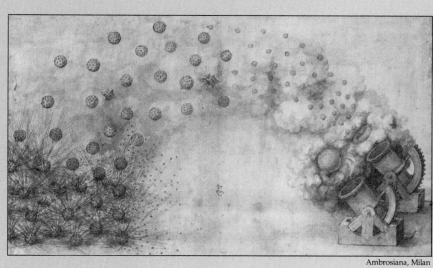

Ambrosiana, Milan

Military devices
(left) Leonardo designed a whole range of war machines for Ludovico Sforza, including these deadly mortar bombs. The holes in the mortars meant that they exploded into fragments – a horribly practical idea. Leonardo assured Ludovico that if bombardment should fail he could 'contrive endless means of defence and offence'.

Anatomical studies
(above) When he was in his last years, Leonardo claimed that he had dissected over 30 bodies of men and women of all ages. He recorded his findings with scientific accuracy, and even planned a treatise on anatomy. His researches include an analysis of the human nervous system and a study of the position of the foetus in the womb.

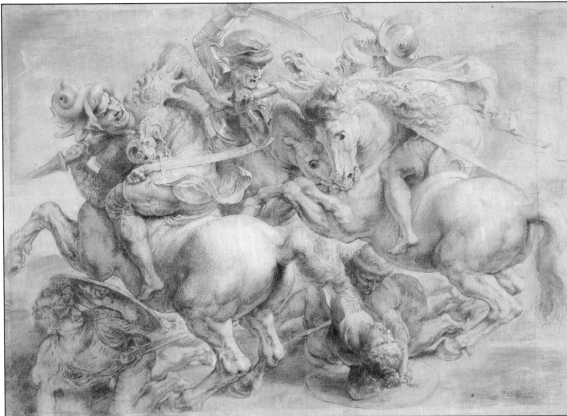

The Battle of Anghiari
(left) In 1503, Leonardo began work on a battle scene for Florence's council chamber. Working opposite him was his rival Michelangelo, who was depicting another scene, The Battle of Cascina. *Michelangelo left his work unfinished. Leonardo used a disastrously experimental technique. All that remains of his great mural are drawings and copies like this one by Rubens.*

Leonardo's beneficiary
(below) This young man has been identified as Francesco Melzi, whom Leonardo favoured in his will.

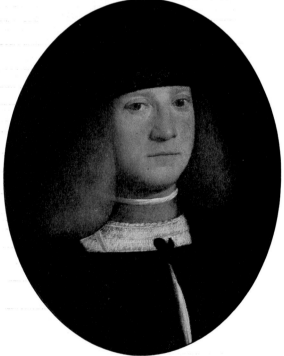

personal dream. For during a week of drunken plunder, the French archers had found his huge clay model, and used it for target practice. His Great Horse was in ruins.

Accompanied by Salai, now a young man of about 20, Leonardo travelled east to Venice. He stayed only a few months, and soon turned his steps southwards to Florence, the home he had not seen for 18 years. In the interim, his reputation had rocketed, and he was received with respect, but it seems that he was not ready to settle in Florence. In 1502 he left the city, enlisting in the service of the infamous Cesare Borgia.

BORGIA'S MILITARY ENGINEER

For Borgia was engaged in conquests in central Italy, and he needed a military engineer. Leonardo was the perfect choice – for apart from being the best brain in Italy, his respectability and renown would lend some credibility to Cesare's treacherous court. So for a few months in 1502-3, Leonardo wandered around Italy inspecting fortifications – and then suddenly shrugged off his connection with Borgia. He returned to Florence to live as an artist again.

It was a productive period for Leonardo. Around this time he produced the most celebrated of all his works – the *Mona Lisa*. But the other major work of this period turned out to be another technical disaster. In 1503, the government of Florence commissioned him to paint an epic picture of *The Battle of Anghiari*, to glorify an encounter in a war with Milan some 60 years before. As with *The Last Supper*, Leonardo used an experimental technique, the ruinous effects of which soon became obvious. The Florentines demanded that he either repair the painting or refund the payments they had made.

Typically, Leonardo ignored the demands. He was living in his villa in nearby Fiesole, drawing and sketching industriously, and was only rescued from some sort of legal action by the arrival of a gracious summons from the French Viceroy in Milan, Charles d'Amboise.

D'Amboise had no authority in the Florentine Republic, but the city had enemies enough without making more. So the Florentines parted

with their artist, who was rapturously received in Milan. Anatomy became Leonardo's ruling passion once more: he was certain that his work would be of lasting benefit to humanity, and pushed himself accordingly.

But his life was not all work. In 1508, he found himself another protégé, a handsome young man named Francesco Melzi, whom he went so far as to adopt as his son. Perhaps, if it had been up to Leonardo, he would have passed the remainder of his life in Milan. But in 1512 an improbable alliance between the Swiss, the Spaniards, the Venetians and the papacy contrived to expel the French from Milan and install as Duke the son of Ludovico Sforza. Leonardo's comfortable world at the Viceroy's court had been shattered. At 61 years of age, he packed up his belongings, and – accompanied by Salai and Melzi – set off for Rome.

A new pope had just been elected – Leo X, the son of Lorenzo de' Medici. Leonardo had some hopes of exciting new commissions, and appears to have been in good spirits at first. But the pope had little time for him: Leonardo was yesterday's man now, with a string of uncompleted works and grandiose failures behind him. So when Francis I, successor to Louis XII of France, offered him a gentler oblivion as an honoured pensioner in a manor house close to the royal palace at Amboise, Leonardo accepted and moved to France.

Ageing, frail, and with his left hand partially paralyzed by a stroke, Leonardo fussed over his manuscripts, preparing them in a half-hearted way for publication. In one of his notebooks he had written: 'As a well-spent day brings happy sleep, so life well used brings happy death.' And quietly, on May 2 1519, a few weeks after his 67th birthday, Leonardo da Vinci died. The world had lost perhaps its most universal genius.

Retirement in France
(above) Leonardo spent his final years in the manor house of Clos-Lucé in the Loire valley. The house is now a Leonardo museum.

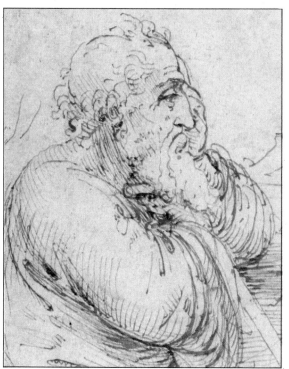

An aged sage
(above) This drawing by Leonardo (c.1513) is sometimes thought to be a self-portrait. Certainly, the image of a world-weary old sage, contemplating his long life would have had much in common with Leonardo in his 60s.

The Death of Leonardo da Vinci
(right) This imaginative reconstruction was painted by the 19th century master Ingres. It shows the artist dying in the arms of King Francis I of France – an indication of the status which Leonardo had achieved.

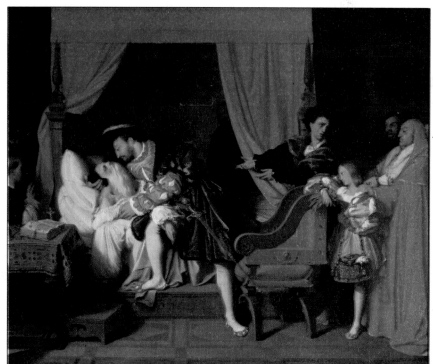

Petit Palais, Paris

'Motions of the Mind'

As a painter, Leonardo wanted to represent not only appearances but also feelings – 'the motions of the mind'. This approach changed the status of the great artist from craftsman to genius.

In his *Lives of the Artists,* first published in 1550, Giorgio Vasari wrote that Leonardo's 'name and fame will never be extinguished'. The claim has been borne out by posterity, for Leonardo is one of the few artists whose reputation has never wavered from his own lifetime to the present day. His contemporaries thought his talent was little less than divine, and in the centuries since his death, painters, poets and philosophers have looked to him as a shining example of the heights to which the human mind and spirit can attain.

Leonardo's surviving artistic output seems a remarkably thin platform for such widespread and lustrous fame. Scarcely a dozen paintings are universally accepted as being from his own hand, and of these several are unfinished or damaged.

Leonardo's achievement, then, is of an altogether exceptional kind, for although he began

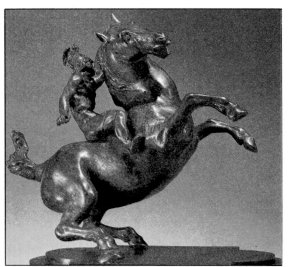

Museum of Fine Arts, Budapest

Leonardo the sculptor
Although Leonardo spent much of his time working on sculptural projects, there is no surviving piece of sculpture that is unquestionably from his own hand. This marvellously spirited bronze horse and rider has the best claim to be considered an authentic work by him. It has an energy and a mastery of equine anatomy typical of Leonardo, and is related in style to his Battle of Anghiari *mural.*

comparatively few major works, and finished even fewer, he has imposed himself on the consciousness of artists and critics (and even the general public) in a way that only a handful of other cultural giants can match. This seeming paradox is explained not simply by the wonderful quality of the few paintings Leonardo did bring to fruition, but also by the revolution in attitudes towards art that he brought about. Virtually single-handed, Leonardo created the idea of the artist as genius. Earlier painters had achieved wealth, fame and position, but they were still regarded essentially as craftsmen, for in the Middle Ages and early Renaissance the visual arts were not considered to be on the same intellectual plane as literature or music.

THE PAINTER-PHILOSOPHER

To Leonardo, the art of painting lay as much in the head as in the hands, and after him it was no more possible to judge a painting by the costliness of its materials than it was to judge a piece of music by the number of notes it contained or a poem by its number of words. Leonardo believed that painting was superior to any other art, and he presented his case ingeniously; people make

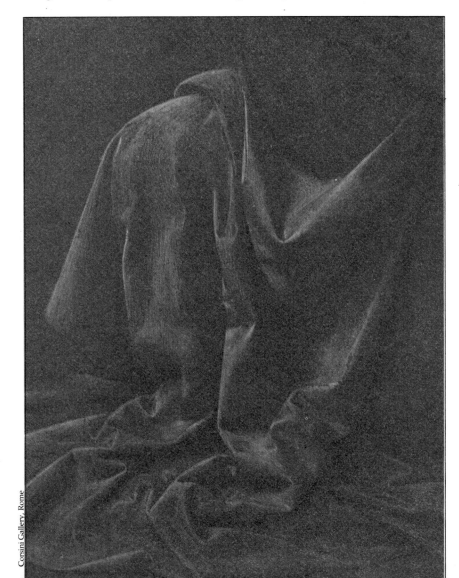

Corsini Gallery, Rome

A patient draughtsman
Leonardo often made elaborate drapery studies for his paintings – this detail of one was probably for The Annunciation *(p.94). Vasari tells us that Leonardo 'would make clay models of figures, draping them with soft rags dipped in plaster and then draw them patiently'.*

pilgrimages to see great paintings, he argued, but no-one travels miles to read a poem. And to him the clinching argument in favour of the visual arts was that anyone would rather lose their hearing than their sight. He thought that painting was superior to sculpture in that the latter involves hard, noisy and messy physical labour, whereas the painter could wear fine clothes and listen to music or poetry as he worked.

Leonardo's fascination with the intellectual problems of art is one reason why his drawings so outnumber his paintings. He thought that the painter had to represent two main things: man and 'the motions of man's mind'. The first part – the naturalistic representation of appearances – was, to Leonardo, straightforward; the second part – the revelation of character through gesture and expression – was more difficult.

Once Leonardo had solved the problems of composition and characterization in his drawings, completing the job – the mere exercise of technical skill – held little appeal. He infuriated his paymasters by putting things off, and his failure to complete *The Virgin of the Rocks* for the church in Milan that had commissioned it led to a law suit.

When he could bring himself to finish a picture, however, Leonardo outshone even the greatest of his contemporaries. Oil painting was at that time a fairly new technique in Italy and Leonardo was

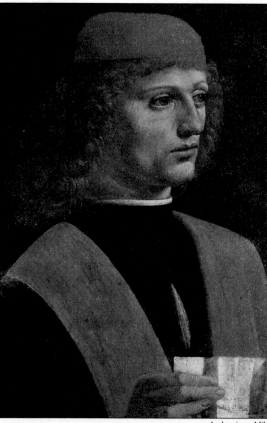

Ambrosiana, Milan

Portrait of a Musician (c.1490)
This unfinished picture is Leonardo's only surviving male portrait. The attribution to Leonardo is disputed by some authorities, but the exquisitely curling hair, elegant fingers and air of intellectual intensity are worthy of the master. Leonardo himself was a skilful musician.

St Jerome (c.1480)
(below) It is not known for whom Leonardo painted this picture or why he left it unfinished. Leonardo's understanding of anatomy shows clearly in the thoroughly convincing portrayal of the ascetic saint's sinewy body.

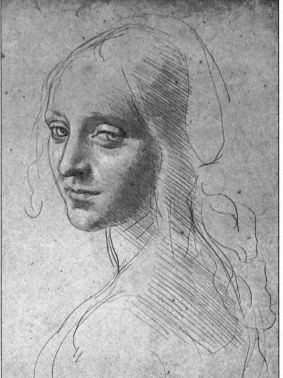

Left-handed shading
(above) Leonardo was left-handed, and this silverpoint drawing shows his distinctive left-handed shading. A right-handed artist instinctively shades with lines going from right down to left, but a left-handed draughtsman shades in the reverse.

one of the first great masters of it. To a profoundly thoughtful worker like him, slow-drying oil paints were the ideal medium, allowing him to make infinitely subtle gradations of tone and to paint details such as plants and rocks with an exquisite precision that would gladden the heart of a botanist or a geologist.

Leonardo wanted to attain the same beauty of finish when he painted murals, so he rejected the time-honoured fresco technique, which demanded great swiftness in execution. His experiments to find a suitable alternative were disastrous; *The Last Supper*, painted in a kind of tempera, began to peel off the wall in his lifetime, and *The Battle of Anghiari* ran down the wall when the paint failed to dry (he was trying to imitate a technique described by the Roman writer Pliny).

THE MASTER DRAUGHTSMAN

With the exception of *The Battle of Anghiari*, almost all Leonardo's paintings were either religious subjects or portraits. His drawings, however, cover an astonishing range of subjects, for he used them not only as preparation for his paintings, but also as an essential tool in his scientific research. He was the most prolific draughtsman of his time and used a wide variety of media, notably pen, chalk and silverpoint, in which the artist draws with a fine silver wire on specially prepared paper. The silver produces extraordinarily delicate lines, but the technique needs great sureness as erasure is impossible.

The sheer variety of Leonardo's interests was the main reason why he finished so little in his primary vocation of painting. Apart from his manifold scientific pursuits, he was also a sculptor and an architect. No work that is indisputably his survives in either medium, but his ideas and expertise were important in both fields.

The splendid bronze group of *St John the Baptist between a Pharisee and a Levite* over the north door of the Baptistery in Florence, for example, is the work of Giovanni Francesco Rustici, but Leonardo played a major role in its creation. Vasari tells us

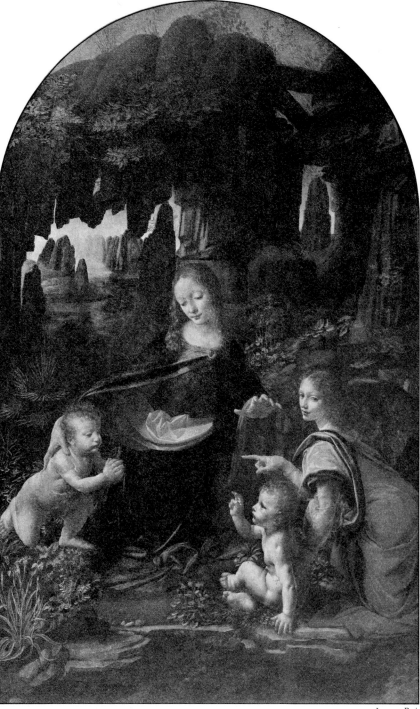

Louvre, Paris

The Virgin of the Rocks (c.1483)
(above) This is the earlier of two versions of the subject that Leonardo painted. The strange rocks that create the grotto setting (detail, above right) are a common feature in Leonardo's work. He was passionately interested in geology, which to him was part of the mystery of creation.

A study in perspective
Leonardo made this complex perspective drawing as a preparatory study for The Adoration of the Magi (p.21). The lines have been drawn in silverpoint, using a rule, and the figures are drawn on top in ink.

Uffizi, Florence

The Pointing Finger

A figure with an enigmatic pointing finger often occurs in Leonardo's work. The finger usually points upwards, but in *The Virgin of the Rocks* the angel points emphatically at the infant John the Baptist. Whatever its significance for Leonardo, the gesture now evokes a sense of mystery.

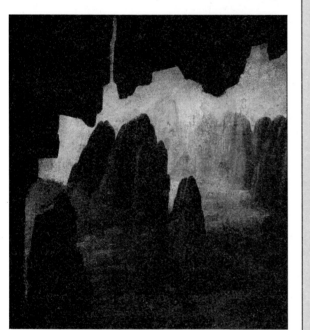

that Rustici 'would allow no one near save Leonardo, who never left him while he was moulding and casting until the work was finished'. In architecture, Leonardo's designs for 'ideal' churches were influential on his friend Bramante, the greatest architect of the High Renaissance, and the ingenious double spiral staircase at the château of Chambord probably derives from an idea of his.

Leonardo's influence was spread also by his writings. His notes were gathered together and published as his *Treatise on Painting* in 1651, but they had wide circulation even before then. The few paintings that he left to posterity (or that survived long enough to be copied and re-copied) had an unprecedented effect on succeeding artists. Indeed, Leonardo's influence has been so great that it is harder to think of major painters who do not owe something to him than of those who do.

Landscapes of the Imagination

Landscape painting did not become established as an independent subject of art until the 17th century. But painters before then often made telling use of landscape backgrounds or settings, naturalistic or imaginative. Mantegna was one of the greatest Italian painters of the generation before Leonardo. His style is strong and hard-edged, and although his rockscape reveals an imaginative power comparable to Leonardo's, it does not have the latter's sense of mystery. Landscape played a comparatively small part in the wide-ranging genius of Rembrandt, the greatest Dutch artist of the 17th century, but he brought to it his own sense of brooding intensity.

National Gallery, London

Andrea Mantegna (c.1430-1506)
The Agony in the Garden
(above) Mantegna depicts Christ in anguish as he prays in the Garden of Gethsemane during the night before his Crucifixion. The sharp-edged rocks create emotional tension.

Rembrandt van Rijn (1606-69)
Stormy Landscape
(below) Rembrandt created drama in his landscapes less by the subject he depicted than by his forceful handling of light and shade. His half-defined forms loom from mysterious shadows.

Herzog Anton Ulrich Museum, Brunswick

THE MAKING OF A MASTERPIECE

The Last Supper

The Last Supper was painted for the refectory (dining-room) of the monastery of Santa Maria delle Grazie in Milan. Leonardo probably took about three years on the work, from 1495 to 1498. The time-honoured method for wall-painting was fresco, but Leonardo rejected this for a more flexible technique using paints that would normally be applied to a wooden panel.

The process proved unstable and the painting soon began to peel off the wall. Vasari recorded that 'the prior was puzzled by Leonardo's habit of sometimes spending half a day at a time contemplating what he had done so far', but when he complained Leonardo explained that 'men of genius sometimes accomplish most when they work the least, for they are thinking out inventions and forming in their minds the perfect idea that they subsequently express with their hands.'

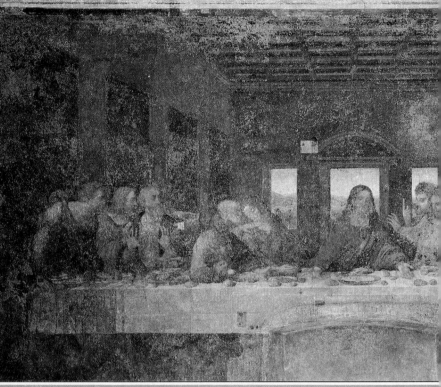

Royal Library, Windsor

A study for St James
(above) Leonardo made several beautiful drawings for individual heads in The Last Supper, *and this red chalk study for St James the Greater (fifth from the right in the painting) is one of the finest. In the lower part of the sheet is an architectural study — Leonardo's mind was always wandering.*

Restoring a masterpiece

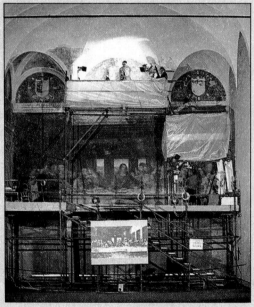

Restoration in progress
(left) The Last Supper began to decay in Leonardo's lifetime, and some 50 years after the artist's death Vasari described it as 'so badly preserved that one can see only a muddle of dots'. It was first restored in 1726, and since then there have been numerous attempts to repair or preserve it, some doing more harm than good. The restoration at present in progress may take five years to complete.

Infinite patience
(right) Sometimes spending a day on an area the size of a postage stamp, the restorer is cleaning off almost five centuries of dirt, mould and overpaint. In some areas of the picture none of Leonardo's original paint survives.

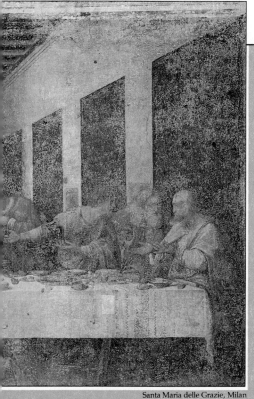

Santa Maria delle Grazie, Milan

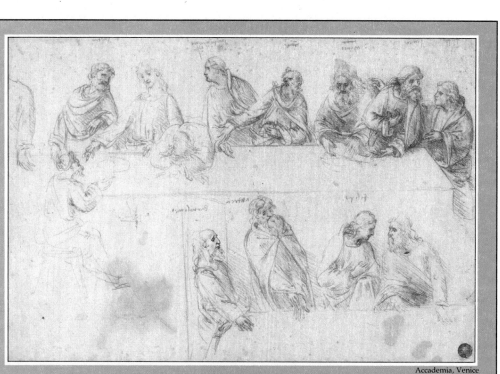

Accademia, Venice

Planning the composition
(above) One of Leonardo's preliminary drawings for The Last Supper *shows that he originally thought of separating Judas from the other figures on the near side of the table. He rejected this as too crude.*

The monks' dining-room
(below) The Last Supper was a highly appropriate subject for a dining-room and was often chosen for the refectory of a monastery. The refectory at Santa Maria delle Grazie was newly built when Leonardo painted his mural, which covers one of the end walls of the building.

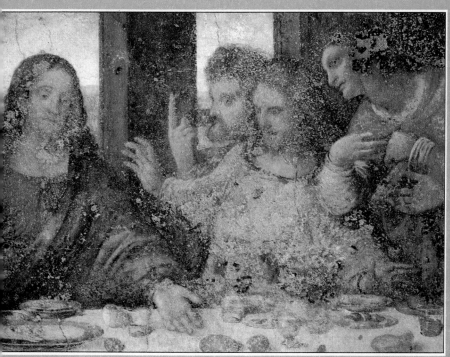

> 'That figure is most praiseworthy which by its action best conveys the passions of the soul.'
>
> Leonardo da Vinci

Groups of three
(above) Leonardo has arranged the twelve disciples into four groups of three. The composition is so skilful and fluent that it is rarely noticed that he has taken liberties with the spacing. The disciples are so tightly packed that they could not possibly all have been sitting down together.

Mike McGuinness

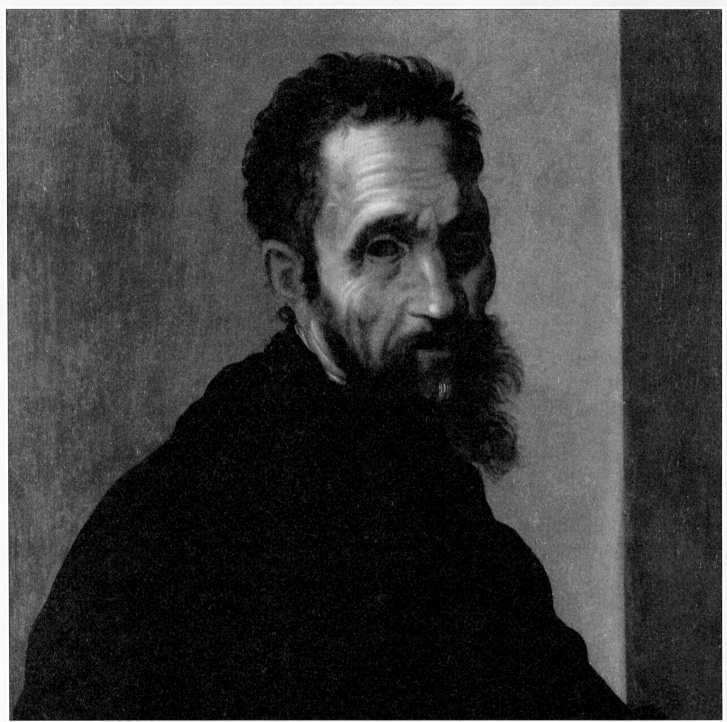

Jacopino del Conte/Portrait of Michelangelo/Casa Buonarroti, Florence

MICHAEL·AGLVS·BONAROTVS·

1475-1564

Michelangelo is one of the greatest artists who ever lived: his astonishing career encompasses the arts of painting, sculpture, architecture and even poetry. A proud citizen of Florence, he was determined from the first to raise the status of his family by virtue of his art. His ambition was soon fulfilled when he was taken into the household of Lorenzo de' Medici.

Michelangelo's reputation preceded him and he subsequently travelled to Rome, lured by prestigious commissions. Here he painted the celebrated Sistine Ceiling frescoes for his most formidable patron, Pope Julius II. Despite his fame, Michelangelo was a sad, highly sensitive and solitary figure. He died at the age of 89 and was buried, with great pomp, in Florence.

The Taddei Tondo *c.1504-5*
Diameter: 47¾" Royal Academy of Arts, London

The Divine Michelangelo

A native of Florence, Michelangelo spent much of his long life in Rome, working for the popes. His creative powers and the diversity of his skills earned him the epithet 'divine'.

Michelangelo di Ludovico Buonarroti Simoni (known as Michelangelo) was born on 6 March 1475 in the Tuscan town of Caprese, near Arezzo. His family were natives of Florence and they returned to the city within a few weeks of the birth, when Ludovico Buonarroti's term as mayor of Caprese had ended.

Soon after their arrival, the Buonarrotis sent the baby to a wet-nurse living on the family farm a few miles away in Settignano. This environment seems to have had a crucial effect on Michelangelo, for the area around Settignano was full of stone quarries. His wet-nurse's father and husband were both stonemasons, and Michelangelo often jested later in life that 'with my wet-nurse's milk, I sucked in the hammer and chisels I use for my statues'.

From an early age the young Michelangelo was consumed with artistic ambition. As a boy of 13, he persuaded his reluctant father to allow him to leave his grammar school and become an apprentice to the artist Domenico Ghirlandaio, one of the most successful fresco painters in Florence.

Michelangelo's remarkable gifts soon became apparent and, within a year or so, he was making pen line drawings that put his master's to shame. By 1489, Michelangelo was sent, along with a few of the best artists in Ghirlandaio's studio, to Lorenzo de' Medici's new 'sculpture school' in the Medici gardens. Here among the trees was one of the most impressive collections of ancient statuary

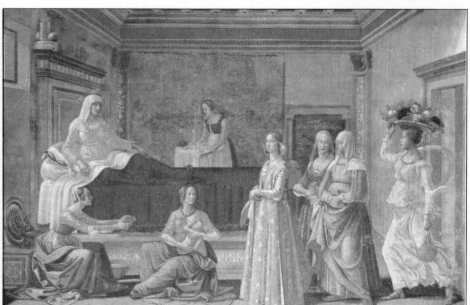

A formative influence
(left) In April 1488 Michelangelo joined the workshop of Domenico Ghirlandaio, one of the finest Florentine fresco-painters of his day. At this time Ghirlandaio was engaged in the biggest commission of his career – a series of frescoes on the life of the Virgin and St John the Baptist in the church of Sta Maria Novella in Florence. As an apprentice, Michelangelo was probably involved in the work, and was introduced to the techniques of fresco painting.

The city of Florence
(above) This view shows Florence in 1490, when Michelangelo was employed in the Medici household. Florence was also the Buonarroti family's native city.

An enlightened ruler
(right) Widely respected for his skilful statesmanship, Lorenzo de' Medici was also a sensitive and intelligent man. A humanist poet and a great patron of the arts, he made his palace a home for leading philosophers and artists.

in Italy, and under the watchful eye of the aged sculptor Bertoldo, Michelangelo began to copy and improve on these antique masterworks.

The young Michelangelo's prodigious skill – and, perhaps, his single-mindedness – soon aroused jealousy among his fellow students in the garden. His biographer and friend, Giorgio Vasari, tells of how another young sculptor, Pietro Torrigiano, later described as a bully, punched him violently in the face, crushing and breaking his nose. Michelangelo was deeply upset by the incident, and by the disfigurement to his face – physically, and psychologically, it seems to have 'marked him for life' (Vasari).

Michelangelo's skill now attracted the personal attention of Lorenzo de' Medici (called 'the Magnificent'), who was effective ruler of Florence at the time. He was so impressed by a statue Michelangelo was carving that he invited him to live in the Medici household.

CHANGING FORTUNES

Michelangelo spent two happy years in the Medici household and worked on an impressive marble relief, *The Battle of the Centaurs*. But when Lorenzo died in 1492, Michelangelo's fortunes began to take a downward turn, and he went back to live with his father. Lorenzo's successor, Piero de' Medici, was friendly to the artist but had little interest in art. Indeed, the only work Piero commissioned from Michelangelo was a snowman, a childish whim after a heavy snowfall in January 1494. As a consolation, Michelangelo devoted his skills to a detailed study of anatomy by dissecting corpses in the church of Santo Spirito – a curious privilege bestowed by the prior in return for a carved wooden crucifix.

Under Piero's rather haphazard reign, political Florence became increasingly unstable and blood and thunder preachers found wide audiences. A charismatic Dominican called Savonarola had a

The bully of the class
(above) Pietro Torrigiano was a fellow student of Michelangelo's in Bertoldo's sculpture class. During a sketching expedition to Masaccio's chapel in the church of the Carmine, he punched Michelangelo in the face and broke his nose.

Carrara marble
(below) Michelangelo favoured the marble quarry at Carrara because the stone was so white and pure. He spent months here personally supervising the cutting and shipping of the stone.

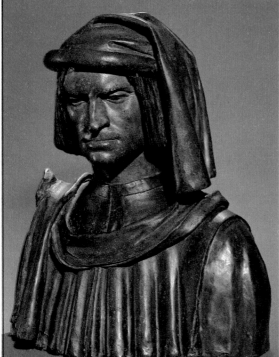

Key Dates

1475 born in Caprese, near Arezzo. Family moves to Florence

1488 apprenticed to Domenico Ghirlandaio

1489 joins Lorenzo de' Medici's 'sculpture school'

1494 Italy invaded by Charles VIII of France. Leaves for Venice

1496 first visit to Rome

1501 returns to Florence; carves *David*

1505 returns to Rome; commissioned to build tomb for Pope Julius II

1508 begins painting the Sistine Ceiling

1527 Rome sacked by Charles V. Medicis expelled from Florence, where Michelangelo supervises the building of fortifications

1529 Medicis return to Florence; flees to Venice but later returns

1534 leaves Florence for Rome, where he meets Tommaso Cavalieri

1536 meets Vittoria Colonna; begins *The Last Judgement*

1547 made Architect-in-Chief of St Peter's. Vittoria Colonna dies

1564 dies in Rome

particularly disturbing influence, denouncing the corruption of Florence and prophesying the imminent doom of the sinful city. The invasion of Italy by Charles VIII of France added fuel to the unrest. Apparently, with the words of Savonarola ringing in his ears, Michelangelo packed up and left for Venice in October 1494 – the first of his many 'flights'.

After a period in Venice, Michelangelo went to Bologna, where he remained for a year. He then returned briefly to Florence in 1495 where he carved a life-size figure of a sleeping Cupid. This was such a fine piece of work that one of the Medicis suggested it could be passed off as an antique. According to rumour the Cupid was later sold in Rome behind Michelangelo's back as a classical statue.

A VISIT TO ROME

In 1496 Michelangelo was summoned to Rome as a result of the famous 'Sleeping Cupid affair' which had made him a reputation. Here, he carved the marble *Bacchus* for the banker, Jacopo Galli, and the famous *Pietà* (p.98), now in St Peter's, for the French Cardinal Jean Bilhères de Lagraulas. The startling beauty and originality of the *Pietà* brought Michelangelo enduring fame. He was soon being heralded as Italy's foremost sculptor. By 1501, he was able to return to Florence as a hero. There he carved the magnificent statue of *David* (p.99) further enhancing his reputation. The statue was placed in front of the Palazzo della

The papal city
(above) Michelangelo first visited Rome in 1496, summoned by the cardinal who had bought his statue of Cupid as an antique. It was the first of many long stays in the city, where his patrons included seven popes. Here he accomplished the most remarkable achievement of his career – the painting of the Sistine Chapel ceiling.

The Laocoön
(left) Michelangelo was present when this famous antique statue of Apollo's disobedient priest was discovered in Rome in 1506. The twisting poses and violent emotion of the three male figures struggling with the sea serpents had an enormous influence on his art.

Pio-Clementino Museum, Vatican

The Tragedy of the Tomb

In 1505, Pope Julius II commissioned Michelangelo to build a monumental tomb to immortalize his memory. This grandiose project plagued Michelangelo for over 40 years. Abandoned by Julius in favour of the rebuilding of St Peter's, the project was revived by successive popes who each modified the design, but then made it impossible for Michelangelo to find the time to complete it. It was finally finished in 1547.

Raphael/Mass at Bolsena (detail)/Stanza d'Eliodoro, Vatican

Signoria, where it stood as a symbol of Republican freedom, courage and moral virtue.

The legendary sculptor went from strength to strength. Soon after the death of Pope Alexander VI he was summoned back to Rome to serve the new Pope, Julius II. Julius was the first of the seven popes that Michelangelo worked for and their relationship was tempestuous.

In the spring of 1505, Julius commissioned Michelangelo to create a tomb for him. It was to be a free-standing shrine with over 40 statues, a grand monument to himself. The scale of the project suited the scope of Michelangelo's vision, and he spent eight months enthusiastically quarrying marble at Carrara. But the Pope soon began to grow impatient at the lack of results and gradually started to lose interest.

A PLAN FOR ST PETER'S

By then, the Pope had conceived an even grander plan for the complete rebuilding of the church of St Peter's in Rome, and he had entrusted the design to his favourite architect, Bramante. When Michelangelo returned to Rome, burning with desire to make his magnificent vision live, the Pope refused to see him.

Michelangelo left Rome for Florence in a fury, deliberately leaving the day before the laying of the cornerstone for the new St Peter's. Pope Julius matched his wrath, however, and sent envoys and demands for his return 'by fair means or foul'. Eventually Michelangelo succumbed, and went to

A Florentine patriot
(below) Following the sacking of Rome in 1527, the Florentine republic made Michelangelo their chief of defences. He is shown here directing the building of fortifications, with S. Miniato church in the background.

Matteo Rosselli/Casa Buonarroti, Florence

the Pope with a rope around his neck – a sarcastic gesture of submission. Julius, who was in a more amenable mood, having just conquered Bologna, rewarded Michelangelo with a commission for a colossal statue of himself, to be cast in bronze. (The statue was later destroyed.)

Michelangelo was still dreaming of completing the tomb, but Julius was bent on redecorating the Sistine ceiling. Michelangelo eventually accepted the commission, possibly goaded on by Bramante's suggestion that he might lack the ability for such a task. But he always insisted that painting was not his trade, and he again tried to get out of the commission when spots of mould started to appear on the first section of his fresco. By 1512, after four years of exhausting labour, however, the ceiling was finally completed. When his work was unveiled, the effect was awe-inspiring and people would travel hundreds of miles to see this work of an 'angel'. As usual, Michelangelo sent the money he received for the work to his demanding family.

Julius died in 1513, leaving money for the completion of his tomb, and Michelangelo moved some marble he had quarried from his workshop near St Peter's to a house in the Macel de' Corvi, which he kept from 1513 until his death. Successive popes were keen that Michelangelo should work for their own glory, and distracted him with other commissions.

The tomb of Julius II
(right) The concept of the tomb changed from a free-standing structure decorated with some 40 figures to a wall tomb in the church of S. Pietro in Vincoli. Finished with the help of another sculptor, only the three lower statues, including the central figure of Moses, are by Michelangelo.

Michelangelo's greatest patron
(left) During the ten years of his pontificat Julius II commissioned some of Michelangelo's finest works, but they were both strong-willed men, and their relationship was extremely tempestuous. A formidable character, Julius was 'hated by many and feared by all'.

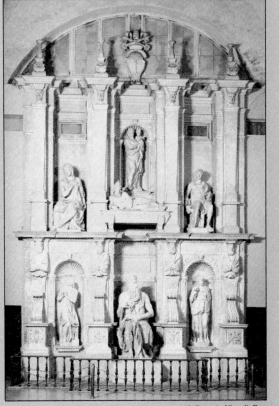

S. Pietro in Vincoli, Rome

Then, in 1527, Rome was sacked by the Imperial troops of Charles V, a mainly protestant army bent on the destruction of the Papacy. An orgy of murder and pillage followed and Pope Clement VII was imprisoned in the Castel Sant' Angelo. The Medici were yet again expelled from Florence, and the republicans put the artist in charge of the fortifications of his native city. In September 1529, fearing treachery, Michelangelo fled wisely to Venice.

Eventually Pope Clement VII, then restored to power in Rome, wrote to pardon Michelangelo and ordered him to continue work on a chapel for the Medicis at San Lorenzo in Florence. Michelangelo finished the tombs for the Medici chapel, but in 1534, three years after his father's death, he left Florence in the tyrannical grip of Alessandro de' Medici, never to return.

Michelangelo went to Rome, where Pope Clement had in mind a grandiose scheme for the decoration of the altar wall of the Sistine Chapel. Clement died before the painting was begun, but his successor, Paul III, set him to work on the project. *The Last Judgement* (p.103) was painted from 1536 to 1541, and is a terrifying vision expressing the artist's own mental suffering.

NEW FRIENDS

Michelangelo had always been a practising Catholic and was a deeply pious man. In later life, his religion became profoundly important to him. This was partly the result of his great affection and admiration for Vittoria Colonna, the Marchioness of Pescara – the only woman with whom he had a special relationship.

For Michelangelo was widely believed to be homosexual and it is true that he showed a preoccupation with the male nude unmatched by any other artist. In the 1530s, he seems to have fallen in love with a beautiful young nobleman, Tommaso Cavalieri, to whom he wrote many love sonnets. Michelangelo insisted that their friendship was Platonic – he believed that a beautiful body was the outward manifestation of a beautiful soul.

Michelangelo was naturally a recluse. He was

The fate of Tityus
(above) This drawing was made for Tommaso Cavalieri – a young man for whom Michelangelo developed a passion.

The Sistine Chapel
(right) On the altar wall is Michelangelo's Last Judgement, *completed 29 years after the ceiling.*

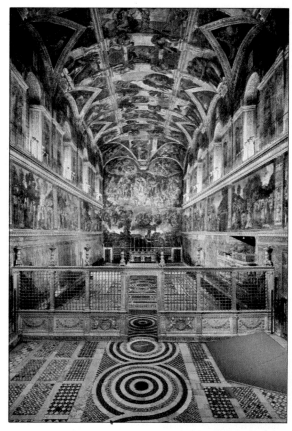

A Spiritual Friendship

Michelangelo's first meeting with Vittoria Colonna in 1536 marked the beginning of a unique relationship. A devout woman and poetess who retired from society after the death of her husband 'to serve God more tranquilly', she inspired a deep admiration in Michelangelo and stimulated and intensified his simple religious faith.

Poem for a Poetess

A man, a god rather, inside a woman,
Through her mouth has his speech,
And this has made me such
I'll never again be mine after I listen.
Ever since she has stolen
Me from myself, I'm sure,
Outside myself I'll give myself my pity.
Her beautiful features summon
Upward from false desire,
So that I see death in all other beauty.
You who bring souls, O lady,
Through fire and water to felicity,
See to it I do not return to me.

(Rime, 235)

Sublimated love
(left and below) Michelangelo executed several beautiful religious drawings for Vittoria, and exchanged many letters and poems with her. In this famous madrigal, he describes her as a man or god speaking inside a woman. The engraving shows him aged 72, a year before Vittoria's death in 1547.

melancholic and introverted, but at the same time emotional and explosive. He lived a temperate life, but in a fair degree of domestic squalor which no servant would tolerate for long. He preferred to be alone 'like a genie shut up inside a bottle', contemplating death. In 1544 and 1545 he suffered two illnesses which did actually bring him close to death. Evidently the great papal commissions had weakened his constitution.

Paul III made Michelangelo Architect-in-Chief of St Peter's, and his work on the church continued throughout the rest of his life, under three successive popes – Julius II, Paul IV and Pius IV. He tried to return to the simplicity of his old rival Bramante's design, but St Peter's was not finished in his lifetime, nor exactly to his designs.

Finally, in his old age, Michelangelo also had time to work for himself and the sculptures of this period, such as the *Duomo Pietà* (below), reveal an intense spirituality and tenderness. Pope Julius II used to remark that he would gladly surrender some of his own years and blood to prolong Michelangelo's life, so that the world would not be deprived too soon of the sculptor's genius. He also had a desire to have Michelangelo embalmed so that his remains, like his works, would be eternal. As it happened, Michelangelo outlived Julius II, and was buried with great pomp and circumstance after his death on 18 February 1564.

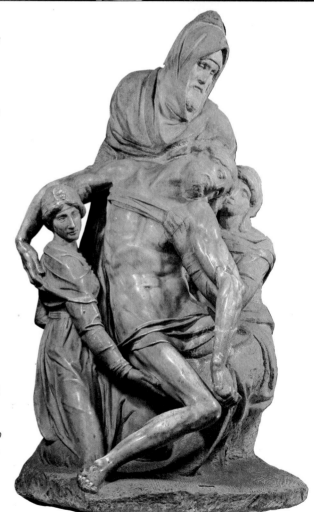

The Capitol

(above) The removal of the antique statue of Marcus Aurelius to the Capitol in 1538 prompted Michelangelo to design a new pedestal and draw up plans for the development of the site – one of several architectural schemes for Rome. Although nothing was built in his lifetime, his design was preserved and finally completed in the mid 17th century.

Vittoria Colonna

(below) One of the outstanding women of the Renaissance, Vittoria Colonna mixed with some of the leading poets and philosophers of the age. She divided her time between a convent in Viterbo, where she devoted herself to poetry and reform within the church, and Rome, where she knew Michelangelo.

Sebastiano del Piombo/Casa Buonarroti, Florence

The Duomo Pietà

(right) Michelangelo carved the Pietà *when he was in his 70s, intending it for his tomb. Unfinished and smashed because of a flaw in the marble, Michelangelo allowed it to be reassembled by a pupil. The figure of Nicodemus, supporting the body of Christ, is a moving self-portrait of the sculptor.*

Florence Cathedral

The Heroic Vision

Michelangelo displayed his colossal powers of invention and his extravagant technical mastery in the arts of painting, sculpture and architecture, creating a new, inspirational and heroic style.

During his lifetime and throughout the centuries, Michelangelo's achievement as an artist has been regarded with awe. As Giorgio Vasari wrote:

'. . . the benign ruler of heaven decided to send into the world an artist who would be skilled in each and every craft, whose work alone would teach us how to attain perfection in design (by correct drawing and by the use of contour and light and shadows, so as to obtain relief) and how to use right judgement in sculpture and, in architecture, create buildings which would be comfortable and secure, healthy, pleasant to look at, well-proportioned and richly ornamented.'

For Michelangelo 'was supreme not in one art alone but in all three' – in painting, sculpture and in architecture.

To begin with, Michelangelo displayed his genius through his mastery of the human figure and, in particular, the male nude. Man, according to the Renaissance, was the measure of all things, the centre of the universe. Accordingly, Michelangelo was not interested in creating convincing landscape settings or in the art of portraiture. Only the human figure, treated in an idealized way, was a noble enough vehicle for the expression of his grand conceptions.

Michelangelo's understanding of the human form was influenced by the powerful works of the

Preliminary studies
(left) Michelangelo always made detailed preparatory drawings for his compositions, using boys or men as models. This highly-finished nude is a study for the central figure of his celebrated Battle of Cascina, *which he only ever completed in 'cartoon' (the working drawing for the mural). Michelangelo chose to show an incident just before the battle, when the Florentine soldiers had stripped off to bathe, only to be startled into action by a cry of alarm.*

British Museum, London

Uffizi, Florence

The Doni Tondo (1503/4)
(left) This Holy Family group shows the hard, sculptural quality of Michelangelo's painting style. The tondo, or circular form, was popular in Florence for depictions of the Madonna and Child.

Sistine Ceiling fresco
(right) The Creation of Sun, Moon and Plants *is one of Michelangelo's most original conceptions. The dynamically powerful figure of the Creator is shown in daring foreshortening – a typical display of skill on Michelangelo's part.*

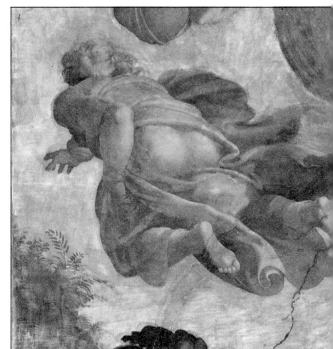

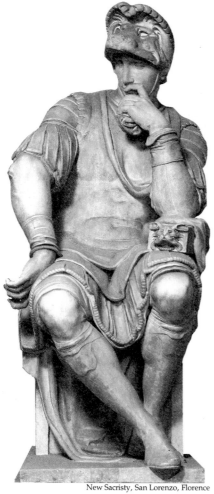

The Laurentian Library Staircase
(right) *This extraordinary free-standing staircase was designed by Michelangelo for the Medici's library in Florence.*

The Awakening Slave
(below) *Michelangelo's four unfinished* Slaves *were originally destined for the Julius Tomb. This figure seems to be struggling to free himself from the stone.*

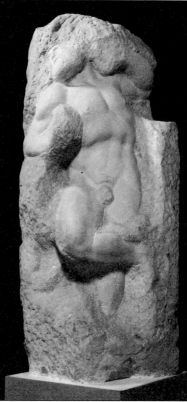

New Sacristy, San Lorenzo, Florence

The Medici Tomb sculpture
(above) *Michelangelo created two tombs for the Medici funerary chapel, to Giulio and Lorenzo de' Medici. Lorenzo is shown in a contemplative pose.*

Accademia, Florence

painter, Masaccio, and the sculptor, Donatello. But his most vital source of inspiration was the sculpture of antiquity, which he first saw in the garden of Lorenzo Medici's palace. The artists of Michelangelo's time were among the first to appreciate the 'liveliness' of classical sculpture. Superior examples, like the *Laocoön* and the *Torso Belvedere,* which had been mentioned by the ancient writer, Pliny the Elder, were in the process of being dug out of the earth. Here were figures who, according to Vasari, 'possessed the appeal and vigour of living flesh', and whose attitudes were natural, graceful and full of movement. One of Michelangelo's earliest works was inspired by a Roman battle sarcophagus, and showed a group of men involved in violent action. These robust, muscular nudes, twisted into a variety of poses, form the basis of Michelangelo's heroic style.

In such late works as *The Last Judgement* the human body has become a tool for the expression of a whole range of human emotions. The contorted, writhing figures reveal a very personal side to Michelangelo's art characterized by struggle and by agonized frustration.

FREED FROM THE STONE

Michelangelo always thought of himself as a sculptor, although he certainly did not despise painting. He described sculpting as 'the art of taking away material'. By chipping away the marble, working from the front of the block backwards, he believed that he was liberating an existing image from its imprisoning block. This 'image' was the concept, or *concetto*, that was already in the artist's mind, and to Michelangelo the work was complete when the concetto had been fully realized.

Michelangelo's architecture was also based on sculptural qualities. In his early commissions, such as the San Lorenzo façade and the Medici Tomb chapel, sculpture forms an integral part of the architectural design. Even the Laurentian Library staircase could be conceived of as a sculptural feature; and the later, purely architectural commissions, such as the magnificent dome of St Peter's, reveal a sculptor's attitude towards volume, mass, and the surface play of light and shade. He disrupted the harmony and stability of early Renaissance designs, and just as he was not afraid to distort human anatomy in the interest of conveying emotion, so he used architectural elements in an expressive and unorthodox way.

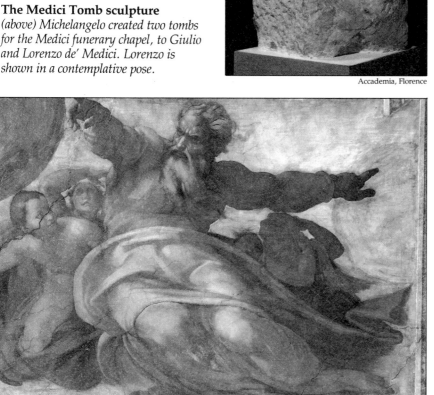

Sistine Chapel, Vatican

45

THE MAKING OF A MASTERPIECE

The Sistine Ceiling

On 10 May 1508 Michelangelo signed the contract for the decoration of the Sistine Ceiling – a momentous task which was to pose one of the greatest human as well as artistic challenges. The work had been commissioned by Pope Julius II, whose uncle, Sixtus IV, had authorized the building of the Sistine Chapel in the Vatican. On the walls were 15th-century frescoes showing scenes from the life of Moses and Christ, while the ceiling was a traditional star-spangled blue. Julius, however, who was bent on the whole-scale 'restoration' of Christian Rome, wanted something grander and more 'progressive'.

By July, the scaffolding was in place and the cardinals, who had complained of the noise and rubble, were able to conduct their services in peace. A few weeks later, five young assistants arrived in Rome, but on finding the door of the Chapel bolted, they took the hint and returned to Florence. In the end, Michelangelo painted the ceiling almost entirely alone, triumphing over months of tremendous physical discomfort.

The completed ceiling was unveiled on 31 October 1512. 'When the work was thrown open', reported Giorgio Vasari, 'the whole world came running to see what Michelangelo had done; and certainly it was such as to make everyone speechless with astonishment.'

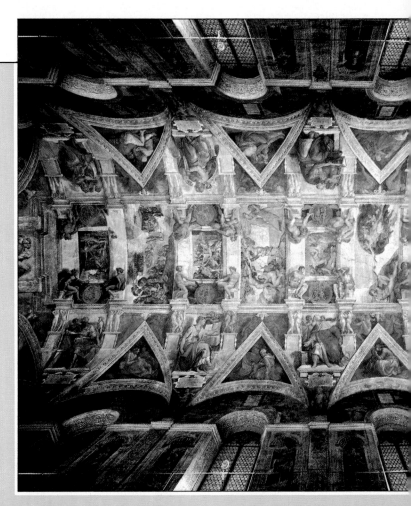

Athletic 'ignudi'
(left) The 'ignudi', or nudes, seated directly above the Prophets and Sibyls, may represent 'angels', although they seem to be an entirely personal contribution. They support bronze medallions, attached to garlands or acorns – the heraldic device of the Della Rovere family of Julius II.

Christian parallels
(right) The prophet Jonah is given pride of place over the altar because he prefigures the Resurrection of Christ: just as he emerged from the belly of a fish, so Christ emerged from the tomb. Michelangelo was particularly pleased with the figure's dramatically fore-shortened pose.

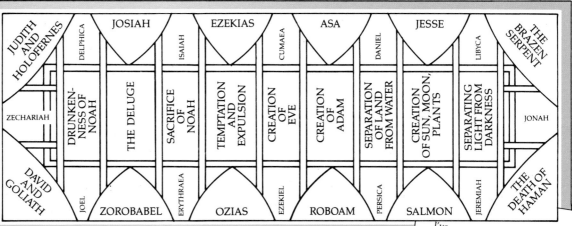

The diagram shows the layout of the Sistine Chapel ceiling:

JUDITH AND HOLOFERNES		JOSIAH		EZEKIAS		ASA		JESSE		THE BRAZEN SERPENT
DELPHICA			ISAIAH		CUMAEA		DANIEL		LIBYCA	
ZECHARIAH	DRUNKEN-NESS OF NOAH	THE DELUGE	SACRIFICE OF NOAH	TEMPTATION AND EXPULSION	CREATION OF EVE	CREATION OF ADAM	SEPARATION OF LAND FROM WATER	CREATION OF SUN, MOON, PLANTS	SEPARATING LIGHT FROM DARKNESS	JONAH
DAVID AND GOLIATH	JOEL		ERYTHRAEA		EZEKIEL		PERSICA		JEREMIAH	THE DEATH OF HAMAN
		ZOROBABEL		OZIAS		ROBOAM		SALMON		

The grandiose scheme

(left and above) According to Michelangelo, the pope let him devise his own scheme for the ceiling, although he clearly had theological advice. Pagan Sibyls and Hebrew Prophets, who foresaw the Christian era, are interspersed with lunettes and spandrels of the Ancestors of Christ. The four corner spandrels show Old Testament heroes, while the nine scenes on the vault illustrate the story of Noah and the Creation.

A feat of endurance

(below) Michelangelo painted the ceiling standing (not lying down) on the scaffolding, reaching overhead with his brush. In a comic verse (right) to his friend, Giovanni da Pistoia, he complained that he was 'bending like a Syrian bow'. According to Vasari, his sight was so badly impaired, that he couldn't read or look at drawings 'save with his head turned backwards', for months afterwards.

> I've got myself a goiter from this strain,
> As water gives the cats in Lombardy
> Or maybe it is in some other country;
> My belly's pushed by force beneath my chin.
>
> My beard toward Heaven, I feel the back of my brain
> Upon my neck, I grow the breast of a Harpy;
> My brush, above my face continually,
> Makes it a splendid floor by dripping down.
>
> My loins have penetrated to my paunch,
> My rump's a crupper, as a counterweight,
> And pointless the unseeing steps I go.
>
> In front of me my skin is being stretched
> While it folds up behind and forms a knot,
> And I am bending like a Syrian bow.
>
> And judgment, hence must grow,
> Borne in mind, peculiar and untrue;
> You cannot shoot well when the gun's askew.
>
> John, come to the rescue
> Of my dead painting now, and of my honour;
> I'm not in a good place, and I'm no painter.

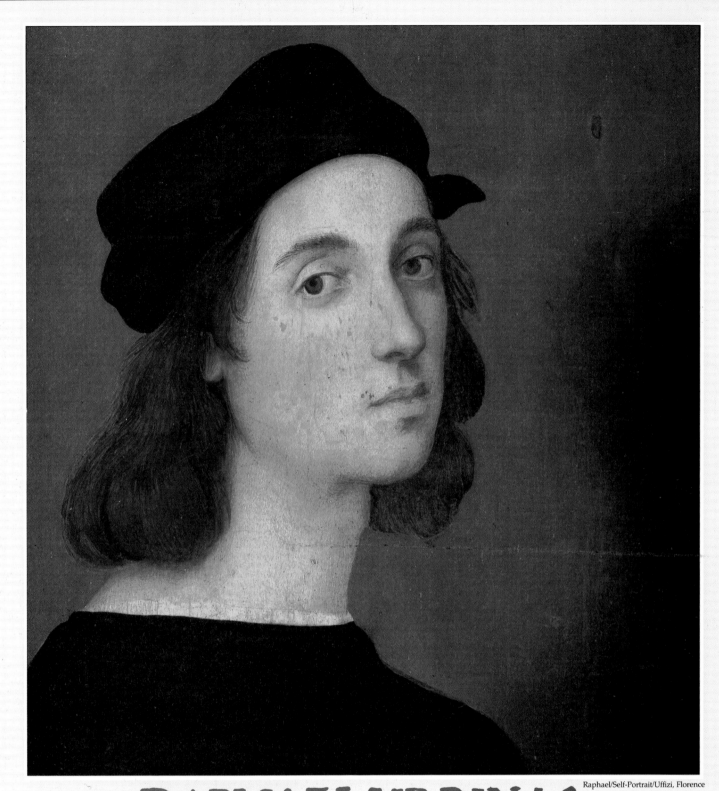

·RAPHAEL·VRBINAS·

1483-1520

Raffaello Sanzio – Raphael – was the perfect Renaissance artist. Gracious and charming as a man, and a painter of superlative skill, he seemed to be the living embodiment of the Renaissance ideal. Though neither as innovative as Leonardo nor as sculptural as Michelangelo, he painted with a beauty of line and colour, and a harmony in composition, that surpassed them both.

Raphael is closely associated with his birthplace, Urbino, but he painted most of his great works – the lovely Madonnas and breathtaking frescoes – in Florence and Rome. In these cities, he was showered with commissions and was one of the greatest painters of his age. But illness struck him down at the height of his fame; he died of fever on 6 April 1520, his 37th birthday.

48

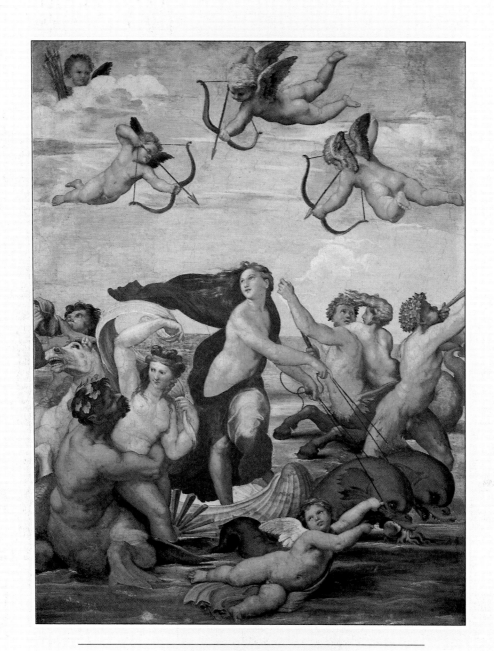

The Triumph of Galatea *1511*
116″ × 88½″ Villa Farnesina, Rome

The Princely Painter

**Raphael's outstanding talent was matched by his graceful manner.
His courteous nature and constant entourage led Vasari to comment
that he lived 'more like a prince than a painter'.**

Key Dates

1483 born in Urbino in central Italy

1494 orphaned and made a ward of his uncle

1500 works in Perugino's workshop in Perugia

1504 moves to Florence

1508 receives commission from Pope Julius II to paint the first *Stanza*

1511 first major project for Agostino Chigi

1514 paints *Madonna della Sedia*

1515 appointed as Conservator of Roman Antiquities in Rome

1517 begins *Transfiguration*

1520 dies at the age of 37

Raffaello Sanzio – Raphael – was born on 6 April 1483, in the central Italian city of Urbino. Little is known of his mother, Magia Ciarla, but his father Giovanni was a poet and painter who worked intermittently at the elegant Court of Urbino. The Ducal Court had been a major centre of artistic activity since the middle of the 15th century and these early connections proved important to Raphael, who enjoyed the friendship and patronage of the Court throughout his short life.

THE YOUNG ORPHAN

By nature Raphael was gentle and modest, and his boyhood familiarity with Court ways no doubt helped to foster the cultured demeanour which endeared him to a series of influential patrons. The young Raphael must also have watched his father at work on his various commissions, and although Giovanni's talent was relatively modest, the atmosphere of artistic activity stimulated the boy's own desire to paint.

In 1491, Raphael's mother died. By 1494 Giovanni too was dead, leaving Raphael an orphan at the age of 11. He was made a ward of his paternal uncle, a priest named Bartolomeo, although he seems to have remained closer to his maternal uncle Simone, with whom he

Ashmolean Museum, Oxford

The ideal city
(left) On a hill above the olive groves of the Marches, Raphael's birthplace of Urbino was seen as an ideal Renaissance city – a focus of learning and all the arts.

The young Raphael?
(above) This picture of a young man is probably by Raphael and may well be a self-portrait painted around 1506, soon after he arrived in Florence at the age of 21.

corresponded for the rest of his life.

We know almost nothing of Raphael's activities during the following six years, but by May 1500 he had left Urbino and was almost certainly in Perugia, in the workshop of Pietro Perugino. Perugino's works have often been underrated in modern times, but in the late 15th century he was one of Italy's foremost painters. When Raphael arrived in Perugia, Perugino was working on a series of frescoes for the Collegio del Cambio (the Bankers' Guild Hall), and Raphael may well have assisted him. From the beginning of his stay with Perugino, however, Raphael was working independently, or with his compatriot Evangelista di Piandimeleto, and is described as 'magister' or

Francesco Ubertini/Street Scene in Florence/Rijksmuseum, Amsterdam

The flowering of Florence

(left) When Raphael arrived in Florence in 1504, the Renaissance culture of the city was at its peak with elegant courtiers and eminent artists thronging the streets.

'master' in the contracts he received.

Raphael stayed with Perugino for four years or so, painting altarpieces and banners for churches in Perugia, and for the neighbouring town of Città di Castello. He also maintained his links with the Court of Urbino, painting several exquisite panels of saints for the crippled and impotent Duke, Guidobaldo da Montefeltro (p.56).

Soon, however, his thoughts turned further afield. From the very beginning, Raphael's career was marked by an avid desire to learn, and to assimilate new ideas. He probably realized that Perugino had taught him all he could, and decided to move to Florence, arriving there in the autumn of 1504 at the age of 21. The experience of Florence must have been truly exhilarating for the young artist, for these were times of great excitement in the Tuscan capital. Michelangelo's marble *David* had just been installed in front of the Town Hall, and Leonardo was at work on the *Battle of Anghiari* for the Great Council Chamber.

IN FLORENCE AND ROME

Raphael responded eagerly to the challenge of his new environment. Fired by his experience of Leonardo's drawings, he began to experiment with the theme of the Virgin and Child, producing the first of the beautiful Madonnas for which he is best known. These Madonnas, together with the occasional portrait, provided the bulk of his commissions during his Florentine years.

In 1508 Raphael received a commission which was to change the course of his career – the

Raphael's mentor

(below) Raphael's years with Perugino in Perugia clearly left a mark – this painting by Perugino shows the same grace and harmony of composition.

Homely fresco

(right) In the house where Raphael was born in Urbino, there is a fresco which may have been painted by his father – or may be Raphael's earliest work.

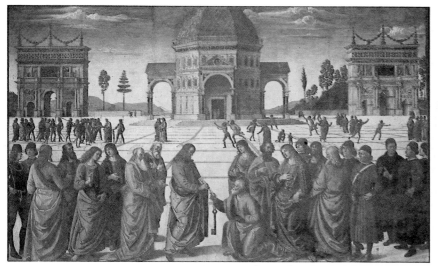

Perugino/Donation of the Keys/Sistine Chapel, Rome

Casa Santi, Urbino

decoration of the Papal Apartments, or 'Stanze', for Julius II. In 1507, Julius, in a characteristic outburst of rage, decided that he could no longer live in the Borgia Apartments, surrounded by the flagrantly self-advertising frescoes commissioned by his hated predecessor, Alexander VI. Accordingly, in 1508 he enlisted a team of artists to decorate four rooms on the second floor of the Vatican Palace. The team included the Milanese artist Bramantino, the Sienese 'Il Sodoma', and Raphael's own master Perugino. Work was already in progress when the young Raphael was summoned to the Papal Court in Rome and given full responsibility for the decorations. This included the right to paint over the work that had already been carried out, although with characteristic diplomacy Raphael left intact the ceiling paintings begun by Perugino.

It remains something of a mystery why

The Judgement of Paris
(left) Prints like this, made by the engraver Marcantonio Raimondi from Raphael's designs, introduced Raphael's works to an unprecedented number of people.

The Courtier

Under the guiding hand of the Duchess, Elisabetta Gonzaga, the Ducal Court of Urbino in the early 16th century cultivated the ideal of the perfect courtier – combining elegance in dress and manners with prowess in sport and the arts and great learning. Baldassare Castiglione (1478-1529) celebrated these qualities in his enormously influential book *The Courtier*, a series of imaginary dialogues published in 1528. Raphael was in many ways the ideal courtier – graceful, charming and highly accomplished in artistic, intellectual and physical pursuits. Raphael's works, with their poise and balance, seem to embody the same courtly ideals.

Louvre, Paris

Baldassare Castiglione
(left and above) In this portrait, Raphael paints his friend, the author of The Courtier *(title page below), in the image of the ideal courtier – soberly and elegantly dressed, and in a relaxed and easy pose.*

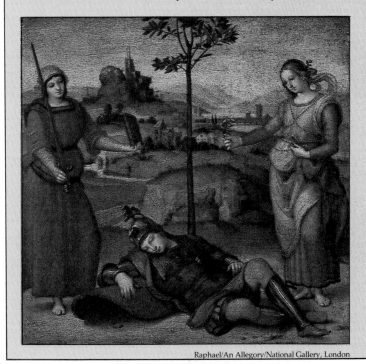

Raphael/An Allegory/National Gallery, London

Knight choosing between Virtue and Pleasure
(left) This allegorical painting displays Raphael's espousal with courtly ideals.

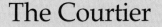

IL LIBRO
DEL
CORTEGIANO
DEL CONTE
BALDASSAR CASTIGLIONE
EDIZIONE FORMATA SOPRA QUELLA D'ALDO, 1528, RISCONTRATA CON ALTRE DELLE PIU' RIPUTATE, ED ARRICCHITA DI UN COPIOSO INDICE DELLE MATERIE.

MILANO
PER GIOVANNI SILVESTRI
M. DCCC. XXII.

Holy patron
(left) Pope Julius II was one of Raphael's greatest patrons, and the frescoes Raphael painted for Julius in the Papal Apartments – including the famous School of Athens *– are among the most breathtaking creations of the Renaissance.*

Raphael in Rome
(below) This fanciful 19th-century painting sums up the legendary days when Raphael (in the centre), Leonardo (on the steps) and Michelangelo (shown in the foreground) were all working in Rome; note the 'Madonna and Child'.

discreetly installed to catch the precious objects which were then retrieved at the end of the day.

To further enrich his villa, Chigi asked Raphael to paint a fresco in the garden loggia, showing the *Triumph of Galatea* (p.49), loosely based on a scene from classical literature. The success of this fresco led to a series of further commissions from Chigi, including the design of his funerary chapel in the church of Santa Maria del Popolo, and the decoration of a second loggia at his villa (p.55).

By the middle of 1511 Raphael had begun work on the second of the apartments for Julius II, the Stanza d'Eliodoro – 'the room of Heliodorus' (p.63). Julius did not live to see the room completed, for he died in February 1513, but the loss of this remarkable patron made little difference to Raphael's career, for the new Pope, Leo X, swiftly recognized his talent. The Stanza d'Eliodoro was completed under Leo's auspices, and he rapidly engaged Raphael in a wealth of new and lucrative projects.

The year 1514 saw Raphael at the height of his career. In August he was formally appointed Papal Architect, in succession to his friend and fellow-

Raphael, with little experience of working in fresco, and no large-scale works to his name, was entrusted with such a momentous task. But the liaison of Raphael with the formidable Julius produced a series of frescoes which rank as the most breathtaking creations of the High Renaissance. The decoration of the first room, the Stanza della Segnatura (the room where official documents were signed), occupied Raphael from the end of 1508 until 1511, and established his reputation as the foremost painter in Rome.

Around the time of its completion, Raphael entered into an arrangement with the Bolognese engraver Marcantonio Raimondi to make prints of some of his drawings which proved, usually, to consist of those he had made as preliminary studies for his works. Raphael realized that reproductive prints were a valuable means of popularizing his designs, as his best works – those in the Stanze – could only be seen by a handful of people within the Papal Court. The prints which Marcantonio made were very popular and contributed enormously to Raphael's growing reputation.

WEALTH FROM THE WEALTHY

In 1511 Raphael carried out his first major project for Agostino Chigi, a wealthy Siennese banker, whose amorous adventures seem to have been matched only by Raphael's own. Chigi was a close friend and adviser to Julius II, and a man of great power who lived on a sumptuous scale. Between 1508 and 1511 he had a palatial villa built for himself by the architect Peruzzi, just outside the walls of Rome. Here he entertained in lavish style, astonishing his guests by throwing the silver plates into the nearby river at the end of every course. Unknown to them, nets had been

La Fornarina

Raphael was famed for his amorous exploits, but little is known of the details – or whether they took place at all. Vasari, however, seemed in little doubt about Raphael's taste for romance. In his *Lives* he described Raphael's 'great fondness for women who he was always anxious to serve'. Accordingly, 'he was always indulging his sexual appetites; and in this matter his friends were probably more indulgent than they should have been'. Following Vasari's lead, various legends have sprung up around Raphael's love-life. *La Fornarina*, a voluptuous semi-nude portrait painted by Raphael in 1518, is reputedly his devoted mistress. On her arm she wears a band bearing the legend 'Raphael Urbinas'.

La Fornarina
An X-ray examination has revealed that the background to this sensuous portrait (left) was originally an elaborate landscape, and the intimate tangle of myrtle, quince and laurel leaves Raphael painted in later may symbolize his deepening commitment to the woman. In Ingres' painting (right), it is the Fornarina who cradles the dying Raphael in her bosom.

Raphael/La Fornarina/Palazzo Barberini, Rome

Ingres/Raphael and La Fornarina/Columbus Museum of Art, Ohio

countryman, Bramante, with responsibility for the fabric of St Peter's. He was also commissioned to begin a third apartment in the Vatican, the Stanza dell'Incendio – 'the room of fire' (p.63). At the same time, he was producing some of his most beautiful Madonnas, such as the *Madonna della Sedia* (p.56), and continued to be active as a portrait-painter. In July of that year, he wrote to his uncle Simone: 'I find my personal estate in Rome to be worth 3,000 gold ducats, with an income of 50 scudi a year, and as architect of St Peter's another 300 gold ducats, and on top of this I am paid for my work what I see fit to ask.'

A PROPOSAL OF MARRIAGE

The same year, Raphael received a proposal of marriage. The influential Cardinal Bibbiena offered Raphael his niece Maria as a wife – a clear indication of Raphael's status and popularity at the Papal Court. Not wishing to offend Bibbiena, Raphael reluctantly agreed, but repeatedly delayed the wedding and Maria died before the marriage could be formalized. Renowned for his charming manner, Raphael is reputed to have had innumerable love-affairs, although his one lasting attachment seems to have been to a courtesan, the

Raphael/Triple Portrait with Leo X/Uffizi, Florence

Pope Leo X
(left) Pope Leo X, like his predecessor Julius II, recognized Raphael's incomparable talent and not only ensured that he completed the painting of the Papal Apartments but engaged him on a host of other projects. This triple portrait of Leo X with two cardinals, including another member of the Medici family, Giulio, is one of Raphael's finest. Painted in 1518, it shows Raphael at the height of his powers, and the exquisite rendering of the cloths and the objects on the table drew from Vasari the comment: 'more lifelike than life itself'.

legendary 'Fornarina'.

In 1515, Leo X appointed Raphael as Conservator of Roman Antiquities in the city. The Pope was anxious to preserve fragments of marble carrying classical inscriptions and instructed Raphael to ensure that none of these should be used in new building work. But Raphael took the task further, and embarked on a project to reconstruct the layout of Ancient Rome, as it had been in the Golden Age. It was a monumental task and together with his projects for the remodelling of St Peter's, diverted much of Raphael's attention from the business of painting. Nonetheless, he found time to design for Leo the cartoons for a set of 10 tapestries to adorn the lower walls of the Sistine Chapel (see p.57). These cartoons were sent to the workshop of Pieter Van Aelst in Brussels for weaving into tapestries.

Because of the growing demands on his time, Raphael began to make increasing use of assistants in his painting commissions. The decoration of the third Papal Apartment, the Stanza dell'Incendio, carried out between 1514 and 1517, was executed largely by Giulio Romano and Gianfrancesco Penni, after Raphael's designs. And his final project for Chigi, a series of frescoes for the vault of the second loggia in Chigi's villa, was carried out entirely by assistants, although the design was certainly Raphael's.

THE ARTIST CRITICIZED

Raphael's rivals were quick to point out the inferior quality of the *Loggia of Cupid and Psyche*, as it was called. In January 1519, just after it had been completed, Leonardo Sellaio, a friend of Michelangelo's, wrote to the sculptor in Florence that the Loggia was 'shameful to a great artist, even worse than the last room in the Palace' (the Stanza dell'Incendio). Sellaio was hardly impartial, but even Vasari noted that the frescoes in the Loggia lacked Raphael's characteristic grace and sweetness, 'because he had them coloured by others, after his own designs'.

Nonetheless, when Raphael did turn his hand to painting, he proved triumphantly that his talent was still unsurpassed. In 1517 he was commissioned by Cardinal Giulio de' Medici to paint a panel of the *Transfiguration*, for his Cathedral Church at Narbonne, in France. The painting was barely finished when Raphael died, but when it was unveiled it was unanimously acclaimed, and confirmed Raphael's position as the supreme painter of his age.

It was to be his last major work, for in the spring of 1520, Raphael fell ill. Although Vasari claimed that his decline was brought on by an excessive bout of love-making, it seems more likely that he contracted a severe fever. He died on his birthday, 6 April, just 37 years of age. At his own request he was buried in the Pantheon, a classical building which he especially loved. In his honour, the *Transfiguration* was kept in Rome, in the church of San Pietro in Montorio.

Villa Farnesina, Rome

Loggia of Cupid and Psyche
(above) When Raphael agreed to paint this loggia in Agostini Chigi's villa in 1517, he was so much in demand that assistants actually executed the work.

Raphael's burial place
(below) Raphael so admired the Pantheon in Rome, the one great building to remain in use since Roman times, that he asked to be buried there.

A Courtly Art

Raphael's harmonious compositions display a seemingly effortless skill and an apparently natural sense of ease and charm – qualities which reflect the elegant world of Castiglione's *Courtier.*

Today, Raphael is usually remembered as a painter of Madonnas. His enchanting variations on the theme of the Virgin and Child seem to us to sum up all that is best in Raphael's art. But the 16th-century view of Raphael was rather different. To the contemporary observer, the essence of Raphael's skill lay in his ability to depict every kind of figure, from the demure young mother to the frightened old man.

In his *Dialogue on Painting* published some 30 years after Raphael's death, the art critic Ludovico Dolce wrote: 'Michelangelo excells in one manner alone, that is in creating muscular nudes, skilfully foreshortened and in vigorous movement . . . But Raphael painted figures of every sort, some delicate, some fearsome and some vigorous'. Vasari expressed similar views, but added that Raphael realized that the good painter 'must be able to embellish his paintings with varied and unusual perspectives of buildings and landscapes, with lovely draperies . . . beautifully executed heads, and countless other things.'

In short, it was the range and variety of Raphael's work that was the secret of his genius. No-one doubted that Michelangelo was supreme in representing the heroic male nude. And in Leonardo's works, the discerning viewer could admire the intelligence and grandeur of his

Madonna della Sedia/Pitti, Florence

St Michael and the Dragon/Louvre, Paris

Madonna of the Chair *(above) This, the most popular of Raphael's Madonnas, shows his mastery of the tondo, or circular form. The colours are an unusually vibrant mix of red, blue, orange and acid green.*

St Michael and the Dragon (c.1505) *(left) This small canvas may have been painted for Guidobaldo, Duke of Urbino. Its 'courtly' theme – the triumph of virtue over evil – is complemented by the graceful figure style.*

underlying idea or *concetto*, even where the works were unfinished. But Raphael had mastered all aspects of painting, including a whole variety of figures which 'perfectly expressed the character of those they represented'.

It was partly this virtuosity which made Raphael the ideal 'courtly' artist. In his *Book of the Courtier*, Baldassare Castiglione had suggested that the courtier should be modestly accomplished in all pursuits and should not excel in one at the expense of the others. Raphael's art can be seen as the pictorial equivalent of this idea. His quiet mastery of every branch of painting, together with his courtly manner, ensured his popularity with the many cultivated men who were familiar with Castiglione's ideals.

Raphael developed his style by a painstaking process of observation and extraction, constantly studying the works of others and combining what he saw into his own distinctive style. Raphael was

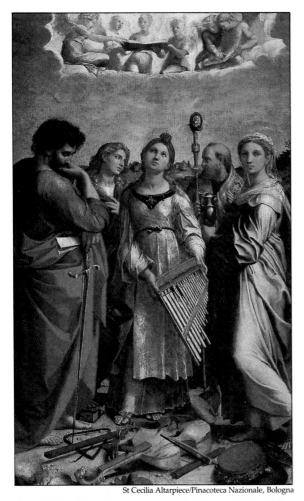

never a mere imitator, and his drawings include few 'literal' copies of other artists' works. The motifs which inspired him were simply starting-points for his own ideas. By the time he came to draw them, they had already gone through various transformations, according to his particular needs.

In his early years, Raphael learnt much from Perugino, particularly in terms of composition. The carefully balanced groups of figures in his *Betrothal of the Virgin* (p.104), for example, clearly recall Perugino's famous *Donation of the Keys* (p.51). Raphael has also followed Perugino's technique of giving variety to his figures by contrasting the angles of their heads.

LEONARDO'S INFLUENCE

Once in Florence, however, Raphael quickly left Perugino behind. Almost immediately, his works betray the influence of Leonardo, both in the softening of outlines and in the increased complexity of his compositions. His Madonnas of this period reflect his admiration for Leonardo's ability to combine the different movements of a small group of figures within a compact triangular shape. But the most important lesson that Raphael learnt from Leonardo was that the emotions must be expressed through the body as a whole.

The fruits of Raphael's Florentine years quickly became apparent in his paintings for the Stanza della Segnatura in the Vatican. Here, for the first time, Raphael displayed his ability to depict a

'Auxiliary' cartoons
(below) In addition to full-scale cartoons, Raphael introduced the use of 'auxiliary' cartoons in his work. In these, the outline of the full-scale cartoon would be traced onto a fresh sheet of paper, and the heads or hands of the figures re-drawn in more detail. This study of two Apostles for the Transfiguration *shows the remarkable beauty of Raphael's drawing style.*

The St Cecilia Altarpiece (1513-14)
(above) Raphael painted several large altarpieces while he was in Rome, including this unconventional work dedicated to the patron saint of music.

The Miraculous Draught of Fishes
(below) This is one of ten coloured 'cartoons', or designs, that were sent to the weavers of Flanders to serve as models for the 'Raphael' tapestries.

Study for *The Madonna of the Goldfinch*/Ashmolean Museum, Oxford

Compositional study
(above) This vigorous pen and ink drawing for the
Madonna of the Goldfinch *shows Raphael's*
admiration for Leonardo's pyramidical figure groupings.

whole range of human types and emotions. In the
School of Athens and the *Disputà* (p.106 and p.62),
characters of every age, type and disposition move
and react with a seemingly infinite variety of
gestures, fused into two harmonious scenes.

Raphael achieved this balanced variety by a
process of painstaking preparation. The range of
Raphael's drawings is immense. For major
projects he made drawings for every stage of the
composition. These include rapid sketches of
heads and hands, detailed drapery studies and
numerous preliminary studies for groups of
figures, often drawn over and readjusted. Finally
there would be the full-scale cartoon which would
be pricked or traced through on to the surface to be
painted. In addition, Raphael sometimes used
secondary or 'auxiliary' cartoons, particularly for
the painting of heads and hands.

'NATURAL' GRACE

Despite Raphael's methodical approach, the
quality which impressed many of Raphael's
contemporaries was the apparent naturalness and
spontaneity of his works. The *School of Athens* and
the *Disputà* reveal nothing of the elaborate
preparation and planning which went into their
making. The visitor who walks into the 'Stanza'
seems to be confronted with a room full of
living beings, reading or conversing with
unselfconscious ease. This apparent artlessness or
'facility' was considered to be a supreme hallmark
of Raphael's art. And it was this quality, together

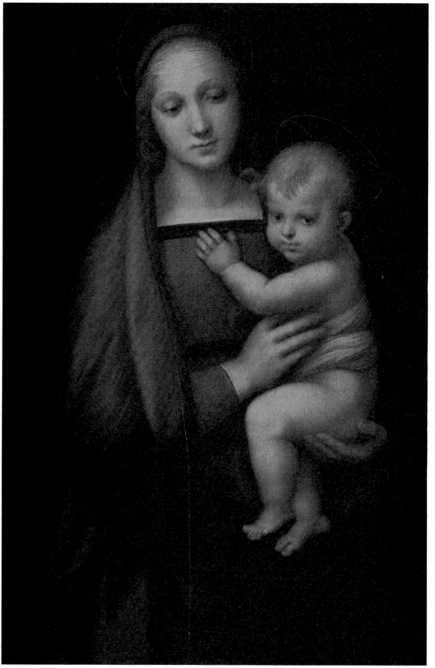

The Madonna of the Granduca/Pitti, Florence

TRADEMARKS
Lowered Eye-lids

Raphael's Madonnas
are characterized by
their grace, sweetness
and modesty, qualities
which are emphasized
by their softened
features and gently
lowered eye-lids. Lost
in reverie, they gaze
quietly and tenderly
downwards.

Madonna del Granduca (c.1506)
(left and detail above) By placing the Madonna and Child against a striking dark background, Raphael has created one of his simplest and most memorable images.

with his virtuosity, which gave Raphael such a close affinity with the world of Castiglione's *Courtier*. For Castiglione, the courtier should do everything with an apparent naturalness and ease, a 'grace' which made everything seem effortless.

It was not simply the figures that onlookers admired in Raphael's 'Stanze'. Equal praise was reserved for his architectural backgrounds, and the variety of his 'special effects'. In describing the *Liberation of Saint Peter* (p.88) for example, Vasari wrote that Raphael 'depicted so skilfully the play of shadows, the flickering reflection of the lights and the vaporous glare of the torches within the surrounding gloom, that he can truly be said to be the master of every other painter.'

In his later works, Raphael's figures show a much greater robustness and solidity, probably reflecting the impact of Michelangelo's figures in the Sistine Chapel. As with all Raphael's work, however, this influence was absorbed gradually, and never took the form of direct copying. This process of assimilation is best illustrated by the *Transfiguration*. Here can be seen echoes of Leonardo's animated gestures and faces, Michelangelo's majestic figures, and the noble forms of classical sculpture. But the combination of all these elements is Raphael's own, and displays his unique narrative power. Each figure is a distinct individual, characterized by every detail of dress, feature and expression. Each one reacts in a totally different way, perfectly in keeping with his character. It is this variety, so vividly portrayed, that typifies the genius of Raphael.

COMPARISONS

The Virgin and Child

Raphael's Madonnas are among the most appealing works of the Renaissance. Their peculiar sweetness and charm derive from a 15th-century Florentine tradition which replaced the stiff, hieratic images of Byzantine art with a much more endearing representation of the relationship between mother and child. In Renaissance Venice, however, the images have a greater solemnity, retaining the dignity of their Byzantine prototypes. Giovanni Bellini's Madonnas are especially moving interpretations of an extremely popular theme.

Antonio Rossellino (1427-1479) Laughing Madonna and Child
(right) This delightful Florentine terracotta emphasizes the maternal aspect of the Virgin and Child theme. The little Christ Child is shown fully-clothed with his hand raised in blessing.

Giovanni Bellini (c.1430-1516) **Madonna of the Meadow**
(below) Bellini's serene vision shows the Madonna of Humility, seated on the ground. The naked Jesus lies sleeping across her lap, just as he will later lie across her knees in death.

Victoria and Albert Museum, London

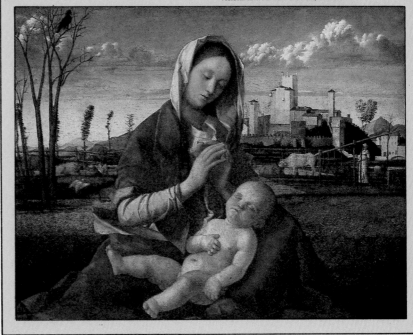

The School of Athens
(Stanza della Segnatura)

The 'School of Athens' is the most famous fresco in the Stanza della Segnatura (p.62) – the papal apartment decorated by Raphael. Its title was coined by a French 17th-century travel guide, in a somewhat misleading attempt to identify the subject-matter. The key to the true meaning of the fresco is provided by the ceiling decoration and, in particular, by the lovely allegorical figure situated directly above. She is accompanied by the inscription *'Causarum Cognitio'* – the definition of Philosophy, being 'the knowledge of things through their highest causes'. She holds two volumes, inscribed *'Moralis'* and *'Naturalis'* – the main branches of philosophy, which are represented by Aristotle and Plato below. The other three frescoes in the rooms, representing Poetry, Law and Theology, are intimately linked with the concept of Philosophy in Renaissance thought. Each of these disciplines leads to a revelation of 'higher' truths and ultimately to a knowledge of the Divine.

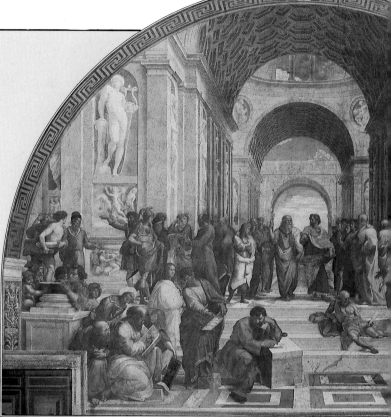

> 'Philosophy is the greatest of the gifts which the immortal Gods bestowed on mortal man.'
> Toscanella

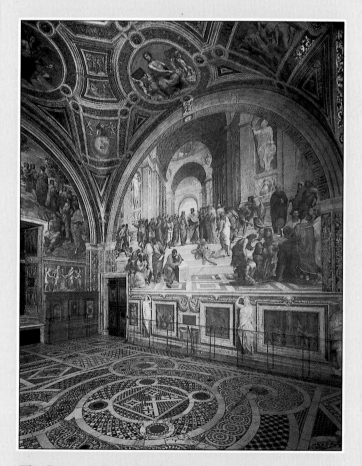

The Stanza della Segnatura
(above) Raphael decorated the walls and ceiling of this modest room in the Vatican between 1508 and 1511. The 'School of Athens' was probably the third fresco to be completed.

'Philosophy'
(right) The robe of the allegorical figure above the fresco is decorated with flowers on the hem, fish on the skirt and flowers on the bodice, symbolizing the branches of moral, natural and contemplative philosophy.

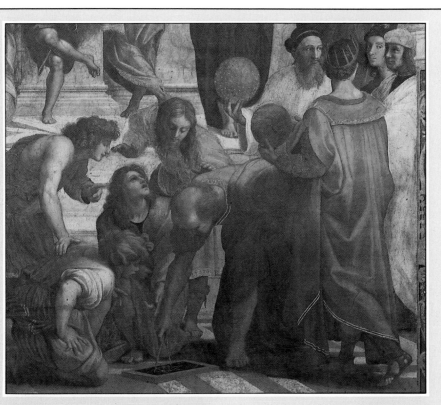

'Geometry'

(left) The various groups of figures in the composition may illustrate the seven Liberal Arts – Geometry and Astronomy are clearly represented. Here, admiring pupils watch a demonstration by Euclid.

Plato and Aristotle

(below) These two ancient philosophers represent natural and moral philosophy. Plato, holding his book the Timaeus, points upwards, while Aristotle, holding the Ethics, gestures before him.

Albertina, Vienna

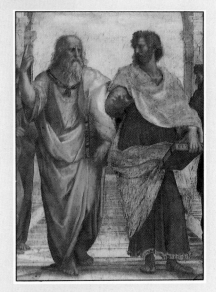

Preliminary study

(left) This delicate silverpoint drawing represents one of the many stages in the evolution of the fresco. The poses and varied attitudes of the figures have already been established and Raphael has moved on to a study of the pattern and fall of the draperies.

Full-scale cartoon

(left) An enormous cartoon, some 9' by 26', survives for the 'School of Athens'. It shows that the brooding figure in the foreground was an after-thought: Raphael may have added him after seeing Michelangelo's monumental figure-style on the Sistine Ceiling – only a few rooms away.

Architectural eloquence

(right) Raphael's philosophers move freely in a mathematically constructed interior, organized around a central vanishing point.

Ambrosiana, Milan

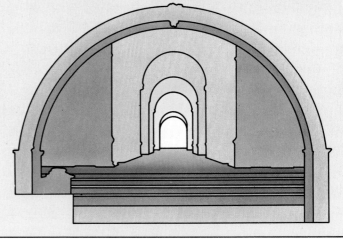

Stanza della Segnatura

In 1508, Pope Julius II gave Raphael his first major commission – to decorate the ceiling and walls of the Stanza della Segnatura, one of the papal apartments in the Vatican. This room was designed as the Pope's library and was also where he signed the decrees of the ecclesiastical court – hence its name. The scheme of the decoration starts on the ceiling, with the personification, in the form of four beautiful women, of Theology, Philosophy, Poetry and the Science of Law. The theme is then expanded and amplified on each of the four walls: the *School of Athens*, Raphael's masterpiece, illustrates Philosophy; the *Disputà*, Theology; the *Parnassus*, Poetry; the *Wall of Justice*, Law. Raphael completed the room within three years, and the reaction to his work established him as one of the greatest artists of the Renaissance.

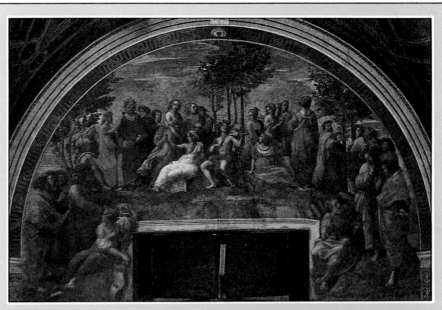

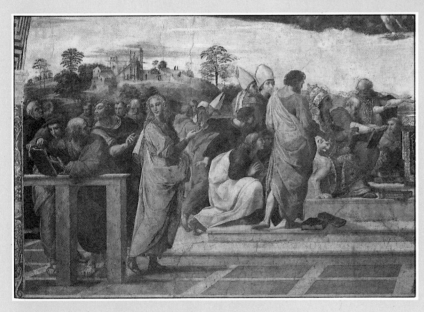

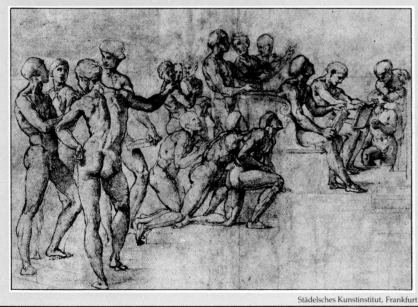

Städelsches Kunstinstitut, Frankfurt

The Parnassus
(top and detail above) A master of figural arrangement, Raphael designed this glorification of ancient and contemporary poets and writers to fit naturally around a large window. The detail shows Apollo's beautiful Muses.

The Disputà (Disputation on the Sacrament)
(above left and left) In this fresco, which faces the School of Athens, *theologians contemplate the mystery of the Eucharist. Many preparatory drawings have survived, which enable us to see how Raphael worked.*

Stanza d' Eliodoro

Following the great success of the Stanza della Segnatura, Raphael was commissioned to fresco another room, the Stanza d'Eliodoro – so called because of its main fresco the *Expulsion of Heliodorus from the Temple* (below). In contrast to the conceptual nature of the Segnatura frescoes, the feeling of this room is one of history and drama. The other frescoes are the *Mass of Bolsena*, the *Liberation of Saint Peter* and the *Meeting of Attila with St Leo the Great*.

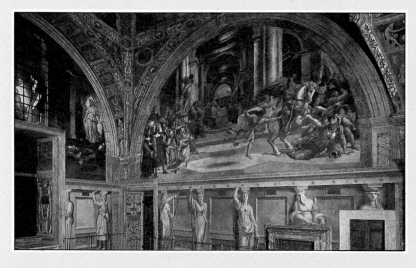

Mass of Bolsena
(detail right) This right-hand section of the fresco shows Julius II's papal guard of Swiss soldiers. They were officially termed protectors of the church in 1512 and awarded with their characteristic sword and beret.

Stanza dell' Incendio

Raphael started work in 1514 on a third room – the Stanza dell' Incendio – this time for Pope Leo X. This was a busy time for Raphael, however, and he could not give his full attention to all the frescoes in the room. The only one which is entirely his design, although not wholly executed by him, is the *Fire in the Borgo*. The others, the *Battle of Ostia*, the *Coronation of Charlemagne* and the *Oath of Leo III* are the work of Raphael's assistants and are markedly inferior in style.

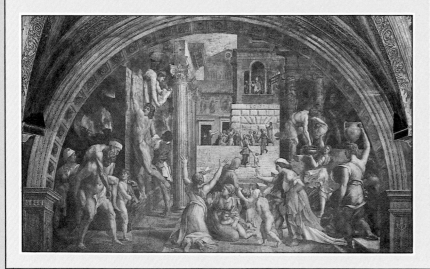

The Fire in the Borgo
(left and detail above) This fresco depicts an incident in the life of Pope Leo IV when, with a blessing from St Peter, he miraculously conquered a raging fire.

Gemäldegalerie, Staatliche Museen Preussischer Kulturbesitz, Berlin (West)

TITIANVS . P.

c.1485-1576

The greatest painter of the Venetian School, Titian dominated art in the city during its most glorious period. He trained in the studio of Giovanni Bellini, the leading painter of the previous generation, and when Bellini died in 1516, Titian was left without a serious rival in Venice – a position he maintained until his death 60 years later. Europe's royalty and aristocracy also eagerly sought his work.

Unlike many of the other giants of Renaissance art, who spread their talents widely, Titian was purely a painter. He left a huge body of work and excelled in virtually every subject – his masterpieces include erotic mythologies, profoundly moving religious works and some of the finest portraits ever painted. When he died, aged about 90, he was a rich man and the most famous artist in Europe.

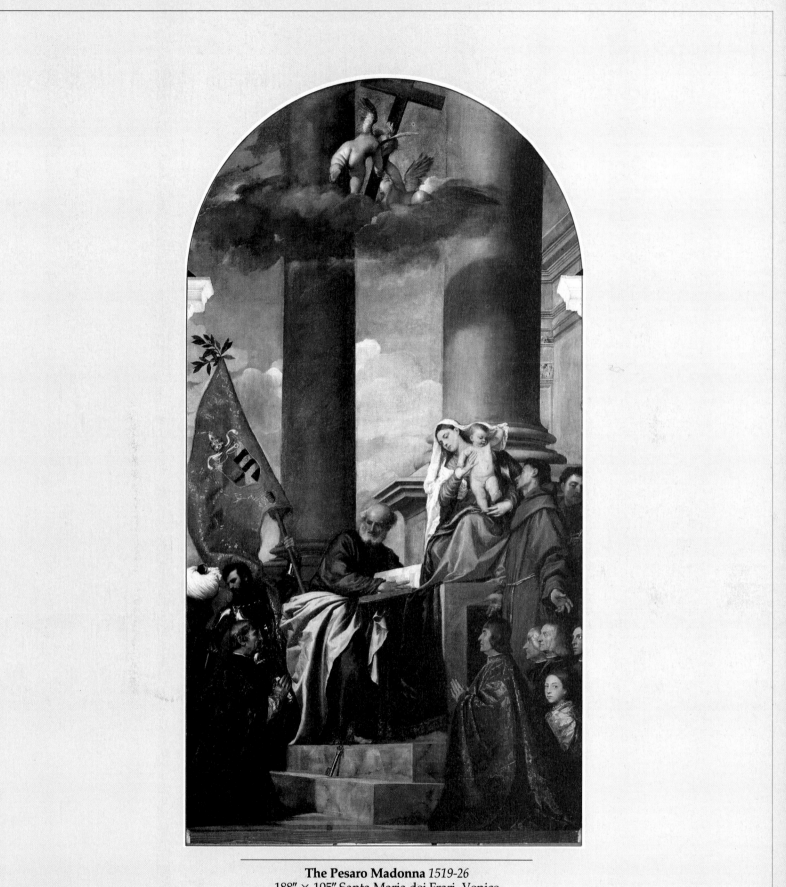

The Pesaro Madonna *1519-26*
188″ × 105″ Santa Maria dei Frari, Venice

Venice's Supreme Painter

Titian dominated Venetian art for 60 years. His superlative skill and ability to charm won him patronage and friendship from princes, a pope and the powerful Holy Roman Emperor, King Charles V.

Key Dates

c.1485 born in Pieve di Cadore, Italy

1508 collaborates with Giorgione on the Fondaco dei Tedeschi, Venice

1516 becomes official painter to the Republic of Venice; begins painting *The Assumption of the Virgin*; visits court of Ferrara

1529 first introduced to Charles V

1533 appointed official painter to Charles V; granted rank of Count Palatine and Knight of the Golden Spur

1545 visits Pope Paul III in Rome

1548 spends nine months with the Imperial court at Augsburg; meets Philip II in Milan

1554 begins series of 'poesie' for Philip II

1576 dies in Venice

Tiziano Vecellio was born in Pieve di Cadore, a small town in the Italian Alps which had become part of the Republic of Venice in 1421. His father Gregorio di Conte Vecellio was a respected town official, whose wife Lucia bore him three more children, Francesco, Orsola and Caterina.

The date of Titian's birth has always been a matter of speculation. Towards the end of his career he himself tended to exaggerate his age to enlist the sympathy of his patrons – a letter to King Philip II of Spain implied that he had been born in 1476 or 1477. Yet some of his admirers and biographers, including Giorgio Vasari, the Florentine artist and critic, suggested a much later date of c.1490, probably in order to surround his early career with an aura of precocity. The truth is probably somewhere between these two extremes – a date around 1485 appears far more likely in the light of Titian's career.

A VENETIAN APPRENTICESHIP

The young Titian and his brother Francesco were duly sent to Venice to stay with their uncle and to learn a trade. Here he studied with the mosaicist Sebastiano Zuccati, and then with the painter Gentile Bellini, but finding him too old-fashioned, Titian transferred to the workshop of Gentile's brother, Giovanni.

He could not have made a better choice. His new master was one of the outstanding painters of Italy. He had developed the recently imported

Titian's birthplace
(left) Titian was born in the small town of Pieve di Cadore in the Italian Alps, about 70 miles from Venice. His family home is now open to the public.

Colourful Venice
(right) Titian first moved to Venice as a young boy, and remained based there for the rest of his long life. The city's waterways create an intensity of light and colour which is reflected in Titian's painting.

An early work
(*right*) The Jealous Husband *(1511) was one of three frescoes on the theme of the miracles of St Anthony which Titian painted for the Scuola di Sant'Antonio in Padua. These are the artist's only surviving frescoes.*

Scuola di Sant'Antonio, Padua

foreign traders was that of the Germans. Their huge warehouse, the Fondaco dei Tedeschi, stood on the Grand Canal next to the old bridge of the Rialto. Here the young Titian, an independent master in 1508, joined with the Venetian painter Giorgione to decorate the facades with allegorical frescoes. According to Vasari, many people mistook Titian's work for Giorgione's and complimented Giorgione on his improved style. Giorgione was so upset that 'until Titian had completely finished and his share in the work had become general knowledge, he would hardly show himself out of doors.'

These frescoes have since crumbled in the damp climate of the lagoon, but the co-operation between the two painters extended far beyond this one commission. With the older Giorgione taking the leading role, the two artists explored new techniques of oil painting, applying the heavy, undiluted medium directly to a coarse canvas.

In 1513 Titian received an invitation from Pope Leo X to visit Rome. This was a unique chance to work alongside Raphael and Michelangelo, yet Titian – who was deeply attached to his Venetian roots and who remained, throughout his life, highly reluctant to travel – turned it down. He continued to work for his local patrons – religious institutions and members of the patrician class

technique of oil painting to supreme perfection, and by the time Titian joined him, Giovanni Bellini was famous for his colouring and for the glowing effects of light and atmosphere in his altarpieces and smaller devotional images.

Venice around 1500 was at the height of its power, one of the richest and biggest cities in Europe. It dominated a vast empire from Cyprus in the eastern Mediterranean to the Italian mainland. An independent republic with an unequalled history of internal peace, justice and freedom, it was the envy of the rest of Italy.

The city attracted merchants from all over the world, and perhaps the largest group among these

After Titian/Metropolitan Museum of Art, New York

Original setting
(*above*) Titian's huge altarpiece, the Assumption of the Virgin *(1516) is still in its original setting in the church of Santa Maria dei Frari, Venice.*

First princely patron
(*left*) In 1517 Duke Alfonso d'Este commissioned Titian to contribute to a series of mythological paintings for the lavish study which adjoined his castle in Ferrara.*

The Legend of Giorgione

In 1508 Titian worked alongside Giorgione on murals for the Fondaco dei Tedeschi, a warehouse on Venice's Grand Canal. At this point their painting styles were so close that their works have often been confused. Attributions are particularly difficult, since the life of Giorgione is shrouded in mystery: only a handful of works are accepted as his.

Vasari described Giorgione as a romantic and musical young man, and considered him to be one of the founders of 'modern' painting. He mainly produced small oil paintings for private collectors, noted for their obscure subject matter and poetic mood.

Giorgione (c.1478-1510)
(left) Giorgione was born in Castelfranco in the Veneto, where this statue stands.

The Tempest
(right) This is one of Giorgione's few surviving documented works. His use of landscape and mood as the main 'subject' was revolutionary, and had a profound influence on Titian's art.

Accademia, Venice

such as Niccolò Aurelio, the Great Chancellor of the Republic, a humanist and collector, who commissioned *Sacred and Profane Love* (p.76).

The call to Rome, however, clearly enhanced Titian's reputation, and after Giovanni Bellini's death in 1516 he succeeded his old master as official painter to the Republic. His first major public commission was the altarpiece of the *Assumption of the Virgin* (p.67), painted for the high altar of Sta Maria dei Frari, one of the major churches in Venice.

In the same year he received an invitation from Alfonso d'Este, Duke of Ferrara, who was to become one of Titian's most important patrons. Through Alfonso, Titian also came into contact with the princely rulers of Mantua and Urbino, whose courts prided themselves on their sophisticated culture and humanist learning.

Over the next two decades, Titian established relationships of friendship and mutual respect with this new group of patrons. Although he continued to work for the Venetian churches, he was much more interested in princely patronage. Quite apart from the status this brought him, he could command far higher fees.

After Titian's first visit to Ferrara, the artist began a series of mythological paintings for the Duke's new study, the Camerino d'Alabastro.

An elegant patron
(right) This striking portrait of Federico Gonzaga, Duke of Mantua was probably painted in 1529. An elegant and highly cultivated man, Federico was both Titian's friend and patron, and was responsible for introducing the artist to the Emperor Charles V.

Prado, Madrid

These works included *Bacchus and Ariadne* and *The Andrians* (p.72). Titian's notoriously slow progress and his dismissive and casual responses to the threats and commands issued via the Duke's agent in Venice, provoked the prince to outbursts of fury. Yet after the death of Leonardo in 1519 and that of Raphael in 1520, and with Michelangelo devoting his time almost exclusively to sculpture and architecture, there was no one to challenge Titian's role as the leading painter in Italy. If the Duke wanted to keep the painter's services, he had to be as patient as any other patron.

FRIEND OF PRINCES

It was not just his professional success which helped Titian to bridge the social gap which existed between painter and prince. He was by all accounts a man of grace and charm, attractive and interesting in conversation. In 1532, Alfonso's nephew, Duke Federico II Gonzaga wrote to his friend Titian begging him to come and stay with him in Mantua, and when the master finally undertook the journey to Rome in 1545, he stopped briefly in Pesaro where he was received by Duke Guidobaldo della Rovere of Urbino with royal honours, and provided with an escort for the rest of his journey.

By that time the princes were flattered to be associated with the great master. Not only was he on his way to Rome as the guest of Pope Paul III Farnese, he was also court painter to Charles V, Emperor of the Holy Roman Empire and King of Spain, the most powerful man of the century. It was no secret that Titian was on friendly, even intimate terms with Charles.

Mauro Pucciarelli

Capodimonte, Naples

Pope Paul III
(above) Titian travelled to Rome in 1545 at the invitation of Pope Paul, and in the expectation of obtaining a church income for his son Pomponio. There he painted this (unfinished) portrait of the frail, ageing Pope flanked by his grandsons Cardinal Alessandro and Ottavio Farnese.

A lost masterpiece
(left) This engraving is a copy of Titian's Death of St Peter Martyr *(1530) which was destroyed by fire in 1867. Vasari described the original altarpiece as the 'most celebrated, the greatest work . . . that Titian in all his life had ever done'.*

Their first meeting, arranged by Federico Gonzaga after Charles' coronation in Bologna in 1529, had been less than successful. The Emperor was rumoured to have paid Titian only one ducat for his portrait, and Gonzaga had to contribute the remaining 149 ducats of the agreed price.

Yet, after another meeting in Bologna three years later, when Titian painted further portraits of the Emperor, Charles' attitude to him changed dramatically. He issued a patent appointing Titian as his exclusive portrait-painter, praising his exquisite talents, likening him to Apelles who had painted Alexander the Great, and elevating him – in an unprecedented fashion for a painter – to the rank of Count Palatine and Knight of the Golden Spur, with all the privileges of knighthood and nobility, including the right of entrance to Court.

To serve the Emperor, Titian had to overcome his aversion to travelling. In 1548 he even had to cross the Alps in mid winter to spend the busiest nine months of his life in Germany, hectically painting portraits of Charles, his family, the princes of Germany and the members of the Imperial Court, all of whom had gathered for a session of the *Reichstag* in Augsburg.

When Charles abdicated and withdrew to a monastery, he took with him a number of paintings by Titian. His son and successor on the

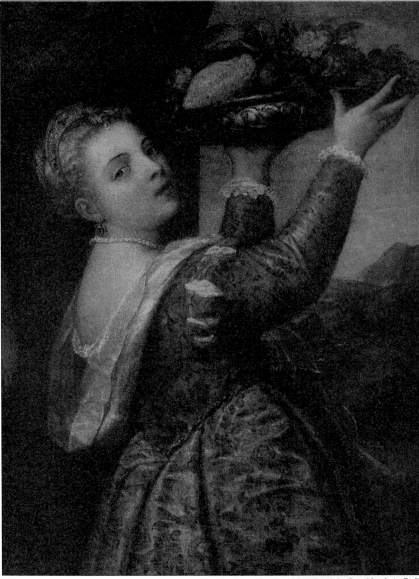

Titian's model daughter
(left) Titian often used his daughter Lavinia as a model. In a variant of this work, she appears in the same pose, but as Salome – carrying the Baptist's head on a platter.

Titian/Lavinia with a Tray of Fruit/Staatliche Gemäldegalerie, Berlin

urgent need to provide for the future of his children. His wife Cornelia had died in 1530, leaving him with two sons and one daughter (another daughter having died in infancy). The children were brought up by his sister Orsola who looked after his household until her death in 1550. The eldest son, Pomponio, was to become a clergyman, but as he led the careless and dissipated life of a well-to-do young gentleman, he more than once incurred his father's displeasure. Orazio, on the other hand, followed his father's footsteps and joined his workshop.

From 1531, Titian lived and worked in a large house in Biri Grande, on the eastern edge of Venice, opposite the islands of San Michele and Murano. This was then an almost rural part of Venice, with gardens overlooking the lagoon. In his house and garden Titian entertained his friends and visitors with a lavish hospitality which was quite at odds with his notorious greed and his self-proclaimed poverty.

SCHOLARLY FRIENDS

Titian's own education as a young boy cannot have been very substantial. Yet throughout his life he attracted the friendship and admiration of some of the most learned men of his time. His first invitation to Rome in 1513 was instigated by the eminent humanist Cardinal Pietro Bembo, and it was said that the great poet Andrea Navagero persuaded him to turn it down.

When in 1527 Spanish and German troops sacked Rome, many artists, poets and humanists fled to Venice, which was famous for its republican

Spanish throne, Philip II, also succeeded his father as Titian's loyal patron.

The correspondence between Titian and the King shows the painter in the least attractive light. He was constantly asking for money, claiming, often correctly, that he had not been paid for previous work, that the annual pension of 200 scudi, bestowed upon him for life by Charles in 1548, had been withheld by the King's agents, and that in his old age (which he exaggerated deliberately) he had to live in misery and poverty.

Surprisingly little is known about Titian's private life. Yet the image he presents of himself, as an impoverished artist working solely for the love of his patron, is clearly wrong. Not only had he reached the unprecedented social status of a nobleman, he was also a rich man.

It is obvious from his letters that Titian felt the

A caricature of Titian
(right) Titian's life was full of financial battles, and he was notoriously money-minded. A contemporary artist Jacopo Bassano caricatured him as a moneylender.

Jacopo Bassano/Christ and the Moneylenders (detail)/National Gallery, London

Titian's Notorious Friend

Poet, playwright and scandalmonger, Pietro Aretino (1492-1556) was Titian's closest friend. The two men first met in Venice in 1527: two years previously, Aretino had been forced to leave Rome after writing a series of pornographic sonnets. Though these poems gained him notoriety, his lasting fame rests mainly on six volumes of letters – many of which were written to Titian.

Aretino delighted in gossip, satire, abuse, and even blackmail – a fact which earned him the nickname 'the scourge of princes'. But in Titian's case, he put his pen to a worthier cause – publicizing his friend's genius, and playing a crucial role in spreading his name and reputation throughout Europe.

Pietro Aretino (1545)
(left) Although he was one of Titian's most ardent admirers, Aretino criticized this portrait of himself for its lack of finish.

Erotic poetry book
(below) In 1524 Aretino wrote a series of sexually explicit poems, accompanied by equally explicit engravings by Marcantonio Raimondi. They caused a storm of controversy in Rome, and the poet was forced to leave the Holy City.

Pitti, Florence

freedom and its safety in the lagoon. Two of the arrivals were the poet Pietro Aretino and the sculptor and architect Jacopo Sansovino. Their close friendship with Titian was such that the Venetians referred to it as the triumvirate, with Titian and Aretino, in particular, exploiting their influence with their respective patrons to further each others interests.

Very little is known about Titian's last years. His eyesight was failing and his hand began to lose its control over the brush. The large workshop, led by Titian's talented son Orazio, was now mainly responsible for carrying out most of the work, with the master adding some final touches to paintings which were then passed off as by his own hand. King Philip remained the major recipient of these pictures, and there were no complaints about obvious workshop productions. As one Spanish nobleman told another in 1575: 'I believe that a blotch by Titian will be better than anything by another artist.'

In Venice new generations of painters had emerged, including Tintoretto and Veronese, with whom Titian and his workshop had to compete for local commissions. Yet none of them could aspire to his universal reputation, and when he died on 27 August 1576, during another outbreak of the plague, the painters of Venice planned to emulate the elaborate festivities with which the Florentines had buried Michelangelo in 1564. Yet the plague prohibited similarly lavish obsequies in honour of Titian, and he was quietly but ceremoniously interred in the church of Sta Maria dei Frari the day after he had died.

Painting for a tomb

(below) Titian began this magnificent Pietà *in about 1575 with the intention that it should be placed above his own tomb. It was completed after his death by one of his many assistants.*

Accademia, Venice

Living Paint

In his long career, Titian was unsurpassed in his field. He brought to new heights the traditional Venetian love of sensuous colour and evolved a revolutionary style of expressive brushwork.

'It is easy to see the haste with which it has been painted, and if there had been more time I would have had him do it over again.' This was Philip II's immediate comment on Titian's *Portrait in Armour* of 1550/51. Dissatisfied, he gave it to his aunt, Mary of Hungary. It took time for him to get used to, and admire, Titian's open brushwork, his loose handling of forms and colours. His aunt was more perceptive. When lending this portrait to Queen Mary of England, who was about to marry Philip, she wrote that the picture, like all others by Titian, had to be viewed from a distance.

BOLD BRUSHWORK

Giorgio Vasari, having visited the artist in 1566, commented similarly on Titian's technique. His early works, Vasari said, had been executed with fineness and an unbelievable diligence, · while 'these last pictures are executed with broad and bold strokes and smudges, so that from nearby nothing can be seen whereas from a distance they seem perfect.'

Vasari, himself an accomplished artist, realized

that this technique which gave to Titian's painting an appearance of spontaneous facility and ease, involved long and hard work: 'It is known that these works are much revised and that he went over them so many times with his colours that one can appreciate how much labour is involved.'

Palma Giovane, one of Titian's last assistants, has left us with a vivid description of his master's working methods. Titian used to sketch in his pictures with large masses of colour which formed the foundation of the composition. He would then turn them to the wall and leave them there, sometimes for several months, without looking at them. Returning to his picture, over long intervals, he would then build up his figures, correct and revise them and make any changes he felt necessary. Finally he would retouch the work, moderate the highlights by rubbing them with his fingers and harmonize the colours and tones; or he would, again with his fingers, add dark strokes or bright red spots to liven up the composition. According to Palma, in these last stages Titian painted more with his fingers than his brushes.

Somewhat grudgingly, Vasari admitted that

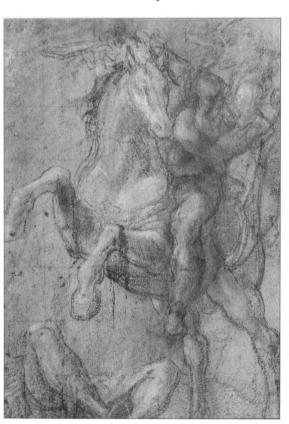

The Andrians (1523-5)
(above) This is one of several large mythologies commissioned by Alfonso d'Este for his new study. Titian was anxious to better the work of his old master, Giovanni Bellini, who had also contributed to the scheme.

A rare drawing
(far left) Titian seems to have made comparatively few drawings. Surprisingly, however, several elaborate preparatory studies exist for his destroyed masterpiece The Battle of Spoleto.

Ranuccio Farnese (1542)
(left) Titian painted superb portraits throughout his career for a string of aristocratic patrons.

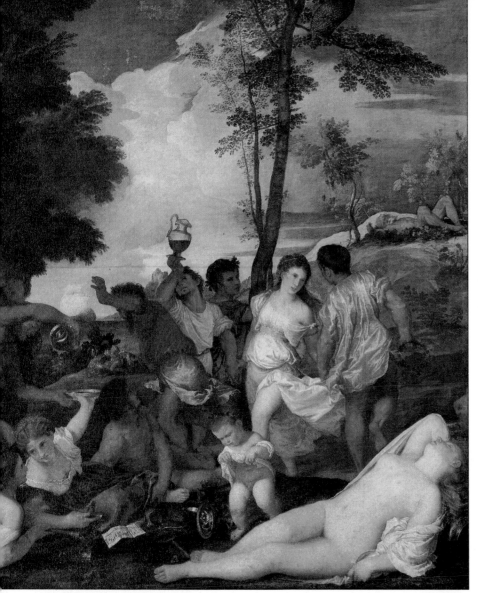

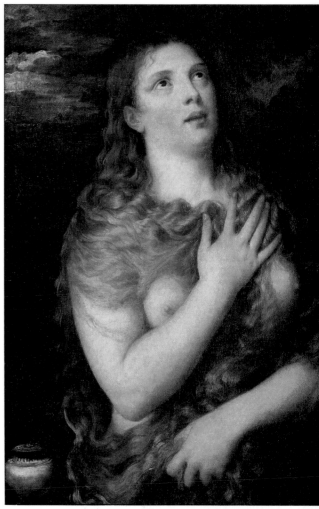

Prado, Madrid

Pitti Gallery, Florence

this technique produced 'judicious, beautiful and stupendous' results. As a Florentine, he believed that the proper way to go about painting was to start with sketches on paper, to work out every detail of a composition in carefully studied drawings. The final drawing could then be transferred almost mechanically to the panel or canvas, and coloured in. This was the method by which the masterpieces of Florentine art, of Leonardo, Raphael and, above all, Michelangelo had been achieved. While Vasari admired the colours of the Venetian painters, he deplored their neglect of drawing – for him the most fundamental part of painting.

In Rome in 1545, Vasari introduced Michelangelo to Titian who was working on a picture of *Danaë*. The visitors praised Titian's work, as was only polite, yet after they had left him Michelangelo told Vasari 'that Titian's colouring and his style much pleased him, but that it was a pity that in Venice men did not learn to draw well from the beginning, and that those painters did not pursue a better method in their studies.'

This was not simply a matter of professional jealousy or competition between Michelangelo and Titian, although that was also part of the argument. The two masters pursued almost totally different aims in their painting. Michelangelo

The Entombment (1559)
(below) The vivid, saturated colours of this religious work – with its glowing reds, blues and golds – are a feature of Titian's late style.

St Mary Magdalen (c.1535)
(above) Popular inventions, like this incredibly sensual interpretation of a devotional theme, were copied and churned out by Titian's busy studio.

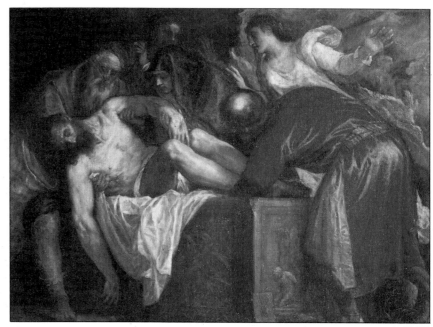

Prado, Madrid

Vigorous draughtsmanship
This powerful drawing may have been a study for
Tarquin and Lucretia. *X-rays show that the painting
(right) was originally similar in composition.*

TRADEMARKS
Free Brushwork

Titian's brushwork has a beauty of its own, irrespective of what it represents. He was the first artist to realize the potential of oil paint, with all its richness and variety of texture.

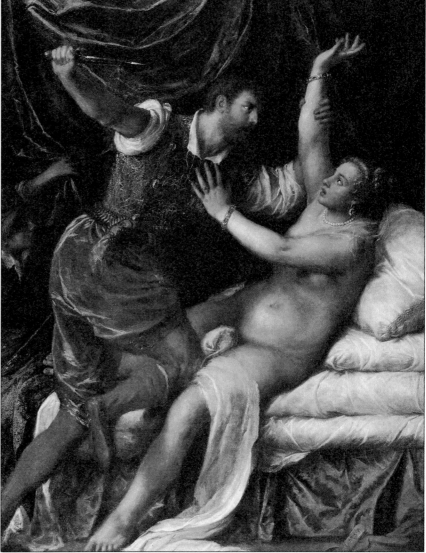

concentrated on the nude male figure as an heroic ideal with expressive and dramatic movements. Titian's paintings, according to his friend Ludovico Dolce, depicted the whole visual world with all its various aspects and different effects. The delicacy of the female form, the softness of flesh, the moisture in the eyes of St Mary Magdalen (p.73) or Lucretia (p.75) – these were qualities which Michelangelo with all his mastery of drawing could not capture in his works. Watching the sun set beyond the Grand Canal, Aretino was reminded of Titian's art and exclaimed 'Oh Titian, where are you now?'; no drawing could convey the effects of light he conjured up in his paintings.

Since his early days, when he had been working with Giorgione, Titian had tried to convey in his pictures an overall sense of mood, of atmosphere: the tranquillity of pastoral landscapes, or the buoyancy of drinking and dancing in *The Andrians* (p.72), the heavenly glow found in *The Assumption* or the murderous drama of the *St Peter Martyr* (p.69). These are all effects which depend on an overall impression, not on the detailed study of particular features. Titian's late

style, often and anachronistically described as 'impressionistic' by modern critics, enforces the overall effect he is aiming at: the spectator has to stand back and take in the whole of the composition. If he gets too close to the painted surface, the picture will dissolve in blots and smudges.

A late work like the *Pietà* (p.71) which was completed after Titian's death, shows all the means which the artist employed to achieve such an overall effect, in this case that of a tragic, gloomy night scene: broad strokes with a heavily loaded brush mark out the individual figures which seem to vibrate in the flickering torchlight.

WORKSHOP PRODUCTIONS

Titian's technique of painting had one further advantage which must have appealed to his economical mind. The intermediate stages of execution, between the initial, inventive sketch and the final retouching, could often be left to assistants. From the 1540s, Titian seems to have employed a large workshop (although probably

Tarquin and Lucretia (c.1571)
*(above and detail right)
This late masterpiece shows the astonishing energy of Titian's style even when he was in his 80s. It depicts a scene from the legendary early history of Rome – the virtuous Lucretia was raped by Tarquin, son of a tyrant, and in anguish killed herself the following day. Tarquin was later exiled and slain. Titian conveys the drama of the tragic story with breathtaking vigour, the bold brushwork helping to suggest the violent movement. Lucretia's expression evokes her terror and despair.*

The Loves of Jupiter

The works of the Roman poet Ovid were extremely popular during the Renaissance and provided a rich fund of inspiration for artists of all kinds. Indeed, his *Metamorphoses*, which recounted stories depicting the transformations that abounded in ancient legend, did more than any other work of literature to transmit to posterity the imaginative beauties of Greek mythology. Jupiter – the supreme god of the Romans – figures prominently in the *Metamorphoses*, as he often disguised himself in various forms in the course of his amorous adventures. Paintings of such subjects appealed greatly to the sophisticated private collectors who began to rival the church as patrons in the 16th century.

Correggio (c.1494-1534) **Jupiter and Io**
Jupiter changed himself into a cloud to visit the beautiful Io, trying to hide his infidelity from his wife, Juno. Correggio's erotic masterpiece was painted for Federico Gonzaga, Duke of Mantua, and was later owned by Charles V.

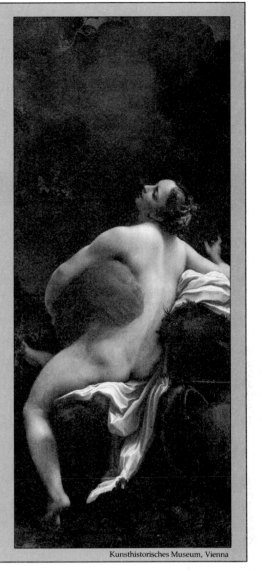

Paolo Veronese (1528-88) **The Rape of Europa**
Veronese was one of the leading Venetian artists in the generation after Titian's death. His painting makes a splendid pageant of the theme, whereas Titian emphasized its dramatic energy.

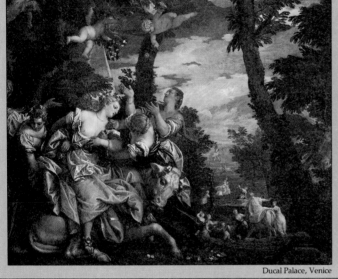

Ducal Palace, Venice

Kunsthistorisches Museum, Vienna

not as large as Raphael's earlier in the century, or Rubens' in the next one). At least 30 of his assistants are recorded by name. Very few of them, perhaps only Tintoretto and El Greco, went on to become great artists in their own right. Most of them, like Titian's son Orazio, his cousin Marco, or Girolamo Dente (who stayed with Titian for 30 years) became totally absorbed in the workshop.

To commission a work by Titian could often mean paying for a workshop production. This was an old Venetian tradition. The earlier workshops of the Bellinis and Vivarinis had operated in much the same way. Yet Titian's own technique seems to have undermined the old system: patrons and critics expected to find his genius expressed in every single brushstroke, and they were often not happy with the way in which assistants did the major work for him 'which he then finishes with two strokes of his brush and sells as his own work.' As Palma Giovane confirms, true lovers of art had caught on to the new notion of the individual 'divine genius', whose work, even if unfinished and sketchy, was more valuable than the polished product of an anonymous workshop.

THE MAKING OF A MASTERPIECE

Sacred and Profane Love

In c.1514 Niccolò Aurelio, one of Venice's most senior civil servants, commissioned the so-called *Sacred and Profane Love*. As far as its subject-matter is concerned, this beautiful picture remains an enigma. Various interpretations have been put forward, of which the most popular maintains that the painting is an allegory of earthly and spiritual love, showing the terrestrial and celestial Venuses. However, there could be a much less esoteric explanation: Niccolò Aurelio married in 1514 and may have commissioned this picture to celebrate the event. The woman dressed in white may be his bride, who is being gently initiated into the mysteries of love by the naked goddess Venus. Cupid, her companion, stirs the waters of the fountain, aiding his mistress in her amorous designs.

Heraldic Clues

Titian has included the family shield of Niccolò Aurelio in the frieze on the fountain (right), and the coat of arms of his bride, Laura Bagarotto, has recently been discovered in the silver dish above. This makes the 'marriage-picture' theory seem even more attractive.

Bridal dress
The woman clothed in white, the traditional colour of Venetian bridal gowns, wears myrtle in her hair – a plant which is sacred to Venus and symbolizes marriage.

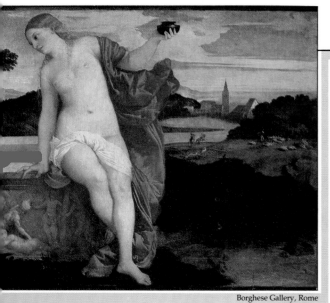

Borghese Gallery, Rome

'Beauty Adorned and
Beauty Unadorned'

Francucci

Idyllic setting
*(above) The lovely
landscape in the
background conjures up the
beauty of the Veneto region
where Titian was born.*

Classical sources
*(left) Titian based the horse
in the fountain frieze
(below) on the famous
bronze horses of San Marco
in Venice.*

Flora (c.1520)
*(right) This portrait
represents the same ideal of
beauty as the two women in
Sacred and Profane
Love.*

Uffizi, Florence

Obscure symbolism
*(left) The meaning of the
mysterious frieze on the
fountain is still unclear.
One theory suggests that it
shows the taming of animal
passion – symbolized by the
restraining of an unbridled
horse. On the other hand,
the relief may have some
private significance of an
erotic nature for the patron.*

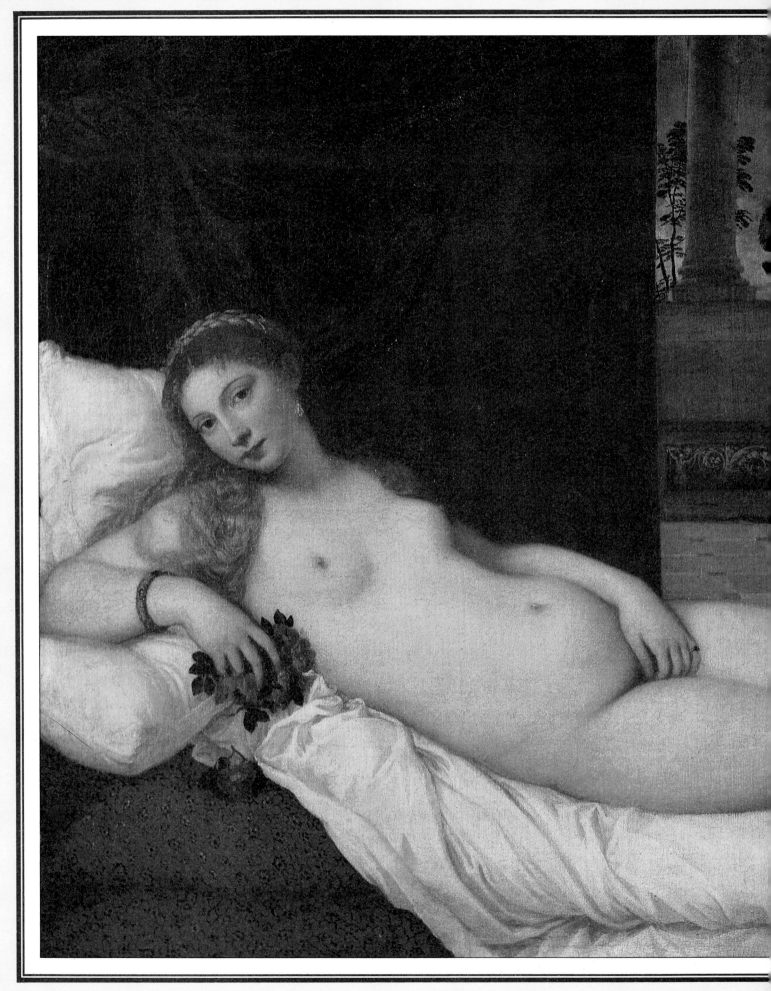

Background

The Renaissance artists were working during years of great political upheaval in Italy. The events of the time directly affected them, as the powerful rulers also influenced the patronage of the arts. Paintings and sculptures were commissioned by the cultured Medici family in Florence and by the infamous Borgias in Rome. Savonarola, another powerful ruler and a zealot monk, led a fervent crusade to rid Florence of the gaiety and artistic freedom of Lorenzo de Medici's court. He finally won Botticelli's support, and the style of the artist's paintings seem to have been influenced thereafter. Leonardo da Vinci is said to have despised the violent atmosphere of Italy in the 1470's, but this did not prevent him from working for the cruel Cesare Borgia – inventing weapons.

Venus of Urbino *1538 by Titian*
46¾″ × 65″ Uffizi, Florence

The Fiery Priest

During the last decade of the 15th century, Florence was wracked by the bitter tirades of the zealot monk Savonarola. Much of his condemnation was directed at the powerful Medici family.

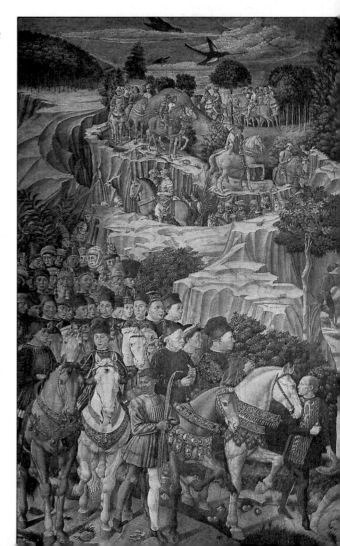

'In a few hours they were burnt, their legs and arms gradually dropping off; part of their bodies remaining hanging to the chains, a quantity of stones was thrown to make them fall, as there was a fear of the people getting hold of them; and then the hangman and those whose business it was hacked down the post and burnt it to the ground, bringing a lot of brushwood and stirring up the fire over the dead bodies, so that the very last piece was consumed.'

Such was the ignominious end of the friar Girolamo Savonarola and his two closest followers, in Florence's Piazza della Signoria on 23 May 1498. The extraordinary charisma of this preacher's personality had exerted a powerful influence over Renaissance Florence, bringing a fear of God and an overwhelming sense of sin to the city which had become the centre of European artistic and cultural life.

A GROWING REPUTATION

Savonarola was born in Ferrara in 1452, the son of a scholar and doctor, and after a sudden conversion became a Dominican monk in 1475. His success as a preacher, religious thinker and writer ensured that his reputation spread and, in 1490, he was transferred to the convent of San Marco in

San Marco
(above) The monastery of San Marco was rebuilt by Cosimo de' Medici and enriched by successive Medici rulers. When Savonarola was made Prior in 1491 he refused to pay homage to Lorenzo as custom demanded, on the grounds that he owed his thanks to God, not Man.

A rejected lover
(left) Girolamo Savonarola was destined to follow his father into the medical profession, but a painful rejection by the lady he had hoped to marry left him full of self-doubt. In 1474, a sermon he heard persuaded him of his vocation and he entered the Monastery of San Domenico at Bologna.

The Medici dynasty
(right) Cosimo the Elder established the powerful Medici as absolute rulers of Florence, although he and his successors never held any official position. This fresco, The Journey of the Magi *by Benozzo Gozzoli, shows Cosimo's grandson, Lorenzo the Magnificent, seated on a horse at the centre of the painting.*

Bartolomeo della Porta/Savonarola/Museum of S. Mark, Florence

Medici patronage
(left) Fra Filippo Lippi (1406-69) was one of many leading Florentine painters, sculptors and architects patronized by Cosimo de' Medici. A Carmelite painter-monk who left the order after a scandalous love affair with a nun, Lippi later became Botticelli's master.

Florence, of which he was made Prior in July of the following year.

Florence proved a powerful catalyst for Savonarola's evangelical crusade. His scrupulous conscience found much to condemn in the prevailing atmosphere of the city and inevitably focused on the influential Medici family.

Cosimo de' Medici (1389-1464) had established the Medici as the virtual rulers of Florence 50 years earlier. During the first half of the century he nurtured the beginnings of the Renaissance, patronizing architects, sculptors and painters, as well as endowing many churches and the monastery of San Marco.

Fra Filippo Lippi/The Coronation of Mary

His grandson Lorenzo, known as 'the Magnificent', continued and increased this cultural patronage, building up an enviable court peppered with the greatest scholars and artists of the age. Lorenzo's humanist upbringing inclined him towards philosophers and thinkers steeped in classical learning, and he encouraged the Platonic Academy established by Cosimo, which boasted some of Italy's finest minds.

Lorenzo was fortunate in taking over the key position in Florence after more than 30 years of peace within the city and stable relations with other Italian city states – the results of his grandfather Cosimo's sensible tactics. Lorenzo himself was pleasure-loving and urbane, a keen poet and writer of bawdy songs, which were intended for the carnivals and festivals regularly held in Florence.

OUTSPOKEN CRITICISM

It was against this backcloth that Savonarola began his crusade to purge the city of corruption. Although a newcomer to Florence, and a 'foreigner' at that, Savonarola soon began to make an impact with his wild prophetic sermons. And it was precisely against the licence and 'paganism' of the Medici court, together with the excessive power of the Medici family, that Savonarola directed his venom.

Savonarola was an ardent republican and

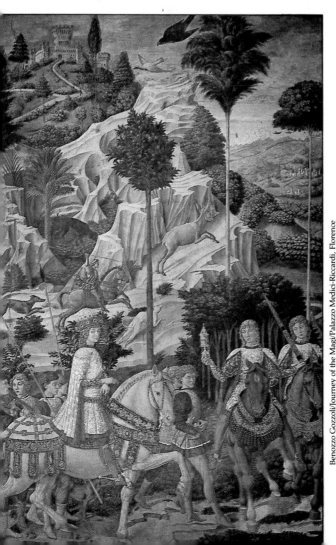

Benozzo Gozzoli/Journey of the Magi/Palazzo Medici-Riccardi, Florence

G. Bugiardini/Michelangelo

Michelangelo and the Medici
(above) As a boy, Michelangelo studied under Bertoldo in the Medici antique sculpture garden, and spent two years in Lorenzo's household.

81

The Platonic Academy
(right) Cosimo de' Medici considered the study of Plato's works to be a valuable means of self-improvement and established an informal Platonic Academy under the direction of the Italian scholar Marsilio Ficino. Lorenzo continued the Academy and is seen here surrounded by the eminent philosophers, writers and artists of the time.

Palazzo Vecchio/Florence

believed that, through their misuse of power and near-dictatorship of Florence, the Medici were bringing the city to ruin and damnation. He was a superb orator, capable of whipping his audience into hysteria, but he also used persuasive arguments to beguile his listeners. Florence, he argued, had been chosen by God for a special destiny, but the corruption of its rulers, its clergy and its culture had incurred God's wrath. The message was clear – repent before it is too late.

The firebrand monk was no mere evangelist – he possessed charm as well as intellect and a broad knowledge. Strangely, he attracted many eminent humanists to his sermons. Fearlessly, the monk denounced the very people who had invited him

to Florence and secured his career. From the pulpit of San Marco, and then from the Duomo – Florence's magnificent new cathedral, packed to bursting with excited audiences – Savonarola prophesied the downfall of Italy's tyrannical princes and the destruction of the city.

Lorenzo himself was intrigued by the preacher and attended several of his sermons. He remained surprisingly tolerant of the monk's vitriolic condemnation, and contented himself with sending delegates to reason with Savonarola, inviting him to meetings at the Medici palace and eventually hinting at banishment unless he toned down his dire warnings.

THE DEATH OF LORENZO

Untouched by these overtures and refusing any liaison with the Medici prince, Savonarola increased the wildness of his prophecies. The influence of the man was immensely strong and when, in 1492, Lorenzo was on his deathbed, he sent for Savonarola to give him a last blessing.

The death of Lorenzo the Magnificent and the instability which followed only heightened Savonarola's popularity. In 1494, when Florence was under threat of invasion, Lorenzo's son Piero, a far weaker ruler, agreed to give up the city to the French king. The Florentines turned against him and he fled. A republican constitution was established along Savonarola's guidelines and – installed in the city's new governing council – the preacher wielded enormous power.

Savonarola's religious fanaticism was now fused with political clout. Whipped into a frenzy of religious intensity, the Florentines responded willingly when Savonarola organized a great bonfire in the city's piazza to burn their 'vanities'.

Sermons in the cathedral
(left) In 1491 Savonarola delivered his first sermon in Florence's recently completed cathedral. As his popularity grew, even this vast edifice was too small to accommodate the huge crowds which flocked to listen to his uncompromising rhetoric.

Lorenzo's successor
(right) Piero de' Medici was a weak ruler who lacked his father's political integrity. His mishandling of the French invasion prompted the Florentines to revolt against him and re-establish the Republic.

The people threw cards, dice, jewellery, ornaments, cosmetics, games, books, songsheets, poetry and even paintings into the flames.

Reverberations were also strongly felt among intellectual and artistic circles. The gaiety and optimism of life at Lorenzo's court was replaced by a sense of gloom and artistic stricture. The leading humanist scholar, Pico della Mirandola, took religious vows shortly before his death, following Savonarola into the Dominican order. Botticelli may also have been affected by Savonarola's mysticism, for his late paintings of religious subjects reveal a spiritual intensity quite unlike the classical grace and harmony of his previous work. And the artist's brother was certainly one of Savonarola's followers, who were known as the *piagnoni* ('snivellers').

In the midst of the upsurge of new, energetic Renaissance thinking which was beginning to spread throughout Italy, Florence – with Savonarola as virtual moral dictator – was plunged into a rigorous austerity more in tune with the Middle Ages. Fearless before any authority other than God's, Savonarola's sermons grew more shrill and blatant, even after his excommunication by the Borgia Pope, Alexander VI, whom he had attacked as the Antichrist.

THE TURNING POINT

But the public's support had been too rapid and too extreme, and inevitably a reaction set in. The people missed the relative freedom of life under the Medici and resented the monk's ardent pro-French policy, which they felt to be damaging to the city's dignity and independence.

Savonarola's downfall was hastened when, in 1498, the still powerful Florentine merchant

families and other members of the city council finally joined forces with the Pope to oust the monk. Early in 1498 he was arrested on the charge of heresy and, under torture, admitted his guilt. In May of that year, in the piazza where he had formerly given his sermons and the people had burnt their vanities, Savonarola – along with two of his most faithful disciples – was hanged and then burnt at the stake.

Savonarola's influence, though strong, was shortlived. Not so the reputation of the Medici, whose power he had sought to end. Their name – and especially that of Lorenzo the Magnificent – lives on through their enlightened contribution to one of the greatest periods of art and thought.

The Adimari Chest/Academy, Florence

A pleasure-loving city *(above) Lorenzo de' Medici encouraged music and carnivals. Savonarola persuaded Florence's citizens to abandon such pleasures.*

A public execution *(below) After 40 days of interrogation and a mock trial before the Pope's commissioners, Savonarola was hanged and burned at the stake.*

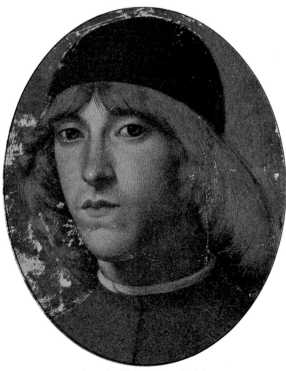

Domenico Ghirlandajo/Piero de Medici

Anonymous/Martyrdom of Savonarola/Museum of S. Marco, Florence

The Borgias

At the time of the Renaissance, Italy was a collection of independent states, ruled by rival families. The most famous of these were the Borgias, infamous for their political intrigue.

Leonardo da Vinci first met Cesare Borgia in 1499 when he accompanied Louis XII of France on his military invasion of Milan, ruled at the time by Leonardo's patron Ludovico Sforza. Borgia was a fascinating figure – an exquisitely dressed and handsome young man who knew how to charm, despite his reputation for audacity, cruelty and licentiousness. He soon realized that Leonardo's extraordinary genius as inventor and engineer would be invaluable to him in his military campaigns, and later invited him to become his military engineer and architect.

Leonardo was in Borgia's service from the summer of 1502 to February 1503, designing fortifications, inventing weapons and preparing military maps as he moved with the army through the Romagna, to the east and north-east of Florence. In his notebooks, Leonardo makes no reference at all to the appalling acts of violence committed all round him during those months.

Leonardo would certainly have been aware that three members of the Borgia family – Cesare, his sister Lucrezia and his father Pope Alexander VI – were widely accused of treachery, murder, torture and incest. Some of these accusations may have been fabricated, or at any rate exaggerated, in rumours started by the family's many enemies. The Borgias were isolated by their Spanish origins and were resented in particular by the powerful Roman families of Orsini and Colonna.

THE RISE OF A DYNASTY

Alexander VI was born Rodrigo de Borja in 1431 in Valencia, Spain, – the name was later Italianized. His uncle, Pope Calixtus III, made him a cardinal, and by the time he received the Keys of St Peter – amid charges of simony – the family was immensely wealthy. In many ways Alexander was an able administrator, but he continued to hand

Pinturicchio/La Disputa di Santa Caterina (detail)/Borgia Apartments, Vatican

The papal city
(left) By the 15th century, Rome had established itself as the Holy City, and the Vatican had become the official residence of the pope. The basilica of St Peter's was situated alongside.

Pinturicchio/Pope Alexander VI (detail)/Borgia Apartments, Vatican

Vannozza dei Catanei
(above) A Roman lady renowned for her charm, Vannozza was Rodrigo Borgia's mistress for about 11 years, and the mother of Cesare, Juan and Luzcrezia.

Pope Alexander VI
(left) Rodrigo Borgia was elected pope on 11 August, 1492, amid widespread charges of corruption. A striking libertine and an able and unscrupulous politician, he pursued a ruthless campaign to secure his family's aggrandisement.

The pope's frescos
(left) This fresco is one of a series commissioned by Pope Alexander VI to decorate the Borgia apartment in the Vatican. The painting shows Catherine of Alexandria disputing with the pagan emperor Maximus. Lucrezia and Cesare were probably the models for Saint Catherine and the emperor, while the mounted horseman in the foreground is thought to be Juan. In the background, the Borgia bull presides over the occasion from the top of a triumphal arch.

out important Church positions to relatives and supporters, while weakening his enemies through confiscation of their property and, it is assumed, by arranging for their 'liquidation' whenever this was necessary.

Alexander had fathered about seven children while still a cardinal and at least one other when he was pope, but it was not uncommon for clerics to have sexual relations with women and acknowledge broods of illegitimate offspring. In fact, if Alexander had a saving grace, it was his boundless affection for his children, particularly for Cesare, Juan and Lucrezia – all by Vannozza dei Catanei, who was his mistress for about 11 years.

The pope's devotion to his beautiful fair-haired daughter prompted scandalous tales of incest, and there was also speculation about relations between Lucrezia and Cesare. Alexander's fondness did not, however, prevent him from arranging a succession of marriages solely in order to cement ties with whichever political ally he happened to need at the time.

Lucrezia's first betrothal, to a Spanish nobleman when she was 11, was annulled to allow a more useful marriage two years later to Giovanni Sforza of Milan. When that political alliance no longer served a purpose, the pope ended the marriage by forcing the unfortunate young husband into a public declaration which implied he was impotent. To strengthen links with the House of Aragon, which ruled the Kingdom of Naples, Lucrezia was married in 1498 to Alfonso, Duke of Bisceglie. By chance, this was a truly happy love match.

Just over two years later, Alfonso was brutally attacked outside the Vatican by a group of unknown assailants. Although he seemed to be recovering from his injuries, some days later he suddenly and mysteriously died. Most reports implicated Cesare, who was said to have called in his personal assassin to kill Alfonso, perhaps out of envy or jealousy over Lucrezia.

Within a month Alexander was seeking a new husband and decided on Alfonso d'Este, heir to the Dukedom of Ferrara. Lucrezia now left Rome for good, and, as custom dictated, parted from her much-loved first child Rodrigo.

Meanwhile Cesare, an archdeacon from the age of 7 and a cardinal from 17, had seized the long-awaited opportunity of throwing off his clerical

Lucrezia Borgia
(right) Alexander's favourite daughter was reputed to be a graceful fair-haired girl who was warm-hearted and generous. A victim of her father's scheming and her brother's possessive love, she outlived her Borgia notoriety and devoted herself to good works.

The Borgia arms
(above) At Alexander's coronation, the Borgia arms – a bull grazing in a gold field – lined the route of the procession. It later became a hated symbol of the tyrannical Borgia dynasty.

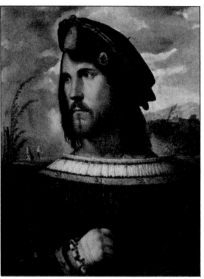

Il Valentino
(right) In some ways Cesare was a magnificent example of Renaissance man – handsome, bold and intelligent, but his ruthlessness and treachery made him feared and hated throughout Italy.

Accademia Carrara, Bergamo

Bartolommeo Veneto/Portrait of a Lady/National Gallery, London

robes and becoming a soldier. When Alexander's first son had died at a young age, his Spanish title, Duke of Gandia, had passed to the third son Juan, because Cesare, as the second born, had from birth been destined for the Church. When in 1497 Juan was stabbed to death and his body thrown into the River Tiber, Cesare was regarded by many as the prime suspect, although no proof was available.

At any rate it enabled Cesare to take over his murdered brother's coveted position of Captain-General of the Papal Troops, which the pope conferred on him after releasing him from his vows. Cesare also acquired the French title of Duke of Valentinois – the origin of Il Valentino, the name often used for him – in return for the pope's annulment of the French King's first marriage and dispensation for his second. While visiting France in 1498, Cesare married the French princess Charlotte d'Albret, by whom he had a daughter, but whom he quickly abandoned.

Italy at this time was a patchwork of independent states, the most important of which were Venice, Milan, Florence, the Spanish-ruled Kingdom of Naples, covering the southern part of the country, and the Papal States, which stretched diagonally across the centre. The north-eastern end of the Papal territories, the Romagna, was effectively ruled by a number of local barons, notable mainly for their greed and incompetence. Cesare's task was ostensibly to bring the Romagna firmly back under Papal rule; in fact it was a means

of gaining Italian lands and the title of Duke of Romagna for himself. One by one the towns fell to Cesare as he disposed of all opposition through trickery and assassination and by terrifying the populace into obedience. Even the well-administered duchies of Urbino and Camerino, loyal to the pope, did not escape.

AN 'IDEAL' RULER

In Niccolò Machiavelli's book *The Prince*, written in 1513, Cesare Borgia is presented as an example of a supremely successful soldier and statesman. Machiavelli had met Il Valentino on at least two occasions when he was on diplomatic missions as Second Chancellor of the Florentine Republic.

Machiavelli stressed that Il Valentino's achievements would not have been possible without good fortune on his side. This fortune deserted Cesare in August 1503 when the pope died, leaving him without protection.

Alexander had fallen ill after dining at Cardinal Adrian's villa and it was widely believed that he had been poisoned by a potion which he had intended for the cardinal. The more likely cause of death was malaria, which was rife in the city that summer.

Cesare too was stricken, and this hampered his desperate plans to secure the election of the 'right' pope. Pius III was a reasonably safe choice, but died within a few weeks, and Cesare was unable to

prevent the subsequent election of Julius II an enemy of the Borgias.

Cesare was forced to flee to Naples, but the Spanish rulers, anxious not to antagonize the new pope, sent him to Spain where he was imprisoned. After two years, Cesare made a characteristically daring escape and found his way to the French court of his brother-in-law Jean de Navarre, who made him captain of his mercenary troops. Cesare was killed at the siege of Viana in Navarre, on 12 March 1507, aged 31.

Lucrezia lived for another 12 years, dying at 39 of complications following childbirth. Her life in Ferrara must have been sad and lonely, for her husband had always regarded her with cold indifference. She relieved the tedium with romantic attachments to the poet Pietro Bembo and her brother-in-law Francesco Gonzaga, but contemporary reports also refer to her charitable works and the amount of respect she had earned from her subjects.

Stories of the Borgias' monstrous depravity and cruelty have crystallized into a semblance of truth through repeated telling, but most cannot actually be proved true. The family's deeds must in any case be viewed against the prevailing morality of an age in which nepotism, political assassinations, sexual promiscuity and street violence were commonplace. The Renaissance, with its unparalleled flowering of arts and learning, was in many other ways a monstrous time in which to rule or be ruled.

Niccolò Machiavelli
(left) Machiavelli spent several months with Cesare Borgia in the Autumn of 1502, as an emissary of the Florentine republic. He greatly admired Cesare's combination of audacity and diplomacy, and saw in him the qualities of leadership needed to unify the squabbling Italian states. During this time Machiavelli also met Leonardo. The two men were drawn together by their intellect, and became close friends.

Palazzo Vecchio, Florence

Dosso Dossi/A Bacchanal/National Gallery, London

Cesare's swift vengeance
(above) Vitellozo Vitelli and Oliverotto da Fermo were two of the condottieri who conspired against Cesare Borgia in 1502. Their execution was reconstructed in the television series The Borgias.

A patroness of the arts
(left) As Duchess of Ferrara, Lucrezia presided over a distinguished court. The painter Dosso Dossi was one of many artists who benefited from her patronage.

The Liberation of Saint Peter *1513-4*
base 260″ Stanza d'Eliodoro, Vatican *by Raphael*

Botticelli

Botticelli is now most famous for his mythologies. Primavera and The Birth of Venus brought new dignity to such painting, hitherto considered a minor form of artistic expression. The interpretation of their symbolism is still debated, but their beauty has made them two of the most popular pictures ever painted.

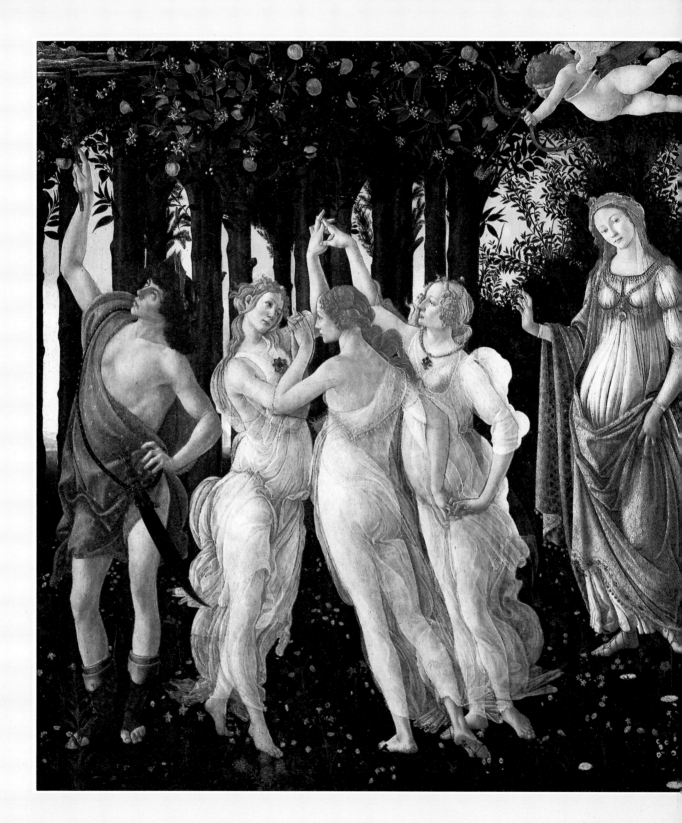

However, Botticelli completed a greater number of religious paintings than any other type. He was commissioned to paint highly decorative altarpieces for numerous Florentine churches, and also produced many smaller paintings of the Virgin and Child, intended for personal devotion. The Madonna of the Magnificat is the most glorious example of this type of painting.

Towards the end of his career, Botticelli's art took on a new seriousness and emotional fervour. The Mystic Nativity, which is, in fact, his only signed and dated work, is one of the most personal and intense paintings in the history of art and its exact meaning remains a puzzle for historians.

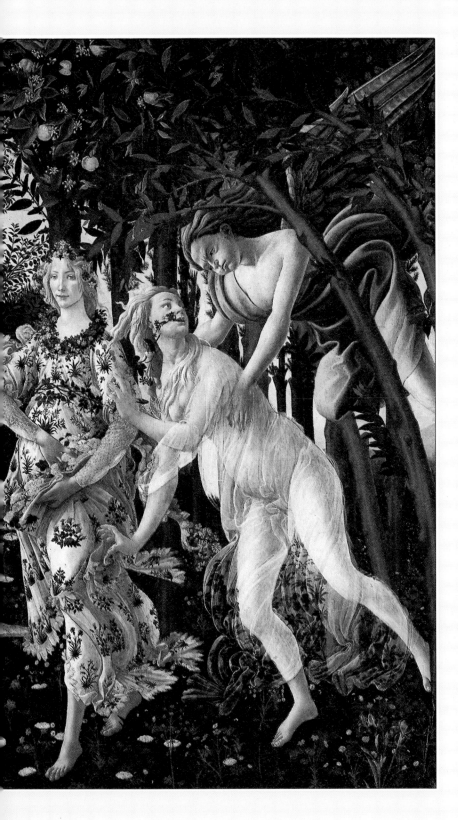

Primavera *c.1478*
79½″ × 123½″ Uffizi, Florence

Primavera is not only one of the supremely beautiful pictures of the Renaissance, but also one of the most discussed paintings in the history of art. Vasari described the subject as 'Venus as a symbol of spring [Primavera] being adorned with flowers by the Graces', and much learned (and sometimes fanciful) scholarship has been devoted to elucidating the meaning of the various figures. From left to right they are: Mercury, the messenger of the gods; the three Graces, handmaidens of Venus; Venus herself (with Cupid above); Flora, the goddess of flowers; Chloris, the nymph who – according to the Roman poet Ovid – was transformed into Flora; and Zephyr, the west wind, who married Flora.

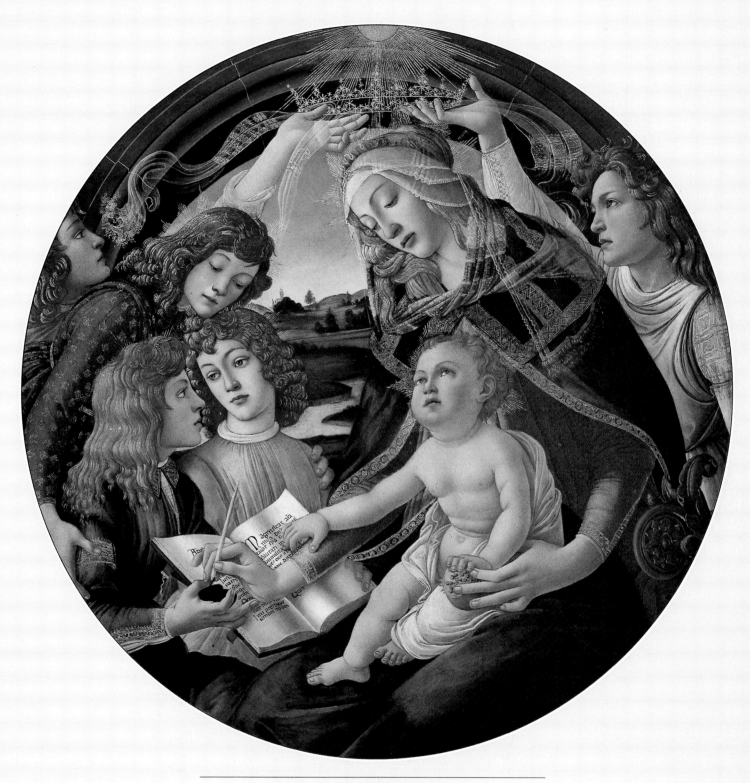

Madonna of the Magnificat *c.1480-85*
diameter 46½″ Uffizi, Florence

This is generally agreed to be Botticelli's most majestic portrayal of the Virgin and Child. It takes its name from the Latin hymn known as the Magnificat (from the first word of the text), which the Virgin is writing in the book: 'And Mary said My soul proclaims the greatness of the Lord' (Luke I, 46).

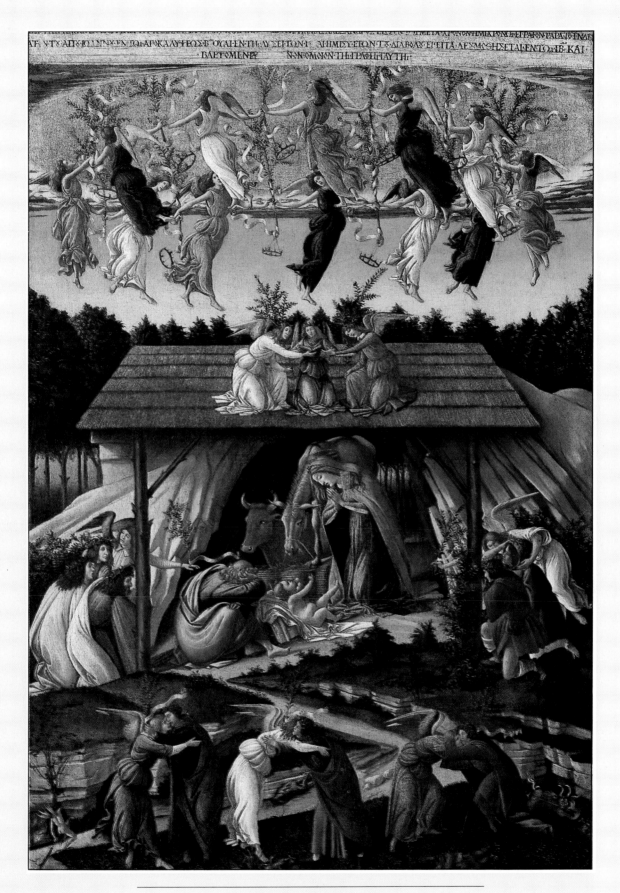

The Mystic Nativity *1500*
42¾″ × 29½″ National Gallery, London

*This rapturous painting has an enigmatic inscription in Greek
referring to 'the troubles of Italy' and alluding to the Apocalypse (many
people expected the world to end in 1500). The exact significance of the
painting is impossible to unravel, but it expresses the peace and
goodwill that will prevail after Christ's second coming.*

Leonardo Da Vinci

Leonardo trained in the studio of Andrea del Verrocchio and his earliest works, such as the exquisite Annunciation painted when he was about 20, reveal the superb standards of craftsmanship that he learned from his redoubtable master.

Throughout his life, religious works vied with portraits as Leonardo's main subject.

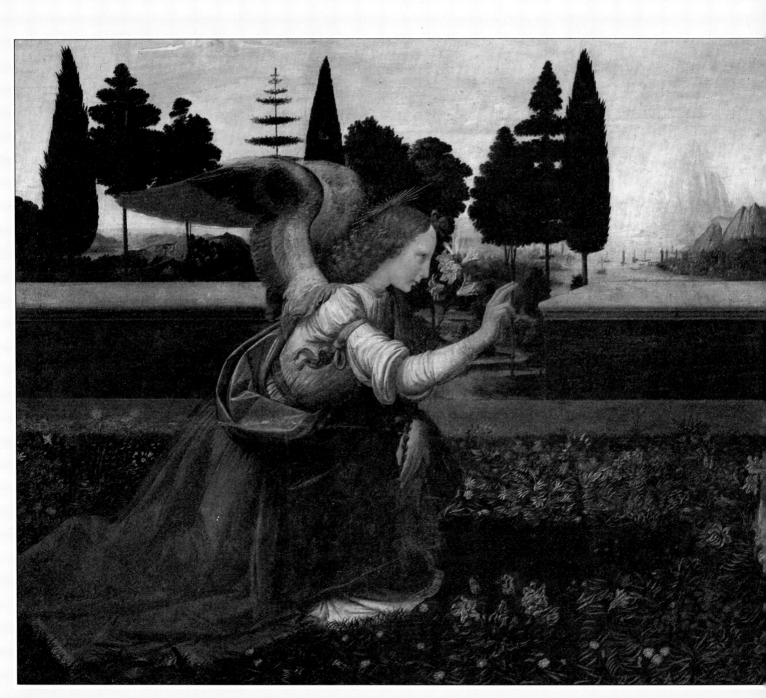

He excelled in painting graceful and gentle portraits. He had a talent for picturing his subjects in calm and beautiful poses. Leonardo painted Mona Lisa (La Gioconda) and the portrait of the same name now hangs in the Louvre as one of his most famous masterpieces.

In religious painting, Leonardo's achievement was diverse, ranging from the majesty of The Last Supper (p.34), which established the rhetorical 'grand manner' that became accepted as the norm for such subjects, to the tender intimacy of The Virgin and Child with St Anne, one of the most beautiful expressions of maternal love in the history of art.

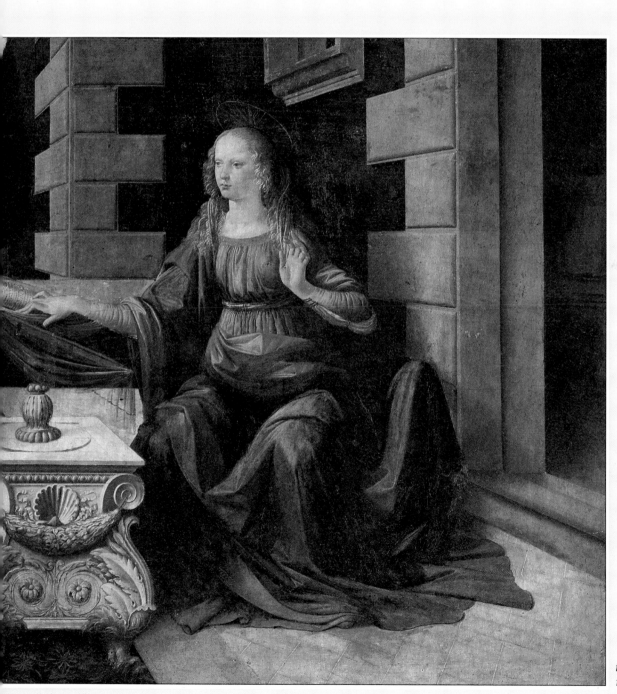

The Annunciation
c.1472
38¾" × 85½"
Uffizi, Florence

There is no documentary evidence concerning this painting, but it is of such high quality that most authorities consider it one of Leonardo's early masterpieces, probably painted soon after he became a master in the painters' guild in Florence. The exquisite 'carpet' of flowers reveals all Leonardo's love of botanical detail, and the angel's wings are, with typical scientific curiosity, modelled on those of a bird.

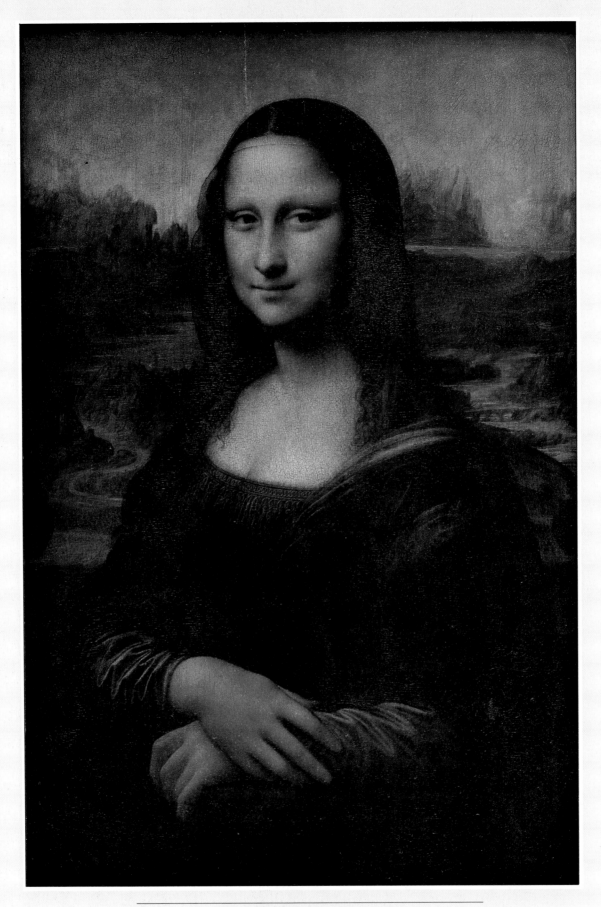

Mona Lisa (La Gioconda) *c.1503*
30¼″ × 20¾″ Louvre, Paris

*This portrait of Lisa Gherardini, wife of the Florentine merchant
Francesco di Zanobi del Giocondo, is now so famous that it is hard to
appreciate how original the pose and expression were in their
naturalism and subtlety. Leonardo is said to have employed musicians
and jesters to keep Mona Lisa amused as he worked.*

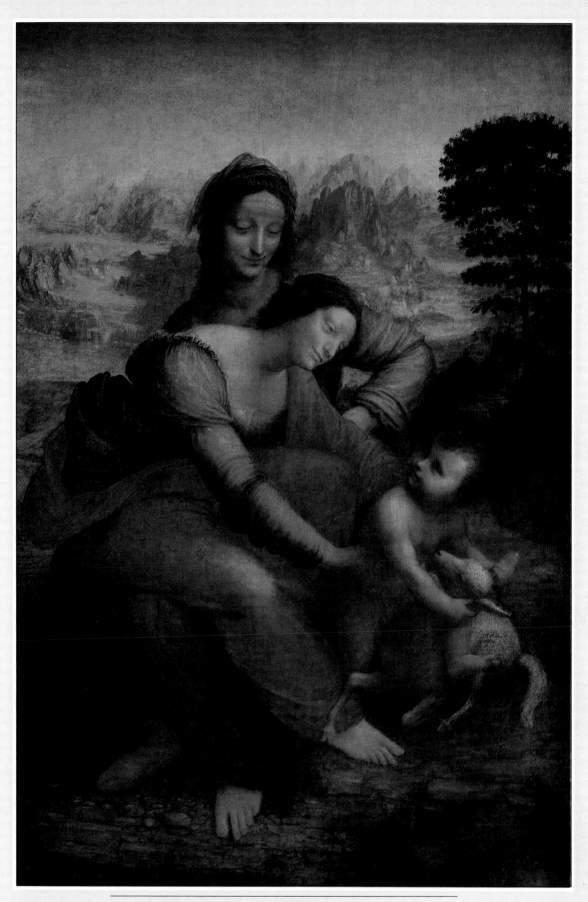

The Virgin and Child with St Anne *c.1510*
66½″ × 51¼″ Louvre, Paris

This is Leonardo's final version of a favourite theme. Although unfinished, it has some breathtaking passages and shows Leonardo's incomparable skill with sfumato *– the blending of tones so subtly that they merge, in his own words, 'without lines or borders in the manner of smoke'.*

MICHAELAGLVS·BONAROTVS·

Having trained as a painter and a sculptor, Michelangelo left Florence and travelled to the holy city of Rome. Here, he sculpted a pietà – an image which was more popular in Northern Europe than in Italy, showing the Virgin with the dead Christ lying across her knees. The delicacy and technical brilliance of the work made his reputation, and on his return to Florence he was entrusted with a major commission – the famous David.

Pietà *1497-1500*
height: 5′8½″
St Peter's, Rome

Michelangelo carved the exquisite St Peter's Pietà *for a French cardinal in Rome. His contemporaries were immediately impressed by the exceptional beauty of the work – in which every fold of drapery was finely sculpted and polished. A few complained, however, about the comparatively youthful appearance of the Virgin.*

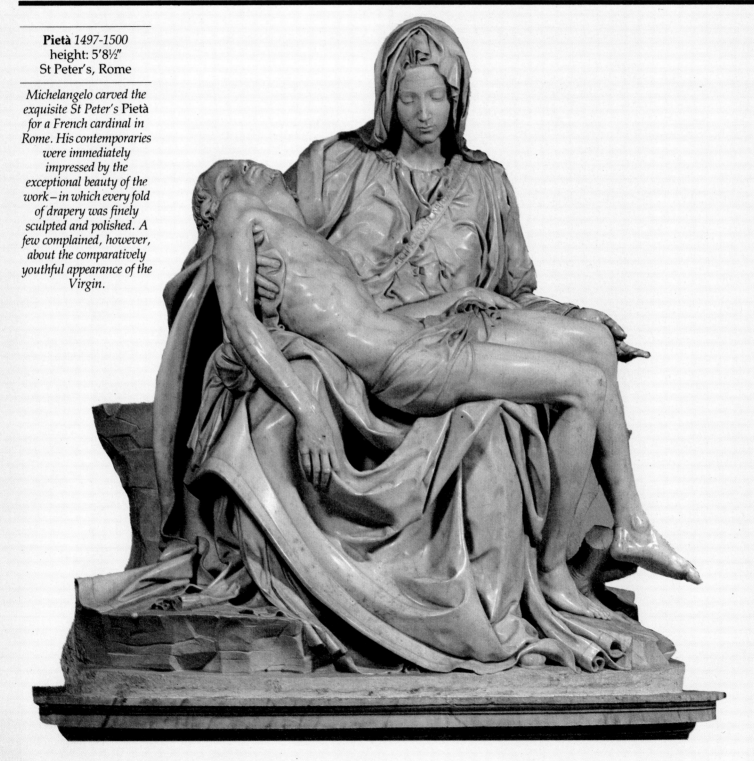

The grace and elegance of the Pietà and the heroic grandeur of David are combined in the Sistine Ceiling frescoes, which demonstrate the full scope of Michelangelo's genius. Over 20 years later, he returned to the Sistine Chapel to paint the terrifying Last Judgement. In this austere masterpiece the gentle linear rhythms of the Pietà have completely disappeared, to be replaced by a fuller, more expressive style.

David *1501-4*
height: 13'5¼" Accademia, Florence

In 1501, Michelangelo returned to Florence to undertake one of his most important official commissions. On his arrival, he was given an enormous block of marble, which had been lying abandoned in the cathedral office of works. Some 40 years earlier, another sculptor had begun to carve a figure from it, but had bungled the attempt. Now the City of Florence wanted Michelangelo to produce a monumental figure of David, which would symbolize the Republican virtues of courage and fortitude. The block was tall, very shallow and considerably flawed. Nevertheless, Michelangelo boldly surmounted these obstacles, sculpting the figure in incredible anatomical detail. He chose to show David just before his battle with Goliath: the young biblical hero stands, with his sling over his shoulder, frozen in a pose of tense anticipation and defiance.

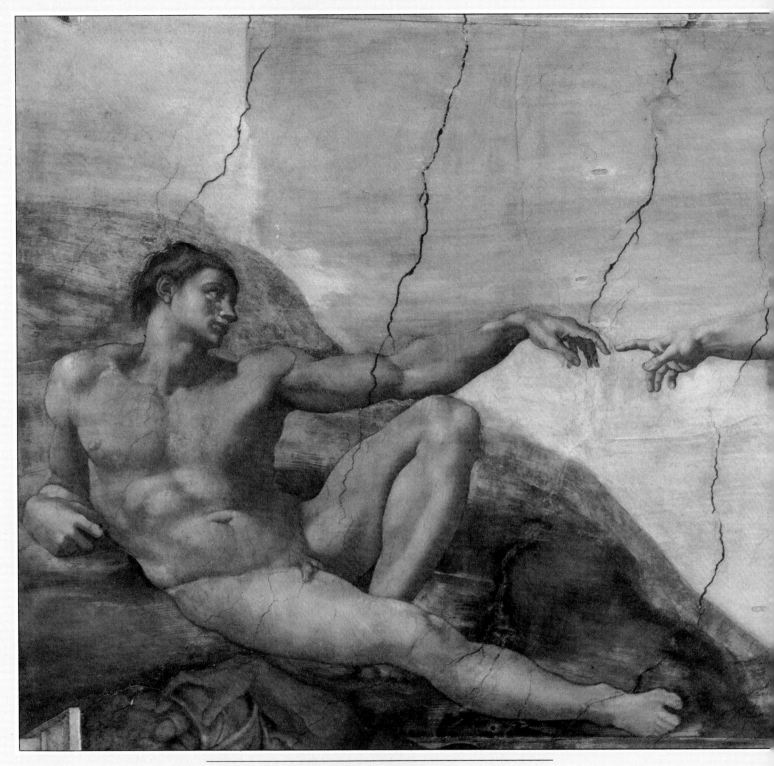

The Sistine Ceiling *1508-12*
Detail: The Creation of Adam *1511*
Vatican, Rome

On the vault of the Sistine Ceiling, Michelangelo painted nine scenes from Genesis, of which the most famous is The Creation of Adam. *Here, the listless body of Adam is about to be animated by the spirit of God at the gentle touch of their fingertips. This potent image may have been suggested by the Latin hymn* Veni Creator Spiritus, *in which God restores strength and courage to the weakened flesh with a touch of his finger.*

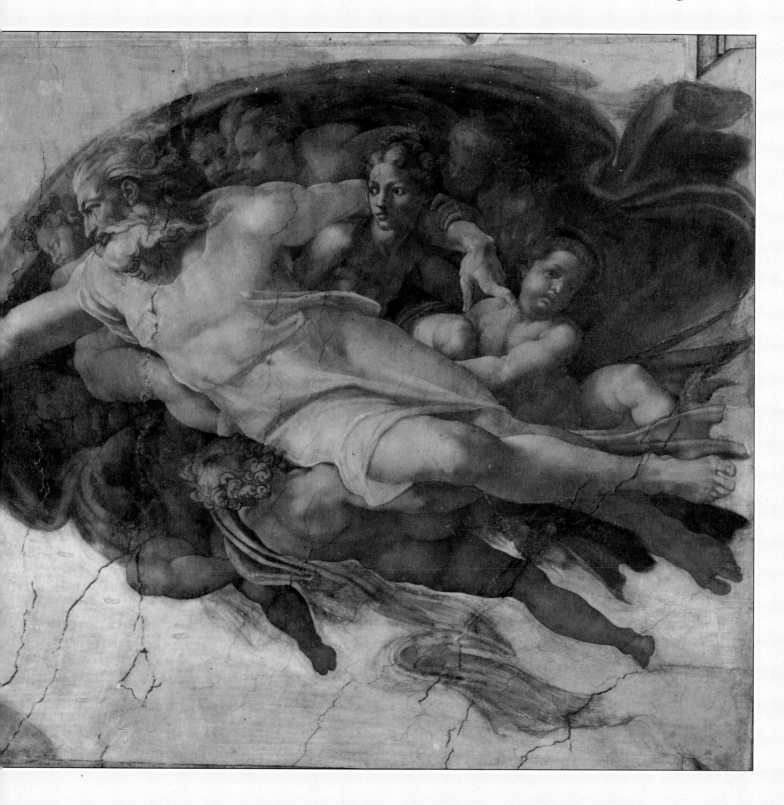

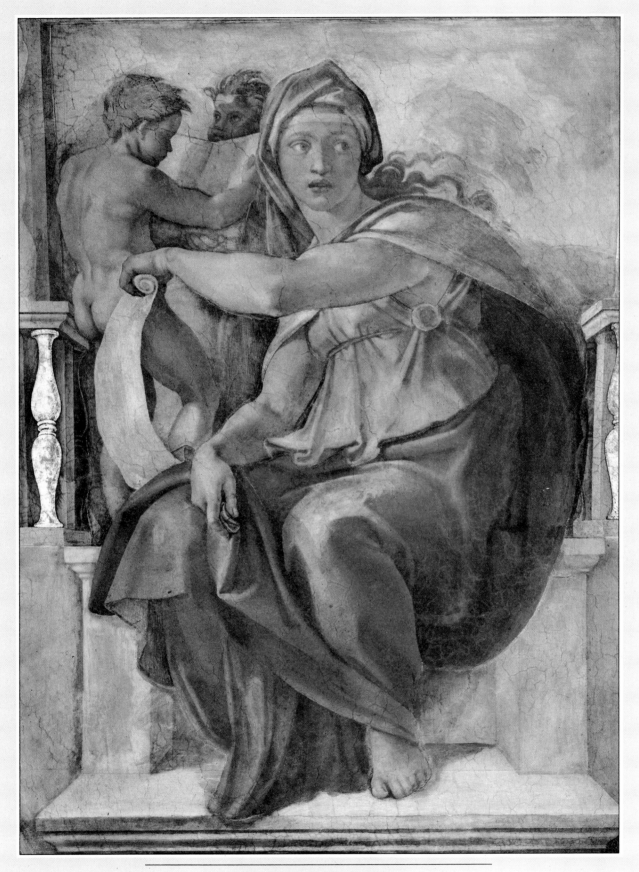

The Sistine Ceiling *1508-12*
Detail: The Delphic Sibyl *1509*
Vatican, Rome

As part of the Sistine ceiling decoration, Michelangelo painted five
pagan Sibyls — ancient Seers who prophesied the coming of Christ. The
Delphic Sibyl was the first to be completed: a lovely sculptural figure
seated on an architectural throne.

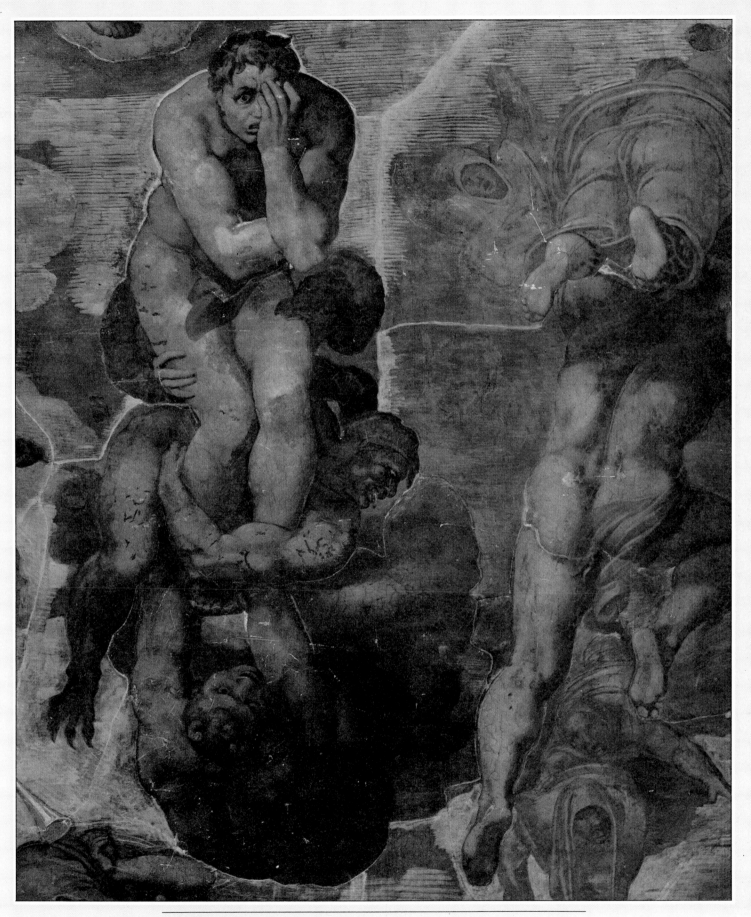

The Last Judgement *1536-41* **Detail: A Condemned Soul** Vatican, Rome

In the lower portion of the fresco, Michelangelo painted the figures of the Damned being
dragged down to Hell. One soul has abandoned all hope: in the midst of scenes of titanic
struggle, he covers his face in sheer terror and despair.

103

·RAPHAEL·VRBINAS·

Raphael's early work was strongly influenced by his master Perugino: The Betrothal of the Virgin has all Perugino's serenity of grace, coupled with a new strength and dignity also to be found in The Entombment. In his Florentine period it was Leonardo's work that affected and influenced him most deeply.

The Betrothal of the Virgin 1504
67″ × 46″ Brera, Milan

(left) The masterpiece of Raphael's early period, in which he showed that he had absorbed everything his master Perugino could teach him and then surpassed him in lucidity of composition and delicacy of touch. Joseph's staff has flowered, showing that he is favoured by God to be Mary's husband. On the right, one of Mary's rejected suitors breaks his staff over his knee.

The Entombment 1507
72½″ × 69¼″ Borghese Gallery, Rome

(right) A prestigious private commission for a church in Perugia, this was Raphael's first attempt at a dramatic multi-figure composition, and as the numerous surviving preparatory drawings show, he took immense pains over its planning. Many critics consider that his inexperience shows in a lack of unity, but there is no denying the beauty of the individual figures and the landscape background.

With his move to Rome, Raphael turned with astonishing assurance from small-scale works to decorative painting in the most heroic manner. He adorned the papal apartments in the Vatican in true Renaissance style, inspired by classical beauty and ancient learning. The School of Athens and the Liberation of Saint Peter (p.88) are two of the most sublime frescoes he painted in the Vatican.

In his later career, Raphael was so overworked that he relied heavily on assistants. Although they successfully completed a huge amount of work, it was paintings from his own hand that continued to evolve in subtlety of expression.

The School of Athens *1509-11*
base 303″ Stanza della Segnatura, Vatican

By common consent, this majestic fresco, in which heroic figures move serenely in an architectural setting of the utmost grandeur, is one of the supreme works of the Renaissance. The painting's familiar title dates only from the 17th century: the scene shows an imaginary assembly of the greatest ancient philosophers (Aristotle and Plato are in the centre) and symbolizes the rational pursuit of truth.

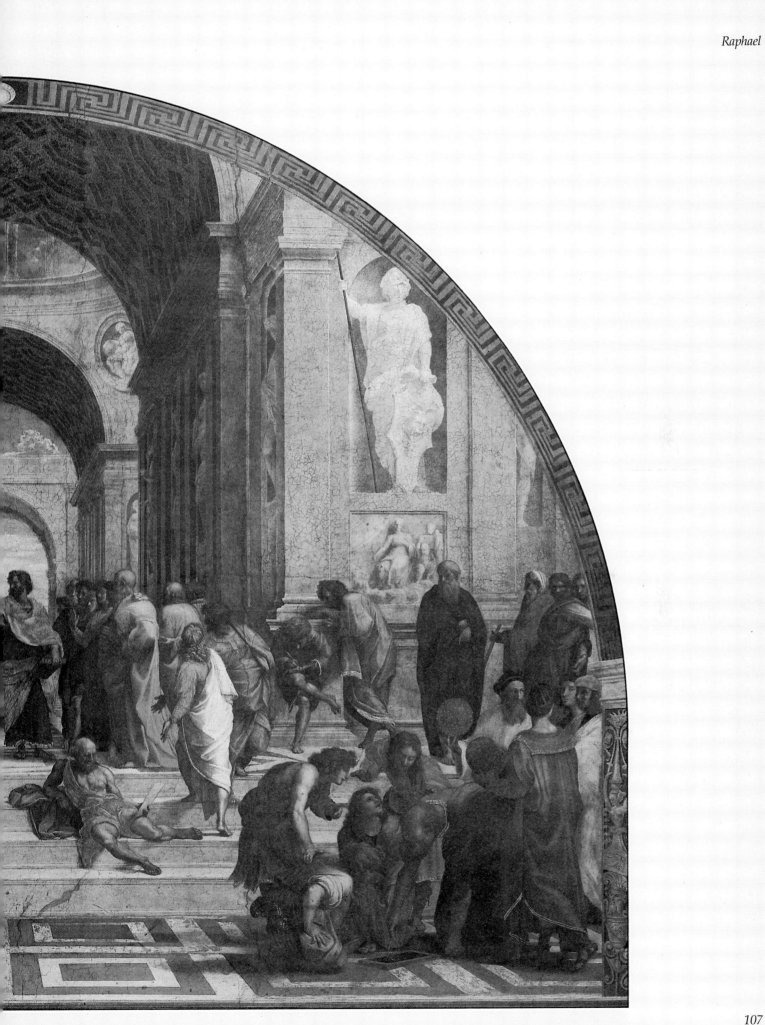

TITIANVS . P.

The early works of Titian, like the Noli Me Tangere, reveal the influence of Giorgione – in the graceful elongation of the figures and the pastoral landscape – although the dramatic intensity of the gestures already heralds Titian's mature style. In the Pesaro Madonna (p.65), the poses and colouring reveal the hallmarks of Titian's individual

Noli Me Tangere *c.1508*
43" × 35¾" National Gallery, London

This early painting tells the story of Christ's appearance to the Magdalen, after the Resurrection. According to the gospel of St John, the Magdalen, who was weeping over the empty tomb, at first mistook him for a gardener. When she recognized Christ she reached out to touch him, but he gently bade her 'touch me not' ('noli me tangere'). Titian shows the graceful figure of Christ holding a gardener's hoe and drawing his robes back from the outstretched hand of the kneeling Magdalen.

genius. He included his patrons in this altarpiece, which was commissioned as a mark of thanks for victory over the Turks. But it was with his portraits that Titian attracted the attention of some of the most important and influential men in Europe. The Emperor Charles V of Spain, whom he painted on horseback, was his most powerful patron. The Man with a Blue Sleeve and The Young Englishman are two other masterpieces of portraiture.

It was Guidobaldo II who acquired the erotic Venus of Urbino (p.78), which could have been more of a Renaissance 'pin-up' than a representation of the classical goddess of love.

The Man with a Blue Sleeve *c.1511*
31¾″ × 26″ National Gallery, London

This half-length portrait, traditionally thought to be of the poet Ariosto, may, in fact, be a self-portrait. The sitter is shown against a plain background, leaning against a parapet on which Titian has inscribed his own initials. His wonderfully self-assured pose and confident gaze are almost as striking as the beautifully painted blue sleeve which, in a brilliant show of illusionism, seems to project out of the picture space.

The Young Englishman *c.1540-45*
43¾″ × 36½″ Pitti Gallery, Florence

During his lifetime, Titian established a reputation as Europe's supreme portraitist. The so-called 'Young Englishman' – the sitter has never been satisfactorily identified – is one of his most penetrating character studies, focusing on the handsome aristocrat's impassive face with its cool, piercing grey eyes.

Charles V on Horseback *1548*
130¾″ × 109¾″ Prado, Madrid

This splendid portrait, which celebrates Charles V's famous victory at the Battle of Mühlberg, shows the Emperor in an equestrian pose which dates back to the antique equestrian statue of Marcus Aurelius in Rome. The marvellous landscape, bathed in the glow of sunset, reveals why Titian was renowned for his ability to paint natural effects.

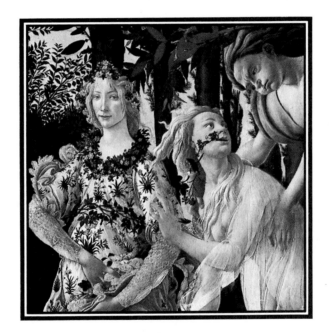

Hippopotamus and Crocodile Hunt *c.1615*
by Peter Paul Rubens
97¼" × 126" Alte Pinakothek, Munich

Introduction

Dutch and Flemish painters, like Rembrandt and Rubens, were part of a 'Golden Age' of art in the 17th century. Both Dutch and Flemish schools were influenced by the Baroque style of the period: a bold, dramatic style, setting out to impress the spectator – which it did.

But despite their close links, the Dutch and Flemish schools also had fundamental differences in outlook, largely due to the turbulent historical background of the period. It was a time when the religious and social tensions in Europe came to a head. Opposing one another were the absolute monarchs and their courts – most of them supported by the Catholic church – and the rising merchant classes – most of them Protestant. The Netherlands, ruled by Spain, mirrored this divide. The north held the trading cities, and in 1648, after 80 years of intermittent war, gained independence and later become known as Holland. Meanwhile, the south – later known as Flanders and then modern Belgium from 1830 – remained ruled by Spain.

This situation had a direct effect on the art of the time and the schools of Dutch and Flemish art evolved according to the political developments of the day. While the Dutch artists worked primarily for the new bourgeois class and their subject-matter and style were more down to earth, the patronage of Flemish art continued to come mainly from the church and court.

Rubens is a splendid example of this difference. Very much in the Catholic camp and a polished courtier himself, he took his commissions from the Jesuits of Antwerp, the Catholic rulers of Flanders, King Louis XIII of France, Marie de' Medici and King Charles I of England. He supplied large-scale altarpieces and decorated churches, painted scenes from the Bible as in *The Prodigal Son* (p.126) and scenes from mythology as in *The Feast of Venus* (pp.206-207).

Van Dyke, too, depended on noble patronage, whether in Genoa, where he painted such pictures as *The Lomellini Family* (p.154) or at the court of Charles I of England. A subtle flatterer, his success as a portraitist depended partly on his ability to get the best out of his sitters. But his style also revolutionised portraiture and determined

its course for two hundred years. Instead of placing his subjects against a plain dark background, posing stiffly, he introduced drapery or a glimpse of landscape in the background and allowed his subjects a casual turn of the head or movement of a hand or foot.

Meanwhile, the Dutch artists were catering for a different clientele – the prosperous merchants who liked material things and had the money to indulge themselves. Being Calvinists, they were not interested in ornate religious art; what they wanted were subjects taken from everyday life – portraits of themselves with their families or colleagues, scenes that recorded events in and around the house, landscapes and still life. Not only did they know what they wanted to look at, they also knew *how* they wanted it to look – detailed and realistic.

Within this framework, the Dutch artists obliged. Hals, for example, produced portraits of the men and women who created the new and thriving Dutch republic, as in *Married Couple in a Garden* (pp.200-201) and *Banquet of the Officers of the St Hadrian Civic Guard Company* (pp.210-211). Rembrandt was able to tackle virtually any subject wanted, from *The Anatomy Lesson of Dr Tulp* (p.170) to the landscape print *The Three Trees* (p.171). His most famous painting *The Night Watch* (p.190-191) was originally called *The Militia Company of Captain Banning Cocq*. Such militia companies were formed to protect the Dutch from the Spanish during the War of Independence. Vermeer, for his part, provided paintings showing interiors with figures reading, writing or playing music, as in *Lady Reading a Letter at an Open Window* (p.177) or *Soldier with a Laughing Girl* (p.221).

Among them, the Flemish and Dutch artists covered a wide variety of subjects – religious, mythological, portraits, landscapes, interiors. Their art has much to offer in its diversity both as a reflection of a period of history and as a testimony to each artist's personal vision. It well deserves its popularity.

Pietro Paulo Rubens

1577-1640

The greatest Flemish artist of the 17th century and one of the most prolific painters of all time, Rubens enjoyed a career of spectacular international success. From the time he returned from Italy at the age of 31 and set up in Antwerp he rapidly became the most sought-after painter in Europe. A brilliant manager as well as a brilliant artist, he ran a thriving workshop that poured out an unending flood of work.

Handsome, cultivated and a superb linguist, Rubens was also employed as a diplomat, and he was knighted by Charles I of England. However, although he lived his life on an international stage and was completely at home painting huge political allegories, there was also a very personal dimension to his art, which comes out in his paintings of his two beautiful wives and his beloved children.

Romulus and Remus and the She-Wolf *c.1617-18*
82¾″ × 83½″ Capitoline Museums, Rome

The Artist-Diplomat

The crowded life of Rubens gives the impression of bustling, productive activity. Artist, diplomat and family man, he still found time to teach and run a busy and prolific workshop.

Ironically, the most famous painter of the Flemish School did not see Flanders until he was 10 years old, for he was born and grew up in Germany. His father, Jan Rubens, a lawyer, had fled from Antwerp in 1568 to escape religious persecution (though born a Catholic he was suspected of having Calvinist sympathies) and settled in Cologne. There he became secretary to Anna of Saxony, the wife of William the Silent, Prince of Orange. Jan and Anna had an affair and she became pregnant. But for the pleading of his wife Maria, a woman of resolute character, he would probably have paid with his life. Instead, he was banished to the small town of Siegen in Westphalia, and there on 28 June 1577 Maria gave birth to the sixth of her seven children. The next day was the feast of St Peter and St Paul, so the baby was named after them – Peeter Pauwel in Flemish, althought in later life he usually signed himself using the Italian form, Pietro Pauolo.

The family were allowed to move back to Cologne in the following year and in March 1587 Jan Rubens died. Soon afterwards the widowed Maria decided to move back to Antwerp with the three children who still formed part of the household – Peter Paul, his brother Philip, who was three years older, and a sister, Blandina, in her twenties (three had died young and the eldest son had left home). The boys had already had the beginnings of a good education from their learned father and were now sent to a Latin school run by a scholar called Rombout Verdonck.

Key dates

1577 born in Siegen, Germany

1587 returns with mother to Antwerp

1598 becomes master in Antwerp guild

1600 leaves for Italy

1603 visits Spain on first diplomatic mission

1609 appointed court painter to Albert and Isabella; marries Isabella Brant

1610-11 paints *Raising of the Cross*

1611-14 paints *Descent from the Cross*

1622-25 paints Marie de' Medici cycle

1626 death of his first wife

1628-9 visits Spain

1629-30 visits England; knighted by Charles I

1630 marries Hélène Fourment

1634 completes ceiling paintings for Whitehall Banqueting House

1635 buys Château de Steen

1640 dies in Antwerp

Home town
(above) Victims of Philip II's aggressively Catholic policy in the Netherlands, Rubens' family left their native Antwerp for Cologne, to return 20 years later on the death of the painter's father. After this, Rubens regarded the city as his base.

Cologne childhood
(right) Although born in Siegen in 1577, Rubens spent most of his first 10 years in Cologne. Despite the shadow cast by the continuing repercussions of his father's infidelity with Ann of Saxony, he was to always regard the city with affection.

Wallraf Richartz Museum, Cologne

British Museum, London

In 1590, however, Peter Paul's schooldays came to an end. His sister married then, and the need to provide a dowry emphasized how strained Maria's financial resources were. The boys were not slow to help Maria out and years later she proudly noted 'From the time of my daughter's marriage, my sons lived at their own cost'. Philip, aged 16, got a job doubling as clerk to a statesman and tutor to his sons, and Peter Paul, aged 13, became a page in the household of the Countess of Lalaing. There he must have gained some of the familiarity with court life that would stand him in such good stead later in his career. However, he did not stay long, for he had already decided that he wanted to be an artist, and his mother let him leave the Countess' service and become apprenticed to a painter called Tobias Verhaecht, who was a relative through marriage.

RUBENS' APPRENTICESHIP

Rubens spent only a short time with Verhaecht before moving to the studio of Adam van Noort. He spent about four years there and then went to study with Otto van Veen to complete his training. All three of these Antwerp painters were fairly mediocre and it is hard to know how much effect they had on Rubens, as very little of his early work survives (he was not a prodigy). Of the three, Van Veen must have been the man nearest to Rubens' heart. He had spent about five years working in Rome, and his thorough knowledge of Italian art was the basis for his successful career.

Rubens became a master in the Antwerp painters' guild in 1598, but he continued to work with Van Veen for another two years. Then, on 9

Mantua sojourn
(above) Rubens was 22 when he left Antwerp in 1600 for Italy and entered the service of Vincenzo Gonzaga, Duke of Mantua. The promising young artist still found time to paint himself with a group of friends he had made at the Ducal court.

The 'Costume Book'
(above right) These sketches of Turkish women come from an album of drawings Rubens compiled for visual reference. Of uncertain date, the collection may possibly range from before his Italian period to 1620.

Duke of Lerma
(right) By 1603 Rubens had sufficiently impressed the Duke to be entrusted with a delicate political mission to Spain. During his rather uncomfortable stay he painted this splendid equestrian portrait of the Duke of Lerma, Philip III's supremely powerful first minister.

Prado, Madrid

Rubens in Rome

At the time when Rubens worked in the city, Rome was the artistic capital of Europe, not just because of the splendours of its remote – and recent – past but also because contemporary painters such as Caravaggio and Annibale Carracci had made it the centre of new developments, drawing artists from all over Europe. Rubens was particularly friendly with the German landscape painter Adam Elsheimer, whose poetic style influenced his own work in this field. But above all, Rubens took his inspiration from the great Renaissance masters of figure painting and the sculpture of the ancient world. So profound was his study of classical civilization that his friend Nicolas-Claude Fabri de Peiresc, a distinguished French antiquarian, later remarked that 'In the field of antiquity his knowledge was the broadest and most excellent I have ever encountered'.

Chiesa Nuova
(left) In 1606, during his second period in Rome, the rising young artist was offered an extremely prestigious commission over the heads of established resident painters – the high altarpiece for the Chiesa Nuova.

Copying the masters
(right) This exquisite sketch is Rubens' faithful copy of one of the Michaelangelo nudes on the Sistine ceiling.

British Museum, London

May 1600, aged 22, he set out for Italy, accompanied by his first pupil, Deodatus del Monte. Italy was to be Rubens' base for the next eight years and to shape his artistic destiny. He went first to Venice where he was fortunate enough to meet an employee of Vincenzo I, Duke of Mantua, and impress him with his sketches. The Duke, too, was impressed when he saw them and immediately took Rubens into his service.

Vincenzo was a noted patron of the arts and working for him enabled Rubens to see many of the greatest treasures of Italian art. The art collection at the Ducal Palace in Mantua was superb, and part of Rubens' job was to make copies of famous paintings elsewhere to supplement it; within two years he had visited most of the foremost centres of Italian art, including Florence and Rome. His first visit to Rome lasted from summer 1601 to spring 1602, and it was at this time that he received his first public commission – three altarpieces for the church of Santa Croce in Gerusalame.

In 1603 Duke Vincenzo entrusted Rubens with a diplomatic mission, his first, taking gifts to Philip III of Spain. Two paintings were irreparably

Successful marriage
(right) On his return to Antwerp from Italy in 1609 Rubens met and married Isabella Brant. Their union, which was blessed with four children, was an extremely happy one, marked by mutual love and respect. After her death some 15 years later he professed that he had 'truly lost an excellent companion. She had no capricious moods, no feminine weaknesses, but was all goodness and honesty'.

Uffizi, Florence

Antwerp palazzo
(right) In 1610 Rubens purchased a large house with extensive grounds in Antwerp. He added to and improved his property to such a measure that the original Flemish town house was transformed into a Renaissance palace complete with Baroque-style triumphal arch, formal garden, a pavilion and two studios. Though never to return to his beloved Italy, his mansion was to be a constant reminder of his stay there.

damaged by rain on the way and Rubens demonstrated his skill and presence of mind by promptly painting replacements. The Spanish royal family had an unrivalled collection of paintings by the great Venetian masters, above all Titian, so Rubens was able to continue his artistic education.

In 1604 Rubens was back in Mantua, but he did comparatively little original work for Vincenzo (who hardly made the best of his talents) and the most productive parts of the rest of his stay in Italy were once again spent in Rome; he was there, with gaps, from December 1605 to October 1608. In the second Roman period Rubens continued his diligent study of the art of the past and present while sharing a house with his brother Philip, who was now librarian to Cardinal Colonna.

Rubens by now had a growing reputation and good contacts and in 1606 he gained a prestigious commission to paint the high altarpiece for Santa Maria in Vallicella, a splendid new church (known in fact as the *Chiesa Nuova*). This was one of the rare commissions with which he had difficulty. His first attempt was judged unsatisfactory, as the light reflected unpleasingly from it, so Rubens painted a replacement on slate, which was less reflective. He never saw the replacement installed, however, for in October 1608 he received news from Philip, now back in Antwerp, that their mother was seriously ill. Without delay, he travelled to be at his mother's side, but she died before he arrived.

RETURN TO ANTWERP

Before his mother's illness had caused Rubens to return home, the Archduke Albert, Regent of the Netherlands, had written to the Duke of Mantua requesting that the brilliant young painter should be released from his service, and now that circumstances had brought Rubens to Antwerp, Albert was not going to let him slip from his grasp. In 1609 Rubens was appointed court painter to Albert and his wife, the Infanta Isabella, and he was, in his own words, 'bound with golden

fetters'. More tender links, also, were forged in that year, when he married the 17-year-old Isabella Brant, daughter of an eminent Antwerp lawyer and the niece of Philip Rubens' wife.

Rubens was soon besieged by pupils wanting to study with him, and in the next few years established and consolidated his reputation as the foremost painter in northern Europe. The works that most resoundingly proclaimed his genius were the two great altarpieces of the *Raising of the Cross* (1610-11) and *The Descent from the Cross* (1611-14) (p.202-203), which showed how completely he had mastered the Italian 'grand manner' – the way of treating lofty themes in the most heroic terms. His domestic life flourished, too. In 1610 he bought the land on which he erected a house of almost palatial splendour, and in the following year his daughter Clara Serena was born, the first of four

Albert and Isabella
(below) Rubens' decision to settle in Antwerp in 1608 came to the ears of the Archduke Albert and his wife Isabella, joint rulers of the Netherlands. The artist accepted the post of court painter with the proviso that he was not obliged to reside at the Brussels' court. When Albert died in 1621, Rubens became the Archduchess' trusted envoy to the fickle courts of France, England and Spain.

children by his wife Isabella.

This was an auspicious time for Rubens to launch into a new phase of his career, for there was a truce between the Northern (Protestant) and the Southern (Catholic) Netherlands (modern day Holland and Belgium) from 1609 to 1621, during which many churches were rebuilt or redecorated. Commissions flooded into Rubens' studio and he was able to execute them all only because of his incredible energy and formidable powers of organization, his assistants doing much of the actual physical act of painting, while the master provided the finishing touches. His constitution was very strong and he worked long hours, habitually rising at 4 am to go to Mass.

The greatest commission he received in Flanders was for the decoration of the Jesuit Church in Antwerp. This was a magnificent new building; Rubens had already supervized the sculptural decoration (he may well have had a hand in actually designing the building), when in 1620 he agreed to design 39 paintings which were executed by assistants (among them the young Van Dyck). The contract was signed on 29 March and the paintings were to be finished by the end of the year. Tragically, all the paintings were destroyed in a fire in 1718, but several superb sketches survive.

Great commissions came from abroad, too, and not just for religious works. Soon after the Jesuit

Royal Banqueting House Ceiling

The nine canvases that Rubens painted for the newly restored Banqueting House in Whitehall are the only works for major decorative schemes of his to remain *in situ*. Commissioned in 1629 during his diplomatic visit to England, they were finally despatched in 1635. So impressed was Charles I by the result that he presented the artist with a valuable gold chain and forbade the presentation of theatrical performances in the chamber for three years 'lest this might suffer by the smoke of many lights'.

Royal favour
(left) Charles I, greatly impressed by Rubens, knighted the artist-diplomat on the eve of the latter's return to Antwerp.

Artistic license
(right) The subject of the Whitehall canvases was the reign of the King's father James I. Rubens used his skills to raise his subject, who had been singularly unprepossessing both as man and ruler, to Olympian heights.

Detail: Van Dyck/Charles I of England and Henrietta of France

Whitehall, London

and for her he travelled on missions to Spain in 1628-9 (where he charmed Philip IV and met his court painter, Velazquez) and to England in 1629-30, where he and the art-loving Charles I showed mutual warmth. Charles knighted him and also commissioned a series of paintings to decorate the ceiling of the Banqueting House, part of the Palace of Whitehall. Rubens painted these in Antwerp and they were sent to England in 1635.

In 1630 Rubens remarried. He was 53 and his bride, Hélène Fourment, the daughter of a prosperous silk merchant and the niece of Rubens' first wife, was 16. 'I resolved to marry again', he wrote, 'not yet being disposed to the austere celibate life . . .' Two sons still survived from his first marriage, and Hélène bore him two more sons and three daughters; he named one of them Isabella Hélène, after both wives. His love of his family shines through the paintings he made of them, and at this stage of his life he began to withdraw from public affairs to devote more time to them and to what he called his *'dolcissima professione'* or 'sweetest of professions'.

A BUSY RETIREMENT

In 1632 he asked Isabella to let him give up his diplomatic duties and in 1635 he bought a splendid country house, the Château de Steen, where he spent much of his time and indulged a new passion for landscape painting. He still worked hard in his studio in Antwerp, however, and the demand for his paintings was unceasing. In 1636 he embarked on one of his biggest commissions – 120 paintings of mythological subjects for the Torre de la Parada, a hunting lodge of Philip IV in Spain. Most of the finished work was done by assistants and Rubens was often unable to paint since his right arm was crippled with gout. The gout spread to his heart and he died in Antwerp on 30 May 1640, aged 62. Eight months later Hélène gave birth to their last child.

Winter love
(above) On his return from England, the 53-year-old painter became infatuated with and married Hélène Fourment, an Antwerp girl of 16 years. This painting is a self-portrait of the artist, his son and his pretty young wife.

Book illustrations
(above) From 1612 onwards Rubens regularly created title pages and occasional illustrations of complex and allegorical design for the Plantin press. This famous printing house was run by Balthasar Moretus, an early Antwerp friend.

Church contract
(below) In 1620 Rubens was commissioned to produce 39 ceiling paintings, two large canvases and various designs for a new Jesuit church in Antwerp. His studio rose admirably to the occasion, completing the work in nine months.

Church decorations were finished he designed a set of 12 tapestries showing the *History of the Emperor Constantine* for Louis XIII of France, and between 1622 and 1625 he carried out a series of 25 enormous paintings for Louis' mother, Marie de' Medici, to decorate her new palace (the Luxembourg) in Paris. This is one of Rubens' greatest achievements, in which he blends history, allegory and portraiture to create a glorious tribute to Marie's thoroughly inglorious life.

In 1626 Rubens' wife died. Although deeply distressed by the loss, Rubens was not a man to brood and he directed his energies not just into painting, but once again into diplomacy. His linguistic skills were put to good use in this role. Italian was as much his native tongue as Flemish, and he also had fluent French, German and Spanish, as well as Latin, which was still an international language. Particularly since the death of the Archduke Albert in 1621, he had become a trusted adviser to the Infanta Isabella,

The Effortless Genius

The artistic career of Rubens went from strength to strength, thanks to a reputation that was second to none; he was regarded as a fast, fluent worker whose confidence matched his versatility and ability.

Leda (c.1601-2)
(left) Rubens' sensuous rendering of the classical myth. Here Leda welcomes her lover, Jupiter, who is in the guise of a swan.

The Prodigal Son (c.1618)
(right) This favoured theme received the individual treatment of being set in a farmyard.

Rubens and Isabella Brant in a Honeysuckle Bower (1609-10)
(below) A tender portrait of Rubens and his first wife, Isabella.

Gemäldegalerie Alte Meister, Dresden

With the possible exception of Picasso, Rubens was the most prolific of all the great artists – so prolific, in fact, that it is difficult to put a figure on his huge output. He not only produced paintings on virtually every kind of subject, and the sketches and drawings for them, but he also designed tapestries, festival decorations, book illustrations and title pages and supplied visual directives for sculptors, architects and metalworkers. In 1621 he wrote 'My talents are such that I have never lacked courage to undertake any design, however vast in size or diversified in subject'. It sounds boastful, but it was simply a statement of fact, for he seemed to have limitless physical and intellectual stamina.

RUBENS' WORKSHOP

It hardly needs saying that Rubens was a fast and fluent worker – Sir Joshua Reynolds, who was an astute critic as well as a great painter, said that his works 'seem to flow with a freedom and prodigality, as if they cost him nothing'. Even Rubens, however, could not have handled the huge number of commissions he accepted without help, and his smoothly run workshop was essential to keep up the flow of work. We do not know how many pupils or assistants Rubens had at any one time, because his status as court painter exempted him from registering them with the guild. Certainly, he employed or collaborated with some of the outstanding Flemish artists of the day, notably Van Dyck and Jan Brueghel.

Alte Pinakothek, Munich

Musée des Beaux Arts, Antwerp

Prado Madrid

Fall of the Damned (c.1620)
(left) Rubens painted this Baroque masterpiece – a scene of naked figures consigned to Hell – for the Jesuit church in Neuburg.

St George and the Dragon (c.1606-1610)
(above) From the colour, action and emotion of this painting we can see why Rubens was hailed as the 'Creator of Baroque'.

The degree to which Rubens worked on a painting himself depended on the significance of the commission and was reflected in the price. We are fortunate that a letter by Rubens survives listing some of his works for sale, in which he specifies some degrees of participation. He lists one painting, 'Original, by my own hand, the eagle painted by Snyders' (Frans Snyders, the greatest animal painter of the day); another, 'Original, by my own hand, with the exception of a most beautiful landscape, by the hand of a master skilled in the genre'; a third, 'begun by one of my pupils . . . but this, as it is not finished, would be entirely retouched by my own hand, and will pass as an original'; and a fourth, 'begun by one of my pupils. . . but all retouched by my hand'.

For a typical commission Rubens would paint a colour sketch (sometimes called a '*modello*'), his assistants would transfer this to a large-scale panel or canvas and Rubens would intervene at whatever stage he thought necessary. In the 20th century there has been a tendency to praise the sketches, in which the master's touch is visible in every stroke, at the expense of the finished work,

Alte Pinakothek, Munich

Prado, Madrid

but Rubens would surely have found this attitude strange. It is often no easy task, even for experts, to determine where the assistant left off and Rubens took over, and the sketches, wonderful though they are, lack the scale and symphonic grandeur of the finished works.

Rubens' style was formed in Italy, on the example of the great painters of the Renaissance and the art of the ancient world, but there is much in his work that shows a continuance of Flemish tradition. The two great altarpieces that triumphantly set the seal on his reputation after his return to Antwerp – *The Raising of the Cross* and *The Descent from the Cross* (pp.202-203) – are in the form of triptychs with folding wings, a type long outmoded in Italy. And they are painted on panel, at this time more popular north of the Alps than in Italy. Rubens often painted on canvas, but he preferred panel, and he never used fresco, in Italy still regarded as the greatest test of a painter's mettle, but very rare in the damper north.

THE TRANSLUCENT TOUCH

The smooth panel on which he painted encouraged the fluency of Rubens' brushwork, which is so much a part of the feelings of movement and vivacity he excelled at conveying. He often used the paint very thinly, allowing the smooth white priming of the panel to shine through the layers of pigment and give an effect of glowing translucency. His brilliant painting of flesh has always been particularly admired. The Italian painter, Guido Reni, is said to have

TRADEMARKS

Ample Flesh

Rubens is probably best known for the voluptuousness of his female nudes. And these plump proportions appealed to him both as a man and as an artist; the curves of a well-fleshed woman were in fashion, and were also more interesting to paint.

The Three Graces (1639)
(above) Painted less than a year before Rubens died, these voluptuous hand-maidens reflect the artist's ideal of feminine beauty. Unlike his earlier, more vigorous and elaborate works, the serenity of this classically posed composition reveals a more mellow and reflective Rubens.

'Milk and blood'
(right) Rubens was renowned for his vibrant painting of flesh. His technique of using a special mixture of red, blue, yellow and white led people to describe the flesh of his ample female subjects as being made of milk and blood.

128

enquired, on seeing one of his pictures, whether he mixed his paint with blood.

Although so much of his career was spent as a public figure, and many of his most prestigious works were huge showpieces for church or state, his genius also had a much more private side, which found expression particularly in his tender portraits of his family and his loving depictions of the Flemish countryside. He rejoiced in the physical beauty of both his wives, and was obviously proud of his children's good looks, too. His landscapes and peasant scenes are now among his most popular works and show him to have been the heir to Pieter Bruegel, whose work he admired.

Rubens' work had enormous influence, both in his lifetime and in succeeding centuries. Hardly any significant Flemish painter of the 17th century was unaffected by his style, and his influence was spread to other countries not only by his voyages abroad and by the paintings exported from his workshop, but also by the engravings after his work that he commissioned. It is perhaps in France that he has had the most fruitful influence, Watteau, Delacroix and Renoir being three of the great French painters whose work is unthinkable without his example. In England, Constable was one his most fervent admirers and declared that 'In no branch of the art is Rubens greater than in landscape'. Rubens' genius, indeed, was so boundless that what to his contemporaries must have seemed like a sideline of his art could still, two centuries later, inspire one of the greatest of all specialists in the subject.

Portrait of a Little Boy (c.1619)

(below) Rubens was very much the family man and often used his children as models. The young subject of this affectionate sketch is thought to be his son Nicolas.

Albertina, Vienna

Artists and their Wives

Artists have painted themselves and their families not only because they are convenient (and free) models, but also for any number of celebratory and commemorative reasons. Double portraits of the artist and his wife were perhaps most often painted to mark the couple's wedding, but the two examples here are rather different. Gabriel Metsu's charming portrayal of his wife and himself in an informal domestic setting embodies the peaceful well-being of Dutch bourgeoise life. The successful Adriaen van der Werff, however, belonged to a later generation – one which, quite obviously, had succumbed to the more mannered sophisticated influence of France.

Adriaen van der Werff (1659-1722) **Self-Portrait**
(right) Obviously proud of his wealth and status, Van der Werff uses the device of a picture within a picture to show off his porcelain-skinned wife and his splendid clothes and gold chain.

Rijksmuseum, Amsterdam

Gabriel Metsu (1629-67) **The Breakfast**
(left) Metsu belonged to the golden age of Dutch painting, a period when works, such as the one shown here, had an unpretentious vigour.

Rijksmuseum, Amsterdam

The Descent from the Cross

Rubens painted *The Descent from the Cross* in 1611-14 immediately after his other great altarpiece, *The Raising of the Cross.* Although they now hang together in Antwerp Cathedral they were not done as a pair. *The Raising* was painted for the church of St Walburga and was later transferred; *The Descent* was always intended for the cathedral. It was commissioned by the Guild of Arquebusiers, a military club, whose patron saint was St Christopher. The saint appears only on the outside of one of the wings, but throughout the whole work Rubens has honoured him by playing on the Greek meaning of his name – Christ-bearer. Thus, in the centre panel, Christ's limp body is borne down from the cross, and in the scenes at either side, *The Visitation* and *The Presentation in the Temple,* Christ is borne respectively in His mother's womb and by Simeon, the high priest of the Temple. Rubens' great altarpiece soon became famous and its influence was spread widely through engravings.

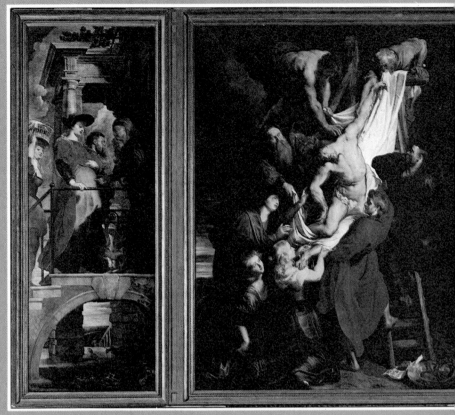

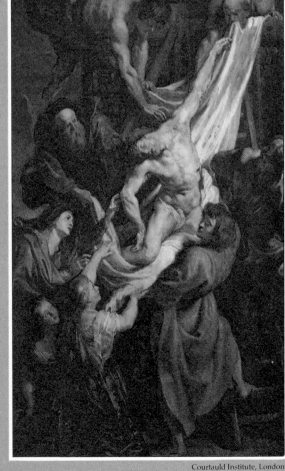

Courtauld Institute, London

Making the modello
(left) For a large commission such as the one from the Arquebusiers, Rubens would have made preliminary sketches. This modello, was painted in oil, before the contract was signed.

The Visitation
(below) In this detail the Virgin, heavily pregnant and dressed in travelling attire, arrives at Her cousins' house – portrayed by Rubens as a luxurious Renaissance villa.

Antwerp Cathedral

Mary Magdalene
(left) Mary Magdalene, portrayed by Rubens with his ideal of female beauty in mind, takes Christ's feet. Her flaxen hair hangs over one shoulder to remind us of the episode where she dried Christ's feet with her hair.

The elderly Simeon
(below) In this detail from the right-hand panel, The Presentation in the Temple, *we see the aged Simeon, clad as a high priest, holding up the Christ Child.*

'. . . this work has the power to touch a hardened soul.'

Roger de Piles (1677)

Antwerp Cathedral
(below) Begun in the 14th century and completed 200 years later, the Cathedral of the Holy Virgin in Antwerp remains the largest church and finest Gothic building in the city. As well as The Raising of the Cross *and* The Descent from the Cross *it also houses* The Assumption, *which is above the high altar.*

Bibliotheque Ambrosiana, Milan

Classical pose
As is often the case with Rubens' subjects, the pose of the dead Christ has been borrowed from classical sculpture – in this case the main figure of the famous Laocoön *which is in the Vatican Museum, Rome.*

The Metropolitan Museum of Art, New York

f Hals

c.1582-1666

One of the greatest portraitists of the 17th century, Frans Hals was born in Antwerp in the early 1580s. Shortly after his birth, his family moved north to Haarlem, where Hals was to stay for the rest of his life. Here he concentrated almost exclusively on painting local sitters. Unlike his great contemporary Van Dyck, Hals felt no inclination to travel, and was not concerned with the achievements of the great Italian masters.

Hals' remarkable style was formed largely in isolation and he was virtually self-taught. The strictly local character of his painting marked a new departure in Dutch art, and helped initiate the development of an independent Dutch school. Although he was successful, Hals lived most of his life in poverty, and the few known facts of his life reveal a series of domestic crises. He died in 1666, over 80 years of age.

The Meagre Company (detail) *1633-36*
82¼″ × 169″ Rijksmuseum, Amsterdam

The Convivial Portraitist

Hals lived and worked in Haarlem for his entire life. Although a highly successful portraitist, with the most prestigious sitters, he was plagued by financial troubles and died impoverished.

Frans Hals was born in Antwerp in 1582 or 1583, the son of Franchoys Hals, a cloth-worker from Mechelen, and Adriaentgen van Geertenrijck of Antwerp. It is not known when Hals' father moved to Antwerp, or when he married, but the couple seem not to have stayed long in the city, for by 1591 they had moved north to Haarlem, one of the largest towns in Holland. On 19 March 1591, Frans' brother Dirck was baptized in Haarlem. Dirck, too, became a painter, and is chiefly remembered for his lively genre scenes.

The family probably moved to Haarlem in, or shortly after, 1585, when Protestant Antwerp fell to invading Spanish forces. The Spanish re-established Catholicism in Antwerp, and the Protestants were given four years to settle their affairs and leave. In 1585, Franchoys had, in fact, declared himself a Catholic, but this could have been simply a tactical move. Like many of their contemporaries, the family may have moved north partly for religious reasons: the offical religion of the Northern Provinces was that of the Reformed Church, but other religions were treated with enlightened tolerance.

Franchoys' main reason for moving north was, however, probably a financial one. Following the Spanish victory, the Dutch effectively crippled trade with Antwerp by blocking the mouth of the River Scheldt. In the wake of the invasion, over 600 cloth-workers and their families migrated to Haarlem, which had a large textile industry, and the Hals family was almost certainly among them.

UNCERTAIN BEGINNINGS

Hals' own early years spent in Haarlem remain something of a mystery. An anonymous biographer of the Mannerist artist Karel van Mander included 'Frans Hals, portraitist' in a list of Van Mander's pupils. But Van Mander himself never claimed to have taught Hals, although he mentioned three of his other pupils in his *Schilderboeck* (The book of painters), published in 1604. It may be that Van Mander was reluctant to acknowledge an association with Hals. Certainly, the two men can have had little in common artistically, and Hals' lack of interest in history painting would not have impressed Van Mander. If Hals was one of his pupils, the relationship must have ended by 1604, when Van Mander is known to have moved to Amsterdam.

The first documented reference to Hals occurs in 1610, when he became a member of the Haarlem

Hals' homeland
Frans Hals was born in Antwerp (above) although his family settled in Haarlem (right) shortly after. Haarlem lies on the River Spaarne in the westerly part of the Netherlands, an area dominated by large expanses of water. The town was a major centre of artistic activity, a position it had maintained since the 15th century. In Hals' time, Haarlem was enjoying great prosperity, one source of which was its breweries, whose beer had a great reputation.

'The Vasari of the North'
(left) Karel Van Mander founded an academy of painting in Haarlem where Hals may have studied. His 'book of painters' earned him the reputation as 'the Vasari of the North'.

First civic commission
(below) By 1616, Hals' reputation as a portraitist of renown was established and he received the first in a series of commissions from the Militia Companies for group portraits.

Banquet of the Officers of the St George Civic Guard Company/Frans Halsmuseum, Haarlem

Guild of St Luke. It was probably in the same year that he married for the first time. His wife, Annetje Harmansdr, bore him two children – the first, a son named Harmen, was baptized on 2 September 1611. The marriage did not last long, however, for Annetje died in 1615. She was buried in a pauper's grave – the first indication of the financial difficulties which were to plague Hals throughout the rest of his life.

MEMBER OF THE MILITIA

Hals' earliest known paintings also date from around 1610, by which time he must have been about 30 years of age. Even allowing for the loss of a number of earlier works, the few remaining facts suggest that Hals reached artistic maturity relatively late, and it was not until 1616 that he received his first major commission – for the group portrait of the *Banquet of the Officers of the St George Civic Guard Company* (above).

Haarlem had two of these militia companies. Although their structure was military, their function was largely social, and they were renowned for their extensive banquets – in 1621 a law was passed stipulating that the banquets should last no more than 3 or 4 days. Unusually, Hals himself was a member of the St George Militia – membership was usually restricted to the ruling class, or to men of means – and he included his own likeness in his 1639 portrait of the officers of the Company. Hals' personal experience of the St

Militia headquarters
(below) Civic Guards proliferated in 17th-century Holland. Many had grand headquarters for which they commissioned large group portraits. With the demise of their military functions – when peace returned – these became mainly social clubs. By the late 17th century, the St George Civic Guard headquarters, illustrated here, had become an inn.

Hendrick C. Vroom/View of Haarlem from Noorder Spaarne/Frans Halsmuseum, Haarlem

HEEREN LOGEMENT.

Municipal Archives, Haarlem

Dirck Hals/Merry Company in a Renaissance Hall/Akademie der bildenden Künste, Vienna

Hals' brother
Known chiefly for his lively interior genre scenes (above), Frans Hals' younger brother, Dirck, was also a painter of some repute.

Frans Hals Museum
(below) The Hals Museum in Haarlem, built in 1608, was formerly a home for old men. Today it has the best collection of Hals' work in the world.

George Militia Company gave him a particular sympathy with their ideals, and enabled him to capture their conviviality and comradeship with unusual perceptiveness and skill.

In 1617 Hals married again. His second wife, Lysbeth Reyniers, was a peasant woman with a quarrelsome temper who is known to have been involved in brawls. She bore the artist at least eight children, three of whom went on to become painters. This ever-expanding family may account in part for Hals' continuing financial difficulties. Although he was undoubtedly successful as a portraitist, Hals was constantly in debt and in addition to his painting he undertook occasional picture-dealing and restoration work in order to make ends meet. In 1616 he was summoned to court for failing to pay maintenance to the guardian of the two children from his first marriage. Conveniently, the artist was away on a brief trip to Antwerp, and his mother answered the charge. During the 1630s Hals was sued by both his landlord and his shoemaker, and in 1654 a local baker seized his property because of an unpaid bill. The goods which Hals surrendered were pitifully meagre, amounting to three beds, pillows, some linen, an oak cupboard and table and five paintings, including one by Van Mander.

A STUBBORN WILL

There is, however, some evidence to suggest that Hals' difficulties were caused partly by his rebellious and independent spirit. In 1636, when he was in serious financial trouble, Hals refused to complete a lucrative commission for the portrait of an Amsterdam militia company known as *The Meagre Company* (p.133), because he was unwilling to make the relatively short journey out of Haarlem. When the guards refused to come to him, Hals downed tools, and the portrait had to be completed by another artist.

Judith Leyster

Judith Leyster was one of the most talented genre painters of the early 17th century, and the first recorded woman artist to be admitted to the Haarlem Guild of St Luke. It is not known if she was actually Hals' pupil, but she certainly came under his influence, and was the only contemporary painter who attempted to emulate his impressionistic technique. Leyster specialized in genre paintings, often depicting children, but she also painted still-lifes and portraits. Her husband, Jan Miensz Molenaer, was also a successful genre painter.

National Gallery of Art, Washington

There was undoubtedly a strain of high-spiritedness in the Hals' family. In 1608, Frans' brother Joost was fined in Haarlem for insulting the city's guards, and for throwing rocks which injured a passer-by. Later, in the 1640s Frans Hals and his wife had their daughter Sara sent to a workhouse to improve her lax morals after she had given birth to an illegitimate daughter. Hals himself was apparently an enthusiastic drinker. According to the 17th-century biographer Arnold Houbraken, Hals was 'filled to the gills every evening,' although the popular image of the painter as an alcoholic and wife-beater is largely without foundation.

The 1630s were Hals' most successful years. By then he was in constant demand both for single portraits and for family groups, and was commissioned to paint three more large militia pieces. His sitters included men from the highest ranks of society – the city's regents, the civic guards, town councillors, merchants and scholars. Later, around 1649, he was to paint the famous

An austere interior
(above) Frans Hals was buried in St Bavo's Church in Haarlem in 1666. This view of the church interior by the architectural painter, Pieter Jansz Saenredam, conveys the bareness of the churches at that time. This was due to the Protestant order that walls be whitewashed and all visual imagery banned.

French scholar René Descartes. Hals was also running a successful studio, although he does not seem to have used his pupils as assistants, and few of them were able to imitate his unique style. Nonetheless, the list of his students includes some of the most distinguished names in Dutch painting, such as his own brother Dirck, and the brilliant genre painter Adriaen Brouwer. The talented Judith Leyster also came under the influence of Hals, and she may even have been a pupil. However, the two artists obviously quarrelled and in 1635 she sued Hals for accepting an apprentice who had defected from her studio.

FINANCIAL HARDSHIP

Hals' success continued until the end of his life, although he suffered a slight drop in commissions after 1640, which may reflect the growing enthusiasm in the Netherlands for the more elegant style of Van Dyck. Nevertheless, it was during his last years that Hals produced some of his best portraits, such as *The Regentesses* (p.139), with its haunting vision of old age.

Hals' financial troubles, however, continued. In 1661 the Guild of St Luke exempted him from payment of his dues, and in 1662 he petitioned the town-councillors for assistance. The following year he was granted an annual subsidy of 200 guilders, and in 1664 they provided him with three cartloads of peat. Hals died two years later, on 29 August 1666, over 80 years of age. He was buried in St Bavo's Church in Haarlem.

Self-Portrait
(left) There is a self-confident look in Leyster's lively self-portrait painted at her easel.

A Boy Playing a Flute
(above) This charming painting is typical of Judith Leyster's work – full of life and realistic detail.

Painterly Bravura

Hals' portraits have a spontaneity and vitality that bring his sitters to life, giving us a vivid impression of the personalities of the men and women who created the thriving Dutch Republic.

Hals was not only the first great master of the Golden Age of Dutch painting, but also one of the most original and distinctive portraitists of any school or period. Almost all his 300 or so surviving paintings are portraits, and even those that are not (some genre scenes and a very occasional religious piece) have a portrait-like character. He was obviously fascinated with faces, and his work brilliantly captures the personalities of the men and women of the buoyant generations that – after winning freedom from Spanish domination – turned Holland into the most prosperous country in Europe.

The qualities that make Hals' portraits so exceptional were well characterized by his contemporary, Theodorus Schrevelius, a Haarlem schoolmaster who in 1648 published a history of the city called *Harlemias.* In an enthusiastic passage on Hals, he wrote: 'By his extraordinary manner of painting, which is uniquely his, he virtually

Mauritshuis, The Hague

Laughing Boy 1620-25
(right) The artist painted several genre scenes of children, usually showing them in simple and endearing activities such as playing musical instruments or blowing soap bubbles. Most of them can be interpreted as representations of one of the five senses or as variations on the vanitas *theme, but this laughing boy seems to carry no such meaning. Hals simply painted him as a study in fleeting expression, capturing his laughter in a few swift brushstrokes.*

The Merry Drinker 1628-30
(left) Portraits of drinkers were commonplace in Dutch art. Many of the pictures had a moralizing intention, but Hals' subject has a sparkle and vigour that advertises the pleasures of drink only.

Portrait of a Seated Woman c.1660
(right) Hals was a master of different moods. The quiet dignity of this unknown woman presents an interesting contrast to the swaggering stances seen in some of the male portraits.

surpasses everyone. His paintings are imbued with such force and vitality that he seems to defy nature herself with his brush.'

Schrevelius, who sat to Hals for his portrait, neatly identified the two outstanding features of Hals' work – his unique brushwork, or 'manner of painting', and the 'force and vitality' of his characterization.

ENERGETIC BRUSHWORK

For Hals, these two qualities were inseparable. The 'force and vitality' of his portraits depends directly on his brisk, energetic brushwork, which gives to his sitters an irresistible appearance of life. Netherlandish portraits before the time of Hals were painted with a high degree of finish, the brushstrokes carefully blended to create a smooth, polished appearance. By contrast, Hals' brushwork seems daringly free; his brushstrokes are brusque, swift and disconnected, particularly

Willem van Heythuyzen 1637-39
(above) Hals portrayed his subject in a very daring attitude, tipped backwards on his chair so that his body forms a strong diagonal across the picture plane. The artist usually employed plain backgrounds, but here he found it necessary to balance the sitter's precarious pose by including the room behind him.

The Regentesses 1666
(below) Hals transformed the apparently unpromising subject of four elderly governesses and their servant into a fascinating portrayal of old age. He did this by emphasizing the individual character of each face and by giving particular prominence to the gnarled hands, which are arranged to form a rhythmic pattern against the shadowy background.

in his more informal portraits such as the enchanting *Laughing Boy* (opposite). Here, the boy's face is modelled in rough strokes of colour, so free that we can distinguish each separate mark of the brush, especially in the painting of the eyes. The spontaneous 'improvized' appearance of the work is increased by the fact that, unlike previous painters, Hals did not stop to blend the tones and colours used in the face, but placed strokes of contrasting colour directly side by side.

Although at first glance Hals' technique might appear arbitrary, he placed his brushstrokes with unerring precision. His paintings are not abstract combinations of tones and colours – his brushstrokes model the shapes and forms of his sitters with remarkable exactness, and are the result of painstaking observation. In *Malle Babbe*, for example, the artist's apparently carefree brushstrokes capture to perfection the dance of light across the surface of an aged face that is momentarily crumpled with laughter. In *The*

Regentesses (p.139), rough dabs of paint model the knotted, tremulous hand that is lying stiffly in the lap of an elderly woman.

SPONTANEOUS METHODS

Hals achieved these effects by adopting a fairly simple working procedure. No drawings by him are known, and he seems to have worked directly onto the canvas without preliminaries. The light in his portraits always comes from the left, from a single source, and by working in this way, he developed a deep and instinctive grasp of the appearance of different types of face under a specific light source. Having mastered this basic problem, Hals could study the individual variations produced by each sitter in minute detail, reproducing them with a few confident strokes of the brush. This spirited brushwork bestowed on his sitters a unique vitality and life. We see his sitters not as fixed or permanent images, but as individuals caught in a passing moment, with a fleeting, transitory expression.

The composition of Hals' portraits is also relatively simple. Unlike Van Dyck, for example, who created a complete environment for his sitters, Hals placed his sitters against a plain background, focusing attention primarily on the face which was for him the main object of interest. For similar reasons, perhaps, Hals' portraits are mainly head-and-shoulders or half-length portrayals; with the exception of group portraits he painted only one full-length.

The liveliness of Hals' approach is seen also in the way he modified the poses of conventional portraiture to make them more informal. One of his favourite devices was to place the sitter seated, with his arm over the back of the chair, turning round to face the spectator as if we had suddenly caught his attention. The turning pose was not exactly new – it had been a standard feature of portraiture since the Renaissance. Hals, however, gave the motif a greater immediacy, by sharpening the twist of the body.

Another of Hals' favourite compositional schemes was to show the sitter with arms akimbo, an elbow projecting towards us out of the picture space. Hals used this device to particularly good effect in his early militia pieces, such as *The Banquet of the Company of St George* (p.135) where several of the men turn towards us with their hands on their hips, as if suddenly disturbed at their revels.

TECHNICAL VARIATIONS

Hals did sometimes modify his style to suit the demands of a particular sitter, or commission. In the *Laughing Cavalier,* for example, the confident and self-assured sitter was clearly anxious to display the sumptuous embroidery on his sleeve (p.209 and p.141). This exquisite decoration offers a clear demonstration both of the sitter's wealth and of his personal taste. Accordingly, Hals has painted the embroidery with small, neat strokes which capture

Symbols and Emblems

During the 1620s and 30s Hals painted a number of lively genre scenes. Like most genre paintings, these make abundant use of symbols and emblems. Such devices were enormously popular in Dutch art, and added a rich complexity of meaning to scenes which, to the modern eye, might appear quite straightforward. While some of Hals' symbols are self-explanatory, others are more obscure and derive from contemporary emblem literature. Emblem books, which originated in the 16th century, contained collections of pictures or pictorial devices, which were given a symbolic meaning by a motto or inscription. These books enjoyed a tremendous vogue in Hals' time, and artists often used them as a source of symbols, confident that the viewer would be able to recognise and to understand fully their true significance.

The Metropolitan Museum of Art

The Shrovetide Revellers
(above) Two of the figures represent characters from theatre; the Hans Wurst and Pickle Herring, with sausages and herrings used as symbols in the painting.

A herring was the symbol of a fool, as was the fox-tail in paintings. The spoon in the third man's hat is a symbol of greed, while the sausages and the bag-pipes have erotic associations.

The National Gallery

Emblematic Embroidery

(left) This complex image of Mercury's cap and staff comes from the Emblematum Libellus *of Andrea Alciati, a popular emblem book which was published in 1534. A similar device appears on the sleeve of the* Laughing Cavalier *and no doubt had a personal significance for the mysterious sitter. Other emblematic devices on the cavalier's sleeve (below) include flaming cornucopias, winged arrows, lovers' knots and bees. These were all familiar elements in emblems on love. These fascinating details, lovingly depicted by Hals, are displayed by the sitter with ostentatious care.*

A Young Man Holding a Skull

(above) This has often been thought to represent Shakespeare's Hamlet soliloquizing on the death of Yorick. In fact it is probably a vanitas *image, designed to remind the viewer of the transience of earthly life. The skull was a common symbol of death and was often included in portraits, to remind the sitter of his own mortality. Here, the boy's vitality and youthful charm lend a particular poignancy to this solemn reminder of death.*

The Metropolitan Museum of Art

The Wallace Collection

The Prodigal Son in a Tavern

(left) This may seem like a simple scene of a drinker and his sweetheart, but it almost certainly depicts the Prodigal Son carousing in a tavern, a common theme in Dutch art, and one with clear moral overtones. The dog symbolizes greed and unchastity.

TRADEMARKS

Informal Poses

A characteristic feature of Hals' portraits is his use of informal poses, especially for his male sitters. Often, his subjects lounge casually in a chair, or stand turned towards us, as if suddenly disturbed. These devices give Hals' portraits an unequalled spontaneity and liveliness.

Staatliche Museen, Berlin

the intricate details and suggest the richness of the stitching. By contrast, the plain cuff and the sash around his waist are painted in a relatively free manner. In the *Portrait of Isabella Coymans* Hals varies his brushwork to similar brilliant effect. Her face is painted with carefully blended brushstrokes to suggest her smooth, healthy complexion, while her jewellery and clothing are painted with the roughest dashes of colour.

THE BEAUTY OF BLACK

In the *Family Group*, Hals' technique is altogether more restrained. During the 1640s fashion in the Netherlands had in fact become more subdued, with sober black costumes becoming *de rigeur* for the well-to-do. Hals has painted the respectable family, particularly the older members, with due respect for their sobriety and discretion. At the same time, the painting demonstrates how Hals could create interest even within a simple expanse of black cloth, by subtly varying his tones. It may have been a painting such as this which led Van Gogh to exclaim that 'Frans Hals has no less than 27 blacks'.

Hals' greatest gift, however, was his talent for characterization. Each one of his sitters is a distinct individual captured, we feel, with their most characteristic expression. Hals' unique genius in this respect is seen most clearly in his large militia

pieces. Commissions such as this presented a particular problem for the artist, who was faced with the task of arranging a large group of figures in such a way that each face was equally visible, and no individual given undue prominence. At the same time, he had to avoid the monotony of placing each figure facing towards the front, as if the painting was a school photograph. Hals solved these problems superbly. In the *Banquet of the Officers of St George*, for example (p.135), he creates an impressive variety by placing the heads of the figures at continually contrasting angles. But the real variety is in creating an array of perfectly characterized individuals. Around the crowded table we see a gallery of personalities and expressions from the cautious, enquiring elderly man, to the confident young ensign, and the delightfully jovial and humorous Colonel seated at the table's head.

Hals was one of the first generation of Dutch painters to live and work exclusively in Holland and this had important implications for his art. Whereas the previous generation of Dutch artists had looked to Italy for their inspiration, Hals had little interest in Italian art with its emphasis on historical subject-matter and its concept of ideal human beauty. He took his subjects from everyday life and portrayed the Dutch people he saw around him. Hals does not appear to have flattered or idealized his sitters. As far as we can

Boy with a Flute 1623-25
(above) This is one of a series of pictures – including Young Man Holding a Skull *(p.141) that show the type of single genre figure that was popular in Dutch art from the 1620s onwards. Hals used the genre in a particularly original manner, deploying strong directional lighting and bold diagonals, and eliminating detail in favour of the overall dramatic effect. The raised hand (right) – suggested by a few slashes of paint – shows that the boy has been interrupted mid-gesture, adding to the animation of the scene.*

tell, he did not modify or 'improve' their features to conform to an accepted standard of beauty. He seems to have shown them exactly as they were with all their peculiarities, and the individuality of their features. It is this which enables us to identify with Hals' sitters as flesh-and-blood personalities. Van Gogh paid a moving tribute to this feature of Hals' painting when he wrote to his brother Theo from Antwerp: 'My thoughts are all the time full of Rembrandt and Hals, not because I see so many of their pictures, but I see among the people here so many types that remind me of that time.'

A LASTING REPUTATION

Van Gogh wrote at a time – the 1880s – when Hals' reputation was at its height. After being almost forgotten for many years after his death, he became a major influence on *avant-garde* French painters such as Manet, who admired the spontaneity of his brushwork. Society portraits were taken with his verve and panache, and he became a particular favourite with American collectors, which explains why so many outstanding works by him are in the USA. From about 1870 to about 1920 Hals was without doubt one of the most popular of the Old Masters. Since then, his status has slipped a little, perhaps because of the almost inevitable comparisons with Rembrandt – a comparison that only a handful of the world's greatest artists could sustain. To be Holland's second greatest portraitist, is, however, no mean distinction.

Single-figure Genre Painting

The tradition of single-figure genre painting originated largely in the work of the 17th-century Italian painter Caravaggio. Drawing on the works of earlier Flemish artists, Caravaggio painted numerous single figures in exotic dress. His achievements were introduced into the Netherlands by the Utrecht Caravaggisti, a group of Dutch artists such as Gerrit van Honthorst, who had been to Rome and seen his works at first hand. Hals was also greatly influenced by the various figures of the Caravaggisti.

Gerrit van Honthorst (1590-1656) The Merry Fiddler *(left) Single genre figures often represent one of the Five Senses. The exact significance of this figure is unclear – it has been suggested that he personifies either Taste or Hearing. But where the artist intended an allegorical meaning this is usually made clear, and the inclusion of both a violin and a wine-glass makes the figure rather ambiguous.*

Rijksmuseum, Amsterdam

Edouard Manet (1832-83) The Spanish Guitarist *(right) Manet said of his exotic guitar-player, 'In painting this figure I had in mind the Madrid masters, and also Hals'. Single genre figures were also popular in 17th-century Spain, and among the 'Madrid masters' Manet was probably thinking primarily of Velásquez – he was certainly influenced by Velásquez's painting technique. Musicians also figure largely in Hals' work.*

Gift of William Church Osborn, 1949

The Metropolitan Museum of Art

THE MAKING OF A MASTERPIECE

Married Couple in a Garden

The subjects of this delightful portrait can probably be identified as the merchant and explorer, Isaac Massa, and his first wife, Beatrix van der Laen. Massa had his own portrait painted twice by Hals and the features in these works correspond closely with those of the sitter here. The portrait was probably painted to commemorate the couple's marriage, on 25 April 1622. It is certainly a marriage portrait for the woman clearly displays her ring, worn here on the index finger, in line with contemporary fashion.

The portrait illustrates particularly well Hals' genius for creating informal images; the couple appear to have just moved away from the company on the lawn, to enjoy a moment alone in a secluded bower. The woman's shy smile and affectionate gesture add to the informality of this charming work so gracefully displaying Hals' expertise.

Contrasting textures
(above) Hals captures perfectly the contrast between the dull texture of the fine lace collar and the black of Massa's coat.

A merry company
(right) These elegant couples in the park recall outdoor merry company scenes, and reinforce the mood of happiness.

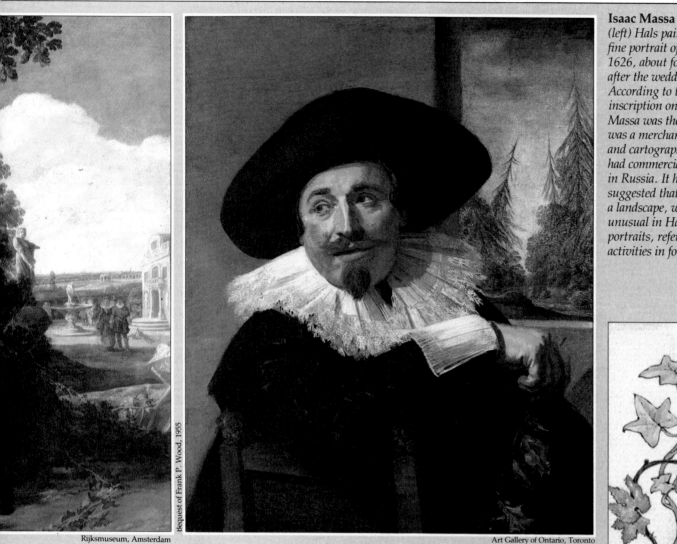

Rijksmuseum, Amsterdam

Bequest of Frank P. Wood, 1955

Art Gallery of Ontario, Toronto

Isaac Massa
(left) Hals painted this fine portrait of Massa in 1626, about four years after the wedding picture. According to the inscription on the chair, Massa was then 41. He was a merchant, explorer and cartographer, who had commercial interests in Russia. It has been suggested that the view of a landscape, which is unusual in Hals' portraits, refers to his activities in foreign parts.

Symbols of love
(right) The portrait contains several symbolic objects. The ivy symbolizes steadfast love, and the vine stands for marital love and dependence. Peacocks are sacred to Juno, goddess of marriage, and the wedding ring symbolizes marital union. The urn may signify the passage of time.

An emblem of fidelity
(above) There was a well-established tradition of depicting pairs of lovers in a garden setting. In this woodcut from Alciati's emblem-book, the lovers with clasped hands symbolize conjugal fidelity.

Ant van Dyck

1599-1641

Anthony Van Dyck was one of the most successful portraitists in the history of art. His dazzling images of the court of Charles I were enormously influential in his own time, and determined the course of English portraiture for the next 200 years. Van Dyck was brilliantly precocious, and although greatly influenced by Rubens – with whom he worked in Antwerp – he was to a large extent a self-taught artist.

In 1621 Van Dyck travelled to Italy, where he made his name painting portraits of the Genoese aristocracy. On his return to Antwerp six years later, he was showered with commissions and was appointed court painter to the Archduchess Isabella. In 1632 Van Dyck was summoned to England by Charles I and made chief painter to the King. But despite such success, Van Dyck never achieved his ambition to be a history-painter.

The Family of Philip Herbert, 4th Earl of Pembroke 130″ × 201″
Collection of The Earl of Pembroke, Wilton House, Wiltshire

The Gallant Portraitist

Van Dyck had a career of glittering international success. In Italy, Flanders and England he perfected a style of aristocratic portraiture that became the model for court artists all over Europe.

Key Dates

1599 born in Antwerp

1609 apprenticed to Hendrick van Balen

1618 enters Antwerp Guild; begins working with Rubens

1620/21 first visit to England

1621 travels to Italy and settles in Genoa

1624 commissioned to paint the *Madonna of the Rosary*

1627 returns to Antwerp

1632 settles in England

1635 paints *Charles I in Three Positions*

1640 marries Mary Ruthven

1641 birth of daughter; Van Dyck dies in London

Wallace Collection

A romantic image
(above) Van Dyck was obviously proud of his good looks and painted several flattering self-portraits. Here, aged about 25, he portrays himself as the shepherd Paris, who in Greek mythology awarded Venus the golden apple in the celestial beauty contest that started off the Trojan War.

The artist's master
(left) Hendrick van Balen (1573-1632) specialized in religious and mythological paintings and was a respected figure who often collaborated with other artists.

Anthony Van Dyck was born in Antwerp on 22 March 1599, the seventh child of Frans Van Dyck and his second wife, Maria Cuypers. In later life Van Dyck became renowned for his aristocratic manner and luxurious life-style, but his parents were ordinary middle-class citizens – Frans was a cloth merchant and Maria an embroiderer.

Van Dyck began his artistic education at an early age. By 1609, when he was only ten, he was already apprenticed to the successful figure-painter, Hendrick Van Balen. But Van Balen made little impression on his young pupil, since Van Dyck was exceptionally precocious. He was also highly ambitious, and by 1615 he had left Van Balen and set up his own studio in Antwerp, together with two young assistants. In doing so Van Dyck was breaking the rules of the painters' guild, for an artist was not supposed to sell his work until he had officially qualified as a master.

During Van Dyck's early years, the artistic scene in Antwerp was dominated by Rubens. His genius posed an obvious challenge to an aspiring young painter, and it may have been Rubens' presence in Antwerp that prompted Van Dyck's early bid for independence and recognition. It was probably also the example of Rubens, who was equally successful as a diplomat and man of court,

been suggested that it was Rubens who encouraged Van Dyck to specialize in portraiture – a field in which Rubens had relatively little interest. In fact Rubens clearly supported Van Dyck in his career and openly admired his talent, owning nine of Van Dyck's works.

By 1620 Van Dyck's reputation in Antwerp was firmly established. So it was not surprising that when, in July of that year, the influential Countess of Arundel passed through the city on her way to visit Italy, and sat to Rubens for his portrait of her, her secretary, Francesco Vercellini, wrote to the Earl of Arundel in London about the progress of the work, and added a note about the young painter. 'Van Dyck is still with Signor Rubens' he reported, 'and his works are hardly less esteemed

His Grace the Duke of Norfolk KG, Arundel Castle

A noble patron
(above) Thomas Howard, 2nd Earl of Arundel, was one of the greatest patrons and collectors of his day – surpassed in England only by Charles I. Here Van Dyck shows Howard with his wife, Aletheia.

Assistant to Rubens
(below) Van Dyck was one of many who worked with Rubens and may have had a hand in this picture. The foliage and fruit are perhaps by Frans Snyders, an eminent specialist in animals and still-life.

Success in Genoa
Van Dyck was in Italy from 1621 to 1627. He visited various places, but had his greatest success in Genoa with his superb portraits of the aristocracy. Genoa was (and still is) the most important port in Italy, and in the 17th century had a flourishing school of painting, enriched by visitors such as Rubens and Van Dyck.

National Gallery, London

that encouraged Van Dyck to adopt an aristocratic manner, and to cultivate the image of himself as a man of sophistication and refinement. Van Dyck also emulated Rubens' painting style, which he mastered with astonishing facility.

EARLY SUCCESS AND FAME

On 11 February 1618, Van Dyck was registered as a master in the Antwerp Guild of St Luke. Later that year he entered into his first direct association with Rubens. Rubens was designing a set of tapestries, showing the story of the Roman consul Decius Mus, for a patron in Genoa. He seems to have engaged Van Dyck to execute the full-scale cartoons after his *modelli*, giving Van Dyck an unparalleled opportunity to observe the master at work. Two years later, when he was just 21, Van Dyck was named as Rubens' chief assistant in the major commission to provide ceiling paintings (now destroyed) for the Jesuit Church in Antwerp, a sure sign of his professional success.

However, despite Van Dyck's prodigious talent and ambition, Rubens does not appear to have felt threatened by the young artist, although it has

than those of his master; he is a young man of twenty-one, and his father and mother, who are very rich, live in this city; so that it will be difficult for him to leave these parts, all the more as he sees the good fortune that attends Rubens.'

The letter suggests that the Earl was keen to procure Van Dyck's services and, despite Vercellini's reservations, Van Dyck was clearly tempted by the prospect of a visit to England. By November 1620 he had arrived in London, where he was to stay for the next three months.

This brief stay was important for Van Dyck, as he established connections with two of England's leading collectors: the Earl of Arundel himself, and his wealthy rival, the Duke of Buckingham. Van Dyck carried out commissions for both men, painting a portrait of the Earl and producing a fine history painting for the Duke. He also had access to their remarkable collections, which were especially rich in the works of the Venetian Old Masters, whom Van Dyck particularly admired – the Earl of Arundel owned 36 paintings by Titian and the Duke had a large collection of works by Veronese. Van Dyck could have seen a few such works in Antwerp but there is little doubt that his

experience of these collections strengthened his enthusiasm for Italian art, and helped influence his decision to travel to Italy the following year.

On 16 February 1621, Van Dyck was granted a payment of £100 for a 'special service' he had carried out for the King, James I. It is not known what this payment was for but, following his experience in Rubens' workshop, he may have been engaged in making tapestry designs for the King's new factory at Mortlake. It seems clear, however, that the King wanted to keep Van Dyck in his service, for on 28 February he was granted a pass to travel for eight months, as 'His Majesty's Servant'. A few days later he returned to Antwerp.

THE ITALIAN PERIOD

Van Dyck stayed in Antwerp until the autumn. Then, on 3 October 1621, he set off for Italy, heading first for the elegant city of Genoa, probably on the advice of Rubens who had been impressed by the city during his own Italian tour. It was here that Van Dyck began his career as portrait-painter to the aristocracy. He had painted a few portraits in Antwerp, and had begun to

A fiery mistress
*(left) Margaret Lemon,
Van Dyck's mistress in
England, was
acknowledged as a great
beauty, but she had a fiery
and unstable temperament
that was liable to erupt in
rages of jealousy. This
tenderly erotic portrait is
based on a famous picture
by Titian, one of the artists
Van Dyck most admired,
showing a woman in a fur
wrap.*

Royal Collection

A Master's Influence

Van Dyck is sometimes loosely referred to as Rubens' pupil, but he was in fact already a highly accomplished artist when he began working for the master in 1618. Nonetheless, Rubens' style exerted an enormous influence on Van Dyck. Many of Van Dyck's early paintings were copies or variants of Rubens' compositions, and the former imitated the latter's work so brilliantly that there is sometimes difficulty, even for those familiar with the artists' work, in distinguishing between their hands.

Kunsthistorisches Museum, Vienna

move away from the stiff formality of conventional Flemish portraiture. Now, under the renewed influence of Italian art, and with the example of Rubens' Genoese portraits before him, his style expanded dramatically and he began to create portraits of unparalleled sophistication and refinement: one such was his *Portrait of Elena Grimaldi* (p.154).

Van Dyck was very much at home in the magnificent *palazzi* of his aristocratic patrons and the 17th century biographer Bellori described Van Dyck on his arrival in Italy by saying 'His manners were those of a lord rather than an ordinary man, for he had formed his habits in the studio of Rubens, amongst noblemen. He was also proud by nature, and anxious for fame, and in addition to his rich clothing he wore plumes in his hat and chains of gold across his chest, and accompanied himself with servants.'

Friends in Italy
(right) During his stay in Genoa, Van Dyck lived with Lucas and Cornelis de Wael, two friends from Antwerp who had settled in Italy. The brothers were painters, engravers and dealers in art. Van Dyck painted their portrait, from which this engraving by Wenceslaus Hollar is taken.

The Emperor Theodosius Refused Entry into Milan Cathedral
(left) This and the painting above illustrate how difficult it often is to distinguish between the work of Rubens and Van Dyck at the time when they collaborated. Most critics now attribute this picture to Rubens and the smaller version above to Van Dyck, but the verdict is by no means unanimous.

The Emperor Theodosius Refused Entry into Milan Cathedral
(above) There are many differences of detail in the two pictures, but they are very similar in handling. The greater sense of weight and physical substance in the larger version suggests, however, that it is by Rubens, while this free copy, which is rather more elegant, is by Van Dyck.

A taste for landscape
(below) A surprising aspect of Van Dyck's genius is revealed in the series of water-colour landscapes he produced in England. They are painted with great freshness and spontaneity and their unaffected simplicity contrasts strongly with the grandeur and formality so typical of his portraits.

summoned by the death of his sister Cornelia. The next six years were to be the most successful and productive of his career; he was employed continuously by the Church, and was inevitably in great demand as a portraitist. By May 1630, he had been appointed Court Painter to the widowed Archduchess Isabella, and painted numerous portraits of Isabella and her entourage, modifying the sumptuous style of his Italian portraits to suit the more austere environment of the Brussels court. He also painted mythological works such as the dazzling *Rinaldo and Armida* (p.153), which was acquired by Charles I in 1629. Van Dyck's *Rinaldo*, with its breathtaking echoes of the Venetian masters, was guaranteed to excite an English audience. Italian paintings dominated the taste of English collectors so it must have aroused considerable enthusiasm in London, and probably influenced Charles' decision to ask Van Dyck to

But Van Dyck's lordly manner did not endear him to his fellow artists. Bellori reports that during a visit to Rome he upset the local community of Flemish artists by refusing to join the festivities which they traditionally organized to welcome newcomers to the city.

Surprisingly, perhaps, and unlike Rubens, Van Dyck did not embark on an extensive sight-seeing tour in Italy. He was a selective traveller and seems to have decided beforehand what he wanted to see – his notebooks record the works of Titian and Veronese and other notable Venetians, together with sketches of street life. But for the most part Van Dyck remained in Genoa, where he found a ready and appreciative market for his portraits regardless of his personal manner.

After a fairly lengthy stay in Italy, Van Dyck returned to Antwerp in the middle of 1627,

Van Dyck in Italy

The sketchbook that Van Dyck kept during his years in Italy, now preserved in the British Museum, provides a valuable insight into his response to Italian art. Although he travelled to most of the major artistic centres in the country, Van Dyck was unusually selective in the works of art he recorded. Unlike most artists who made the trip to Italy, and in marked contrast to Rubens, Van Dyck had little interest in the art of antiquity and made only one drawing after a classical sculpture. His sketchbook focuses on the works of Venetian High Renaissance artists such as Titian, Tintoretto and Veronese, whose paintings he had particularly admired in the collections of Flemish and English connoisseurs.

British Museum, London

A visit to Palermo
(left) In 1624, Van Dyck was invited to Sicily by the Viceroy Emmanuele Filiberto of Savoy. In Palermo, the capital city, he painted his biggest religious commission in Italy, an altarpiece for the Oratorio del Rosario.

A venerable artist
(above) In Palermo, Van Dyck met the portraitist Sofonisba Anguissola, who had been the most famous woman painter of her time. She was in her 90s and almost blind, but Van Dyck wrote that her brain was 'most alert'.

England. In due course, early in 1632, no doubt encouraged by the Earl of Arundel, Charles invited Van Dyck to the English court.

PAINTER TO CHARLES I

Despite this royal invitation it is not altogether clear why Van Dyck should have moved to London, since he had established a successful and varied career in Antwerp. But he was clearly attracted by the life of the Court, and Charles, who became King in 1625, had a formidable reputation as a patron of the arts. Rubens described him as 'the greatest amateur of painting among the princes of the world', and he had given Rubens one of his grandest commissions – the ceiling paintings in the Whitehall Banqueting House.

The King certainly treated Van Dyck with extraordinary generosity. He was lodged in a house at Blackfriars at the King's expense, provided with a summer residence at Eltham, and granted an annual pension of £200. On 5 July 1632, he was knighted, and the following year presented with a gold chain worth £110. Bellori gives a vivid description of Van Dyck's life-style in London. According to the biographer, his house was visited

The King's agent
Nicholas Lanier (1588-1666) was Master of the King's Music and was also employed by Charles I as an agent to buy paintings on the Continent. He was himself a talented amateur painter. Van Dyck painted this portrait of him in Antwerp in 1630, and Lanier may well have influenced his decision to settle in London two years later.

Kunsthistorisches Museum, Vienna

by the greatest nobility of the day who, following the King's example, liked to watch him work and pass the time in his company. In his house, 'he kept servants, musicians, singers and fools, and with these diversions he entertained all the great men who came daily to sit for the portraits'.

Van Dyck worked hard for these rewards; the King and his courtiers were demanding patrons. During the nine years he spent in England, Van Dyck painted around 30 large portraits of the monarchs, who had a special landing stage constructed outside his house in Blackfriars so they could visit him more easily by river. He also had an unending stream of commissions from the aristocracy, and his output of portraits during

Baltimore Museum of Art

these years was truly prodigious.

Van Dyck was clearly attractive to women. Although not tall he was well-proportioned and according to Bellori was 'blond with a fair complexion.' His name has been romantically linked with a number of his female sitters, and he had an illegitimate daughter, Maria Teresa, whom he honoured in his will. His accepted mistress was the fiery Margaret Lemon who was described by the engraver Hollar as 'a dangerous woman' and 'a demon of jealousy' who caused the most horrible scenes when ladies belonging to London society had been sitting without a chaperone for their portraits. In a fit of jealousy she tried to bite off Van Dyck's thumb in order to prevent him from painting again.

Despite his success Van Dyck did not intend to settle in England. In March 1634, he returned to Antwerp to visit his family, and bought some property near the Château de Steen, the country residence which Rubens purchased the following year. On the death of Rubens in 1640, Van Dyck made repeated trips back to his native town, no doubt anxious to claim his position as the leading painter in Flanders. But events overtook him, and he died in London in 1641.

Alte Pinakothek, Munich

The English years
(above left and above)
After Van Dyck left England at the end of his first brief stay in 1621, he is not known to have had any contact with the English court for another eight years. In 1629, however, Charles I bought his painting of Rinaldo and Armida *(above left), and this splendid work probably inspired the King to tempt Van Dyck into his service. He arrived in England in 1632 and was based there for the rest of his life. But even though he married an English woman, portrayed above as a cellist, he never really settled and kept up his links with the Continent.*

Van Dyck's last years were not without their disappointments. Despite his talent for portraiture Van Dyck maintained the ambition to be a successful history painter like Rubens, and clearly hoped for a large-scale commission from King Charles. In 1639 plans were made for a series of canvases to decorate the Queen's Bedchamber at Greenwich but Van Dyck was not included in the scheme, and the commission was given to Jacob Jordaens, another assistant to Rubens. In January 1641 Van Dyck travelled to Paris, hoping to gain a major commission from Louis XIII who was planning to decorate the principal gallery in the Louvre. Again he was unsuccessful, and by May he was back in London.

MARRIAGE AND DEATH

A brighter note in these final years was Van Dyck's marriage, early in 1640, to Mary Ruthven who was one of the Queen's ladies-in-waiting. But the marriage did not last long as on 9 December 1641, Van Dyck died, his delicate constitution undermined by the unremitting pressure of work. His eight-day-old daughter, Justiniana, was baptized the same day.

Aristocratic Images

Quick to absorb the inspiration and style of the greatest Italian portrait painters, Van Dyck developed his own extraordinary gifts to become one of the most memorable and influential portraitists ever.

During the course of his career Van Dyck revolutionized English portraiture. In his own lifetime he created an image of the court of Charles I which has since become the 'official' one – an image of elegant courtiers tinged with melancholy, posed gracefully in a mellow landscape. In the years after his death, Van Dyck's dazzling portrait-style left its mark on every English portrait artist and laid the foundation for the achievements of Gainsborough and Reynolds.

Van Dyck's early portraits, painted during his first Antwerp period, followed the conventional style of Dutch and Flemish portraiture. The sitters stand facing the spectator, posed stiffly against a plain dark background. But by around 1620, under the influence of the Venetian painters, and particularly that of Titian, Van Dyck had begun to create more complex settings for his subjects, placing them against a modest architectural background or a glimpse of landscape.

It was also from the Venetians that Van Dyck learnt how to break up the stiff frontality of the conventional Flemish portrait with a casual turn of the head, or a movement of the hand or foot.

These developments reached a peak in Van Dyck's magnificent Genoese portraits, which included his first full-lengths. Here, Van Dyck exploited the grandiose surroundings of his

François Langlois
(right) The sitter for this portrait was a dealer who secured works for Charles I and the Earl of Arundel. Van Dyck emphasizes Langlois' talent for music, and his romantic but sympathetic and humorous disposition.

National Gallery of Art, Washington

The Lomellini Family
(left) In this famous group portrait from his Genoese period, Van Dyck deliberately places the figures in a grandiose setting, so that even the children seem aware of their own dignity.

An aristocratic patron
(above) Van Dyck's fine and detailed treatment of the Marchesa Elena Grimaldi contrasts sharply with the freely-painted figure of her servant, and adds visual interest to this portrait.

National Galleries of Scotland, Edinburgh

Cowdray Park, Sussex

Private Collection

Rijksmuseum, Amsterdam

A royal union
(*left*) *One of Van Dyck's most important commissions was to paint the young Prince William of Orange and Princess Mary Stuart, on their marriage in 1641.*

A preparatory sketch
(*above*) *A swift but tender sketch of Charles I's younger children – a preliminary to a group portrait – shows Van Dyck's sensitivity as a painter of infants.*

patrons' palaces with exceptional skill. The architectural backgrounds of these portraits are used firstly to create a stable composition, as in *The Lomellini Family* (p.154), where the background of niches and columns forms a solid framework for the figures. Secondly, and most important, the architecture is used to emphasize the dignity and status of the sitters.

In the *Portrait of Elena Grimaldi* (p.154) for example, the fluted columns on the right are used to accentuate the slender proportions and upright stance of the *marchesa*, in marked contrast to the stooping attitude of her servant. Van Dyck further emphasizes the sitter's elevated position by adopting a low view-point so that the figure appears to tower over the spectator, and over the landscape beyond. Van Dyck's ability to integrate his sitters with their backgrounds, and to create an environment which subtly flattered his subjects, constituted an important element in his success.

ITALIAN INFLUENCE

When Van Dyck arrived in England, portraiture at the English court was dominated by Dutch and Flemish portrait artists such as Daniel Mytens, who had been summoned to England by the Earl of Arundel. Van Dyck's dazzling Italianate style must have come as a revelation to his

TRADEMARKS

Graceful Hands

To indicate the artistocratic birth and bearing of his subjects, Van Dyck often depicted them with elegant – and elegantly drooping – wrists and hands.

contemporaries and, shortly after his appointment as King's Painter, Mytens faded from the scene.

When in England, Van Dyck's portrait-style underwent a perceptible change. With a few notable exceptions such as *The Pembroke Family* group portrait, and the portraits of the King, the backgrounds of the English portraits are less sumptuous and more generalized, often being reduced to a single architectural 'prop' such as a column, broken up by a large piece of flowing drapery. Such changes probably reflect the fact that Van Dyck was working largely in his own studio, rather than in the homes of his sitters. At the same time Van Dyck began to focus more closely on the details and textures of his sitters' costumes, painting them with unequalled skill.

Unlike Rubens, Van Dyck approached his paintings in terms of surface and line. Consequently his figures occupy a relatively shallow space, which brings them close to the front of the painting. Their movements and gestures

Two brothers
(above left and detail) One of Van Dyck's most brilliant portraits depicts Lord John and Lord Bernard Stuart in the splendid attire and with the graceful hauteur that were the hallmarks of the cavalier. Both brothers died a few years later in the Civil War.

Character studies
(right) These wonderful sketches of a head, seen from different angles, show Van Dyck's interest in a popular 17th-century tradition.

156

run across the surface of the picture, creating elegant linear rhythms; they rarely move away from us into the distance, or turn at sharp angles to the picture plane. Rubens, on the other hand, was concerned with solid form. His passionate interest in sculpture led him to think of his painted figures as truly three-dimensional. Van Dyck's figures are less substantial and seem to be painted in webs of surface colour.

SUBTLE FLATTERY

Van Dyck's success as a portraitist depended partly on his ability to get the best out of his sitters. Although he retained a keen eye for the individual, he subtly flattered sitters by giving them slender, attenuated figures, elegant hands and graceful, dignified movements. Not surprisingly, his female portraits are the most idealized, although not all his female sitters were pleased with the results. The Countess of Sussex clearly thought that Van Dyck had not flattered her enough, and complained that the portrait '. . . makes me quite out of love with myself, the face is so big and so fat. . . it looks like one of the winds puffing.'

But, for the most part, Van Dyck's female sitters display less individuality than the Countess of Sussex and many show a striking resemblance to the image Van Dyck created of the Queen, Henrietta Maria. The Queen was certainly no beauty. The King's young niece, Princess Sophia, having become accustomed to Van Dyck's portraits, expressed her surprise on finding the Queen to be 'a little woman, with long lean arms, crooked shoulders, and teeth protruding from her mouth like guns from a fort.'

Van Dyck retained the ambition to be a successful history-painter, and was also sought after for his religious canvases. But his real achievement was in portraiture where, in the words of the critic De Piles, he combined 'Great Character of Spirit, Nobleness, Grace and Truth.'

Equestrian Portraits

The equestrian portrait originated in classical times. The prototype for all later versions was the bronze statue of the Roman Emperor Marcus Aurelius which stood on the Capitol in Rome. During the time of the Roman Empire, the equestrian portrait was reserved for the Emperor alone, so the model of the Marcus Aurelius carried associations of imperial power. In his two mounted portraits of Charles I, Van Dyck capitalized on these associations, consciously depicting Charles as the 'Emperor' of Great Britain. Van Dyck was also influenced by Rubens who painted numerous imposing versions of the equestrian portrait including *A Knight of the Golden Fleece*.

Sir Peter Paul Rubens (1577-1640) **A Knight of the Golden Fleece** *(right) Painted in about 1610, this portrait of a noble warrior and steed was emulated by Van Dyck, and strongly influenced European equestrian portraiture.*

Sir Edwin Landseer (1802-1873) **Queen Victoria at Osborne** *(below) Landseer approaches the equestrian theme with greater informality, showing the Queen seated on her horse reading a letter, her groom and dogs in attendance.*

Royal Collection

Private Collection

Royal Collection

THE MAKING OF A MASTERPIECE

Charles I in Three Positions

Van Dyck painted this magnificent portrait as a model for the Italian sculptor Bernini, who had been commissioned to make a marble bust of the King. The bust had been requested by the Queen, Henrietta Maria, and the commission was arranged by the sculptor's chief patron, Pope Urban VIII. The Pope's cooperation was largely a diplomatic gesture for he had hopes that Charles I would lead England back to the Catholic church.

The portrait was begun in the summer of 1635 and was sent to the sculptor in Rome the following year. The bust was despatched to England under special escort in April 1637, after it had been on public exhibition in Rome, and was presented to the King and Queen three months later. It was rapturously received, both for 'the exquisiteness of the work' and the 'likeness and near resemblance it had to the King's countenance'.

The commission was an important one for Van Dyck, since he knew that the portrait would be seen by the most important patrons and collectors in Rome. He clearly took particular pains with the work, giving it a degree of detail and refinement not strictly necessary for the sculptor's purposes but which might attract favourable attention from patrons. Bernini was reputedly struck by the King's air of brooding melancholy, ironically remarking that his countenance seemed to forebode unhappiness.

'No king . . . has been imaged in such variety of genius.'

Sir David Piper

Subtle colouring
(below) The colour scheme of the portrait is of great beauty, especially in the contrast between the three different costumes worn by the King.

Characteristic features
(right) Van Dyck modelled Charles I's head with extreme care and delicacy, capturing to perfection his heavy-lidded eyes, long nose and fine hair.

After Bernini
(*above*) The original Bernini bust was lost in a fire at Whitehall Palace in 1698, and a copy was subsequently made, perhaps from a cast. All the familiar details are present, including the characteristically uneven hair length.

A further commission
(*below*) Van Dyck painted three portraits of Queen Henrietta Maria, in profile and full-face, for a bust of herself which she commissioned from Bernini in 1639. But the portraits were never sent because of England's increasing civil turmoil.

Kunsthistorisches Museum, Vienna

Van Dyck's inspiration
(*above*) Lorenzo Lotto's famous triple portrait of a jeweller hung at Whitehall in Van Dyck's time – with an attribution to Titian – and very likely provided part of the inspiration for Van Dyck's own work.

The Royal Collection

National Gallery, London

Rembrandt

1606-1669

The son of a miller from Leiden, Rembrandt was the greatest of all Dutch painters and a prolific draughtsman and etcher. He lived in a golden age for Dutch art, but whereas most of his contemporaries were specialists, Rembrandt produced virtually every type of subject. It was as a portraitist that he made his name, however. By his late 20s he was the most popular painter in Amsterdam, and happily married to a wealthy bride.

Thereafter his career was clouded by misfortune – his wife, mistress and five of his six children died, and a financial crisis led to his insolvency when he was 50. Throughout his personal troubles he continued to work triumphantly, although many of his contemporaries preferred the slicker painting of his pupils. It was only in the 19th century that Rembrandt became generally recognized as one of the supreme artists of all time.

The Polish Rider *c.1655*
45¼″ × 53¼″ Frick Collection, New York

Holland's Supreme Genius

**Rembrandt's early success was followed by tragedy and bankruptcy
in later life. Yet his work was not diminished by his misfortune, and
he produced some of the most powerful pictures ever painted.**

Key dates

1606 born in Leiden

1620 enters Leiden University

c.1624-25 studies with Pieter Lastman. Sets up studio in Leiden

1631/2 moves to Amsterdam

1632 paints *Anatomy Lesson of Dr Tulp*

1634 marries Saskia van Uylenburgh

1641 birth of his son Titus

1642 death of Saskia. Paints *The Night Watch*

c.1645 Hendrickje Stoffels enters household

1654 birth of daughter Cornelia

1656 declared insolvent

1661 commissioned to paint *The Syndics* and *The Oath of Julius Civilis*

1663 death of Hendrickje

1668 death of Titus

1669 dies in Amsterdam

Rembrandt Harmenzoon van Rijn was born in Leiden (also spelt Leyden) on 15 July 1606. His father Harmen (Rembrandt's middle name means 'son of Harmen') was a miller and his mother Cornelia was the daughter of a baker. The family took their name from the nearby 'Rijnmill', a mill on the Rijn (a tributary of the Rhine).

At this time Leiden was second only to Amsterdam in size and importance among the towns of the Netherlands, and Rembrandt's family were comfortably off members of the lower middle class. Rembrandt was the eighth of his mother's nine children.

Rembrandt's mother?
(right) This dignified portrait of an old woman was once thought to have been Rembrandt's mother. She was a devout and serious woman as this painting portrays, but at that time, c.1629, she is unlikely to have looked as old as this sitter.

The artist's home town
(below) Rembrandt was born and educated in Leiden, the second largest town in the Netherlands at the time. Its university, which Rembrandt attended, was one of the most respected in Europe.

Although almost nothing is known of Rembrandt's boyhood, it is safe to assume that he was intellectually the brightest of the children, for while his brothers were sent to learn trades, he became a pupil at the Latin School in Leiden when he was about seven. There he must have gained a thorough knowledge of Latin and absorbed the background of classical history and mythology that would later be put to use in his paintings.

By the age of 14, Rembrandt was studying at Leiden University, which was one of the most distinguished in Europe. His stay was short-lived, however, for within a few months he had

Ashmolean Museum, Oxford

National Gallery, London

The artist's father c.1630
Shortly before his father's death, Rembrandt made this study of the old man. His expression suggests possible blindness – a frequent theme in Rembrandt's later works.

Swanenburgh is an obscure figure and Rembrandt probably learnt little more than the rudiments of his trade from him, for although in the course of his career he painted most subjects, he never tried his hand at either of Swanenburgh's specialities – architectural scenes and views of hell.

A NEW MASTER

None of Rembrandt's work from this stage in his life survives but he is said to have shown so much promise that his father decided to further his career by sending him to Amsterdam to study with a much more significant artist than Swanenburgh – Pieter Lastman, at this time one of the leading painters in the country. Lastman had travelled in Italy as a young man and had come back eager to show off all he had learned there. His paintings were clever, lively and polished, full of vivid gestures and expressions, and he liked to paint historical and mythological subjects in which he could demonstrate his skill in depicting elaborate costumes and exotic details. Rembrandt stayed only six months with him, but Lastman's work had a powerful effect; he inherited his master's love of colourful stories and his earliest surviving paintings are heavily indebted to him in both subject and treatment.

After he left Lastman, Rembrandt may also have spent some time working in the studios of Jan Pynas and Joris van Schooten, but this can only have been briefly, for by 1625 he had set up as an

convinced his parents that his talents were artistic rather than scholarly, so they abandoned their plans for him to become a member of a learned profession and allowed him to be apprenticed to a painter. The decision was no doubt a very reluctant one, for having a lawyer or a civic administrator as a son would have taken them a rung or two up the social ladder.

The earliest source of information we have on Rembrandt is contained in the second edition (1641) of a book called *Beschrijvinge der Stadt Leyden* (Description of the City of Leiden), by Jan Orlers, who was mayor of the city. He tells us that Rembrandt's parents 'took him to the well painting Mr Jacob Isaaxszoon van Swanenburgh in order that he might be taught and educated by him, with whom he remained about three years'.

Rembrandt's master
(above) Rembrandt first went to Amsterdam to study under Pieter Lastman, a Dutch painter known for his biblical, historical and (shown here) mythological scenes.

Dressed for success
(right) Rembrandt's many self-portraits reflect his changing fortunes. Here, in 1629, he portrays himself as an elegant, intelligent man on the threshold of success.

Mauritshuis, The Hague

Friend and Collaborator

Jan Lievens (1607-74), Rembrandt's friend and collaborator during his early career, was a remarkably precocious artist, having set up as an independent painter by the age of 13. In fact, the diplomat Constantijn Huygens wrote of the two young painters 'Rembrandt surpasses Lievens in taste and liveliness of feeling, but the latter exceeds the former in a certain imaginative grandeur and boldness of subjects and figures'. But, unlike Rembrandt, Lievens did not fulfil his early promise. He had a successful career, but his later work, although elegant and accomplished, lacked vigour and freshness.

Lievens: Self-Portrait (c.1644)
(left) From 1644 onwards Lievens divided his time between Amsterdam and the Hague, where he was regarded as an accomplished painter and a popular portraitist.

The Raising of Lazarus (1631)
(below) In his earlier work Lievens was a master of understated drama, as we can see here in this powerful representation of Lazarus emerging from the tomb.

National Gallery, London

Brighton Museum and Art Gallery

A permanent home
(below) With the realization that there was a prosperous career to be had in painting portraits, Rembrandt moved to Amsterdam where he could be sure of influential commissions. He worked hard and productively to secure his position as the city's leading portraitist.

A lover's drawing
(right) To commemorate his engagement in 1633 to Saskia, the well-to-do cousin of his friend and associate, Hendrik van Uylenburgh, Rembrandt drew this tender portrait. He used the Renaissance technique of silverpoint to emphasize how preciously he regarded his fiancée.

independent artist in Leiden. There he worked in close association with Jan Lievens who was a year younger than himself. Like Rembrandt, Lievens was a native of Leiden and had studied in Amsterdam with Lastman. They probably shared a studio for a while and their work was sometimes so similar as to cause confusion: an inventory made in 1632 lists a picture as 'done by Rembrandt or Jan Lievens', and there is a portrait of a child in the Rijksmuseum in Amsterdam signed 'Rembrandt geretucee. . .Lieve. . .' (Lievens retouched by Rembrandt).

The two young artists soon established reputations as major talents in the making. On 14 February 1628, Rembrandt – still only 21 – took on his first pupil, Gerard Dou, and in that year a visitor from Utrecht, the lawyer Aernout van Buchellm, wrote in his notebook 'The Leiden miller's son is greatly praised'. In the following year another visitor to Leiden wrote a much fuller account of Rembrandt in his formative years. This was Constantijn Huygens, secretary to the head of state, Prince Frederik Henry of Orange, and one of the most remarkable men of his time. A diplomat and polylingual scholar (he translated John Donne's poems into Dutch), he was also passionately interested in the arts and would have

become a painter himself but for parental disapproval. Huygens called on Rembrandt and Lievens (the latter had painted his portrait two years earlier) and praised both of them highly. He suggested they should visit Italy, 'for if they become familiar with Raphael and Michelangelo, they would reach the height of painting.' But the two artists said they had no time to travel and that they could in any case see plenty of good Italian paintings in Holland.

SUCCESS AS A PORTRAIT PAINTER

Although he painted (and etched) several portraits of himself and members of his family during his Leiden period, Rembrandt concentrated on figure paintings, notably ones of old men depicted as biblical characters or philosophers, and it was not until 1631 that he is known to have produced his first formal commissioned portrait. This was of the rich Amsterdam merchant Nicolaes Ruts. Rembrandt must have realized that in such works he had a recipe for success, for in late 1631 or early 1632 he moved to Amsterdam and during the next few years devoted himself almost exclusively to portraiture. He moved into the home of the picture

dealer van Uylenburgh, with whom he had had business dealings while he was still living in Leiden, and very rapidly became the city's leading portraitist. There were other talented portrait painters working there, notably Thomas de Keyser, but Rembrandt could match them in delicacy of painting costumes and glossiness of finish, and far outstripped them in capturing on canvas a sense of life and personality.

Rembrandt worked with enormous energy in his early days in Amsterdam to consolidate his success. About 50 of his surviving paintings are dated 1632 or 1633 (almost all of them portraits) and even without allowing for the ones that must have disappeared over the centuries, that is a prodigious output. His most famous painting from this time is undoubtedly *The Anatomy Lesson of Dr Tulp* (p.170), which more than any other work showed how far he was ahead of his rivals. Such group portraits were very popular in the Netherlands, and it was a hard task for the painter to bring together a group of virtually identically dressed men without making the picture look rather like a school photograph. Rembrandt's brilliantly arranged group showed the originality of his mind and his superb painterly skills. In 1634, Rembrandt, then 28, married Saskia van

An influential patron
(above) Rembrandt first met the statesman Constantijn Huygens in Leiden. Then, when the artist moved to Amsterdam, Huygens became his most influential patron, procuring commissions from Frederik Henry, Prince of Orange, for whom he acted as private secretary.

165

Uylenburgh, the 21-year-old cousin of his picture-dealer associate. Saskia was not only from a higher social class than Rembrandt but also fairly well off as she was an orphan and had been left money by her parents. The couple lived with her cousin Hendrik van Uylenburgh for a while and then rented a house on the fashionable Niewe Doelenstraat. We have no first-hand accounts of Rembrandt's relationship with Saskia, but they are hardly necessary, for it was obvious from his paintings and drawings that he worshipped her. Unfortunately their happiness was marred by a succession of infant deaths; between 1635 and 1640 Saskia gave birth to a boy (Rumbartus) and two girls (both named Cornelia after Rembrandt's mother), but none lived longer than two months. Saskia had never been robust and the repeated ordeal weakened her considerably.

Although he had these domestic worries to contend with, Rembrandt's material fortunes were never greater than in the second half of the 1630s. He had all the pupils and commissions he could handle. Writing 50 years after his death, the Dutch painter and historian Arnold Houbracken said that clients had to beg him for pictures and the large sums he was earning enabled him to indulge his passion for collecting. He bought not only paintings, drawings and engravings, but also arms and armour, medals, old costumes, indeed anything that took his fancy or that he thought might come in useful as a prop.

CHANGING FORTUNES

The direction of Rembrandt's career changed in the 1640s. He virtually gave up the type of formal portrait with which he had made his reputation (although he still painted people he knew) and religious paintings began to occupy a correspondingly greater part in his work, which became less flamboyant and more introspective. Various reasons have been suggested to explain this change. The deaths of his mother in 1640 and Saskia in 1642 must have upset him deeply and he may well have found solace in religion. At the same time the pupils he had taught so well were beginning to take some of his market in fashionable portraiture. There may be something in both these ideas, but it is more likely that Rembrandt had simply had enough of routine portraiture and wanted to get back to his first love, which was painting stories from the Bible.

The year before Saskia died she had given birth to a son, Titus, the only one of her four children to survive to adulthood. A woman called Geertge Dircx, the widow of a trumpeter, was hired as the baby's nurse, and after Saskia's death she became Rembrandt's mistress. When she was replaced in his affections by Hendrickje Stoffels, a servant who had entered his household in about 1645, Geertge left and sued Rembrandt for breach of promise. After some unsavoury legal action, Rembrandt managed to get her shut up in an asylum in Gouda, where she remained for five

Rembrandt's Graphic Work

Rembrandt was enormously prolific as a draughtsman and etcher as well as a painter. Most of his drawings are completely private works and many of them seem to be totally spontaneous reactions to the things he saw around him. Unlike the paintings and etchings, very few of the drawings are dated but they give an intimate insight into Rembrandt's mastery.

British Museum, London

Study of a pig
(above) Rembrandt rarely painted animals but he often drew them whether they were unusual, or commonplace like this pig.

Woman Carrying a Child Downstairs
(left) This drawing probably dates from the 1630s and so may well represent Rembrandt's wife, Saskia, carrying one of their children.

Reunion des Musees Nationaux

Pierpont Morgan Library, New York

Barber Institute of Fine Arts, Birmingham University

British Museum, London

Studies of Heads and Figures
(left) These rapid sketches show Rembrandt's ability to convey quirks of gesture and expression.

Sleeping woman
(above) Rembrandt never surpassed the technical bravura of this drawing, which may represent his mistress Hendrickje.

The Omval
(right) The Omval was the name given to a group of houses on a strip of land near the river in Amsterdam. Rembrandt knew it well and made this etching in 1645.

The Singel Canal, Amersfoort
(below) Rembrandt seems to have rarely left Amsterdam, but he made this drawing on a trip to eastern Holland.

Louvre, Paris

British Museum, London

Portrait of Titus
The only child of Rembrandt and Saskia to survive infancy was a son called Titus. He became an artist himself and also acted as his father's dealer.

years. It was in the 1640s that Rembrandt began to take a great interest in landscape, and it has been suggested that the walks in the country gave him a welcome rest from his domestic troubles.

Hendrickje, who was about 20 years younger than Rembrandt, remained with him until she died in 1663, and Rembrandt's portrayals of her are as tender and loving as those of Saskia. But, because of a clause in Saskia's will according to which Rembrandt would forfeit his share of her estate if he remarried, he was unable to legalize his relationship with Hendrickje. This got her into trouble with the church authorities, who forbade her to take communion because she was living in sin. In 1652 she had a baby who soon died, but in 1654 she gave birth to a girl, called Cornelia as Saskia's daughters had been, who was to be the only one of Rembrandt's children to outlive him.

Now that he was no longer earning a small fortune with his portraits, Rembrandt had difficulty in keeping up the payment on his expensive house, and in the early 1650s his

The Town Hall Controversy

Amsterdam Town Hall, begun in 1648, was the greatest building erected in Holland in the 17th century, a symbol of the city's prestige in its finest period. It was richly decorated with paintings and sculpture by several of the leading Dutch artists of the day. In 1661, Rembrandt received a commission (taking over from a former pupil, Govert Flinck, who had died the previous year) to paint the Oath of Julius Civilis, a subject from ancient history. Rembrandt's painting was installed in 1662, but for unknown reasons was removed the following year – possibly because of the crude realism in the portrayal of Julius – and replaced with a picture by another ex-pupil, Juriaen Ovens.

Commemorative medal
(above) A gold commemorative medal, bearing an image of the classically styled Town Hall, marked its dedication in 1655.

Original plan
(left) Rembrandt's ink and wash preliminary study for the controversial painting gives some indication of the original size of the work – it measured about 18ft. When it was taken down after a year, it is said that Rembrandt cut it down to its present size himself, probably to make it easier to sell.

An appropriate choice
(above) The theme of the painting was chosen because it tells the story of how the one-eyed Julius Civilis assembled the leaders of the Batavians (the original inhabitants of Holland) one night and made them swear to rise against the occupying Romans. The parallel with the Dutch struggle for Independence from Spain, granted in 1648, was obvious.

Living in style

(left) At the height of his career Rembrandt bought a grand house on St Anthoniesbreestraat, a fashionable street in Amsterdam. But during the 21 years he lived there, it became the scene of personal tragedy: his wife and three of his children died there, and eventually, financial difficulties forced him to move. The house is now a Rembrandt museum.

Final years

(below) Rembrandt's enigmatic expression in this self-portrait, painted in 1669, the year of his death, reveals a man who learned to accept, without defeat or bitterness, all the blows life dealt him.

making a fresh start, for his output surged and in 1661 he produced more dated paintings than in any year since the early 1630s.

But despite his renewed success, and foreign acclaim, there was much personal sadness in Rembrandt's final years. Hendrickje died in 1663 and his beloved son, Titus, followed her in 1668. Titus had married in that year and his wife gave birth to Rembrandt's granddaughter, Titia, in March 1669. Rembrandt lived out his final days with his daughter Cornelia and an old servant woman. He lived simply and Houbracken said he was 'often content with some bread and cheese or pickled herrings as his whole meal'. We have only the evidence of the paintings to go on, particularly the self-portraits, but from them it appears that Rembrandt faced his hardships with dignity and no trace of bitterness. His work continued to grow in freedom of technique and depth of expression to the very end of his life, and his late masterpieces take their place among the greatest works of art ever created. He died on 4 October 1669, aged 63, and was buried beside Hendrickje and Titus in the Westerkerk four days later. Cornelia married a painter, Cornelius Suythof, in the following year, and had two children whom she named Rembrandt and Hendrickje.

financial troubles became acute, as he took out one loan to pay off another. He began selling parts of his collections at auction, but more drastic action was called for, and in 1656 he transferred ownership of the house to Titus and was declared insolvent. To avoid the degradation of bankruptcy he applied for and was granted a *cessio bonorum*, a legal procedure which involved the sale of debtor's goods but which allowed him to retain considerable freedom provided he could convince the court of his honesty and good faith. Rembrandt's collections were finally dispersed in two auctions in 1657 and 1658, and in the latter year his house was sold, although he was not forced to move out until the end of 1660. To protect him from his creditors, Hendrickje and Titus formed a business partnership, with Rembrandt technically their employee; in this way he was able to keep the earnings from his work.

THE FINAL YEARS

According to the romantic image of Rembrandt beloved of novelists and film makers, the artist became a pauper and a recluse in his final years. Although it is true that he was never again free from financial worries, this picture is a grave distortion of the truth. Certainly he lived more modestly in lodgings on the Rozengracht, which was in a poorer district on the other side of the city from his house on St Anthoniesbreestraat, and Houbracken tells us that 'in the autumn of his life he kept company mainly with common people and such as practised art', but he was anything but forgotten. The move may in fact have given the artist renewed energy, with the feeling that he was

National Gallery, London

The Compassionate Eye

A brilliant and versatile artist, Rembrandt painted a wide variety of themes during his career, but it is his compassionate handling of his subjects which give his works their universal appeal.

The Anatomy Lesson of Doctor Tulp (1632) *(left) Rembrandt's first large painting was commissioned by Nicolaes Tulp, a prominent Amsterdam physician. The painting revolutionized the traditional concept of the group portrait and established Rembrandt's reputation as a portrait painter.*

Belshazzar's Feast *(below) One of the many religious works which Rembrandt painted in his lifetime, Belshazzar's Feast (c.1635) is painted in an extravagant Baroque style, and shows the artist's debt to Caravaggio and Lastman. The subject, taken from the Book of Daniel, is depicted by Rembrandt in a dramatic, almost theatrical manner.*

Mauritshuis, The Hague

Rembrandt stands apart from all other 17th-century Dutch artists not only because of the quality of his work, but also on account of its range. The amount of painting produced in Holland in Rembrandt's period was huge, for the country was prosperous and democratic, and pictures were not the preserve of the rich and privileged as they were in aristocratic cultures. Most paintings were produced by specialists, who often worked in restricted fields. Some confined themselves not just to landscapes, but to winter landscapes or dune landscapes, not just to still-life in general, but to paintings of fish or flowers. Although Rembrandt excelled at portraits and religious scenes, he painted most subjects in the course of his career, including some, such as *The Polish Rider* (p.161), that defy classification.

He not only painted them, but etched and drew them also, for he was a superlative etcher (few would deny that he was the greatest ever master of the technique) and a prolific and brilliant draughtsman. Although scholars disagree on the exact extent of Rembrandt's output (some being more cautious than others as to whether certain works should be attributed to the master himself or to his pupils and imitators), the number of his surviving paintings is usually put at over 500, his etchings at around 300 and his drawings at well over 1000. In all three fields Rembrandt evolved a highly original style and technique.

THE NETHERLANDISH INFLUENCE

As a painter, he began working in the detailed manner that was part of his heritage and stemmed ultimately from the innovations in oil painting of Jan van Eyck. His commissioned portraits of the 1630s, such as *The Anatomy Lesson of Dr Tulp*, are the best examples of the clarity and polish of his early work, but even in his most formal pictures his brushwork is never laboured or finicky. In his more personal work of the same period, particularly self-portraits and portraits of his family, he allowed himself more freedom, often applying the paint quite thickly, and even using the handle of the brush to scrape through it.

National Gallery, London

When, in the 1640s, he began to paint more to please himself than to satisfy his customers, his style became much broader, his brushwork suggesting form and texture rather than minutely delineating it, and in the 1650s and 1660s his *impasto* (thickly applied paint) was one of the most remarkable features of his work. Rembrandt's biographer, Houbraken, wrote that 'in the last years of his life, he worked so fast that his pictures, when examined from close by, looked as if they had been daubed with a bricklayer's trowel' and went on to record that 'it is said he once painted a portrait in which the colours were so heavily loaded that you could lift it from the floor by the nose.' Houbraken's comments are colourful but

A rare oil sketch
(above) This small, but poignant oil sketch of The Entombment of Christ *may be a study for one of a series of paintings on the Passion, executed for Prince Frederik Henry of Orange. Unlike many of his contemporaries, Rembrandt rarely made oil studies for larger paintings, preferring to rework the subject on the canvas itself.*

Penetrating portraits
(above) During the 1630s Rembrandt painted over 65 portraits. This painting of Agatha Bas, the wife of a wealthy Amsterdam merchant, dates from 1641 and is more penetrating than many earlier works. The intense gaze and the beautifully observed detail of the lace, the embroidered bodice and the fan make the portrait particularly memorable.

Dutch landscapes
(below) Rembrandt developed a new interest in landscape at the end of the 1630s and for 15 years produced numerous drawings and etchings of the countryside around Amsterdam. One of the finest examples of his landscape prints is The Three Trees, *which shows his wonderful ability to convey both atmosphere and space.*

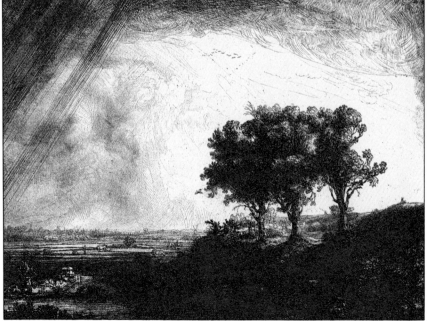

exaggerated, and a better notion of the wonderful richness and total expressive mastery of Rembrandt's technique is perhaps conveyed in the celebrated remark of the German Impressionist painter, Max Liebermann: 'Whenever I see a Frans Hals [Rembrandt's greatest predecessor in Dutch portraiture], I feel like painting, but when I see a Rembrandt, I feel like giving up!'

Rembrandt's etchings and drawings show equal mastery. At times he used the etching needle as fluently as if it were a pen, but at others he reworked the copper plate again and again to produce an effect of sonorous richness. His drawings, especially those of his mature years, were done mainly with a thick reed pen and were usually self-sufficient works. With a few quick strokes he could bring an animal to life, convey the drama of a biblical story or suggest the airy breadth of the Dutch countryside.

Rembrandt's greatness, however, lies not only in his unsurpassed technical skills, but also in the emotional range and depth of his work. Although very little is recorded of his personal life, his marvellous series of self-portraits gives us the feeling that we know him more intimately than any other great artist.

This remarkable sense of human sympathy

British Museum, London

COMPARISONS

Group Portraits

The group portrait is a singularly Dutch tradition which originated during the 16th century in response to a demand from officers of guilds, militia companies and charitable organizations for paintings to decorate the walls of their meeting houses. On occasions the picture included as many as 20 people, each of whom contributed towards the painter's fee, but the compositions were generally static, with the sitters arranged in rows or crescents. This convention, broken by Rembrandt's highly original group portraits, is evident in works by his contemporaries Thomas de Keyser and Frans Hals.

Frans Halsmuseum, Haarlem

Stedelijk Museum, Amsterdam

Thomas de Keyser
(1596/7-1667)
The Anatomy Lesson of
Dr Sebastian Egbertsz
(left) Thomas de Keyser was the leading portraitist in Amsterdam before Rembrandt's arrival in the winter of 1631/32. This group portrait from 1619 celebrates the anatomy lesson given by Dr Egbertsz in the conventional way, with a series of posed portraits of fellow surgeons arranged symetrically around a central skeleton.

Frans Hals
(1581/5-1666)
Lady Governors of the Old
Men's Home at Haarlem
(above) One of the most celebrated portraitists in 17th-century Dutch art, Frans Hals spent his entire career in Haarlem. This dignified painting dates from the end of his life and, although it lacks the dynamic vitality and jovial humour of some of his earlier and best known group portraits of civic guards, shows a deeper understanding of character and age.

TRADEMARKS

Strong Frontal Lighting

In many of his works Rembrandt uses strong frontal lighting to focus the viewer's attention on the main feature of the picture. In the case of portraits it highlights the sitter's face and helps to create the mood.

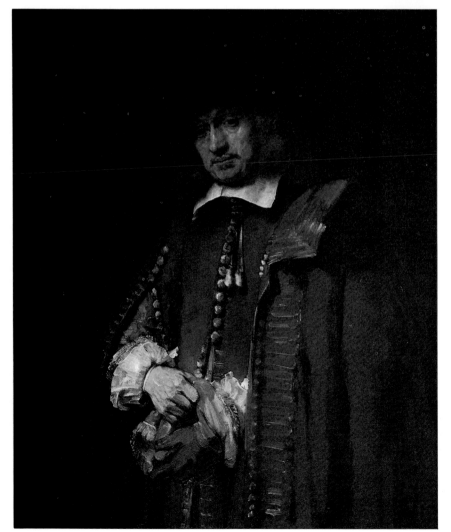

The Three Crosses
(left) *A supreme master of the etching technique, Rembrandt used a variety of tools to give rich pictorial effects. One of his most dramatic religious etchings,* The Three Crosses *was reworked after 10 years to give an even more powerful, mystical image.*

Portrait of Jan Six (1654)
(below and detail right) *In this painting of his friend and patron, Rembrandt created one of his most impressive portraits. The low viewpoint and dark shadows suggest a forceful presence, while the vigorous brushwork gives spontaneity.*

Six Collection, Amsterdam

extends to his other work, whether he was painting imaginary scenes or portraying the people he saw around him, from rich businessmen to hapless beggars. Although he avidly collected the art of the past and learned greatly from its example, contemporaries were struck by how directly he observed what he saw. The poet Andries Pels, for example, wrote in 1681: 'If he painted, as sometimes would happen, a nude woman,/ He chose no Greek Venus as his model,/ But rather a washerwoman. . ./ Flabby breasts,/ Ill-shaped hands, nay, the traces of the lacings/ Of the corselets on the stomach, of the garters on the legs,/ Must be visible, if Nature was to get her due.' This was not praise, for it was felt that Rembrandt had wasted his talent on lowly subjects.

A REAPPRAISAL

This attitude towards Rembrandt prevailed throughout the 18th century. Although he had many admirers and most critics admitted he was unsurpassed in his mastery of light and shade, he was generally considered to be vulgar. The real change in his critical fortunes came in the Romantic period, with the idea that an artist should express his innermost feelings and flout conventions. In 1851 Delacroix expressed the opinion that Rembrandt would one day be considered a greater painter than Raphael – 'a piece of blasphemy that will make every good academician's hair stand on end.' His prediction came true within 50 years, however, and now when we look for an artist with whom Rembrandt can be compared in breadth and depth of feeling, we turn not to another painter but to Shakespeare.

THE MAKING OF A MASTERPIECE

The Night Watch

Rembrandt's most famous painting – a masterpiece of Baroque complexity – was completed in 1642, the year of Saskia's death. Known somewhat erroneously since the late 18th century as *The Night Watch*, its original title was *The Militia Company of Captain Banning Cocq*, and the subject is the company 'marching out' in daylight – as cleaning in 1946-7 revealed.

Militia companies such as the Kloveniers Company, who commissioned the painting in 1640, had been formed in the 16th century to protect Dutch cities from the Spanish during the War of Independence. In Rembrandt's time their role was mainly ceremonial, and the need for the Watch had long since disappeared, but by showing the company in action, Rembrandt created a work of unprecedented vigour. The painting remained in the Kloveniersdoelen (the Musketeers' Assembly Hall) in Amsterdam until 1715, when it was moved to the Town Hall.

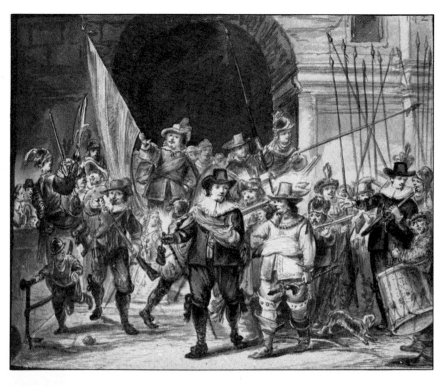

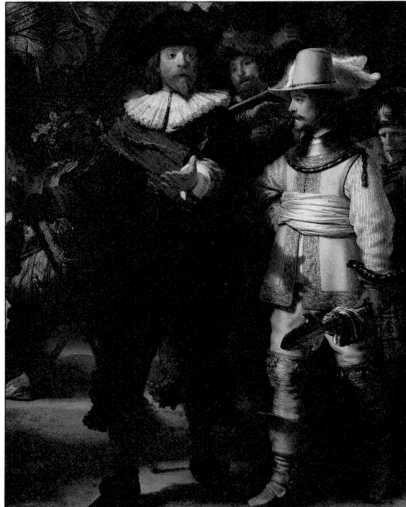

The central figures
(left) Captain Frans Banning Cocq (in black with red sash) orders his Lieutenant, Willem van Ruytenburch (in yellow with ceremonial lance) to march the company out. Both figures are lit by a shaft of light which falls from the top left of the painting, creating the shadow of the Captain's left hand.

A little enigma
(right) The presence of the little girl, so prominent in the painting, has prompted much debate. She may be a symbolic device – the dead fowl at her waist alluding to the Captain's name, or to a shooting match the company may be about to take part in – or simply a means of balancing colours in the painting.

A watercolour copy
(above) Captain Cocq was apparently so pleased with Rembrandt's picture, that he commissioned a watercolour copy for his family album. The copy includes slightly more than the present painting, which lost some 24" (and two background figures) from the left-hand side and smaller amounts from the other three edges when moved to the Town Hall.

The Kloveniersdoelen
(above) The Musketeers' Assembly Hall was an impressive building set back from the edge of the Nieuwe Doelenstraat, where Rembrandt also lived. Between 1639 and 1645 it was decorated with 8 group portraits.

Contrasting styles
(left) The Company of Captain Roelof Bicker was painted for the Doelen by Bartholomeus van der Helst in 1639. A conventional composition, it illustrates the revolutionary nature of Rembrandt's painting.

I. Ver-Meer

1632-1675

Vermeer is one of the most highly regarded Dutch artists of all time, yet his life remains shrouded in obscurity. As far as we know, he spent all his life in his native town of Delft, where he seems to have worked as an art dealer and run a tavern in order to support his family of 11 children. It is hardly surprising that painting appears to have been a part-time activity, and Vermeer's output was very small.

There are only about 35 authenticated works by Vermeer, but in them the artist perfected a style and approach to painting that were entirely his own. His best-known pictures show interiors with one or two figures reading, writing or playing music, quietly absorbed in their tasks. The colours are always fresh and cool, the paint sparkles with reflected light, and the total image is one of composed serenity.

Lady Reading a Letter at an Open Window *c.1658*
33¾″ × 25¼″ Dresden, Gemäldegalerie

'The Sphinx of Delft'

**Vermeer was born in Delft and spent all his life in the town.
But although local records give a few glimpses of his life,
he remains an enigmatic figure, aptly called 'the Sphinx of Delft.'**

Among the many great painters of 17th-century Holland, Vermeer now stands second only to Rembrandt in both popular appeal and scholarly esteem. His pictures rank among the most familiar and best-loved images in world art. However, knowledge of his life is sadly limited because almost all the contemporary references to him are colourless official documents.

Johannes (or Jan) Vermeer was born in Delft and baptized in the town's New Church on 31 October 1632. He was the second of two children (the other was a girl) of Reynier Janszoon and Digna Balthasars; it was only from 1640 that his father Reynier started using the surname Vermeer. At the time of his marriage in 1615 Reynier had given his occupation as silkworker, but he later became an innkeeper and he also dealt in paintings. In 1623 he was almost bankrupt, but he subsequently prospered (perhaps due to his

Early influences

(below and right) Vermeer's father tried his hand at several trades and prospered most from a combination of picture dealing and innkeeping. Both activities seem to have had their influence on Johannes for he soon indulged his taste in art and, after his father's death in 1652, it is assumed that he took charge of the inn.

Jan Steen; Two Kinds of Games/Rijksmuseum, Amsterdam

fortunate or skilful dealing in the art market), and in 1641 he bought an inn and a large house called 'Mechelen' in the main square of Delft. The young Vermeer grew up in this tavern, which may have had something of the atmosphere conveyed in the paintings of Steen (above).

Delft, where Vermeer was to spend his entire life, was then Holland's fourth largest town. It was prosperous and tranquil, with a particularly attractive centre dominated by the medieval buildings and spires that appear in many views of the town painted by Delft artists. The town had a tradition of painting stretching back to the late 15th century, although it had become something of an artistic backwater by the time of Vermeer's birth. Around 1650, however, several talented painters settled in the town, and Vermeer's career coincided with a brief golden period in Delft painting.

It is not known which of the Delft artists Vermeer chose as his master, but with a picture dealer for a father it must have been easy to indulge a taste in art and find a suitable teacher; Leonaert Bramer has often been suggested as a possible candidate. He spent most of his life

Detail: David Teniers: The Gallery of Archduke Leopold in Brussels

The artist's wife?
(right) Vermeer married Catharina Bolnes, after some resistance from her mother, in 1653. Catharina possibly modelled for this work in the same year. Despite a modest income, the couple had 11 children.

Key Dates

1632 born in Delft, Holland

1641 father buys inn and house called 'Mechelen'

c.1650 Fabritius moves to Delft

1653 marries Catharina Bolnes; made a master in Delft painters' guild

1654 Delft partially destroyed by an explosion which kills Fabritius

1662-63 made official of Delft's painters' guild

1670-71 reappointed official of painters' guild

1672 visits The Hague

1675 dies in Delft; wife declared bankrupt

Vermeer; Woman in Blue Reading a Letter/Rijksmuseum, Amsterdam

working in Delft, and there is a documented connection between him and Vermeer – it was Bramer who intervened on Vermeer's behalf when his future mother-in-law, Maria Thins, at first refused to sign the marriage contract. Bramer is an interesting minor artist who had travelled in Italy and France, and is remembered mainly for his dramatically lit night scenes. However, there are no similarities between his dark, crowded pictures and Vermeer's paintings, which casts doubt on the idea that he was Vermeer's artistic mentor.

There are more obvious stylistic links between Vermeer's work and that of Carel Fabritius, who had studied with Rembrandt and who moved to Delft in about 1650. The fact that Fabritius seems to have shared Vermeer's interest in optical experimentation in his paintings further reinforces the suggestion of a connection between the two artists, but in the absence of any documentation, the precise nature of the relationship must remain obscure. Fabritius was killed in the most disastrous event in Delft's history, when the gunpowder magazine exploded in 1654 destroying part of the town. The artist's death led a Delft publisher to compose a memorial poem, the last verse of which mentions Vermeer: 'Thus this Phoenix was extinguished, To our loss, at the height of his power. But happily there arose from his fire Vermeer, who followed in his footsteps with mastery.' Whether or not this implies a master-pupil relationship between the two artists, it shows that they were to some extent linked together in the public mind.

THE ARTIST MARRIES

Vermeer was made a master in the painters' guild on 29 December 1653. Earlier that year he had married Catharina Bolnes. She came from a higher social class, and her mother, who was divorced and wealthy, at first objected to the match. But Bramer and another respected citizen went to see her and persuaded her to change her mind, no doubt assuring her of her future son-in-law's talent and good prospects. Little is known of the details of the marriage. The couple had 11 children and, although they do not appear in Vermeer's paintings, it is quite likely that Catharina served as a model for pictures such as *Woman in Blue Reading a Letter* (above). Catharina was a Catholic, and it is possible that Vermeer was converted to his wife's faith. The *Allegory of Faith*

The artist's home town
(left) In 1632 Johannes Vermeer was born in Delft, then Holland's fourth largest town. He lived there all his life and is only once documented as having made a visit elsewhere.

Delftware
(right) Delft had principally achieved its prosperity by producing a particular type of beautiful glazed earthenware to which the town gave its name.

Carel Fabritius

Carel Fabritius (1622-54) was Rembrandt's most gifted pupil, and one of the few who managed to overcome his overwhelming influence to create a highly personal style. Fabritius settled in Delft in about 1650, and he exerted a profound influence on painting in the town until his life was cut short by the explosion of 1654. His use of a natural daylight atmosphere and luminous tones must have been a revelation to the young Vermeer, and the similarities between their work has led to speculation that Fabritius was Vermeer's master.

Mauritshuis, The Hague

The Goldfinch
(above) This little panel anticipates Vermeer's work in its simplicity and in its use of a dark object placed against a light background for tonal contrast.

Self-Portrait
(left) The broad handling of paint in this portrait shows the influence of Rembrandt, but there is an air of self-possession and confidence in the artist's expression.

National Gallery, London

Delft disaster
(above) In 1654 much of Vermeer's home town was destroyed when a gunpowder magazine exploded. The artist was left unscathed but his possible master, Carel Fabritius, died.

(p.188) symbolizes the Catholic faith in particular, and Vermeer's youngest son had the typically Catholic name of Ignatius.

Vermeer's father had died the year before the marriage, and it is sometimes assumed that the young painter took over the running of the inn. There is no direct evidence for this, but it is not improbable as Vermeer continued to live in 'Mechelen', and he would probably have needed a

Hard times
(left) A few months after Vermeer's death, his wife was declared bankrupt. The invasion of Holland by a French army had caused the art market to collapse, but even before that Vermeer is recorded as having to borrow money and let out his house.

source of income in addition to painting to support his growing family.

It is highly likely that Vermeer took over his father's art business as well. He certainly dealt in paintings and must have had something of a reputation as a connoisseur, for in 1672 he went to The Hague (the only time he is recorded as leaving Delft) to be an 'expert witness' in a dispute concerning the authenticity of a group of Italian paintings. Vermeer gave them short shrift, declaring that they were not only 'no outstanding Italian paintings, but, on the contrary, great pieces of rubbish'.

Vermeer must have been a respected figure among his fellow artists in Delft because in 1662-63, and again in 1670-71, he was a 'hooftman' ('headman' or governor) of the painters' guild. We know that his pictures were highly prized by some because of the account of Balthasar de Montconys, a French art dealer who visited Delft in 1663: 'I saw the painter Vermeer who did not have any of his works' he wrote in his journal, 'but we did see one at a baker's, for which six hundred livres had been paid, although it contained but a single figure, for

Egbert van der Poel; Conflagration of a Dutch Town at Night/Staatliche Kunsthalle, Karlsruhe

which six pistoles would have been too high a price in my opinion.' Vermeer's pictures were either bought by the humble burghers of Delft, or given to tradesmen to offset family debts. There is also some evidence that Vermeer had a regular patron, Jacob Dissius, who apparently owned 19 of the artist's works in 1682, seven years after the artist's death.

MONEY TROUBLES

In spite of this patronage, Vermeer found himself in financial difficulties. In 1657 he is recorded as borrowing 200 guilden, and in 1672 he rented out his house for 180 guilden a year and moved in with his mother-in-law. Later that year Holland was invaded by a French army, and although the occupying force was soon driven out, the economic crisis that accompanied the trouble caused the art market to collapse. Vermeer's already unstable business affairs collapsed with it. When Vermeer died late in 1675 at the age of 43, he left a large unpaid debt, eight children under age, and a host of financial problems for his widow. A few months after his funeral in Delft's Old Church, Catharina was declared bankrupt.

Vermeer's reputation was entirely eclipsed after his death, and his pictures were often sold at auction as works by masters such as de Hooch and Metsu. It was not until the 19th century that he was rescued from oblivion by the French journalist Theophile Thoré who succeeded in identifying about two thirds of the Vermeers we know today. Thereafter, Vermeer's fame grew quickly, and now all but a handful of Vermeer's authenticated paintings are the prize possessions of the world's greatest galleries, but the artist still remains, as Proust once described him, 'an enigma in an epoch in which nothing resembled or explained him.'

Museum of Fine Arts, Boston (Purchased, Maria T.B. Hopkins Fund)

The Procuress
(above) Vermeer's mother-in-law owned Dirck van Baburen's Procuress *(1611). It appears in the backgrounds of two of Vermeer's works (p.183 and p.223).*

A pale imitation
(right) Vermeer's work was rediscovered in the 19th century and by the 1920s Van Meegeren was fooling the art market with his forgeries.

Van Meegeren; Woman Reading Music

Pure Harmony

Vermeer produced a small body of work of exceptional beauty and clarity. He is best remembered for his gentle scenes of domestic life, which can, however, often be read on another level.

Christ in the House of Mary and Martha
(left) This is Vermeer's earliest surviving work and his only painting on a biblical theme. But although the subject-matter is uncharacteristic there are several typical stylistic features: the sensitive treatment of light, the calm, naturalistic poses and the interest in richly patterned textiles.

The Procuress (1656)
(below) This genre work reveals the influence of van Baburen's The Procuress *(p.181), which Vermeer's family owned.*

with his name that even 30 years after his reputation was established by Theophile Thoré, one of them – the signed *Diana and her Companions* – was attributed to an obscure namesake, Jan Vermeer of Utrecht. The only other picture of this type by Vermeer is *Christ in the House of Mary and Martha* (left), but it is possible that other early works were destroyed in the explosion of 1654 in Delft. Both these pictures show the influence of Italian painting with which Vermeer was well acquainted through the family art-dealing business. They were probably painted a year or two before *The Procuress*, his first dated work.

DOMESTIC SCENES

The Procuress (below) provides a transition to the next phase of Vermeer's development, for although – like the history paintings – it is a large-scale work of a warm tonality, it takes its subject from contemporary life, as did virtually all his subsequent pictures. After *The Procuress*, however, Vermeer favoured much quieter subjects, generally involving only one or two figures

Although a few of the pictures attributed to Vermeer are still the subject of scholarly controversy, it is generally agreed that the number of surviving paintings from his hand is not much more than 35. There are good reasons for thinking that the number was never substantially larger than this, for most of the Vermeers mentioned in 17th and early 18th-century sources can be identified with paintings that survive today, and only a few of the paintings now given to him are not mentioned in these sources. It is almost inevitable that in the course of centuries some of Vermeer's work must have accidentally perished, but it is reasonably certain that the majority has survived intact.

DATED WORKS

Vermeer often signed his work, but only three of his 30-odd paintings are dated. *The Procuress* (1656) *The Astronomer* (1668) and *The Geographer* (1669). None of the remainder can be firmly dated on other evidence, so it has proved difficult to construct a convincing chronology for his work. Nevertheless, three broad phases are generally recognized in Vermeer's development. In the first, he painted large-scale history pictures which are so different from the quiet domestic scenes associated

The Pearl Earring
*(above) This fresh and simple portrait is remarkable for
its delicacy and immediacy. The lustre of the pearl
earring is imparted to the girl's eyes and moist lips.*

The Pearl Necklace
*(above) This is one of
Vermeer's most beautiful
works, relying on the
most subtle of light and
colouristic effects. It
probably conveys a gentle
moral on the theme of
worldly vanities.*

**Lady Seated at the
Virginals**
*(right) This late work
forms a pair with the*
Lady Standing at the
Virginals *(p.187). Both
are concerned with the
relationship between
music and love.*

engaged in simple everyday tasks or making
music, and his colouring became much cooler.
This represents the middle phase of Vermeer's
career (into which most of his pictures fall), when
he created those gentle images of domestic life that
raised genre painting to a level that has never been
surpassed. His two celebrated townscape pictures
also date from this period of great achievement.

In the final phase of Vermeer's work, many
critics discern a certain hardening of style and loss
of freshness. He was such a marvellous craftsman
that he never painted any picture that does not
have passages of great beauty, but the works that
are attributed to his final years, when his financial
problems were worsening, do seem to lack the
utter naturalness of his finest works. Among these
later productions is the only one of Vermeer's
paintings that is generally considered a

conspicuous failure – the *Allegory of Faith* (p.188). The lumbering personification of Faith produces an almost comical effect and it is tempting to imagine that Vermeer took the commission reluctantly, for his talents were totally unsuited to this type of work, which Rubens, for example, did so well. Several of Vermeer's other paintings are imbued with symbolic meaning (most obviously *A Woman Weighing Pearls*), but the *Allegory of Faith* is the only work where symbolism is the primary intention; all the others make perfect sense on a naturalistic level.

EARLY INFLUENCES

Superficially, Vermeer's genre paintings are very similar to those of many of his Dutch contemporaries. In his early career he was heavily influenced by the works of the Utrecht masters, Baburen, Terbrugghen and Honthorst, who worked in the dramatic style of the Italian artist, Caravaggio. Baburen's *The Procuress* (p.181) appears in the background of two of his works and was clearly one of his favourite paintings. But what sets Vermeer apart from his fellow artists is that he would not settle for anything less than perfection. His best works have a sense of harmony and serenity that lifts them from the sober prose of run-of-the-mill interior scenes to the realms of poetry, and his colouring and brushwork are among the miracles of art.

Vermeer is particularly associated with subtle harmonies of blue, pale yellow and grey, but one of his most remarkable characteristics is his ability to use bright and strongly lit colours without them ever seeming to jar. In *The Lacemaker*, for example, the three primary colours – blue, red and yellow – are set off boldly against one another. This vibrant blend of colour is enhanced by his masterly brushwork. In reproductions, Vermeer's paintings sometimes look smooth and highly detailed, but in front of the originals one is always aware of the marks of the brush. The paint is often applied quite broadly (in *Maid with a Milk Jug* (p.185) the contrast between highlight and shadow on the woman's left arm brings Manet to mind), and little raised points of paint suggest the play of light on objects in a way that is totally convincing optically and of the utmost delicacy pictorially. The Dutch painter and critic Jan Veth remarked that his paint looks like crushed pearls melted together.

WORKING METHODS

Nothing is known for certain about Vermeer's working methods. No drawings by him are known, so it may well be that he painted directly onto the canvas. This seems to be borne out by the representation of the artist in *The Artist's Studio* (p.188), where the design is indicated on the canvas in progress with a few strokes of light paint and there is no elaborate underpainting. The only other technical point illustrated by this painting (which it is reasonable to assume represents

The Camera Obscura

It has long been thought that Vermeer used a *camera obscura* to help with his compositions. Many characteristics of his work, such as the white dots of paint he frequently employed, and his enlargement of foreground figures, may relate to the optical effects produced by the device. There were two basic types of camera obscura in Vermeer's time: the simplest kind was a darkened room with a small aperture through which light could pass, which was especially useful in composing landscapes; the more developed variety was a smaller box with lenses, which could be used for interior views.

The viewing box
(left) This compact machine would have been useful for assessing perspective in paintings of interiors.

Foreground enlargement
(below) A detail from View of Delft *shows the enlargement of foreground detail typical of the use of the camera obscura.*

Mauritshuis, The Hague

Rijksmuseum, Amsterdam

Maid with a Milk Jug
(left and detail above) The tiny specks of light in this painting are like those seen through an unfocused lens. This implies that Vermeer had observed the phenomenon himself.

The darkened room
(above) The most simple form of the camera obscura is a darkened room with an aperture. The image is reflected on the wall upside down and reversed.

The portable camera obscura
(below) Here a lens focuses the image, which is reflected by a slanted mirror onto a translucent screen. It is the right way up, but is reversed.

The use of lenses
(above) A diagram dated 1642 demonstrates how lenses could be used to correct an image so that it was reproduced faithfully.

A scientific association?
(left) Anthony van Leeuwenhoeck was working on lenses and microscopes in Delft during Vermeer's lifetime, and it is quite likely that the artist knew of his experiments in optics.

Sleeping Girl
(right) Described in an early auction catalogue as 'a drunken, sleeping young woman at a table', this painting may represent the sin of 'idleness' or 'sloth'. The curious spatial construction with its sloping foreground points to the use of an optical device like the camera obscura.

Bequest of Benjamin Altman, 1913

Metropolitan Museum of Art, N.Y.

Vermeer's own practices) is that the artist is using a mahlstick – a stick with a padded knob at one end, which is held against the canvas so the painter can support his right hand when painting detailed passages. Apart from these few technical clues, this work also demonstrates Vermeer's use of popular handbooks like Cesare Ripa's *Iconologia* for standard symbolic details and allegorical attributes – like the sculpted mask symbolizing 'imitation'.

INTEREST IN OPTICS

In spite of the lack of documentary knowledge, most critics have come to the conclusion that Vermeer often made use of a *camera obscura*. This was a device that worked on the same optical principle as the modern photographic camera, but instead of projecting an image by means of a lens onto light-sensitive film, the camera obscura projected it onto a drawing or painting surface, so that the outline of the image could be traced. It was a speedy way of ensuring accuracy for certain types of subjects (it appealed to townscape painters but was of no use to portraitists) and had a

COMPARISONS

The Domestic Interior

Flemish masters of the 15th century often included domestic detail in their religious works, and this observation of everyday life paved the way for 17th century Dutch genre paintings, which depict domesticity for its own sake. Interest in the humble interior continued into the next century in the work of artists such as Chardin, and culminated in the 19th century with the laundresses, cooks and maids painted by the Impressionists.

Jean-Baptiste-Siméon Chardin (1699-1779) **The Scullery Maid**
(left) Chardin's solemn interiors with one or two figures going about their business, have a simplicity and stillness that recall Vermeer's domestic scenes.

School of Campin The Mérode Altarpiece St Joseph c.1425
(right) The right-hand wing of this Flemish altarpiece shows St Joseph in his carpenter's shop; a 15th-century Netherlandish town can be glimpsed through the window.

Hunterian Art Gallery, University of Glasgow

Cloisters Collection, 1956/Metropolitan Museum of Art, N.Y.

considerable vogue in the 18th century, although it was well known before then. There are two main features of Vermeer's work that point towards the use of a camera obscura. The first is his exaggerated perspective, in which figures and objects in the foreground seem to loom very large compared with the others further back. Anyone who has used a wide-angle lens on a camera will know that this is just the effect they can create. The second indication is the way in which certain parts of Vermeer's paintings – particularly sparkling highlights – often look fuzzy or out of focus: again this is exactly what one would expect to happen with the primitive lenses then in use.

After Vermeer's death, the biologist Anthony van Leeuwenhoeck, who later became famous for his work with microscopes, was appointed trustee of his estate. There is no other indication that the great painter and the great scientist knew each other, but a common interest in optics could well have brought them together. As with so much to do with Vermeer, there is wide scope for speculation as the facts of the matter remain intriguingly elusive.

Lady Standing at the Virginals
(above and right) The meaning of this work is implicit in the painting hanging on the wall, showing Cupid, the god of love, holding up a playing card. Such images were described in detail in emblem books of the time, as symbols of fidelity – often with the motto 'Only One'. Vermeer's painting may allude to the relationship between true love and musical harmony. The woman's gentle radiance and quietly confident gaze seems to reinforce this interpretation.

TRADEMARKS

Pictures within Pictures

The pictures that appear in the background of many of Vermeer's paintings usually have a symbolic meaning which would have been readily understood by his contemporaries. Several of the pictures themselves were once owned by the Vermeer family.

The Artist's Studio

This allegory on the art of painting, popularly known as *The Artist's Studio*, shows an artist in historical dress painting a portrait of Clio, the Muse of History. The inclusion of a map of the Netherlands on the back wall implies that the allegory refers specifically to Netherlandish painting, and it may be that Vermeer was seeking to emphasize the importance of history painting in the art of his country. Nothing is known for certain about the circumstances in which the picture was painted, but it is possible that Vermeer intended it as a gift to the Delft Guild of St Luke, of which he was an officer. At around the time he was painting the picture, the Guild was having new headquarters built on the Voldegracht behind Vermeer's house. The building was adorned with statues and paintings of the liberal arts, so a picture like this, with its complex symbolism, would have been in keeping with the rest of the decoration. Vermeer, however, was so attached to this work that he kept it until his death in 1675.

Kunsthistorisches Museum, Vienna

Curtain onto another world
(left) A richly-coloured tapestry falls in heavy folds across the left-hand side of the composition. It is drawn aside to usher us into the artificial space of the picture.

Allegory of Faith
(right) For his second and more overtly allegorical painting, Vermeer referred to the same handbook that he used for The Artist's Studio – *Cesare Ripa's* Iconologia. *From this source he borrowed various symbolic details like the chalice, the crown of thorns, the apple and the snake.*

Bequest of Michael Friedsam, 1931

Metropolitan Museum, N.Y.

Louvre, Paris

Symbolic attributes
(left) In Le Sueur's painting of the muses, Clio (on the left) is given the same attributes as Vermeer's muse — both artists used Ripa's manual, then an extremely popular source-book.

Points of light
(below) Vermeer's so-called pointillé technique is seen in the gleaming chandelier, where the highlights on the bronze are meticulously suggested by splotches or dots of paint.

'A certain piece of Painting in which is represented the Art of Painting.'

Vermeer's mother-in-law

Historical costume
(left) Vermeer has represented the artist in late medieval costume, so that he would have been recognized by a 17th-century observer as an 'old master'. The muse, Clio, is shown exactly according to the description in Ripa: 'a maiden with a laurel garland who holds a trumpet in her right hand and with her left a book.' These 'antique' details suggest that Vermeer's allegory is inspired by his veneration of history painting, the highest profession. Clio, the muse of History — holding a trumpet symbolizing fame — is about to be immortalized.

Background

At the beginning of the 17th century the map of Europe looked very different to how it does today. The countries which came to be known as Holland and Belgium didn't exist. They were then known as the Netherlands or Low Countries, and were ruled by Spain. It was an uneasy relationship on the part of the Protestant North which waged an 80-year war against their Catholic overlords. By 1609 they had established their own republic, the 'United Provinces'. In 1648 this received full independence and came to be known as Holland, after the biggest and most prosperous of the provinces.

Although not officially independent until the middle of the century, the United Provinces actually began to develop as a nation from the first years of the century.

It was a prosperous time for them. Sustained by a flourishing economy, the new bourgeois class saw no incompatibility between love of money-making and love of art and took over the patronage previously provided by the Church. The Golden Age of Dutch Art of which Hals, Rembrandt and Vermeer were a part, was thus ushered in.

Flemish art continued to develop in the Catholic south, gaining new impetus from the contributions of Rubens and Van Dyck. The south remained under the domination of a succession of foreign powers until 1830, when it finally achieved independence and became known as Belgium.

The Night Watch *1642*
by Rembrandt van Rijn
144″ × 172″ Rijksmuseum, Amsterdam

Commercial Amsterdam

In Rembrandt's time, Amsterdam was the bustling commercial centre of Europe. Its warehouses were filled with saleable goods and its famous Stock Exchange hummed with profitable activity.

J. van der Ulft/Place du Dam à Amsterdam/Musée Condé, Chantilly

was collected, stored, sold and re-sold. Ships were crammed into its harbour like sardines in a can; loaded lighters (open boats which carried cargo from the quays to the ships) plied up and down the canals; its vast warehouses bulged with goods that had been bought cheaply and would be sold when the price was right; and its markets and stock exchange bustled with the affairs of businessmen from all over the world.

The most significant commodity handled by Amsterdam was money; permission to export monetary metals was rare in the 17th century and the Dutch Exchange Bank (founded in 1609) enjoyed considerable freedom in this respect. The confidence inspired by this bank encouraged the circulation of bills of exchange as negotiable instruments of credit, thereby creating a very modern background for the enterprising 17th-century businessman.

The great building of the Amsterdam Stock Exchange was finished in 1631 and some 4,500

Rembrandt's Amsterdam was the commercial and cultural capital of the most densely populated and prosperous area in 17th-century Europe. Its affluent citizens marvelled at their flourishing economy but modestly considered that God was simply rewarding them for the sacrifices they had made on behalf of true religion during the long struggle against Spanish occupation. The whole of mainly Protestant Holland had been under Catholic Spain's rule in the 16th century but the Dutch had waged an 80-year-long war of independence and, by the early 17th century (1609), they had established their own republic, the 'United Provinces' (see page 196).

God's beneficence seemed to be manifest everywhere in thriving Amsterdam, the world's leading marketplace, where every conceivable commodity

Thriving commerce
(above) In this mid 16th-century view of Amsterdam's main square, merchants negotiate and trade in front of the weighhouse and the new Town Hall.

A busy Stock Exchange
(right) Amsterdam's Stock Exchange was the hub of the city's financial activities. Up to 4,500 merchants passed through its noisy, crowded halls every day.

Emanuel de Witte

Willem van der Vorm Foundation/Museum Boymans-van Beuningen, Rotterdam

merchants of every race and creed crowded into it every day. It was an immensely noisy and exciting scene and the speculation reached a degree of sophistication and abstraction that was unparalleled.

Government stocks and prestigious shares in the Dutch East India Company were prime targets for speculators. Through the pooling of funds invested by its stockholders, the East India Company's vast resources enabled it to send ships round the Cape of Good Hope to cruise the Indian Ocean, the Java Sea and the Pacific as far north as Japan, establishing fortified trading posts in scores of islands and coastal enclaves. The risks were great, but so were the profits – by 1650 the Company's stock certificates were returning 500 per cent per year.

A prosperous couple
(right) The silk, brocade and lace in this couple's dress testifies to the comparative luxury enjoyed by some of Amsterdam's richer inhabitants.

Wealth from overseas
(below) Founded in 1602, the Dutch East India Company had outposts all over the East. This picture shows their Bengal headquarters, and Dutch ships on the Ganges.

Schuylenburgh van Hendrik/Rijksmuseum, Amsterdam

Abraham Storck/Christie's

Pieter Codde/Mauritshuis, The Hague

The close alliance between Amsterdam's administrative body – the *Vroedschap*, the *Heeren*, or simply the Regents – and the business community made all this expansion manageable. Through the burgomasters, the Regents intervened in every aspect of Amsterdam life, from the supervision of the postal service to the care of orphans and the setting up of institutions that fostered business. The Regents set up the Chamber of Assurance (1598); the East India Company (1602) and the impressively profitable but not quite as spectacular West India Company (1621); the new Stock Exchange (1608); the special Corn Exchange (1616), the Exchange Bank and the Lending Bank (1614). Moreover, such was the commitment of Amsterdam's leaders to freedom of enterprise that they welcomed skilled or moneyed foreigners to their city, regardless of creed (apart from Catholicism).

A TOLERANT SOCIETY

In the interests of trade, the town fathers admitted foreign craftsmen in large numbers, found housing for strangers and offered extra rewards if they introduced new techniques or improved existing ones. Accordingly, Amsterdam was the home of a large Jewish community, many of them refugees from intolerant Portugal and Spain. Through his contacts with Jews – at least 35 of his portraits of them survive – Rembrandt drew inspiration for his depictions of the great figures of the Old Testament from whom they were descended.

Amsterdam harbour
(left) Dutch wealth was based on the overseas trade that passed through Amsterdam harbour. Business boomed as Protestant merchants fled from the rival port of Antwerp following persecution by their Spanish rulers.

To foreigners it seemed a miracle that Amsterdam, once a fishing village, and its marshy hinterland had become the pivot of world trade. 'The art of industry has made a masterpiece of nature's miscarriage' was how one French visitor put it. But in Rembrandt's day the city was refurbished to better fulfil its new status. The 'plan of the three canals', based on a massive land reclamation project, was approved by the Regents and put into effect between 1612 and 1665.

ECONOMIC EXPANSION

Through the use of stakes and cowhides to provide stable foundations, the area within the city's boundaries was extended from 180 to 720 hectares. The new-style Amsterdam acquired its distinctive crescent shape from the three great canals, linked to one another by smaller ones. It was along these canals – the Heerengracht, the Keizersgracht and the Prinsengracht – that the richest citizens had their magnificent houses built, and this period was generally complemented by the first intensive phase of building in brick and stone. The city's population kept pace with its economic take-off and more than justified such expansion.

Amsterdamers were noted for their diligence and efficiency. Travellers commented that there were few vagrants to be seen, largely because charity was not available to the able bodied, and the city was thriving. Everyone seemed to work: children were trained and assisted in family workshops and businesses; old people remained

A city of art lovers
(above) Art dealing flourished in newly rich Amsterdam, and artists were able to sell their works to an expanding art market of middle-class buyers, rather than having to rely on individual aristocratic patrons. As the pictures in this painting show, Dutch artistic taste was quite wide-ranging.

Canal architecture
(left) Wealthy merchants lived in distinctive gabled houses along Amsterdam's three main canals. These waterways – the Heerengracht, the Keizersgracht and the Prinsengracht – were all built during Rembrandt's lifetime.

active as long as they could; and the managerial abilities of the burghers' wives, who often took over their husbands' affairs, testified to the excellent education available to both sexes.

Just as they combined their business affairs with involvement in municipal responsibilities, so the Amsterdamers saw no incompatibility between love of money-making and love of the arts and scholarship. The English distinction between gentlemen and tradesmen did not apply. The writer Pieter Hooft was also a government official and a man of business; the poet Joost van der Vondel a stocking merchant; and the brilliant scientist Anthonie van Leeuwenhoek a conscientious book-keeper.

A NEW ART PUBLIC

The Regents of Amsterdam resisted the Calvinist zealots who continually urged them to crack down on a liberal cultural life and maintained a pragmatic approach. Thus they refused to destroy church organs, allowing them to be used for the secular concerts that they sponsored. In general the new secular elite took over the patronage of the arts to a far greater extent than the Church ever had. In fact, private homes and public buildings now replaced cathedrals and castles as the showhouses for artistic endeavour.

Flemish School/Cognoscenti in a Room Hung With Pictures/National Gallery, London

Serious citizens
(right) De Hooch's painting perfectly conveys the subdued and diligent character of Amsterdam's soberly-dressed inhabitants, who were devout Calvinists, shrewd merchants and responsible citizens.

Just as the Dutch refused to let strict Calvinist dictates impinge on all of their worldly affairs, so they also avoided any ideological constraints on their trading activities – for shrewd Dutch merchants the customer was always right. The warehouses of Amsterdam regularly supplied foreign armies, for example, and not just those of Holland's allies. But such flexibilities meant that the only other Protestant Republic, Cromwell's England, was allowed to become Holland's chief competitor rather than its greatest friend.

The first Anglo-Dutch War (1652-4) broke out when longstanding commercial and colonial rivalries between these two maritime powers were made worse by the English Navigation Act of 1651, which permitted only English ships to serve English colonial ports. This war nearly ruined Amsterdam because Dutch commercial life depended on the passage of the great trading fleets from America, Africa and Asia through the English Channel. In 1653 the port of Amsterdam was under a blockade that lasted for weeks until it was finally broken by Admiral Tromp at a fearful cost in lives and men. The fortunes of artists are always sensitive to national fortunes. It is extremely likely that Rembrandt's sad plight in 1656 owed something to the national disaster that had unnerved many of his potential clients.

Walther/Victoria & Albert Museum, London

A Dutch obsession
(left) The tulip was introduced to Holland from Turkey in the early 17th century, and rapidly became a national obsession. Enormous sums of money could be made by breeding the striped and variegated species, but when the bottom fell out of the tulip market in 1637, the whole economy felt the effect.

An allegory of wealth
(right) This allegory of wealth – in which Amsterdam personified as a queen accepts gifts from the four continents – forms the frontispiece to a history of the city published in 1663. Printing was an important industry in 17th-century Amsterdam, which had over 40 printing establishments.

Dutch Independence

The bitter struggle between the Northern Protestant provinces and their Spanish overlords lasted for almost a century, and ended in the creation of the modern Dutch nation.

In 1585, Alexander Farnese, Duke of Parma, seized Antwerp for the Spanish, and the Hals family amongst others moved north to Holland. Since the real start of the Netherlands revolt in the 1560s, thousands of refugees had left the southern provinces, taking their skills and wealth to the independent North or even abroad. Seventeen northern Netherland provinces were uneasily united in a Calvinist-organised rebellion against the Spanish overlords; the revolt was sustained by profits from Dutch trade, and given some respectability by the leading noble family, The House of Orange.

Spanish foreign interests were too widespread, and resources were never concentrated to crush the Netherlands. When Phillip II of Spain died in 1598, he left his daughter Isabella and her husband Albert to rule the southern Netherlands, with orders to curb the success of the so-called United Provinces. In effect, the Low Countries were partitioned into a Protestant North and a Catholic South – which roughly corresponded to the modern nations of Holland and Belgium.

Isabella and Albert, known as the Archdukes, had a personal sympathy with the land they governed. In 1609, a 12 year truce was signed between the equally exhausted Spanish and Dutch, and the Archdukes set about repairing the devastated South. They achieved an economic and spiritual regeneration: the population rose, trade and industry recovered and Catholicism launched a missionary offensive against Protestantism. This enlightened government gave the southern Netherlands a sense of itself – an embryonic national identity, which enabled it to survive the later Dutch and French invasions when Spanish aid was limited.

War had helped unify the United Provinces,

Fishing for souls
(below) The Dutch artist Adriaen van der Venne used Christ's promise 'I will make you fishers of men' to make an ironic comment on the jealousy that existed between the rival religious powers of the Dutch Republic and Spain. The Dutch Protestants on the left bank face the Spanish Catholics on the right, while in the centre boats from both sides compete with each other for the capture of the souls of the innocent.

Rijksmuseum, Amsterdam

The Spanish fury
(left) The Spanish ruled the southern Netherlands by terror. A horrifying incident of their brutality occurred in 1576, when the Spanish garrison in Antwerp mutinied and sacked the city, pillaging property and killing without mercy. When the city fell to the Spanish in 1585 many Flemish Protestants fled to the North, fearing for their lives.

and the ceasefire of 1609 showed up the differing factions. The House of Orange needed military command to maintain its power, while the province of Holland (the richest and therefore the strongest in the union) desired peace. War had been expensive, and since 1605 the Spanish Army had been led by the able Spinola and little had been achieved by the United Provinces. In addition, the Spanish were heaping up embargoes on Dutch trade – a particularly effective form of warfare. But the 12 year truce was not an idle time for the Dutch. An unofficial war continued in the form of pirating trade in the Spanish colonies, while the government of the United Provinces concluded alliances with Spain's enemies. The idea was to divert Spanish resources away from the Netherlands to other trouble spots. So the Dutch formed a series of Islamic alliances – with Morocco in 1608, the Ottoman Empire in 1611 and Algiers in 1612, and soon became the chief supplier of arms to North Africa.

AN INDEPENDENT NATION

The Truce of 1609 had at least one effect the Spanish had cause to regret – the acceptance of the Dutch as an independent nation by other world powers. Consequently, England and France both sent permanent ambassadors to The Hague, and the Dutch began to test their new-found position in world affairs. In 1616 the United Provinces offered support to the Duke of Savoy in his dispute with Spain and this conflict might have reopened in the Low Countries if the Pope had not successfully intervened. A similar situation which arose when the Dutch supported Venice was only saved by diplomacy. Meanwhile the Spanish

Firenze, Gall. Pitti

The effects of war
(above) Rubens' allegory on the destruction of war had a personal relevance. As ambassador, the artist had tried to reconcile warring Spain and the Netherlands.

Dutch whalers in a storm
(left) Whaling was an important source of income for the Dutch, who relied on profits from trade to subsidise their rebellion against Spanish rule.

A mercantile power
(below) Dutch economic strength was founded on maritime trade. The merchant fleet grew from around 400 ships in 1532 to over 2500 vessels a century later.

Verbeek/Dutch Merchantman in a Storm with a Whale/National Maritime Museum

A. van de Venne/Middelburg Harbour/Rijkmuseum, Amsterdam

Berckheyde/Flowermarket/Rijksmuseum, Amsterdam

Prince Maurice of Nassau
(left) The cause of Dutch Independence was greatly helped by the military genius of Prince Maurice of Nassau. During the 1590s his army gradually forced the Spanish to withdraw from Dutch territory.

Civic pride
(above) Work on Amsterdam's new Town Hall – seen here from one of the canals – was begun in 1648, the year that the Treaty of Munster was signed. The treaty amounted to a final recognition of Dutch independence, and the Town Hall became a symbol of Amsterdam's civic pride and her important place in the new Dutch nation.

diverted much of their New World silver to defend their colonies, particularly the Philippines, against Dutch naval attack. As the Englishman Owen Feltham wrote a few years later of the Dutch: 'They are the little swordfish pricking the bellies of the Whale'. The slow-moving Spanish Whale seemed an increasingly easy target.

War was resumed in 1621. In the United Provinces, the peace party of Johan van Oldenbarnevelt had been routed and its leader executed: in Spain, colonial power had become the greatest issue, no longer was religion a great motivating force. Thus the war was predominantly an economic struggle, while the military and naval stalemate was occasionally enlivened by significant victories. Again the Spanish placed embargoes on Dutch trade; ironically the Dutch merchants responded by profiting from supplying the Spanish army in the southern Netherlands that their government was fighting. The Dutch navy continued to prick the Spanish colonial belly, and in 1624 seized parts of Portuguese Brazil, though only to lose them the following year.

DUTCH RETALIATION

Meanwhile Spain enjoyed two victories over the Dutch. In 1625 Spanish troops captured the prestigious town of Breda, and in the following year the Spanish fleet beat the Dutch off Gibraltar. The Dutch retaliated by forming an alliance with England and Denmark against the Habsburgs' German interests, which effectively diverted Spain's attention to Denmark. In this period the Dutch also seized the Spanish treasure fleet – a

serious blow to an Empire continually facing bankruptcy. Throughout the 1620s the Spanish were anxious for peace (at one point the artist Rubens was an unsuccessful peace envoy between the two countries) but the United Provinces would not agree to the terms, which included a stipulation for greater Dutch religious tolerance.

The United Provinces may have been holding their own against Spain, but to do so meant alliance with France. When the southern

Netherlands showed signs of revolt in the late 1620s, the French supported the rebel cause. There was to be no question of a United Netherlands – if the South was overrun, the land was to be partitioned between France and the United Provinces. But in 1636 the Spanish took the offensive and sent an army into Picardy. However, Spain's resources were so overstretched that such a venture was doomed to failure. By 1639 French armies had cut the land route to Spain and the Dutch had decisively beaten the Spanish fleet in the Battle of the Downs. But the United Provinces were beginning to realize the danger of a powerful France as ally and neighbour. In 1639 Richelieu reduced the French subsidy to The Hague, because the Dutch were not causing enough trouble to employ Spanish resources.

PEACE CONCLUDED

As late as 1644, the bankrupt Spanish army in Flanders attempted to invade France. The victorious French captured towns in the southern Netherlands and this constituted a veiled threat to the United Provinces. But peace negotiations were under way and the Spanish made every effort to detach the United Provinces from French influence. By the Treaty of Munster in 1648, Spain at last fully recognized Dutch independence. Despite secret negotiations by the House of Orange to prolong the war, the Dutch peace faction prevailed.

William II of Orange died suddenly and during the minority of his son, the United Provinces were governed by an uneasy democratic coalition, with Jan de Witt, the Grand Pensionary or chief officer of the province of Holland, playing a guiding role. As the Spanish Empire failed, France loomed as

D.van Delen/Rijksmuseum, Amsterdam

the greater threat to the independent Dutch. The Spanish army in Flanders was financed after 1648 largely by Amsterdam bankers, for it was politicially, if not financially, expedient to have a buffer state between the United Provinces and France. A complete reversal of the Dutch-Spanish conflict was finally brought about by Louis XIV's ambitions to invade the Low Countries. Ironically, in 1674 it was the turn of the Spanish to ally with the Dutch against the might of France. Not only had Spain unreservedly acknowledged the independence of the United Provinces, and been forced to depend on the Dutch to maintain the Spanish Netherlands, but even the Dutch had sought an alliance with their former enemy against France. The wheel had indeed turned.

The States General
(above) The States General was the sovereign voice of the United Provinces, although each state kept its autonomous administration and decisions that affected all the states were referred to referendum. This painting shows the meeting that took place in 1651 when the States General tried to draw up a new constitution for the nation.

A celebration of peace
(left) Peace was finally concluded between the Netherlands and Spain with the signing of the Treaty of Munster in 1648. The St George's Guard in Amsterdam celebrated the event in characteristic style – with a lavish banquet.

Holland's symbol
(right) The lion was the traditional symbol of all the northern and southern Netherlandish provinces in the years before Dutch Independence. In 1648 Nicholas Visscher gave the age-old image an ironic slant when he used it to symbolize the northern province of Holland standing alone.

tholomeus van der Helst/Rijksmuseum, Amsterdam

Married Couple in a Garden *c.1622 by Frans Hals*
55″ × 65½″ Rijksmuseum, Amsterdam

Rubens' prodigious output w
for its range as well as its she
painted virtually every type o
was then known and his geni
that he excelled at everything

His immense reputation w
primarily on his great showp
they were religious, such as T

The Descent from the Cross *1611-14*
main panel 165″ × 126″, wings 165″ × 59″
Antwerp Cathedral

*Rubens probably obtained the commissions for this mighty
work through his friend Nicholas Rockox, who was an
official of the Guild of Arquebusiers, for which the altarpiece
was painted. He included a portrait of Rockox in the right
wing. The commission was given to Rubens in September
1611; he delivered the central panel in September 1612 and
the wings followed in February and March 1614. Rubens
drew freely on works he had seen in Italy for the composition
and various details of the Descent, but he blended them into
an inspired new whole. His superb colour sketches for the
central panel and for the wings, representing* The
Visitation *(on the left) and* The Presentation in the
Temple *(on the right) are in the Courtauld Institute
Galleries in London.*

from the Cross, or secular, such as The Marie de' Medici cycle.

Slightly more modest in scale, but still meant to be seen in grandiose settings, are works such as The Hippopotamus and Crocodile Hunt (frontispiece). Part of a series of four large hunting scenes that the artist painted for Maximilian, Duke of Bavaria, Rubens may have derived the inspiration for the fight between men and animals from Leonardo's famous painting of The Battle of Anghiari. Rubens made a copy of this painting when he was in Italy.

On a very different theme, but equally displaying the artist's love of drama, is The Feast of Venus, huge and spectacular.

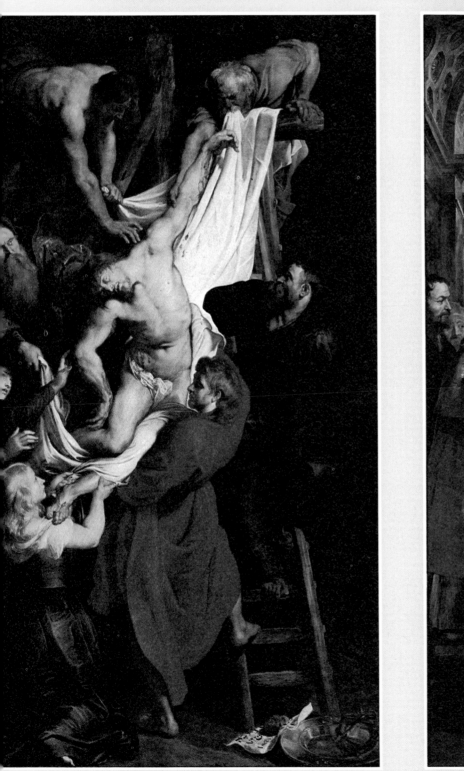

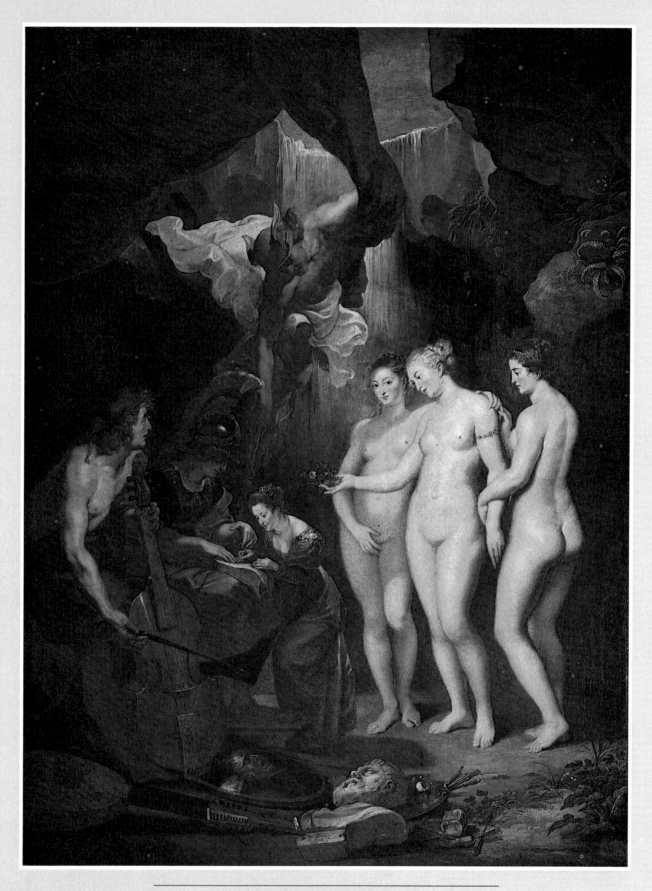

The Education of Marie de' Medici *1622-25*
156″ × 117″ Louvre, Paris

Rubens' great series on the life of Marie de' Medici is a triumph of imagination over fact. Marie was a rather fat and unappealing figure, but Rubens invests the trivial events of her life with Olympian splendour. Here she is tutored by Minerva, the goddess of wisdom, and other divinities, in a grotto on Mount Parnassus.

Marie de' Medici Arriving at Marseilles *1622-25*
156″ × 117″ Louvre, Paris

In this, one of the most famous scenes of the Marie de' Medici cycle, the future Queen of France arrives from Florence for her marriage to Henry IV. She is greeted by an allegorical personification of France, while above the figure of Fame sounds a clarion call on his trumpets. Sea-gods and nymphs join in the celebrations.

The Feast of Venus
c.1630-40 85½" × 138"
Kunsthistorisches
Museum, Vienna

*Few paintings convey
more exultantly than this
Rubens' love of life, in
particular life's sensuous
pleasures. The painting
centres on a statue of
Venus around which
celebrants are transported
by the delights of love.
Rubens' second wife,
Hélène Fourment, seems
to have been the model for
the girl on the extreme
left, and his pleasure in
her ample physical charms
no doubt played its part in
the inspiration of this
painting.*

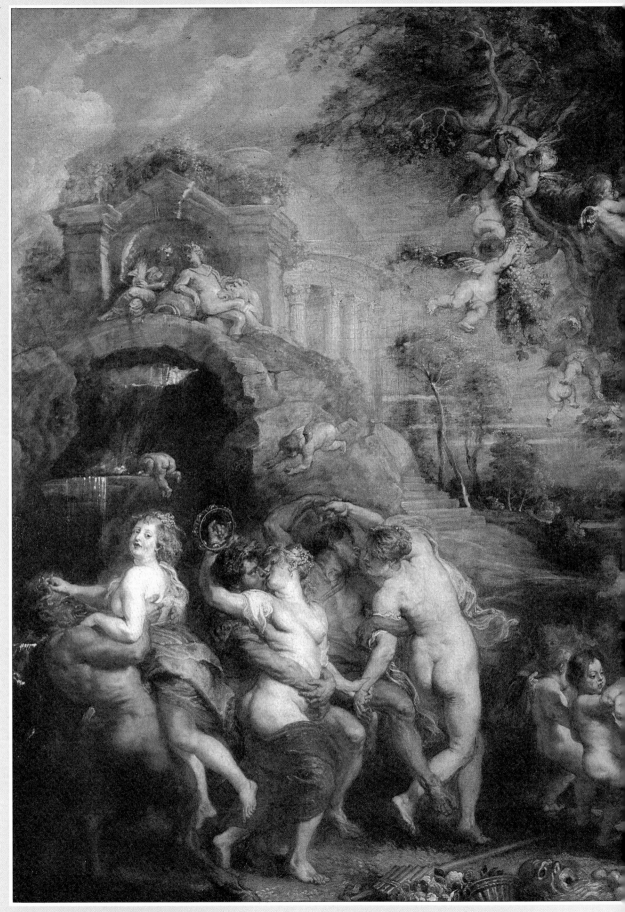

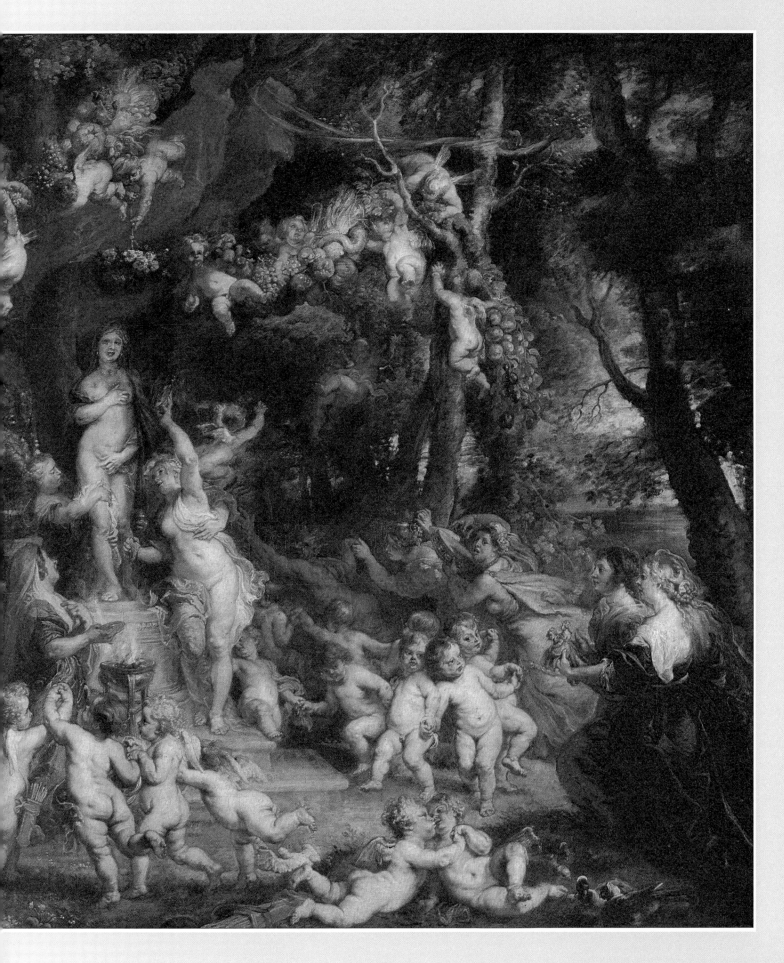

Hals was almost exclusively a portraitist and he was equally a master with paintings of men, women and children, double portraits and group portraits. The sitters in Hals' paintings usually seem to enjoy life, and no other painter has depicted smiles and laughter so convincingly, as is shown so memorably in such works as the enchanting

Nurse and Child *c.1620*
33¾″ × 25½″ Staatliche Museen, West Berlin

This is one of the most captivating of Hals' early works. The woman and child are observed with great freshness and look out as if they had just been diverted by the spectator. Although he is renowned for the boldness of his brushwork, Hals showed here how beautifully and delicately he could paint elaborately detailed costume when the occasion demanded. The sex of the child is uncertain, as boys and girls this young were dressed alike at this period so it was difficult to tell them apart.

Nurse and Child and the famous picture of The Laughing Calvalier.

It is perhaps in his group portraits that Hals best shows his remarkable skill in characterization (as well as his inventiveness in composition). His picture of a Married Couple in a Garden (pp.200-201) conveys the ordered contentment of a society that in its modest way marks one of the high points of European civilization. And The Banquet of the Officers of the St Hadrian Civic Guard Company, one of a remarkable series of such pictures, is at the same time, a triumphant portrayal of warm and high-spirited comradeship and a tour de force of technical virtuosity.

The Laughing Cavalier 1624
33¾" × 27¼" Wallace
Collection, London

Apart from the Mona Lisa, this is probably the most famous portrait in the world. Its great fame came fairly late, however, and its familiar but inaccurate title (the sitter is smiling rather than laughing) did not appear in print until 1888. In the 18th century it fetched fairly modest prices at auction, but in 1865 Lord Hertford bought it for 51,000 francs, a sensational sum that heralded the great boom in Hals' popularity.

Banquet of the Officers of the St Hadrian Civic Guard Company *c.1627*
72″ × 105″ Frans Hals
Museum, Haarlem

This group portrait was probably painted in 1627 to mark the farewell banquet given to the officers of the company after they had served their term of office. As with all his civic guard portraits, Hals succeeds brilliantly in conveying the animation of a crowd of figures, each officer individualized but integrated into an organized composition.

Ant van Dyck

Van Dyck is celebrated as one of the greatest of all portraitists. The splendour of his compositions, the elegant ease with which he invested his sitters and his brilliant skills in painting fine materials made him the ideal court artist, and his portraits of Charles I, his wife Henrietta Maria and the royal children have given to their era a unique romantic aura.

Christ Crowned with Thorns *c.1620*
88″ × 77″ Prado, Madrid

Van Dyck painted two closely similar versions of this picture at about the same time; the other one was in Berlin, but was destroyed during the Second World War. No doubt a patron was impressed by the work and commissioned a replica. The heavy musculature of the figures shows the overwhelming influence of Rubens on the young Van Dyck.

These dazzling images of court life were enormously influential in his own time and also determined the course of English portraiture for the next 200 years. Rather than positioning his sitters stiffly against a dark background, he placed them against modest architectural detail or else a glimpse of landscape. He also introduced a note of informality with a turn of the head or a movement of the hand.

Van Dyck's genius extended beyond portraiture however. Especially in his early career, he painted some memorable religious works, notably Christ Crowned with Thorns and The Rest on the Flight into Egypt, with its personal vein of melancholy.

The Rest on the Flight into Egypt *c.1630*
52¾″ × 42½″ Alte Pinakothek, Munich

This is one of Van Dyck's tenderest religious paintings and one of the masterpieces of his second Antwerp period (1628-32) between his lengthy stays in Italy and England. Van Dyck was remarkably sensitive to female beauty, and the head of the Virgin, with its poignant, troubled expression, is one of the loveliest he ever painted.

Anthony Van Dyck

Five Children of Charles I *1637*
64½″ × 78¼″ Royal Collection

This is the latest and most ambitious of Van Dyck's portraits of the royal children and he took great pains over its planning, making preparatory drawings of individual figures and a beautiful oil study of the two youngest children (p.155). Each child is characterized with great delicacy and the quality of the brushwork is superlative. The animal and still life details, as well as the children, are brilliantly depicted.

215

Rembrandt

Rembrandt was a prolific artist, painting virtually every type of subject then known, and his imaginative and creative powers were so great that he often crossed the boundaries of conventional categories. The *Self-Portrait with Saskia*, for example, is primarily a representation of the painter and his wife, but it may also have a religious

Self-Portrait with Saskia
c.1635
64″ × 52″ Dresden,
Gemäldegalerie

This exuberant work was probably painted soon after Rembrandt's marriage to Saskia when his career was at its most buoyant and his personal life at its happiest. It is generally thought that the picture is not a straightforward portrait, but is meant to have some moralizing intention. Several scholars consider that Rembrandt has here represented himself as the Prodigal Son, who 'took his journey into a far country, and there wasted his substance with riotous living' (Luke 15:13) and who is often shown in a tavern or brothel setting.

216

significance. His painting of Saskia as the goddess Flora is also a vehicle for depicting his wife, this time in a mythological context. Another fine example of his portraiture is The Jewish Bride.

Even when working in the well-established Dutch tradition of group portraiture, Rembrandt found bold new solutions to the old compositional problems. He found alternatives to arranging the sitters in static rows or crescents. In The Night Watch (pp.190-191) for example, he took the revolutionary step of making a pictorial drama out of what was a commonplace event. The Syndics is in the same genre, but is given quieter treatment.

Saskia as Flora *1635*
48½″ × 38½″ National Gallery, London

Rembrandt painted several pictures of Saskia of a similar type – he obviously loved dressing her up in beautiful costumes. The subject matter of the picture has been much discussed, some scholars thinking that it may represent Prosperine, daughter of the corn goddess Ceres, but the emphasis on flowers is so strong that there seems little doubt that Saskia represents the floral goddess. Such Arcadian subjects were enjoying a great vogue in Holland at this time, following the popularity of the play Granida *(1605) by Pieter Hooft, in which two lovers live an idyllic life in the woods.*

The Syndics of the Amsterdam Cloth Workers' Guild 1661-62
75½" × 110" Rijksmuseum, Amsterdam

This work is ranked by most critics among Rembrandt's greatest masterpieces. X-rays show that he experimented with the positioning of the figures before finalizing them.

The Jewish Bride c.1665
48" × 65½" Rijksmuseum, Amsterdam

Whether this painting is simply a double portrait or, as some critics think, a biblical subject (Isaac and Rebecca?), it is one of Rembrandt's most glorious achievements as a colourist.

I.Ver-Meer

Most of Vermeer's paintings are small – even tiny – in scale and involve only one or two figures engaged in some unremarkable domestic activity. Sometimes there is the suggestion of a concealed meaning, as in The Concert, where the inclusion of another painting – The Procuress by Dirck van Baburen – within the painting hints that

The Glass of Wine *c.1658-60*
25" × 30" Staatliche Museen, West Berlin

This painting has many of the characteristics we think of as typical of Vermeer's works: a single source of light on the left, a chair placed at a three-quarter angle to the viewer, an elaborate carpet on the table, a picture on an otherwise bare wall and quiet figures absorbed in an everyday activity.

darker passions may be flowing behind the tranquil scene and that all is not what it seems. The motif of a picture within a picture occurs frequently in his paintings. It can also be seen in The Glass of Wine, for example.

The spellbinding beauty of his paintings depends very much on his sensitivity to light and his flawless technique, every pinpoint of light rendered with unerring sureness in works such as Soldier with a Laughing Girl. Astonishingly, Vermeer could transfer this optical subtlety from the intimacy of his studio to the outside world: The Little Street is one of his most charming works.

Soldier with a Laughing Girl *c.1658-60*
19¾" × 18" Frick Collection, New York

Until 1866, when it was identified by Theophile Thoré in a private collection in Paris, this picture was attributed to Pieter de Hooch. Fifteen years later it was sold for 88,000 francs, then an enormous sum, an indication of how much Thoré's work had done to establish Vermeer's reputation.

The Little Street *c.1660*
21¼" × 17" Rijksmuseum, Amsterdam

Vermeer's two landscape paintings are his most original works, for in them he seems to look with an utterly fresh eye and without any sense of contrivance. This picture is particularly loved in Holland, where it is called simply the 'Straatje' (the Street). The blue-looking foliage has been caused by fading of yellow from the green.

The Concert *c.1660-65*
27¼″ × 24¾″ Isabella Stewart Gardner Museum, Boston

The right-hand painting on the wall behind the three figures is The
Procuress *by Dirck van Baburen (p.181); it appears in another of
Vermeer's works and it seems that his mother-in-law owned it. The
sexual subject hints that stronger passions may lurk behind the quiet
exteriors of Vermeer's figures.*

The Stages of Life *c.1835*
by Caspar David Friedrich
28½″ × 37″ Museum der Bildenden
Künste, Leipzig

Introduction

Romanticism came into being after 1760 and continued until halfway through the following century. Defining it isn't easy: both the style and subject matter of the painters are very diverse but central to Romanticism was the belief in spontaneity and self-expression. All the artists, in differing manners, tried to do on canvas what poets had done in writing – to capture their feelings.

It is this which sets Romanticism apart from what came before. The artists did not feel tied to the traditional subject-matter of art – the Bible, the saints, mythology – nor to classical proportions. They took the freedom to paint whatever they liked as they saw it, not how people _expected_ them to see it.

Such diversity is illustrated by Blake who chose, among other subjects, to illustrate the works of Shakespeare, Milton and Dante, and by Goya who took a traditional theme and presented it in a very different way. In his painting _The Royal Family_ (p.234), even as First Painter to the King he asserted his independence, refusing to flatter where flattery was very definitely the order of the day. Friedrich, too, upset expectations, in his devotional landscape _The Cross in the Mountains_ (p.262). As for Turner, by the end of his life he became a painter of light itself. In his painting _Snowstorm_ (p.283) the details of the boat are lost in the swirling dazzling light and contrasting shadows. It is as if the particularities are not important, what is, is the _emotion_ the storm arouses.

Romanticism wasn't confined to one European country. Friedrich, Turner and Constable, from Germany and England, show contrasting approaches to Romantic landscape: Friedrich creating still, serene works, that express a yearning for the unknown and the supernatural, Turner expressing the violence of the elements with unprecedented force and Constable showing an intense emotional involvement with parts of the English landscape at its most peaceful and charming. In Spain and England, Goya and Blake were two supreme individualists, creating images from politics and contemporary social issues as well as from their own inner lives.

Romanticism appeared when it did for a wide variety of reasons. It went hand in glove with a time of great upheaval both politically

and socially. The inheritance of the 18th century Enlightenment, which valued order above individualism, was questioned, as was Newton's view of the world as machine – for Blake's feelings on this see his work *Newton* (p.321) where the scientist is shown symbolizing the dangers of rationalism by obsessively measuring life with dividers. There was the French Revolution in 1789, followed by other waves of unrest across Europe in the cause of self-assertion or nationalism; the industrial revolution; urbanization. Such trends had a volatile effect, making people aware of a need to shape their own lives and individualism came to the fore.

The measure of this individualism, translated into art, is shown by another important departure made by the Romantics. Goya, Blake and Friedrich in their different ways, began to make visible the workings of the mind in their paintings; to show the subconscious being within. Goya, after a severe illness in 1792-3, turned increasingly to sombre and sinister subjects. He began to probe the darker side of human nature and his work took on a nightmarish quality. Friedrich, a deeply religious man obsessed by death, created mysterious landscapes that were symbols of a spiritual state, see *Abbey in Oakwoods* (pp. 322-323), while Blake created his own mythological world and claimed to be inspired by spirits, see *Ghost of a Flea* (p.249). Friedrich advised artists to close 'the bodily eye' when beginning a painting and Blake saw imagination as the greatest liberator of the human spirit.

What these artists revealed to the world of man's inner condition was visionary. In their recognition of nightmare, hallucination, madness and eroticism as part of the human psyche, and their courage to acknowledge it, they anticipated ideas that were later explored and expanded by Freud. As such they have contributed to our understanding of the 20th-century world, and in art in particular, to abstract expressionism. They are to be thanked for their personal revolution in a time of social revolution and for their introduction of the concept of self-expression at a time when it did not exist.

Goya

1746-1828

Francisco de Goya was the greatest painter of 18th century Spain. Born in an isolated village, he went to Madrid at 18 to work in the studio of Francisco Bayeu, whose sister he later married. Madrid was the centre of Spanish culture and society, but Goya was slow to make his name, becoming a royal painter only when he was 43. From then on his future was assured, and he quickly rose to even higher eminence.

Goya first earned his reputation painting cartoons for tapestries, and further success came from portraits. But his most remarkable works were produced after a serious illness left him permanently deaf. Paintings and etchings of his bizarre, fantastic 'imaginings' were followed by satires on high society and ghastly visions of the horrors of war. His late 'black paintings' were more dramatic still, with immense, if gloomy, impact.

The Bullfight *c.1827*
29″ × 43¼″ National Gallery, Washington

The 'Deaf Man' of Madrid

At the age of 47 – four years after his appointment as painter to the Spanish king – Goya was struck by deafness. He watched in silence the downfall of the monarchy and the disasters of war.

Francisco de Goya y Lucientes, the son of a gilder, was born on 30 March 1746 in the desolate village of Fuendetodos in western Spain. When he was 14, the family moved to Saragossa, the capital of his native region of Aragon, and Francisco was apprenticed to the painter José Luzán – at that time the leading artist of Saragossa. (One of his specialities was adding drapery to nude figures in religious pictures, for which he was given the official title of 'Reviser of Indecent Paintings'.) In Saragossa, Goya also met the painter Francisco Bayeu, who was 12 years older than him and enjoying the rapidly growing success that in 1763 led him to the court of Madrid. Goya moved to Madrid soon after Bayeu and worked in his studio.

MADRID, CENTRE OF THE ARTS

To be established at Madrid was, at this time, virtually the only way in which a provincial Spanish artist could gain more than mere local recognition. The great wealth of the Spanish monarchy and its lavish patronage of the arts also attracted some of the major painters from elsewhere in Europe. In the 1760s and 1770s the two most important painters at the court were the Venetian Giambattista Tiepolo and the German Anton Raffael Mengs, both of whom had a major influence on Goya's evolution as an artist.

In 1763 and 1766 Goya made unsuccessful attempts to enter the recently founded Madrid Academy of Art and then, probably in 1770, he did what was customary for ambitious young artists: he went to Italy. Here he enjoyed his first minor success, getting an honourable mention in a

Key Dates

1746 born 30 March in Fuendetodos, Spain
1764 moves to Madrid
1770 visits Rome
1773 marries Josefa Bayeu in Madrid
1774 first cartoon for royal tapestries
1784 birth of Goya's only surviving heir his son Javier
1789 appointed royal painter by Charles IV
1793 serious illness leaves him deaf
1796 stays at Duchess of Alba's estate
1808 French seize Madrid
1812 death of Josefa
1814 Spanish monarchy restored; Goya paints *The Third of May 1808*
1819 buys 'House of the Deaf Man' outside Madrid; suffers serious illness
1824 settles in Bordeaux
1828 dies in Bordeaux

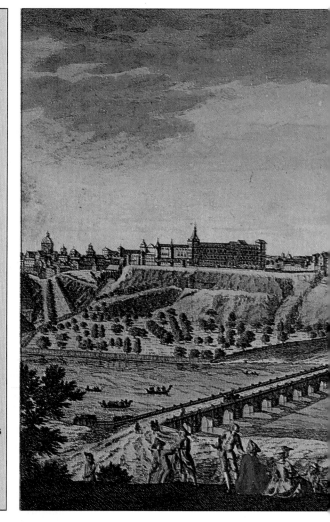

Goya/Josefa Bayeu/detail/Prado, Madrid

Josefa Bayeu
In 1773, Goya married Josefa Bayeu, the sister of his teacher. She bore him several children, but only his son Javier reached maturity. Josefa, painted here by Goya, died in 1812 at Madrid.

The family home
Goya grew up in the rocky, arid region of Aragon. His birthplace, a two-storey stone house in the village of Fuendetodos, has been preserved as a memorial to him.

The Spanish capital
When Goya moved to Madrid in 1764, to work with his future brother-in-law, Francisco Bayeu, he entered one of Europe's most modern cities, already equipped with both street lights and sanitation. This view across the River Manzanares shows a panorama stretching from the Royal Palace on the left to the magnificent Church of S. Francisco el Grande on the right.

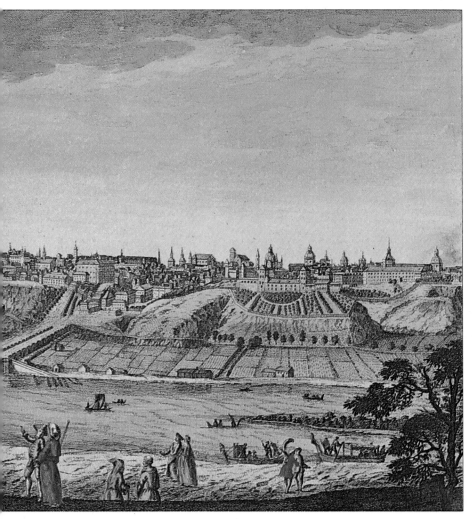

In the 1790s, with the tapestry designs completed, Goya devoted himself principally to the types of work by which he is best known today – portraits and imaginative compositions. Towards the end of 1793 a traumatic change occurred in his life when he developed a mysterious illness – variously and unconvincingly interpreted as syphilis, lead poisoning from the use of white paint, and even a particularly severe nervous breakdown. At any rate, it caused him temporary paralysis and partial blindness, and left him permanently deaf. The illness had a significant effect on the development of Goya's art. While convalescing in 1793 he painted a series of small oil paintings of bizarre subjects of 'fantasy and invention', as Goya himself described them, telling the Academy later that he had produced them 'In order to occupy an imagination mortified by the contemplation of my sufferings'.

Goya's increasingly introverted and morbidly imaginative tendencies as an artist were not greatly appreciated by his contemporaries. But they did not in any way impede his rising eminence in the Madrid art world. In 1795, on the death of Bayeu, he was promoted to Director of Painting at the

A tapestry for the King
Goya's first important commission in Madrid was to design tapestries for King Charles III. The Swing was woven by the Royal Tapestry Manufactory from a painting by Goya in 1779.

painting competition organized by the Art Academy of Parma. In 1771 he returned to Spain, and two years later married Bayeu's sister, Josefa. The following year he was summoned to work, first under Mengs and then Bayeu, on cartoons for tapestries to be woven at the Royal Factory of Santa Barbara in Madrid. This task was to occupy him sporadically until 1792.

Goya's beginnings as an artist were slow and unremarkable. It was not until the 1780s, when he was already in his mid-30s, that important official recognition came his way. In 1780 he was elected a member of the Madrid Academy and five years later he was made Deputy Director of Painting there. After Charles IV was crowned in 1789, Goya achieved his ambition of becoming one of the royal painters, a promotion which he celebrated by adding the aristocratic 'de' to his name.

The Royal Family
(left) Goya painted The Family of Charles IV *in 1800. His avoidance of flattery led one critic to comment that the King and Queen looked like 'the corner baker and his wife after they have won the lottery'. Prince Ferdinand is in blue on the left; his bride-to-be has her face averted, as their engagement had not been officially announced. Goya himself is in the background at his easel.*

The Escorial Palace
(right) As court painter, Goya often visited this royal residence in the Guadarrama mountains outside Madrid. This palace-monastery, built in 1563 as a retreat, is where the Spanish monarchs are buried.

Academy, and in 1798 received the prestigious commission to decorate the Madrid church of S. Antonio de la Florida. The following year he was appointed First Painter to the King. By now he could count among his friends and patrons many leading intellectuals and aristocrats in Madrid.

THE NAKED MAJA

Goya was on particularly close terms with the widowed Duchess of Alba – a beautiful, intelligent and powerful woman. Their relationship was the source of much gossip, especially after Goya spent the summer of 1796 on her estate in Andalusia, where the Duchess had moved after the death of her husband. One of the most popular legends in the history of art holds that she was the model for Goya's famous pair of paintings, *The Naked Maja* (opposite) and *The Clothed Maja* (pp.312-313).

Such speculation has often been used to flesh out the rather meagre information we have concerning the less public aspects of Goya's personality. He has been depicted variously as a relentless womanizer, a manic-depressive, a revolutionary, and a sort of Hamlet-like figure viewing society with growing scepticism and pessimism and ultimately achieving an almost other-worldly detachment from it. However, the evidence for all this is scanty. The known facts of Goya's life reveal little more than a great concern with his social standing, financial shrewdness, a love of pigeon-shooting, and an unwillingness to allow political or other forms of idealism get in the way of the practical considerations of living.

The first half of Goya's life was a time of political stability in Spain. But the reign of Charles IV (1789-1808) saw mounting unrest, made even worse by the international repercussions of the French Revolution. Charles was a weak and lazy ruler, greatly influenced by his strong-minded wife, Maria Luisa, who in turn was led by the upstart favourite, Manuel de Godoy. The rule of this 'trinity on earth', as the queen described it, was highly unpopular with both nobility and public alike. Eventually, in 1808, mass disturbances caused the downfall of Godoy and forced Charles IV to resign in favour of his son Ferdinand VII.

Ferdinand, in league with the French, at first welcomed Napoleon's armies into Spain. But almost immediately he was forced to hand over his throne to Napoleon's brother, Joseph. The French occupation provoked serious rioting in Madrid and led to a bloody civil war. Goya's own allegiances are not clear, but he was appalled by the brutality of the fighting, and in his horrific series of etchings, the *Disasters of War*, he portrayed atrocities committed by both sides.

HONOURED BY THE ENEMY

Whatever Goya's political views, he also had to make a living, and it was therefore prudent of him, if not especially principled, to swear allegiance to the French king and accept from him in 1811 the Royal Order of Spain. This caused him trouble later when Ferdinand VII was restored to the throne in 1814, following the intervention of British troops under the Duke of Wellington (whom Goya

The British blockade Cadiz
At the turn of the century, the Spanish monarchy was shaken by the upheavals of the Napoleonic wars, in which they were at first reluctant allies of the French. In 1796, the two countries planned a joint attack on the English coast, but their navies were foiled by Nelson at the Battle of Cape St Vincent in February 1797. Nelson then blockaded Cadiz for a year.

The Beautiful Duchess

In 1796, Goya's relationship with the widowed Duchess of Alba caused scandal in Madrid. At 34, this high-born lady was nearly 16 years younger than Goya, and famous for her capricious nature. She and her husband had been Goya's patrons, and when the Duke died that summer, she retired with the artist to her country estate at Sanlucar. Here it has been supposed they became lovers. Certainly his notebook reveals an idyllic atmosphere, and some of his sketches depict women in erotic poses, for which the Duchess may have modelled.

The Duchess in love
Goya's portrait of the Duchess, dated 1797, suggests a close relationship between them. The names inscribed on her two rings are 'Alba' and 'Goya' and she points to the words 'Solo (only) Goya', written in the sand.

The Naked Maja (c.1800)
Legend has it that the Duchess of Alba posed for this erotic painting, which later led Goya into the hands of the Inquisition.

Prado, Madrid

Hispanic Society of America, New York

was also quite happy to portray). But Goya escaped the punishment meted out to some of his liberal friends by claiming that he had never worn the medal awarded to him by the French. In addition he offered to paint for the king his two famous scenes of the Madrid rioting that had led to the war: *The Second of May, 1808* (overleaf) and *The Third of May, 1808* (pp.300-301).

The gloom of Goya's later paintings reflects the morbidly repressive atmosphere in Spain following the restoration of Ferdinand VII. Universities and theatres were closed down, press censorship was introduced, and the dreadful religious tribunal, the Inquisition, was re-established. No sooner had Goya been exonerated from the charge of having 'accepted employment from the usurper' than he found himself summoned in front of the Inquisition to explain why and for whom he had painted the allegedly obscene *Naked Maja* and its companion piece. The artist had other problems to contend with. His wife had died in 1812, and he was now embarked on an affair with a married woman, Leocadia Weiss, which put him at the centre of malicious gossip.

WITHDRAWAL FROM PUBLIC LIFE

Ferdinand VII took hardly any interest in Goya, but kept him on as his First Painter. And when Goya eventually retired from the post, Ferdinand awarded him a generous pension, which enabled him to live comfortably until his death. He virtually withdrew from public life after 1815, and worked almost exclusively for himself and for his close circle of friends.

Napoleon enters Madrid
Six months after deposing the Spanish monarchy, Napoleon himself entered Madrid on 4 December 1808. He stayed only briefly, to direct operations against the Spanish resistance and the advancing British forces.

In 1819, serious illness struck Goya again, and he recovered only thanks to the intervention of the fashionable Madrid doctor, Eugenio Garcia Arrieta. In gratitude, Goya painted an extraordinary double portrait, showing himself half-dying in bed being supported by Arrieta, who is offering him a draught of medicine; in the background is a group of dark and sinister figures. Similar reflections on death and old age are to be found in the 'black paintings' that he executed between 1820 and 1823 on the walls of his newly acquired house (the 'Quinta del Sordo' or 'House of the Deaf Man') in the country outside Madrid.

The three years during which the artist was engaged on these works, perhaps the most terrifying and technically astonishing in his career, saw a brief moment of liberalization in Ferdinand's regime. However, by the end of 1823, reaction had set in again, and many of Goya's liberal friends sought refuge in France. A number of them went to Bordeaux, including Leocadia Weiss, who took the two children she had supposedly had by Goya.

Prado, Madrid

The Sleep of Reason Produces Monsters
Designed originally as the frontispiece to his Caprichos *series, this etching, dated 1797-8, sums up Goya's view of humanity. When reason is allowed to sleep, monsters of the irrational world take over.*

British Museum, London

Self-portrait with Dr Arrieta (1820)
(left) As the inscription beneath the picture explains, Goya painted this moving portrait of himself and his doctor after recovering from 'an acute and dangerous illness suffered at the end of 1819, at the age of 73.'

House of the Deaf Man
(below) In February 1819, Goya bought a country property of 25 acres on the right bank of the River Manzanares, with the single-storey Quinta del Sordo (House of the Deaf Man). After his illness, Goya decorated the walls with 14 'black paintings'.

La Manola (1820)
(above) This portrait is thought to be of Leocadia Weiss, who lived with Goya until his death. Although one of the 'black paintings' decorating the walls of the Quinta del Sordo, it has none of the nightmarish quality of the others.

He joined her there soon afterwards, having been granted temporary leave of absence by the king on the pretext that he needed to take the waters at Plombières for his health.

Goya was found by his friends now to be 'deaf, old, slow and feeble'. But his enthusiasm for life was apparently as strong as ever, and his artistic powers were undimmed. He still had enough strength to make an extended sight-seeing trip to Paris, and even began experimenting with the new medium of lithography in his series the *Bulls of Bordeaux*. To the surprise of his fellow exiles, he made two brief return trips to Spain, on the first of which (in 1826) he officially handed in his resignation as court painter.

In the spring of 1828, he was visited in Bordeaux by his daughter-in-law and grandchildren. The excitement caused by their visit made him, in his own words, a 'little indisposed'. He died on 16 April following a paralytic stroke, aged 82. His mortal remains were returned to Spain in 1900 and interred in the cemetery of San Isidro in Madrid.

237

The Dark Side of Humanity

Goya began his career designing colourful tapestries for royal palaces. But his own traumatic illness and the dreadful events of the war against France led him to depict scenes of horrific violence.

Goya is almost universally regarded as the greatest European painter of his period. The originality, emotional range and technical freedom of his work set him apart from other artists. Indeed, among his contemporaries we have to look to Beethoven to find his equal in grandeur of imagination and power of expression.

Although Goya produced a huge amount of work as a painter and a graphic artist, he was slow to develop, and it was not until he was well over 30 that he produced work that was especially remarkable or original. His early career was taken up mainly with the repetitive task of designing tapestries to be executed at the Royal Factory of Santa Barbara in Madrid.

A TRAUMATIC ILLNESS

Goya was employed on the tapestry designs until 1792, but by that time the direction of his art had changed radically. In the 1780s he had some success as a religious painter, and in 1789 he was appointed one of the painters to the king, which meant that painting portraits would be one of his major tasks. But the most significant change in his approach to art came with the severe but mysterious illness which he suffered in 1792-3.

The traumatic effect this had on him deepened his awareness of the pain and suffering in human life, and he turned increasingly to sombre or sinister subjects.

In the two fields for which he is best known – portraiture and imaginative subjects – Goya showed both his links with the great masters of the past and his startling originality. He is reputed to have said that his only masters were 'Velázquez, Rembrandt and Nature'. These two painters (the leading artists of Spain and Holland in the 17th century) were among the greatest portraitists who ever lived, and Goya followed them in their penetrating depiction of character. Goya also shared with them a virtuosity in the handling of paint that distinguishes him from most contemporary artists, who favoured a smooth,

An unorthodox painter
(left) This is a detail from a self-portrait Goya painted in about 1790. His lack of orthodoxy is seen not only in his odd appearance, but also in the vigorous sketchy technique and the way in which Goya has boldly silhouetted himself against the golden light.

The Second of May, 1808 (1814)
(right) Goya commemorated the uprising of the people of Madrid against Napoleon's cavalry in one of the most terrifying and convincing battle scenes in the history of art. There is no sense of good triumphing over evil; instead Goya shows ghastly and bloody confusion. His theme is not patriotism, but horror at man's inhumanity.

Collection Villagonzalo, Madrid

The Straw Manikin (1792)
(left) Between 1775 and 1792 Goya made 63 full-size cartoons for the royal tapestry works. The designs had to be bold and colourful to make suitable wall-hangings. Some of them are huge, the largest being more than 20 feet wide; this one is 8'9" by 5'3".

The master engraver
(below) Goya made almost 300 engravings in his career, but was over 50 when he published the first of his great series, the Caprichos, *in 1799. Three other major series followed: the* Disasters of War *(begun 1810),* Tauromaquia *(begun 1815) and the* Proverbios *(begun 1816).*

Prado, Madrid

Etching from the Proverbios/British Museum, London

Etching from the Tauromaquia/Biblioteca Nacional, Madrid

Etching from the Disasters of War/British Museum, London

Prado, Madrid

239

COMPARISONS

Bizarre Fantasies

Goya's imaginative scenes are deeply personal works, but they also form part of a long tradition of elaborate and bizarre fantasy. Hieronymus Bosch was a Flemish artist, whose paintings were particularly popular in Spain – the royal family owned the finest collection in the world. In the 20th century the Spanish painter Salvador Dali is the most famous representative of Surrealism – a movement that explored the subconscious in disturbing, irrational scenes.

Salvador Dali
(b.1904)
Premonition of Civil War
(below) Dali depicts a world of neurotic fantasies rendered horribly believable by his smooth technique.

Hieronymus Bosch
(c.1450-1516)
The Temptation of St Anthony (detail)
(below) Bosch's weird and colourful paintings draw on folk legends as well as religious symbolism. Although he has become immensely popular in the 20th century and has been intensively studied, much about his work is still baffling to scholars.

Philadelphia Museum of Art/© DACS 1986

Museu Nacional, Lisbon

detailed finish. 'Where does one see lines in nature?' he asked. 'I see no lines or details, I don't count each hair on the head of a passer-by, or the buttons on his coat. There is no reason why my brush should see more than I do.'

In his imaginative scenes Goya also drew on a rich tradition, for Spain was a country of religious fervour and the agonies and ecstasies of the saints had been celebrated in art for centuries, often with a grisly concentration on the suffering of martyrs. Two centuries before Goya, the Spanish king Philip II had avidly collected the bizarre works of the Flemish painter Hieronymus Bosch, and Goya would have seen the work of his great spiritual predecessor in the royal collection.

THE BLACK PAINTINGS

Goya's probing of the darker side of human nature began to emerge in his series of etchings the *Caprichos*, in which he combined caricatures of contemporary life with gruesome fantasy. The ultimate development of this kind of theme came in his so-called 'black paintings', which he painted on the walls of his own house soon after recovering from his near fatal illness of 1819. In these virtually colourless works depicting morbid and terrifying scenes, Goya handled paint with a freedom that

could almost be called ferocious. Here Goya was painting purely for himself – a startling notion at this time, when there was no concept of artistic self-expression.

Goya's technical virtuosity and resourcefulness are as apparent in his graphic work as in his painting. He drew in pencil, in ink and in brush wash, among other media, and as a printmaker he excelled in aquatint, etching and lithography. Aquatint and etching both use acid to 'bite' into a metal printing plate a design that the artist has brushed or drawn on it; lithography involves drawing on stone with a wax crayon and then printing from it using an oil-based ink that adheres only to the parts that have been touched by the wax. Lithography was invented in 1798 and Goya was the first great master of the technique.

SERIES OF ENGRAVINGS

As well as the *Caprichos*, Goya produced three other great series of engravings: the *Disasters of War*, which records the appalling events following the French invasion of 1808; the *Tauromaquia*, a series on bullfighting; and the *Proverbios*, an enigmatic series showing various aspects of human folly. Of these, the *Disasters of War* are perhaps the most devastating. There are no heroes in Goya's war, and no glory – only death and mutilation, pain and degradation. His prints still have a shocking impact today, even though we have become accustomed to seeing such brutalities recorded in photographs and films. They stand as timeless portrayals of the conflicting forces of good and evil, life and death, light and darkness.

Academia de San Fernando, Madrid

Anguished Faces

Goya often exaggerates facial contortions, but they always look appropriate in the context of his paintings. He endured a great deal of suffering during his own illnesses and painted both physical and mental agony with a conviction few artists have matched.

The Madhouse (c.1800) *(above and right) Goya was not the first artist to depict madhouse scenes but no-one before him had evoked such pain and pity. There was a tradition of including lunatics who crown themselves as monarchs or popes, as shown in the detail. Goya's madmen, however, are not stock characters but disquieting portrayals of individuals in genuine mental torment.*

The Third of May, 1808

In 1814 Goya painted two large and powerful canvases to commemorate the uprising in 1808 of the citizens of Madrid against the French army of occupation. The first (p.238) shows street fighting on 2 May, and the second shows the reprisals taken by the French the next day. Dozens of rioters were executed alongside numerous other captives, who had been arrested without any proof of their involvement in the revolt. Goya offered to paint the pictures when Ferdinand VII was restored to the Spanish throne 'to perpetuate by means of the brush the most notable and heroic actions and scenes of our glorious insurrection against the tyrant.'

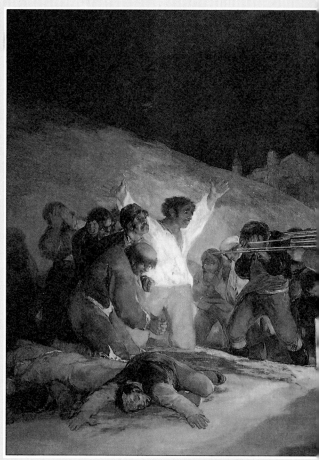

The execution site
The shootings took place at the Montaña del Principe Pío on the outskirts of Madrid, near the Royal Palace. The executions lasted all day long.

Sally Holmes

The Second of May

The riot on 2 May, shown below in a contemporary engraving, was put down by Joachim Murat (right), Napoleon's brother-in-law and a dashing cavalry commander. He had hundreds of Spaniards executed.

Buildings in the background
Although Goya made no attempt at topographical accuracy, the buildings in The Third of May *may have been suggested by the nearby Royal Palace.*

The firing squad
(below) In grim contrast to the terrified victims, the French executioners are shown as ruthless – and faceless – automatons. Their uniforms are sombre, their gestures mechanical.

'Light and shade play upon atrocious horrors'

Charles Baudelaire

Prado, Madrid

Biblioteca Nacional, Madrid

The victims
Goya shows a whole gallery of expressions of terror and despair. The unforgettable central figure, arms outstretched, stares with impotent defiance.

A common sight
Goya did not himself witness the executions, but he had seen similar events in the war. This etching is from his **Disasters of War,** *begun in 1810.*

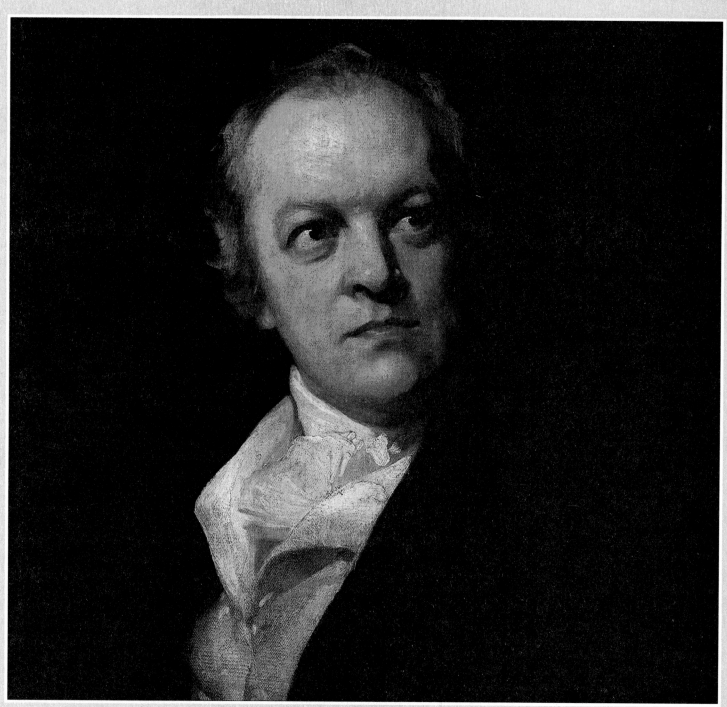

National Portrait Gallery, London

WILLIAM BLAKE

1757-1827

One of the most distinctive of all English artists, William Blake was a brilliant poet as well as a great painter. A fiercely independent man, he started his career as a commercial engraver, but in his thirties began illustrating his own poems. He soon created a completely personal style and an original technique that perfectly expressed the full intensity of his visionary experiences.

Blake is now recognized as one of the giants of the Romantic period, but in his lifetime his genius was appreciated by only a small circle of admirers. He had few patrons and much of his life was spent in poverty. But lack of material success was of little consequence to Blake – he was completely dedicated to his work and lived in the world of the imagination and the spirit, rather than the world of the flesh.

The Good and Evil Angels *c.1795*
17½″ × 23″ Tate Gallery, London

The Visionary Engraver

Blake spent most of his life working as an engraver in London. He was always poor, but derived strength from a happy marriage, deep political convictions and an exceptionally rich spiritual existence.

Blake by his wife
Catherine Blake made this pencil drawing of her husband shortly before his death. It shows Blake as she remembered him 'in his fiery youth'.

Fitzwilliam Museum, Cambridge

Key Dates

William Blake was born on 28 November 1757 at 28 Broad Street, off Golden Square in London. He was the second child of a fairly prosperous hosier, and the family occupied a spacious old house in a district made up of private houses and respectable shops. Blake's father positively encouraged his son's artistic leanings. He bought him a few plaster casts, gave him pocket money to buy his own prints, and sent him, at the age of ten, to Henry Pars' drawing school in the Strand, then the best and most fashionable preparatory school for young artists. Here he learnt to draw by copying plaster casts of classical statues.

When the time came for Blake to be apprenticed, his father was unable to afford the cost of his entrance to a painter's studio, and anyway he wanted his son to have the security of a craft. And so, for a premium of 50 guineas, he arranged for Blake to join the workshop of James Basire, master-engraver to the Society of Antiquaries, in Lincoln's Inn Fields.

THE MASTER ENGRAVER

Blake worked under Basire for seven years, becoming himself a master of all the techniques of engraving, etching, stippling and copying. He helped Basire with his engravings for books, among them Jacob Bryant's famous *New System of Mythology*, which introduced him to the world of ancient religions and legends. Another profound influence was the study he made, at Basire's suggestion, of Gothic architecture and sculpture in Westminster Abbey and other old churches in London. Blake's lifelong love of Gothic art dates from these visits to the Abbey.

After his seven-year apprenticeship, Blake set out to earn his living as an engraver. He continued to live in his father's house and worked on commissions for such publications as the *Ladies' Magazine*. He enrolled as a student at the newly-founded Royal Academy, but could not tolerate the life drawing he was required to do there. According to him, 'copying nature' deadened the vigour of his imagination.

In 1782, at the age of 25, Blake married. His wife, Catherine Boucher, was the illiterate daughter of a Battersea market gardener, and this choice of partner did not please his father. The couple moved to a house in nearby Green Street, but two years later Blake's father died and William and Catherine returned to Broad Street, living at No. 27, next door to his old home. They were joined by Blake's younger brother, Robert, who became a pupil as well as a member of the household.

For two and a half happy, though not financially successful years, this much-loved brother was Blake's professional and intellectual companion. Then, tragically, Robert fell ill and died, leaving Blake broken-hearted. He nursed him so selflessly that he is said to have gone without sleep for a fortnight. At the moment of his death Blake claimed he had seen 'the released spirit ascend heavenward, clapping its hands for joy.' He continued to communicate with his brother's spirit throughout the rest of his life, deriving much comfort from their conversations. Blake also communicated freely with angels and other Biblical figures.

After Robert's death, Blake moved to a house in

A Londoner, born and bred
Blake was born in this spacious cornerhouse in Soho, where he lived until he was 25. Two years later he set up a small print-selling shop next door to his old home.

Westminster Abbey
(left) During his seven-year apprenticeship to the engraver James Basire, Blake often made drawings in Westminster Abbey. According to his earliest biographer, this 'kindled a fervent love of the Gothic which lasted throughout his life'.

The Abbey monuments
(right) This coloured drawing is one of a series Blake made in 1775; they were used as the basis for engravings illustrating the Abbey's monuments, published in 1780.

W. Blake/King Sebert

247

The French Revolution, 1789

As a young man, Blake welcomed the French Revolution, and even wrote a poem celebrating it. He maintained his hatred of the monarchy throughout his life.

Poland Street, Soho, where he struggled to fulfil the few commissions that came his way. He was too unworldly in his commercial dealings and too proud in his relations with clients to make himself rich. In his politics he was then extremely radical and took to wearing a red bonnet when the French Revolution broke out. As both a man and an artist, he was a visionary whose imaginative world was far more splendid and inspiring than anything he discovered in the real world. Above all, he was a deeply religious man, for whom everything possessed its own spiritual essence and life.

In 1788 Blake made his first experiments with 'illuminated printing', that is combining words and images together on a single copper plate. For some time he was unable to hit on a technique that was both cheap and suitable, and it worried him badly. Then, one day his dead brother appeared to him in a vision and gave him explicit directions, which he promptly put into action. They proved to

Blake's Soho

Blake lived most of his life in the district of Soho, in the West End of London. Built in the 18th century, this has consistently been a home for craftsmen, artists and writers – among them Canaletto and Shelley as well as Karl Marx and the critic William Hazlitt.

Today Soho is best-known as a red-light district and the centre of London's Chinatown, but in Blake's time it was a typical urban mixture of grand houses – in the squares – and terraces for artisans' families. There was also a workhouse in the district.

Soho Square
(right) In Blake's day, Soho Square was an elegant residential area not far from open fields. Blake lived nearby, first in the family home in Broad Street (now Broadwick Street), then with his wife in Green Street and later in Poland Street.

be perfect for his needs. Using this method, he printed copies of *Songs of Innocence* the following year and taught Mrs Blake how to bind them.

In 1794 he wrote and illustrated his *Songs of Experience*, which betray a much bleaker and more pessimistic outlook. It is believed that he never issued them separately, but always combined them with *Songs of Innocence* in order to show 'the two Contrary States of the Human Soul,' as he put it on the title-page. Helped by his wife, he continued to make and colour sets of the prints as they were commissioned by his customers until the time of his death.

'PARADISE' IN LAMBETH

Shortly before the death of his mother in 1792, the Blakes had left Poland Street and moved to 13 Hercules Buildings in Lambeth. This was evidently a pretty terrace house with a strip of garden behind, in which Blake allowed a wandering vine to grow unpruned and form a little arbour. Here, according to legend, a friend once discovered Mr and Mrs Blake wearing nothing but helmets and reading aloud from *Paradise Lost*. In any case, the seven years they spent in Lambeth were happy and productive. It was in this house, in 1795, that Blake designed the magnificent series of colour prints, including *God Judging Adam* (p.319), which are generally thought to mark the high water of his genius as a print-maker.

By and large Blake was not lucky in his patrons, but there was one man who never failed him – Thomas Butts, a civil servant and art collector. Blake referred to him as 'my employer', but in fact he seems to have left Blake free to follow his creative impulse. He simply placed a standing order, as it were, asking for 50 small pictures at a

Visionary powers
(above) Blake claimed that he was frequently visited by spirits and angels. The Ghost of a Flea *(c.1819) is a blood-curdling record of one of his most bizarre visionary experiences. According to his friend John Varley, this extraordinary monster visited Blake twice.*

A country interlude
(left) Blake and his wife moved to this idyllic cottage in Felpham, Sussex in 1800. They rented it for three years at £20 per annum, until a fracas with a uniformed soldier sent them hurrying back to London.

guinea each. Blake was able to confide in Butts and was a frequent visitor to his house, which by the end of Blake's life overflowed with his pictures.

William Hayley, a country gentleman and minor poet, was another of Blake's patrons. He commissioned Blake to engrave plates for his proposed life of the poet William Cowper and invited the Blakes to move to Felpham in Sussex to be near his own residence. In 1800 Blake left London for the first time to begin what he later called his 'three years' slumber on the banks of the ocean'. At first Blake thought his new cottage a little paradise, and both he and Catherine loved to go for walks, exploring the countryside.

THE DAUGHTERS OF INSPIRATION

Blake was overwhelmed by the beauty of nature, but he did not take up landscape painting, nor did he ever see nature in anything other than visionary terms. 'Everything is human! Mighty! Sublime!' he wrote. During this period he not only communed with his 'daughters of inspiration', who descended from the tops of trees to talk with him, but he also discovered that the vegetable world was inhabited by fairies. 'Did you ever see a fairy's funeral, madam?' he asked an astounded lady at a party, and proceeded to describe one he had witnessed the previous night.

Meanwhile, his relationship with Hayley was not proving easy. He worked loyally at the jobs he was given, but found them imaginatively unrewarding. By 1802 he was getting restive and would probably have fallen out with Hayley if events had not intervened. In the summer of 1803 Blake had a fight with a soldier who had been sent to cut the grass in his garden. Blake, who was opposed to the war against France, was reported as saying, 'Damn the King, and damn all his

C.R. Stanley/View of the Strand/London Museum

The Patron's Reward

In 1809 Blake held an exhibition at his brother's shop in Soho, showing his new painting, the *Canterbury Pilgrims*, together with 15 other pictures. Subscribers were invited to order engravings, but not one order was taken. His ever-faithful patron Thomas Butts bought the *Canterbury Pilgrims* – one of Blake's masterpieces – for just £10.

The loyal patron
(left) *The minor civil servant Thomas Butts filled his house with Blake's pictures.*

Canterbury Pilgrims
(right) *Blake's painting shows a scene from Chaucer's* Canterbury Tales. *The procession presents a picture of 'universal human life'.*

British Museum

F.J. Fields/Manchester City Art Gallery

The Spirits of Fountain Court

(above) From 1821 until his death in August 1827, Blake lived at No. 3 Fountain Court. This atmospheric picture shows the sparse furnishings of his bedroom – and, hovering over the bed, Blake's spirit visitors.

The Strand

(left) Fountain Court was just off the Strand – an area Blake knew from his drawing school days.

water-colours to Butts. However, in the summer of 1818 his life was radically changed by meeting John Linnell, a young portrait and landscape painter, who began to pay him regular sums of money in exchange for a large part of his output. Linnell also introduced him to a group of young admirers, including Samuel Palmer, the painter who came closest to inheriting Blake's visionary inspiration, and John Varley, a landscape painter who was fascinated by astrology and readily swallowed Blake's accounts of his visionary experiences.

POOR BUT HAPPY

In 1821 the Blakes moved to no. 3 Fountain Court, off the Strand, a house owned by his brother-in-law. Although they still lived in very poor circumstances, he seems to have been much happier here. He continued to be an object of veneration to his younger friends. Samuel Palmer went so far as to kiss the threshold whenever he

The final resting place

Blake died in poverty, aged 69, and was buried in an unmarked grave in Bunhill Fields. Not until 100 years later was this tombstone erected in his memory.

soldiers, they are all slaves.' He was tried for assault and sedition. Hayley managed to get him acquitted, but Blake had to leave Felpham.

He was now 45. On his return to London he chose to live in South Molton Street, but could only afford to rent one floor of a house. Here he lived for the next 17 years, mostly in poverty. He brought back from Felpham his long poem, *Milton*, which he claimed had been dictated to him by his angels, with some assistance from Milton himself. He set about etching plates for this book, and also began work on his engravings for *Jerusalem*, a book which he continued to enlarge until as late as 1820. In the end, he illuminated only one copy.

For the next ten years Blake's life is difficult to trace. He lived in obscurity, continuing to write and paint, but selling very little except his

called. And Linnell commissioned Blake, at the age of 65, to make 22 magnificent engravings illustrating *The Book of Job*, paying him £5 per plate. Linnell also proposed the second masterpiece of Blake's last years, his illustrations for Dante's *Divine Comedy*. He worked on these until his death, completing over 100 large designs, but engraving only seven plates.

A friend who visited him during his last days recorded that, after finishing a piece of work, 'his glance fell on his loving Kate, no longer young or beautiful, but who had lived with him in these and like humble rooms, in hourly companionship, ever ready helpfulness, and reverent sympathy, for now 45 years. 'Stay!' he cried. 'Keep as you are! you have ever been an angel to me: I will draw you!' This was his last work and, sadly, it has been lost. Blake died at Fountain Court on 12 August 1827. To the last he sang his own songs of praise and joy.

Glasgow Museums and Art Galleries, Stirling Maxwell Collection, Pollok House

The Power of the Imagination

An engraver by trade, Blake developed original techniques to illustrate his own poems – and those of Shakespeare, Milton and Dante – with images of strange and unusual power.

Library of Congress, Washington DC

Library of Congress, Washington DC

The art of illumination
These 'illuminated' pages come from Blake's Songs of Innocence (far left), published in 1789, and its sequel, Songs of Experience (left), which appeared in 1794. They combine words and images in a way that recalls medieval manuscripts, but Blake's intensity of vision is completely personal. He finished each copy of the book by hand, so no two copies are identical.

Tate Gallery, London

William Blake was unique in being almost as great a poet as he was a painter, and it is not absurd to say that for a while he painted his poems and wrote his pictures. From the start, he was intent on developing his own personal symbolism, both in words and pictures, but by the end of his life his poetic world had become highly complicated and difficult to interpret. For this reason, his later poetry is not much read today. His art, however, retained a brilliant clarity and simplicity, though his mystical references are sometimes obscure.

Blake's apprenticeship to James Basire gave him the chance to study engravings of Old Masters, most notably Michelangelo and Raphael. Their influence, spiced with a fashionable interest in the horrific, is to be seen in his earliest engravings. But it was his taste for medieval art, stimulated by his visits to Westminster Abbey, which showed most strongly in *Songs of Innocence* (1789), his first truly

original work, not only as painter and poet, but also as printer.

The printing method Blake used – which he believed had been revealed to him by his dead brother – had the advantage of being cheap, although it called for an exceptional degree of skill and patience. First, he laboriously transferred the text of his poem, in reverse of course, on to a prepared copper plate. Then he added his design and marginal decorations. When these images had been 'etched' into the plate by the use of acid, he made a print, using one or sometimes two tinted inks. Finally, he added his water-colour 'illumination' to the page, with pen or paintbrush.

This extraordinary method turned each copy of *Songs of Innocence* into a separate work of art, for Blake was able to vary the colour range from volume to volume. Early copies have the translucent delicacy of a rainbow, while some later

252

Jerusalem
The title-page to Blake's most famous poem is dated 1804, but he worked on the illustrations until about 1820.

Canute
(right) One of a series of 'visionary heads' Blake drew in 1819-20 for the painter John Varley, who was keenly interested in astrology and the supernatural.

Satan, Sin and Death (1808)
(right) The power and imaginative grandeur of Milton's Paradise Lost *made a strong appeal to Blake. This water-colour illustration shows the crowned Satan about to fight with Death when Sin intervenes, telling him Death is their son.*

copies are more jewelled and glow with gold paint. In 1794, using the same technique, he added *Songs of Experience* and thereafter always printed the two sets of *Songs* as a single book. The designs for *Experience* are noticeably more severe and dark, matching the grimmer character of these poems.

A SECRET TECHNIQUE

Meanwhile, Blake had been experimenting with a new method of print-making, using thick pigments of his own invention based on carpenter's glue. He claimed that this secret had been revealed to him by Joseph, the carpenter father of Jesus. And in 1795 he composed a series of 12 large colour prints, which were not associated with any text. Their bold images, clear-cut forms and rich texture put them among his finest works.

These prints of 1795 draw their subject matter from a bewilderingly wide range of sources, including the Old and the New Testaments, Shakespeare and Milton. Nevertheless, Blake evidently conceived the series as a whole. The clue to their precise meaning still lies buried in his writings, though it is generally thought that each print represents a stage in the Fall of Man, as Blake saw it. Thus, *Newton* (p.321) shows man as a slave

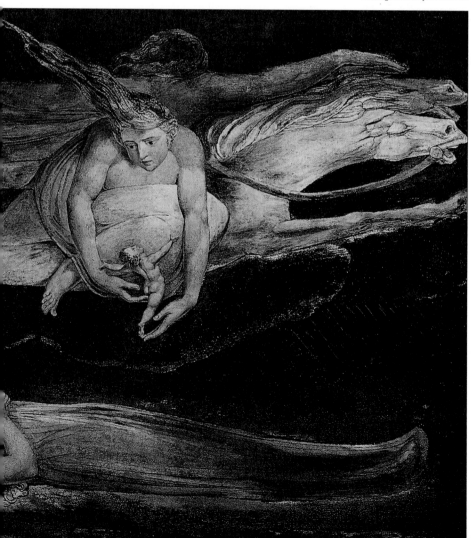

Pity (c.1795)
(left) This print, which Blake finished in water-colour, was inspired by a line from Shakespeare's Macbeth – *'Pity, like a naked newborn babe'.*

to pure reason, unenlightened by the imagination, a state of mind hated by Blake. By contrast, the crawling, bestial figure in *Nebuchadnezzar* shows man as a slave to the senses.

FREEING THE SPIRIT

All his life Blake fought against oppression, whether it took a political, intellectual or religious form. What he valued above all was imagination and its power to liberate the human spirit from its earthly confinement. Throughout his work, humanity under many different guises struggles to escape from the tyranny of Urizen, who is always depicted as a ferocious, bearded old man, symbol of both the authoritarian father and God, the unfeeling creator of systems and laws. Opposed to him is 'Jesus, the Imagination', otherwise called 'the God within', who reigns in every human soul.

Blake set himself the impossible task of creating a visual symbolism with which to express his spiritual visions, which owed nothing to ordinary existence. It is perhaps for this reason that some of the finest work he did towards the end of his life

Engraver at work
Blake used various methods of engraving, but they all involved cutting a design into a plate of metal or block of wood, rolling ink over it and taking an impression. Before the development of photography this was not just an art form, but the chief means of reproducing an image on paper.

COMPARISONS

The Painter Poets

Many artists have excelled in more than one field, but few have matched Blake's eminence as both a painter and a poet. Michelangelo was so supremely great as a painter, sculptor and architect that his literary work tends to be overshadowed, but he was one of the finest Italian poets of the 16th century. Rossetti, whose father was Italian, made translations of Dante, as well as writing his own poems, the most famous of which is *The Blessed Damozel*.

Michelangelo (1475-1564) **The Creator**
(below) Blake made several copies of such figures – from the Sistine Chapel of the Vatican in Rome – which influenced his own portrayal of the human body.

Manchester City Art Gallery

D.G. Rossetti (1828-82) **Astarte Syriaca**
(above) Rossetti greatly admired Blake and when still a student bought one of his manuscripts. His mysterious symbolism reflects Blake's influence.

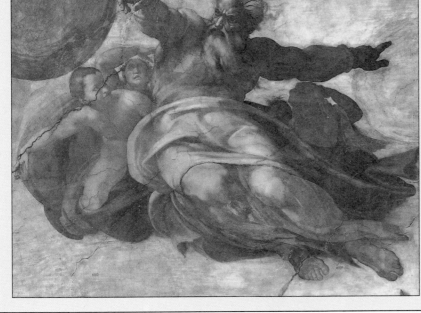

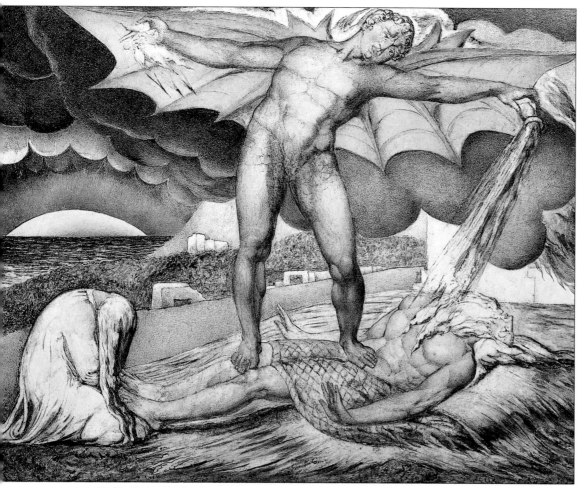

A distinctive feature of Blake's work is his treatment of long hair. He gives it almost a life of its own, twisting the thick folds into vigorous cascades, which sometimes stand out from the head as if floating on air.

Tate Gallery, London

was inspired by visions other than his own – especially those of the Bible writers and of Dante. His engravings for *The Book of Job* amount to a new interpretation of Job's character: he created some unforgettable images for this series, especially the fearsome *Satan Smiting Job with Sore Boils*. And, as the critic John Ruskin noted, Blake was able to surpass even Rembrandt in rendering the effects of glaring, flickering light.

Blake's last years were occupied by his illustrations to Dante's *Divine Comedy*. This series was to have been engraved too, but he died having finished only seven plates. However, he did draw over 100 large designs, some of them painted in glowing water-colours. These beautifully delicate paintings display a new sensuousness and variety of mood; they provide a fitting climax to a career of ceaseless and fiercely independent creativity.

To sum up Blake's work, one cannot do better than quote his own words: 'The imagination is not a State: it is the Human existence itself.'

Blake's last design
The final engraving Blake completed, in 1827, was a visiting card for his friend George Cumberland. Although tiny (only three inches long) it is full of vitality.

Satan Smiting Job with Sore Boils (c.1826)
(above and right) Blake simplifies the forms of the human body and creates bold contrasts between different shapes and textures. The detail shows mounds of thick, twisted hair set against Job's sinewy flesh. Blake often returned to the same theme, and this is the final and most powerful version of a subject he had treated twice before.

Fitzwilliam Museum, Cambridge

255

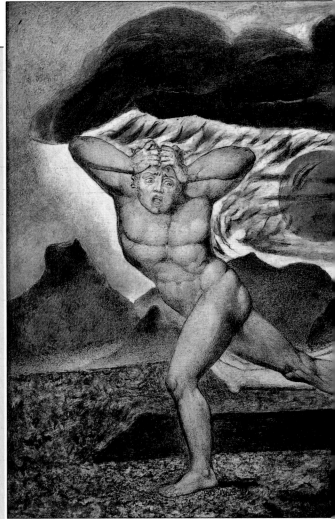

THE MAKING OF A MASTERPIECE

The Body of Abel Found by Adam and Eve

In one of his finest paintings, Blake shows the murderer Cain running in horror from the scene of his crime, while his father and mother look on in anguish. The exact scene is not described in the Bible – Genesis tells us only that God saw what Cain had done and condemned him to the life of an outcast. Blake was struck by the story's emotional force and had made sketches and a water-colour version 20 years earlier. The final painting (1826) is on a mahogany panel covered with layers of priming, on which he has drawn in ink. This shows through the surface paintwork of delicate tempera – water-colour mixed with diluted glue.

Pencil sketch
This drawing is a study for Blake's water-colour, shown on the opposite page. The main elements of Cain's pose are rendered with brisk strokes of the pencil.

British Museum

The Story of Cain and Abel

And Adam knew Eve his wife; and she conceived and bare Cain, and said, I have gotten a man from the Lord.

And she again bare his brother Abel. And Abel was a keeper of sheep, but Cain was a tiller of the ground.
. . .
And Cain talked with Abel his brother: and it came to pass, when they were in the field, that Cain rose up against Abel his brother, and slew him.

And the Lord said unto Cain, Where is Abel thy brother? And he said, I know not: Am I my brother's keeper?

And he said, What hast thou done? The voice of thy brother's blood crieth unto me from the ground.

And now art thou cursed from the earth, which hath opened her mouth to receive thy brother's blood from thy hand.
. . .
And Cain went out from the presence of the Lord, and dwelt in the land of Nod, on the east of Eden.

Genesis, Chapter 4

(right) A 14th-century manuscript illumination emphasizes the bloodiness of Cain's deed. Like Blake, the artist chooses a spade for the murder weapon, for Cain was 'a tiller of the ground'.

Bodleian Library film strip

Tate Gallery, London

The setting sun
Blake applied powdered gold as well as paint to the mahogany panel. Here it suggests the fiery glow of the sun. The technique may have been suggested to Blake by medieval manuscripts.

A water-colour version
Blake painted this water-colour in about 1805. Although the composition is almost identical to the later tempera version, the colour schemes are noticeably different.

> 'I am under the direction of messengers from heaven.'
>
> William Blake

Adam's anguish
The head of Adam is drawn in much less detail than that of his murderous son, but powerfully conveys the father's numb horror and confusion.

Fogg Art Museum, University of Harvard

257

Friedrich

1774 – 1840

The greatest of the German Romantic artists, Caspar David Friedrich devoted his life to landscape painting, creating mysterious and compelling images of remarkable spiritual intensity. A serious, melancholy figure, whose forbidding appearance was softened by a childlike simplicity, he was only truly content when contemplating the rugged landscapes of his Pomeranian homeland or the stunning German countryside.

Friedrich spent most of his life in Dresden, where he supported the German patriotic movement in the Wars of Liberation. He enjoyed moderate success as an artist, attracting the patronage of the Prussian and the Russian royal families, and made a successful marriage in his mid-forties. But after a major stroke in 1835 he was forced virtually to abandon oil painting. He died in 1840, a sad and broken man.

The Large Enclosure near Dresden *1832*
29″ × 40″ Gemäldegalerie, Dresden

The Melancholy Romantic

A devout, introspective man, Friedrich spent much of his time alone in the countryside of his beloved Germany. But marriage at 44 to a young, gentle wife brought him unexpected domestic happiness.

Caspar David Friedrich was born on 5 September 1774 in the small town of Greifswald on the Baltic coast, the son of a candle-maker and soap-boiler. Friedrich's father, Adolf Gottlieb, was a fairly successful businessman, but more importantly he was a devout Protestant. And like many middle-class children in northern Germany at the time, Caspar David and his nine brothers and sisters experienced a strict, and almost spartan upbringing. This way of life had a lasting influence on the artist: years later, visitors would comment on the frugality of his home and studio.

It seems that Friedrich always had a natural tendency towards introspection and melancholia. This was intensified by a tragic series of deaths in his childhood: he lost his mother in 1781, when he was just seven years old, and two sisters – one in 1782 and another in 1791. But the most traumatic event was the death of his brother, who drowned while trying to save Friedrich himself in a skating accident. This seems to have added a sense of guilt to his grief, making the contemplation of death almost a duty for him. As he later put it: 'To live

Friedrich/Mutter Heiden/Private Collection

'Mother Heide'
Caspar David's mother died when he was seven years old. After her death, the kindly 'Mother Heide' was employed to keep house and look after the children.

A.G. Friedrich/Oskar Reinhart Foundation. Winterthur

The artist's father
Friedrich drew his father, wrapped up in winter clothes, during a visit home in 1801-2. Adolf's devout, frugal way of life had a lasting influence on him.

Kunsthalle, Hamburg

Friedrich at 27
(left) A sepia self-portrait shows the artist at the time he specialized in this technique. He portrays himself with the trappings of his trade: an eyeshade and a bottle of brown ink or water attached to the buttonhole of his coat.

Memories of home
(right) Friedrich based this imaginary view of a harbour in moonlight on his childhood home of Greifswald. The image of silhouetted ships on still water held a lifelong fascination for him.

Medieval ruins

The ruined Cistercian abbey of Eldena just outside Greifswald provided Friedrich with a picturesque motif which he used again and again in his paintings.

one day eternally, one must give oneself over to death many times.'

The fact that Friedrich's preoccupation with religion and death led him to devote his life to landscape painting makes him very much a child of his time. Possibly the works of a local poet, L.T. Kosegarten, first turned his thoughts in this particular direction. For Kosegarten, who was an admirer of such English nature poets as Thomas Gray, was a pastor as well as a poet, and found religious inspiration in the contemplation of nature, which he referred to as 'Christ's bible'.

PICTURESQUE LANDSCAPES

Caspar David's first art teacher, Johann Gottfried Quistorp, was a friend of Kosegarten. He seems to have nurtured his young pupil's poetic sentiments, but may also have had a more practical purpose in mind when he encouraged Friedrich's specialization in landscape painting. For the vogue for nature poetry had stimulated the public taste for paintings of the countryside – in particular for picturesque views with primeval or medieval associations. And such views were in rich supply for the young painter: indeed, he was surrounded by them in the remote north German province of Pomerania where he lived. There were many signs of pre-historic settlements in the area, particularly

the huge dolmens known as 'Giant's Graves' on the island of Rügen, just off the Baltic coast. The ruined medieval abbey of Eldena a few miles from Greifswald also inspired him.

When he was 20, Friedrich left his home town and travelled to the Danish capital, Copenhagen, to study art. The academy there was the most celebrated in northern Europe, and Friedrich came into contact with the severe Neo-Classical style prevalent at that time. Like all other students, he set about studying the human figure, but was also strongly influenced by the work of one of his teachers, Jens Juel, who often painted local views full of mood and with sentimental associations. Friedrich felt at odds with the strict, academic

Key Dates

1774 born in Greifswald, on north German coast

1781 mother dies

1787 brother drowns while trying to save Friedrich's life

1794-8 studies art at Copenhagen Academy

1798 settles in Dresden

1803 possible suicide attempt

1805 awarded joint first prize by Goethe for two sepias at Weimar exhibition

1808 exhibits *Cross in the Mountains*

1810 *Abbey in the Oakwoods* bought by Crown Prince of Prussia. Elected member of Berlin Academy

1818 marries Caroline Bommer; visits Greifswald and Rügen

1825 suffers stroke

1835 suffers further severe stroke

1840 dies in Dresden

Port by Moonlight/Oskar Reinhart Foundation, Winterthur

The cliffs of Rügen

Friedrich made several visits to this starkly beautiful island off the Pomeranian coast, and was inspired by its sheer, chalk cliffs and rocky shoreline.

approach to art which he encountered at Copenhagen, and later wrote: 'All the teaching and instructing kill man's spiritual nature.'

In 1798, after a brief stay in Berlin, Friedrich went to live in Dresden, which was to remain his base for the rest of his life. The Saxon capital was one of the main art centres of Germany, with a fine collection of Old Masters and a flourishing community of artists and intellectuals. He only ever left the city to visit his relatives back in his native Pomerania, and to make journeys in northern and central Germany to gather material for his landscapes.

At first Friedrich's existence was harsh, but although he lived a somewhat secluded life, the letters written during his first years in Dresden indicate that this was a relatively happy time. Until his name became known in the city, he made his living in various ways: he was employed as a drawing master and even resorted to acting as a guide for tourists. Gradually, he built up a reputation for views of the wild areas of his homeland.

Staring eyes
(left) Friedrich created this disturbing self-portrait when he was 37. Its most distinctive features are his staring eyes and the long side-burns, which he may have grown to hide the scar resulting from a suicide attempt in 1803.

The poet Goethe
(right) In 1805, Germany's leading poet Johann von Goethe gave Friedrich first prize in the Weimar art exhibition. Though he admired Friedrich's skill, Goethe did not approve of his subject matter.

Nationalgalerie, West Berlin

The move to Dresden was critical to Friedrich, for he arrived around the time when the city was becoming the centre of an influential group of writers and critics known as the 'Dresden Romantics'. Rejecting the dry rationality of the classical age, they turned instead to an exploration of the exotic, irrational and mystical aspects of experience. One of the major figures of the group, the critic Friedrich Schlegel, was the first to use the word Romantic to describe the dynamic spirituality of the 'modern age'. And though Friedrich had little contact with the leading members of the group, he had friends among their circle, and quickly absorbed their ideas.

ATTEMPTED SUICIDE

It was around 1800 that the artist first began to introduce the mystical and dramatic themes expounded by the Dresden Romantics into his pictures. But there may have also been personal reasons behind this change in his art. Around 1803 he went through an acute period of introspection and depression, and is reported to have tried to kill himself by cutting his throat. There is even a tradition that he grew his beard in order to hide the resulting scar. It is certainly true that Friedrich cultivated a monk-like appearance after this date, acquiring a reputation as an isolated eccentric.

Despite this traumatic incident, the period

The Cross in the Mountains (1808)
This stunning altarpiece stirred up a great controversy when Friedrich exhibited it in 1808. The idea of a devotional landscape painting was anathema to many of his contemporaries, and arguments between supporters and opponents of the painting raged in the newspapers for over two years. Friedrich's most vehement critic, Freiherr von Ramdohr, thought it a 'veritable presumption, if landscape painting were to sneak into the church and creep on to the altar'.

Staatliche Kunstsammlungen, Dresden

J.H.W. Tischbein/Goethe in the Roman Campagna/Städelsches Kunstinstitut, Frankfurt-am-Main

marks the beginning of his success as an artist. Over the next 10 years Friedrich was to become celebrated throughout Germany, and was patronized by such influential leaders as the Prussian Royal Family and the Duke of Weimar.

An important moment came in 1805 when he shared first prize for the sepias (paintings in a monochrome brown wash) that he sent to the annual exhibition in Weimar. The prize was awarded by the Weimar Friends of Art – in effect, the poet Johann Wolfgang von Goethe and his friend the painter Heinrich Meyer. Goethe was the most celebrated poet and leading cultural figure in Germany at that time and had established an annual art competition in Weimar in the hope of raising pictorial standards. Since his own artistic tastes were classical, it was a rare departure to award a prize for landscape paintings.

Friedrich's growing reputation seems to have encouraged him to move from sepia to the more challenging technique of oil painting. The results of this change can be seen most dramatically in his

Travels in the Mountains

Friedrich made many trips into the remote countryside of Germany, to commune with nature and collect motifs for his paintings. He restricted himself deliberately to his own homeland, and never left Germany after 1798.

Although he preferred to be alone on his travels, Friedrich occasionally made trips with fellow artists. In July 1810, he went on a sketching tour of the Riesengebirge – the 'Giant Mountains' to the south-east of Dresden – with his friend Georg Friedrich Kersting. The dramatic scenery impressed him greatly, and the journey provided him with images which he used in paintings up to 25 years later.

The travelling artist
This water-colour by Kersting shows Friedrich – his pack on his back – during their sketching tour of the mountains.

Spectacular scenery
The vast panoramic views of the Riesengebirge had a powerful impact on Friedrich's imagination.

The Struggle against Napoleon

Friedrich was an ardent patriot, and when Germany came under the domination of Napoleon in 1806, he was a firm supporter of the German struggle to expel the French from his fatherland. Even before the outbreak of the Wars of Liberation in 1813, he belonged to a group of nationalist writers, philosophers and painters, which included his friend Georg Friedrich Kersting. Unlike Kersting, he took no active role in the fighting, but allied himself to the Freedom Fighters and celebrated their victory against Napoleon in the Battle of Leipzig with a symbolic painting of a French cavalryman about to be swallowed up by a German pine forest.

G.F. Kersting/Soldiers on Sentry Duty/Nationalgalerie, West Berlin

Bulloz

The Battle of Dresden
(left) The Battle of Dresden in August 1813 was the last of Napoleon's victories in Germany. Two months later, he was defeated by the Germans at Leipzig.

Freedom fighters
(above) Three nationalists pose in their resistance uniforms. Friedrich expressed his allegiance to the cause by wearing such a costume.

highly controversial picture, *The Cross in the Mountains* (p.262). Completed in 1808, it shows a silhouette of a mountain top with a cross on it. Contemporaries were astounded that the artist had chosen a 'view' to function as an altarpiece, but Friedrich even designed a special frame for it, with religious symbols to emphasize the point.

Although he was harshly criticized for this work, the notoriety it brought him appears to have done Friedrich more good than harm. In 1810, he enhanced his reputation further when he exhibited *Abbey in the Oakwoods* (pp.98-99), and its companion picture *Monk by the Sea*. The pictures were acquired by the Prussian Crown Prince, and Friedrich was made a member of the Berlin Academy.

Friedrich's success as a strange and extreme artist was closely related to the current vogue for the Romantics. Since 1806 Germany had been overrun by Napoleon, and Romanticism became a cultural rallying point, a patriotic means of emphasizing 'Germanness'. Its pure spirituality, naturalism and vigour were in stark contrast to the

Woman at the Window (1822)
Four years after his wedding, Friedrich painted this tender picture of his young wife Caroline at the window of their house in Dresden, overlooking the River Elbe.

Nationalgalerie, West Berlin

'artificial posturings' of French art, and Friedrich – the wild man from the north – was an appropriate symbol for such a movement.

But the movement that enhanced Friedrich's reputation also helped bring about its decline. At a time when Germany was divided into a number of small states, Friedrich was among those patriots who sought unification of the country, as a means of bringing about a democratic society and ending the archaic rule of kings and dukes. But after the Napoleonic Wars, the traditional rulers were very much back in power, seeking to eradicate such radicalism. Friedrich became an increasingly isolated figure, regarded as out of date both for his ideas and for the eccentricity of his art.

A HAPPY MARRIAGE

However, this decline was a slow and gradual one. At first he made a good living from his art, and in 1816 was made a member of the Dresden Academy – a position that carried a small stipend. He felt sure enough of his position to get married in 1818.

Many friends remarked that Friedrich's lifestyle was little altered by the acquisition of a quiet and unassuming partner. He was 44, and his wife Caroline was less than half his age. But there is a new tone of happiness in his letters: 'It is indeed a droll thing having a wife,' he wrote. 'There is more eating, more drinking, more sleeping, more laughing, more bantering, more fooling around.' Deeply fond of children, Friedrich welcomed the arrival of his own two daughters and a son. And from this time, too, his art shows a greater interest in domestic scenes and daily events.

A royal patron
(left) Tsar Nicholas I of Russia bought many of Friedrich's paintings, largely through the encouragement of the artist's faithful friend, the Russian poet Vasili Zhukovsky. Royal patronage was particularly important at the end of Friedrich's life, when he was ill and in dire financial straits.

The city of Dresden
Friedrich made the Saxon capital of Dresden his home from 1798 until his death in 1840. He delighted in its fine art treasures, beautiful architecture and surrounding countryside, describing the city as 'the German Florence'.

Around this time, Friedrich was making new contacts among a younger generation of artists. His most enduring friendship was with the Norwegian artist Johann Christian Dahl, who arrived in Dresden in 1818. From 1823, Friedrich and Dahl lived in the same house, on the banks of the River Elbe.

For the younger generation, Dahl was the leader, and in 1824 it was Dahl, rather than Friedrich, who was appointed to the teaching post of Professor of Landscape at the Academy. Despite this, they remained friends – though there was a dark period when Friedrich suspected his wife of having an affair with his friend. The suspicions were without foundation, and are probably best explained as a consequence of the growing ill health that he endured in his last years.

In 1825 Friedrich suffered a stroke. This was followed by other attacks, the most severe being that of 1835, which left him greatly incapacitated. Yet this period was one of great artistic achievement. He developed a new sensitivity to colour and many of his most poignant works – including *The Large Enclosure* (p.259) and *The Stages of Life* (pp.226-227) come from this time.

This was also the period in which he wrote down most of his ideas on art. Though these mainly consisted of attacks upon the empty naturalism and vainglorious classicism of his contemporaries, there are also positive statements of his spiritual approach to art, including his most quoted remark: 'Close your bodily eye, so that you may see your picture first with the spiritual eye. Then bring to the light of day that which you have seen in the darkness so that it may react on others from the outside inwards.'

When Friedrich died in 1840 he was almost a forgotten figure. Not until the end of the 19th century – when symbolism came back into fashion – did his reputation begin to rise once more.

Landscapes of the Spirit

Friedrich transformed the landscape of his native Pomerania into a mystical world, infused with religious feeling. From precise studies of natural objects, he created strange, otherworldly images.

Caspar David Friedrich is the most important German painter of the Romantic era. He lived at a time when landscape painting took on a new significance, to become a means of celebrating the natural world and the divine power that created it. 'The divine is everywhere,' wrote Friedrich, 'even in a grain of sand.' And for him, the mystical experience of nature was such a central concern that he even painted a landscape for an altarpiece.

ART FROM THE INNER DARKNESS

Before beginning a picture, Friedrich advised an artist to 'close his bodily eye' and then bring to light what he saw in the inner darkness. Accounts of the artist in his studio suggest that he did, to some extent, put this into practice. As the painting by Georg Kersting shows (below), he had nothing but the barest essentials around him so that he would not be distracted from his contemplation. His friend Carus records that Friedrich would stand silently before his canvas until the image of a picture stood 'lifelike before his soul'. Then he would sketch it on to the blank canvas in thin outlines and proceed directly to the painting.

The idea that Friedrich worked entirely from the imagination is slightly exaggerated. It is evident

A grounding in sepia
(left) Before he began to paint in oils, Friedrich worked mainly in sepia ink. He produced small-scale works like the Wanderer at a Milestone *(1802), as well as ambitious landscape views.*

Staatliche Graphische Sammlungen, Munich

Spiritual imagery
(right) Friedrich often used natural elements as religious symbols. In Oak Tree in the Snow *(1829), the leafless tree is a symbol of death, but also of the hope of resurrection. The dead branch on the ground resembles the crucified Christ.*

Friedrich's studio
(left) Georg Kersting's picture of Friedrich in his Studio *(1812) shows the artist standing quietly before a canvas in his bare room. Friedrich felt that ornaments would distract him from his contemplation.*

Morning in the Riesengebirge (1810-11)
Friedrich painted this religious landscape on his return from a walking tour of the Riesengebirge mountains. He built up the composition from sketches he had made on the trip, as well as drawings he had made up to 10 years earlier.

Nationalgalerie, West Berlin

that he consistently used sketches he had made for such individual features as rocks and trees in his pictures. However, he does seem to have used the contemplative method to arrive at his compositions. Despite the fact that his drawings have survived in great number, there are virtually no compositional sketches among them.

This reliance on the mental image emphasizes the visionary nature of Friedrich's work. However, he was not unique – the method was standard among painters of 'ideal' landscapes. What was unusual about Friedrich was that he used the process to arrive at images with powerful, almost hypnotic, impact – memorable images that would stick in the mind.

Early in his career he began to use contrast as a feature of his designs. A central image, like a tree, would be silhouetted against an indefinite background. And Friedrich chose evocative subjects: 'moonlight, sunset glow, the ocean, the

Charlottenburg Castle, West Berlin

Times of Day (1820/21)
(right) These evocations of Morning *and* Evening *are part of a four-picture series showing the 'Times of Day', which – like the four seasons – were traditionally seen as allegories of the stages of life. In* Morning, *a fisherman pushes his boat out through the mists into the deep waters of life. In* Evening, *the setting sun shines through the trees as a promise of eternity.*

beach, snowy landscapes, churchyards, bleak moors, forest torrents, rocky valleys and the like.' Contemporaries were struck by the haunting, enigmatic quality of his work and searched his paintings for hidden meanings.

RELIGIOUS SYMBOLS

Friedrich often used his landscapes to convey religious ideas. In his description of the *Cross in the Mountains* altarpiece (p.262), for example, he wrote that the rock was a symbol of unshakeable faith, while the evergreen fir trees symbolized the eternal hope of mankind. But he also recognized that his paintings could be interpreted on another, naturalistic level. Describing one of his landscapes, he wrote: 'On a bare stony seashore there stands, raised on high, a cross – to those who see it as such, a consolation, to those who do not, simply a cross.'

For the detailed forms in his pictures, Friedrich

Niedersächsisches Landesmuseum, Hanover

Niedersächsisches Landesmuseum, Hanover

267

Nationalgalerie, West Berlin

Man and Woman Gazing at the Moon (1830/35)
(right and below) In this intimate work, the dark moonlit landscape becomes the natural setting for spiritual contemplation. The couple stand together, by the rock of faith, looking at the waxing moon – a symbol of Christ. The ridge of evergreens beyond the dead tree symbolizes mankind's eternal hope of salvation.

drew freely on the sketches that he made on his many journeys through northern and central Germany. By and large it seems that these studies were made because the objects interested him, rather than because he had a particular composition in mind. For the most part they were of single objects or small groups – overall views are much rarer. Nor was he concerned about the original location of the forms he combined in his paintings. Rocks and fir trees from northern Bohemia would be incorporated with dolmens and oak trees from Pomerania, apparently without any qualms. It seems that his main concern was to achieve the most striking effect.

A PROBLEM WITH PEOPLE

When it came to putting people in his landscapes, Friedrich was never very happy painting the figures. In his early works, his friend Kersting sometimes drew the figures for him. Later, Friedrich almost invariably chose to show his figures in back view.

Friedrich only began to paint in oils after 10 years of working in water-colour and sepia. From the first he had thought of these media as the means of colouring or tinting drawings, and this habit affected his method of using oils. He painted very thinly, using small brushes. When painting in

Museum Folkwang, Essen

Woman in the Setting Sun (c.1818)
(above) In some of his more visionary works, Friedrich used a balanced, symmetrical composition. Here, a woman stands transfixed before the sinking sun, an image of God the Father. Like most of Friedrich's figures, she is shown with her back towards us.

TRADEMARKS

Moonlit Landscapes

Trevor Lawrence

Friedrich often bathed his landscapes in bright moonlight, silhouetting natural forms, like a dying tree, against the pale sky. In the enigmatic evening light, these forms become charged with a deeper meaning.

COMPARISONS

Devotional Paintings

When Friedrich designed the *Cross in the Mountains* (p.262) as an altarpiece, he was breaking one of art's most sacred conventions. Traditionally, a religious story or allegory had been told exclusively through the human drama. The figures were immediately recognizable by their attributes – from a simple halo to a palm branch – and the biblical narrative was made explicit through rhetorical gesture and expression. Even in Friedrich's time, it was felt that the imagery of landscape painting was too unfamiliar and obscure for devotional purposes.

Albrecht Dürer (1471-1528) **The Adoration of the Trinity**
(left) This altarpiece was commissioned by a Nuremberg merchant for the chapel of an alms-house. It shows the holy trinity surrounded by adoring saints and Old Testament prophets, with members of the laity and clergy below. The naturalistic landscape beneath them plays a very minor role in the composition.

Mathis Grünewald (1470/80-1528) **The Resurrection**
(right) In this panel from Grünewald's Isenheim Altarpiece *(1515) the biblical story is conveyed through a straight-forward, if bizarre, image. The resurrected Christ hovers above his tomb, displaying his wounds and the moon forms a radiant halo around his head. The simplified nocturnal landscape serves merely as a background setting for the supernatural drama.*

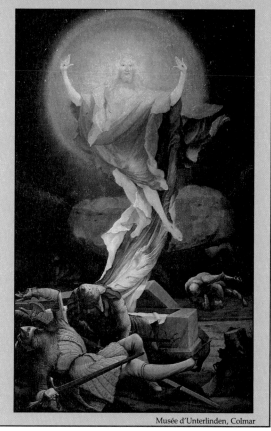

sepia he had been in the habit of 'stippling' areas – covering them with minute dots, to give a sense of texture and vibrancy. In his early oils he used a similar method to convey the brilliance of sunlight or the shimmer of moonlight.

Over the years Friedrich gradually extended his range of colours and the breadth of his brush strokes. In the 1820s, he came under the influence of his friend J.C. Dahl, the Norwegian painter. Dahl was in the habit of using oil to make direct studies from nature and Friedrich followed suit on a number of occasions. His enchanting picture of his wife looking out of the window of his studio (p.264) was painted in this manner.

Friedrich appears to have abandoned this practice after 1824, but did not forget the lessons he had learnt. His last oil paintings are executed in a richer, thicker manner, and show an enhanced sense of colour. This is particularly true of works like *The Large Enclosure* (p.259) and *The Stages of Life* (frontispiece). In these the purples, yellows and deep blues of the evening sky are conveyed in broad, smooth areas of paint.

Friedrich also continued to paint in water-colour and sepia throughout his life, but he tended to use these media more for topographical than for imaginative work. Only after his stroke in 1835 did he return to using sepia predominantly, painting images which are often meditations on death.

THE MAKING OF A MASTERPIECE

The Stages of Life

Friedrich probably painted *The Stages of Life* in 1835, shortly before his second major stroke. It shows the popular promenading point of Utkiek in Wieck, where the people of Greifswald often went to watch the ships as they approached Greifswald harbour. The five figures on the shore have been identified as Friedrich himself and members of his family. They are mirrored by five ships on the sea, sailing quietly towards the bay. Their mysterious silhouettes and the strange gestures of the figures suggest that this is more than just a memento of a family excursion. The picture has been interpreted as a metaphorical voyage through life, ending in death – 'the eternal resting place'.

Fishing tackle
(above) Friedrich based this section of the painting on a sketch he had made in Greifswald, 17 years earlier. The long poles with red flags were used to mark the nets lying on the shore. It has been suggested that the hauled-in nets, like the overturned boat further along the beach, are symbols of mortality and death.

Greifswald Harbour
(left) Friedrich painted the harbour of his native town repeatedly, always using the same evocative imagery. He saw the harbour as a place of death, where skeletal ships found peace after their arduous voyages.

A Swedish birthplace
(above) The two small children in the picture are waving the Swedish flag, for Friedrich's Greifswald was originally part of Swedish Pomerania. In 1815, however, Swedish Pomerania was absorbed into Prussia.

A vivid sunset
(right) The ships are silhouetted against a poetic evening sky, streaked with violet and yellow, and with a glimpse of the sickle moon.

Early pencil sketches
(below) The studies of ships that Friedrich used for the painting date back to 1818. Years later, he has emphasized the mast's crucifix form.

Museum der Bildenden Kunst, Leipzig

Nasjonalgalleriet, Oslo

'The beauty of nature reminds our soul of life and of what is beyond it.'

Vasili Zhukovsky

The Four Stages of Life

The figures in the picture represent the four stages of life – childhood, youth, maturity and old age. Friedrich's young children, Gustav Adolf and Agnes, play with a flag, watched by his eldest daughter, Emma. The man facing us is probably a nephew; the elderly man is Friedrich himself.

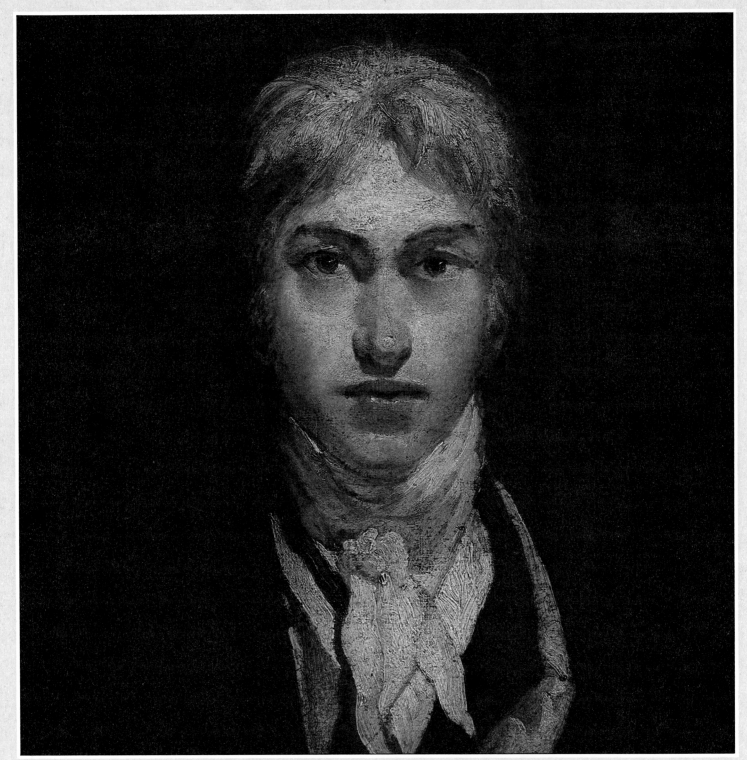

JMW Turner RA

1775-1851

JMW Turner was one of the greatest of all British artists. He worked extremely quickly, but the brilliance and originality of his painting is unrivalled. By the age of 30 he was a successful artist and a prominent member of the Royal Academy, yet he remained a gruff, reclusive and intensely secretive character, renowned for his unkempt dress and meanness with money.

Brought up in London, he was fascinated by the Thames: water and ships were always his strongest inspiration. The river-side area of the city remained his home base all his life, but he travelled extensively – throughout Britain and Europe – in search of new dramatic landscapes to paint. When he died at the age of 76, he left a vast legacy of over 20,000 works.

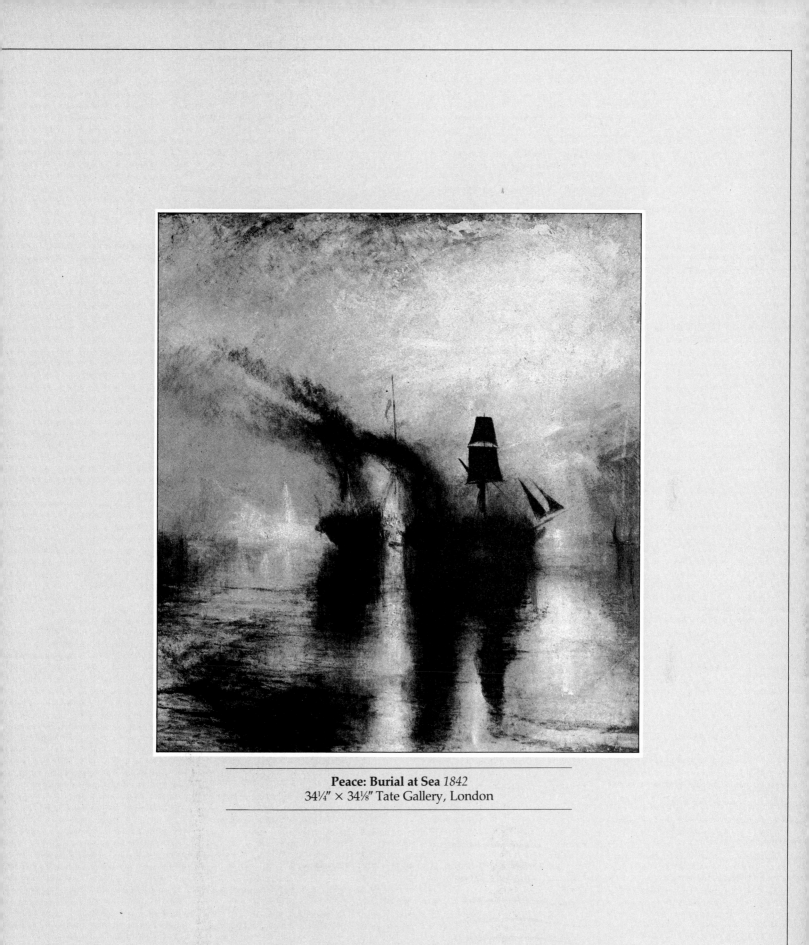

Peace: Burial at Sea *1842*
34¼″ × 34⅛″ Tate Gallery, London

Genius at the Academy

Despite his abrupt, unconventional manner and daringly original style of painting, Turner was proud of his prominence in the Royal Academy – the home of Britain's artistic establishment.

Key Dates

1775 born in Covent Garden, London

1790 exhibits first work at RA

1799 elected associate member of RA

1800 mother admitted to Bethlem Hospital for the insane

1802 elected as full member of RA. First trip to continent

1807 made professor of perspective at RA

1819 first trip to Italy – made 1,500 sketches in two months

1828 second visit to Italy

1829 death of father

1833 meets Mrs Booth, his mistress for life

1838 paints *The Fighting Temeraire*

1843 Ruskin's *Modern Painters* published: a defence of Turner

1844 paints *Rain, Steam and Speed*

1851 dies in Chelsea

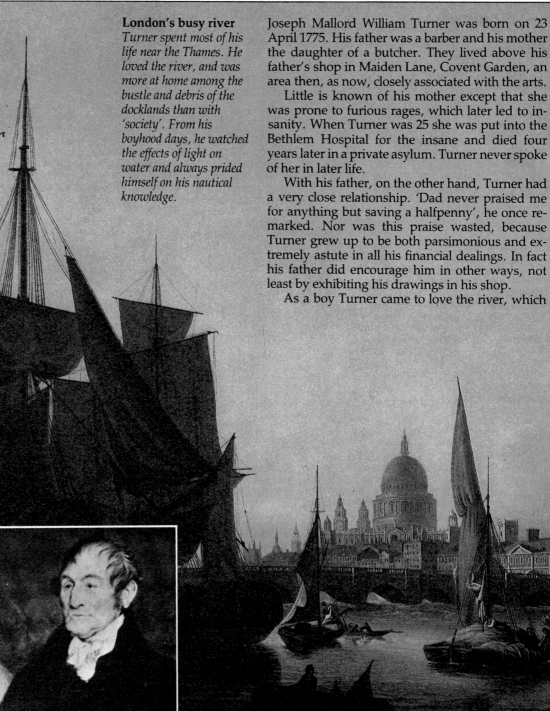

London's busy river
Turner spent most of his life near the Thames. He loved the river, and was more at home among the bustle and debris of the docklands than with 'society'. From his boyhood days, he watched the effects of light on water and always prided himself on his nautical knowledge.

Turner's 'Daddy'
The artist and his father were devoted to each other. 'Daddy' encouraged his son's gift from the beginning, and exhibited Turner's youthful drawings in his barber shop. He also encouraged the carefulness with money for which the artist became renowned. When Daddy died in 1829, Turner said he felt as if he had lost an only child.

Joseph Mallord William Turner was born on 23 April 1775. His father was a barber and his mother the daughter of a butcher. They lived above his father's shop in Maiden Lane, Covent Garden, an area then, as now, closely associated with the arts.

Little is known of his mother except that she was prone to furious rages, which later led to insanity. When Turner was 25 she was put into the Bethlem Hospital for the insane and died four years later in a private asylum. Turner never spoke of her in later life.

With his father, on the other hand, Turner had a very close relationship. 'Dad never praised me for anything but saving a halfpenny', he once remarked. Nor was this praise wasted, because Turner grew up to be both parsimonious and extremely astute in all his financial dealings. In fact his father did encourage him in other ways, not least by exhibiting his drawings in his shop.

As a boy Turner came to love the river, which

A life class at the RA
Turner entered the RA school at the age of 14 and became a professor there at 32. He remained fiercely loyal to the Academy throughout his life, referring to it as his mother. His own mother had died in a mental asylum when he was 29.

The artist at 21
While at the RA school, Turner earned money in the evenings by copying other artists' work at the 'academy' run by Dr Monro, who sketched this portrait of his talented employee in 1796. In the same year, Turner exhibited his first oil painting at the RA.

was within a few minutes' walk of his home. The restless water of the Thames, the ever-shifting play of light on its surface, fog and mist rising from it to veil the ships' sails and rigging, as well as the business of the dockside, were scenes which haunted him all his life. He saw something of the countryside too when he was sent, for the sake of his health, to stay with his butcher uncle in Brentford, where he attended the Free School.

Turner received no definite education in art. Such training as he did pick up, however, combined with his great natural talent, were enough to qualify him, at the age of 14, for free tuition at the Royal Academy school. The following year, 1790, he successfully submitted a water-colour for the

Academy's annual exhibition. During the next ten years he not only worked hard, but learnt fast, and soon attracted both critical approval and patrons.

While at the Royal Academy he studied with Thomas Malton, who painted detailed water-colours of architectural subjects. And for three years from 1794, Turner worked at the 'Monro School', copying other artists' works for 2/6 an evening. Among the artists whose work he copied was JR Cozens. Turner's contemporary (and rival) Thomas Girtin copied the outlines; Turner added water-colour washes. Cozens' wild, romantic landscapes from Switzerland and Italy seem to have inspired the young artist to see and paint such scenes himself. By 1798 he was able to say that he had more commissions than he could fulfil.

A MOROSE, SECRETIVE CHARACTER

In stature Turner was short, and he later grew stocky and heavy, though he never lost his formidable energy. His face was dominated by a prominent nose and a pair of vigilant eyes. Most portraits show him to have been somewhat dishevelled, probably the result of his lifelong habit of saving money by buying cheap clothes. In manner he was abrupt and taciturn, even morose, and only revealed the warmer side of his character with people he knew very well. He allowed an air of mystery to surround his working methods and he was notoriously secretive about his private life.

J.T. Serres/River Thames

In the year he joined the Academy school he made the first of the innumerable journeys which were to form the pattern of his professional life. He displayed a tremendous stamina for travelling, to which he added an indefatigable capacity for making rapid, incisive sketches in his notebooks. These became the basis of many 'topographical' watercolours: the detailed studies of Gothic buildings he painted until 1796 when he showed his first exhibited oil painting, *Fishermen at Sea*. The picture is a moonlit scene, dramatically illustrating the dangers undertaken by fishermen as they struggle in a gale just off the Isle of Wight's Needles.

After only his second application, Turner was elected an Associate of the Royal Academy on the last day of the 18th century. Unlike Constable, his near contemporary, Turner was by this time financially independent. As a result, he was able to leave home in 1800 and take lodgings in Harley Street. Around this time he also began to support Sarah Danby, a recently widowed woman with four children. She bore two of Turner's children and their relationship continued for some years, but he never married her or lived with her. If the erotic drawings he made of nude women during this period are anything to go by, Turner's nature had a vigorously sensual side; however, he did not permit any relationship to encroach on his ruthless programme of work.

In the spring of 1799, William Beckford, a rich collector of art and one of Turner's patrons, invited the public to his house to study a pair of famous paintings by Claude. These works had a decisive impact on Turner, who immediately decided to paint historical pictures on the same grand scale. It was a typical reaction: instead of being overawed

Travels along the Rhine
Turner visited the mountainous Rhineland on four occasions. He was always stimulated by new, dramatic landscapes, and made frequent sketching tours in Britain and Europe.

Lord Egremont of Petworth

After the death of his father, Turner found solace in frequent visits to Petworth, the ancestral home of the kindly eccentric Lord Egremont, a patron of the arts. Between 1831 and the peer's death in 1837, Turner often lived for months at a time in the casual elegance of his Sussex estate.

Lord Egremont was renowned for his easy-going hospitality, his generosity and his innumerable mistresses. Petworth was often filled with aristocratic houseguests, but amid the well-heeled gaiety, the reclusive artist was free to keep himself to himself. He had his own studio on the top of the mansion where he could work in isolation.

A patron of the arts
George O'Brien, 3rd Earl of Egremont was a keen collector of art, both past and present. He also offered hospitality to artists such as Turner, who painted The Square Dining Room at Petworth *(right).*

Snowstorm, Mount Cenis

When Turner attempted to cross the snow-laden Alps on his way back from Italy in January 1820, the stagecoach overturned on the summit of Mount Cenis. Turner had to make the long descent by foot. He recorded the incident the same year in this water-colour.

Birmingham Museum and Art Gallery

by the old masters, Turner instinctively responded by trying to imitate, compete with and, if possible, surpass them. Throughout his life, he was renowned for his fiercely competitive attitude towards his fellow artists.

In 1802, when Turner was still only 26, he was elected a full member of the RA. Despite periodic disagreements with his colleagues and occasional absences from its exhibitions, he made the Academy his professional and emotional home for the rest of his life. He always remained loyal to the RA, seeing it almost as his 'mother' – just as he saw his paintings as his 'children'.

PROFESSOR AT THE ACADEMY

In 1807 (at the age of 32) Turner was made professor of perspective at the RA. And although his pupils regularly turned up, they learnt little. Turner would spend the whole time mumbling to his assistant, and no-one could hear a thing.

Turner made his first trip to the Continent in 1802, soon after the Treaty of Amiens had been signed. Having looted many of the great art collections during his conquest of Europe, Napoleon decided to put his treasures on show at the Louvre and Turner was one of the first painters to cross the Channel to see them. He landed at Calais in a high gale which, typically, he sketched on the spot, adding the caption 'nearly swampt'.

Before going to Paris, he fulfilled a long-held ambition by travelling to Switzerland. To save money, he bought his own small carriage. The journey was hard and exhausting and later he talked slightingly of the country, but he made over 400 small drawings in his sketchbooks, and the

The British Museum

Riverside retreat

Turner had Sandycombe Lodge built beside the Thames at Twickenham in 1811. He called the place Solus Lodge at first – referring to his desire to be alone.

him, but nothing affected him more profoundly than the Italian light. In only two months he made nearly 1,500 pencil sketches in and around Rome and he was able to watch and draw a timely eruption of Vesuvius, a spectacle much to his taste.

From now onwards Turner was determined to express his own vision of light and its power. No other artist before him had brought the same intensity to the treatment of light as pure colour. He made no dramatic break with the past, but there was a noticeable division between work he did to maintain his income and experimental paintings in which his originality was fully realized.

He continued to travel and to accept commissions. Among these was a royal commission to portray the battle of Trafalgar, in which he tried to put his undoubted patriotism and his love of the sea, while also ensuring strict nautical accuracy. To his great disappointment, the picture was not well received at Court. In 1828 he was back in Rome and

The fascinations of Venice
Turner visited Venice on several occasions, and became fascinated by the extraordinary quality of the city's light as it reflected off the canal water.

Swiss Alps were among the subjects he returned to most often in his painting. Back in Paris ten weeks later, he devoted himself to a thorough study of more than 30 paintings in the Louvre.

His financial position continued to improve and in 1804 he felt confident enough to extend his house in Harley Street by building a large exhibition gallery where he held his own one-man shows. This was a novelty among British painters, but throughout his life Turner was increasingly concerned that his work should be seen and understood as an evolving whole.

For the next 15 years Turner confined his travels to Britain, visiting the homes and estates of his patrons and making studies of landscape and architecture. His passion for ships, the sea and rivers, never diminished. He sketched HMS *Victory* when she entered the Medway in 1805, still carrying the body of Nelson on deck.

After living in Hammersmith for a time, he moved up the river to Isleworth, where he supervised the building of a new house on land at Twickenham which he now owned. Here he was joined by his father, who took charge of his business affairs and acted as his studio assistant.

As his career progressed, Turner was slowly recognized as one of the country's leading landscape painters. Despite the violent hostility of Sir George Beaumont, one of Constable's patrons, Turner's importance became undeniable in 1819 when two major exhibitions included his work.

FIRST VISIT TO ITALY

That same year, 1819, saw a radical turning point in his life, for he made his first visit to Italy. He was now 44 and at the height of his powers. Every aspect of Italy and its art seems to have impressed

Turner's Secret Life

Turner was exceptionally secretive, especially over women. He kept a mistress first in Margate, then London, and assumed her surname – Booth.

The mystery which surrounds Turner's private life was increased when the art critic John Ruskin destroyed many of his dead hero's erotic pictures. Supposedly, these were executed during weekends of drunken debauchery amid the dockside taverns of Wapping, East London.

Erotic secrets
One of Turner's erotic sketches. Many such 'lewd' pictures were destroyed after the critic John Ruskin discovered them among the Turner bequest in the National Gallery vaults: he thought they tainted his idol's memory.

Puggy Booth
To maintain secrecy during his life with Mrs Booth, Turner adopted her surname. His physique earned him the unfortunate nickname 'Puggy Booth'. Even in silhouette, his beaky nose and stout, gnome-like figure are easily recognizable.

Turner's East End pub
(right) Taverns were popular and lucrative in the dockside areas of Turner's London. So when the artist inherited property in Wapping, he decided to make it earn money for him. He converted his two cottages into a pub.

a new explosive impact of colour developed in his paintings.

The death of his father the following year at the age of eighty-five was a tremendous blow. Indeed, a friend said later that, 'Turner never appeared the same man after his father's death; his family was broken up'. Visits to Petworth house as the guest of Lord Egremont brought some solace and provoked a series of dazzling interiors.

Soon after, around 1833, it appears that he sought comfort of a more personal kind through his relationship with Sophia Booth, a landlady in Margate. Like Sarah Danby, Mrs Booth was only recently widowed when Turner began to take an interest in her, and she too had independent means; in fact, she had been married twice before. As usual, mystery cloaks the relationship, but Turner kept her as his companion until he died.

In the early 1830s he began to exhibit scenes of Venice and following a visit there in 1835 the city

The British Museum

The Turner Bequest
Turner thought of his paintings as his children and wanted them to be kept together after his death. The South Kensington Museum (above) provided a temporary home, but the collection gradually dispersed. The Tate now holds the biggest number.

and its extraordinary light became an obsession with him that lasted throughout the remainder of his life. It was an attack on one of his first Venice pictures that led the critic John Ruskin, then only 17, to write a pamphlet in his defence. This gesture ultimately led to the publication of Ruskin's five famous volumes on *Modern Painters*.

The last phase of Turner's life produced many of his most famous pictures, including *The Fighting Temeraire, Rain, Steam and Speed* and *Peace – Burial at Sea,* his homage to Sir David Wilkie, an old friend and rival who had died at sea on his way back from the Middle East. He did not lose his zest for painting nature in the raw and went so far as to have himself lashed to the mast of the steamboat in order to sketch a storm.

A GALLERY IN CHELSEA

He bought a house at Cheyne Walk, in Chelsea, where he installed Mrs Booth and built a small gallery in the roof. The house faced south and stood on a bend in the river; from his bedroom he could look out on the water and its traffic. He became more reclusive than ever, calling himself Mr Booth. By now he was over 70 and his health was beginning to fail at last.

With deliberate finality, Turner titled the last picture he sent for exhibition at the RA *The Visit to the Tomb.* He died, on 19 December 1851, in his bedroom overlooking the Thames.

He was buried in St Paul's Cathedral. Before the funeral, the mourners gathered in his picture gallery and were astonished to see the huge numbers of paintings collected there, many of them rotting in their stretchers and stained by water dripping from a skylight. In his will he left some 300 oil paintings and nearly 20,000 water-colours to the nation, asking that they should be housed in a special gallery. He also directed that his fortune, which amounted to £140,000, should go to founding an institution for needy male English artists. His wishes have not been respected.

The Drama of Nature

Turner began his career as a precise recorder of picturesque places, but developed into one of the great painters of the imagination, conjuring dramatic visions from the full majesty of nature.

Turner is generally considered to have been the most original genius of landscape painting of the 19th century, though it would be true to say that by the end of his life he had become a painter, not of land, sea and sky, but of light itself. Certainly, no other painter matched the sheer brilliance of his colours, and none used light to create such powerful and overwhelming images of nature and its impact on human destiny.

A TASTE FOR THE PICTURESQUE

As a young man, Turner was gifted with both a precocious talent and a strong sense of ambition. Devoted from the first to landscape, he received some training in topography (the detailed depiction of places) and soon became adept at drawing ruined abbeys, crumbling castle walls, decaying villages and subjects favoured by a fashionable taste for the 'picturesque'. Turner's visual memory was extremely acute, and never forsook him, but his engravings and water-colours of this early period were based, as were almost all his works, on the innumerable sketches he always made on his journeys, whether to the Scottish Highlands or

Ashmolean Museum. Oxford

Tintern Abbey
Gothic ruins made a strong appeal to Turner's romantic imagination: he painted many such views in his early career. This water-colour dates from about 1795.

The Thames near Walton Bridges
(below) In 1806-7 Turner made numerous outdoor oil sketches of the Thames. This one, showing a famous beauty spot in Surrey, is painted on a wooden panel.

The Slave Ship (1840)
(detail above) Turner loved the sea and depicted its moods with a violent intensity that no other painter matched. This picture is based on the true story of a ship's captain with an epidemic on board: he threw his cargo of slaves overboard, as he could claim insurance on those who drowned, but not on those who died of disease.

Tate Gallery, London

Glacier Valley of Chamonix (1802)
(right) During his first visit to Switzerland, Turner filled six sketchbooks with more than 400 drawings. Like this one, they often show the awesome grandeur of the Alps.

British Museum, London

The Parting of Hero and Leander (detail)
(right) Turner often made mythological stories the basis of his landscapes. For some contemporary critics the power of his imagination was too strong: one called this work, dated 1837, 'the dream of a sick genius'.

National Gallery, London

Museum of Fine Arts, Boston

British Museum, London

Venice: Moonrise
(1840)
The beauty of Venice was irresistible to Turner. This superb water-colour, done on his third visit to the city, shows the expressiveness of his technique. According to an eye-witness, he poured wet paint on to the paper, then 'he tore, he scratched, he scrubbed at it in a kind of frenzy'.

the Swiss Alps. He was tirelessly energetic and got up in time to see the sun rise whenever he could.

Once he had taken up oils, he made a name for himself by adapting the style of other famous landscape painters to the romantic style of his day. These versions of such masters as Claude, Richard Wilson and Rembrandt were made in a spirit of rivalry, rather than homage. Throughout, he freely indulged his preference for the melodramatic and catastrophic. Whirlwinds, avalanches, storms at sea and the destruction of great civilizations were his constant subjects.

Due entirely to his own neglect of them, many of Turner's oil paintings were badly damaged during his lifetime, but fortunately his huge collection of sketches was much better preserved. In 1806-7 he was painting oil sketches directly from nature; as often as not, his subject was the Thames Valley, which he painted while being rowed in a boat. Their vivid grasp of detail and atmosphere anticipates Constable's equally celebrated sketches by almost ten years.

THE ROMANCE OF THE RIVER

Turner associated London and the Thames with other great civilizations – Venice, ancient Rome and Carthage. In one of his Thames sketchbooks, Phoenician ships sweep down the river at Twickenham. Turner was fascinated by every kind of ship and boat, and prided himself on his nautical knowledge. No sooner had HMS *Victory* limped

into port after the Battle of Trafalgar, than Turner was on board, interviewing the crew and making numerous sketches.

Despite his mastery of oils, Turner never lost his interest in water-colours, which he used both as an aid to his memory in sketches and as a serious medium in its own right. In fact, his technique in oils was indebted to his experiments in water-colours, for he devised a way of floating a beautifully subtle film of mother-of-pearl paint over his canvases, which gave them a unique delicacy.

By 1805, Turner was applying paint boldly and freely, and later began to compose his paintings around circular or winding shapes, allowing the eye to be drawn into his receding whorls of colour. This proved especially effective when he came to paint seascapes. Another typical feature is that Turner's viewpoint nearly always looks directly into the sun. In his later masterpieces, the immaterial vehicles of colour – steam, smoke, mist,

clouds and so on – envelop the forms, which are seen to merge, dissolve and lose themselves in the general blaze of light. Indeed, in some of his most personal works, he dispensed with form altogether, relying entirely on the power of colour.

He realized that one colour had a greater power than two, and two greater than three. Colour now acquired an almost symbolic significance. Jotting down colours in one of his sketchbooks, he wrote 'fire and blood' instead of 'red'.

VIEWS OF VENICE

Turner's tendency towards abstraction did not by any means prevent him painting pictures which, in their subject matter at least, were very particular. His picture *Snowstorm*, painted in 1842, carried the subtitle *Steamboat off a Harbour's Mouth Making Signals in Shallow Water and Going by the Lead*, which shows both his love of circumstantial detail and

COMPARISONS
Views along the Thames

The River Thames provides some of London's finest views and has long been a favourite subject with artists. Their work reflects the changing pattern of activity on and along one of the world's busiest waterways.

Apart from Turner, two of the greatest painters to be inspired by the Thames were the Italian Canaletto, who spent most of the decade 1746-56 in England, and the French Impressionist Claude Monet, who first visited London in 1870-71. In the two paintings shown here, Canaletto's deft brush brings to life a wealth of incident on and off the water; Monet shows the much more sober commercial world of the age of steam.

Claude Monet (1840-1926) **The Thames below Westminster**
Monet is not concerned with giving an accurate representation of the scene – indeed the Houses of Parliament may not be immediately recognized by everyone. Instead, the artist conveys atmosphere, and succeeds marvellously in suggesting the mood of an overcast day.

Canaletto (1697-1768) **The Thames from Somerset House**
Canaletto's painting is detailed and clear, in a bright light that looks more Italian than English. At first glance the picture could be mistaken for one of his views of the Grand Canal in Venice.

National Gallery, London

pride in the painting's factual accuracy. His views of Venice, especially those executed immediately after his visits, are moving exactly because they combine strict architectural authenticity with an almost magical luminosity of atmosphere. And, as the young lady who followed Turner's example by sticking her head out of the train-carriage window was able to confirm, Turner's observation of such phenomena as trains running through storms *(Rain, Steam and Speed)* was also highly accurate.

Turner's avalanches and storms expressed his belief in the insignificance of man faced with the overpowering and destructive force of nature, but at the same time his radiant colours and light testify to nature's life-giving essence. It is the tension between these two great contrary visions that made Turner the genius he was. As Ruskin said of him: 'Here and there, once in a couple of centuries, one man will rise past clearness and become dark with excess of light.'

Turner caricatured
This drawing, published in 1846, shows the mockery Turner endured from uncomprehending critics. His Snowstorm *was described as 'soapsuds and whitewash'.*

Vortex of the Storm

One characteristic feature of Turner's painting is his use of whirling, vortex-like compositions to suggest a sense of energy and movement. The most spectacular example is the famous *Snowstorm* (below, and detail right), where his surging waves make the seas of most other painters look like boating lakes. Turner was on the boat during the storm and is said to have had himself tied to the mast to observe it.

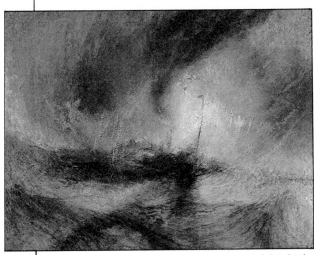

Tate Gallery, London

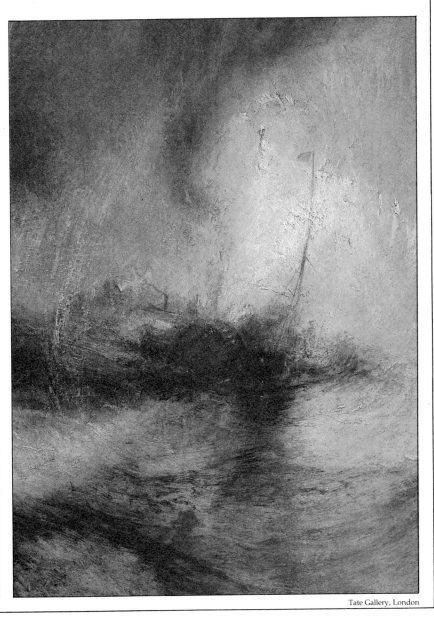

Tate Gallery, London

THE MAKING OF A MASTERPIECE
The Fighting Temeraire

One summer's evening in 1838, Turner was a passenger on a packet steamer chugging along the Thames from Margate to London. Standing by the rail, he watched the warship *Temeraire*, which had fought heroically in the Battle of Trafalgar, being towed up the river by a steamer in the midst of 'a great blazing sunset'. The 98-gun veteran was on her way to the wrecker's yard, to be broken up for scrap. Turner realized immediately that the spectacle would make a magnificent painting, and rapidly made a number of little sketches on cards. The next year *The Fighting Temeraire* was exhibited at the Royal Academy to great acclaim. The novelist William Thackeray, writing under the pseudonym Michael Angelo Titmarsh, summed up the enthusiasm of both public and critics when he compared the picture's effect with a performance of 'God save the Queen'.

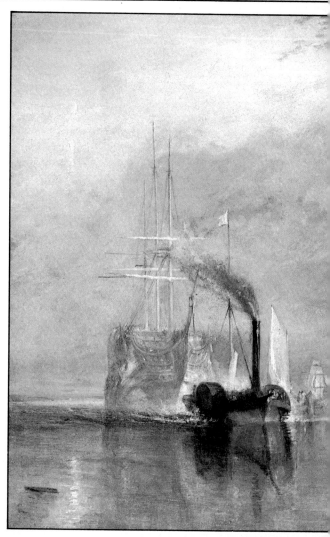

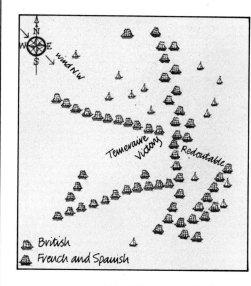

The Battle of Trafalgar
The Temeraire fought her most famous action at the Battle of Trafalgar on 21 October 1805, when she avenged the death of Nelson. The English engaged the combined French and Spanish fleet off Cape Trafalgar, just south of Cadiz, with the Temeraire sailing directly astern of the Victory. A sniper on the Redoubtable shot Nelson from the masthead, and the Temeraire promptly replied by blasting the French ship.

Black and white drama
The silvery-white of the doomed Temeraire endows the ship with a ghostly majesty. But the black tug, belching flame and soot, appears evil, almost demonic. The choice of colours contrasts the declining days of sail with the new era of steam.

A blood-red sunset
(right) The glorious colours of Turner's painting are carefully contrived to heighten the emotional impact. The blazing sunset is symbolic not just of an era coming to its end, but of bloodshed – a death by sacrifice.

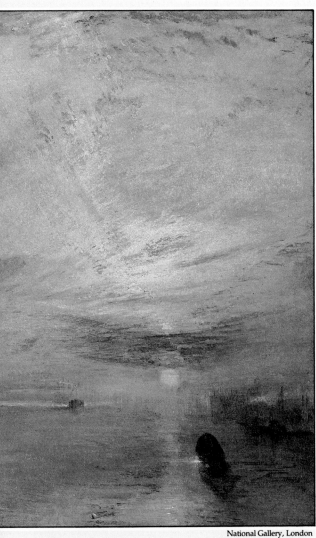

National Gallery, London

The last voyage
(left and below) On 6 September 1838 the Temeraire was remasted at Sheerness, where she had been used to store food, and taken up the Thames to the Beatson ship-breaker's yard. When she arrived, she was broken up for her great oak timbers and copper fittings.

National Maritime Museum, London

'The sun of the Temeraire is setting in glory'

The Morning Chronicle 1839

Rapid jottings
(right) The little sketches of the Temeraire that Turner excitedly made on cards have unfortunately never been traced. But the lively pencil drawings of ships that fill his many sketchbooks give us a good idea of the sort of jottings he made.

1776-1837

John Constable, perhaps the greatest and most original of all British landscape artists, is renowned especially for his views of the Stour Valley in Suffolk, Salisbury Cathedral and Hampstead Heath. He was brought up in the country, and out of his deep love for the English landscape grew a determination to record its beauty: to capture its moistness, light and atmosphere, as well as its shapes and colours.

Today, Constable's genius is acknowledged throughout the world, but during his own lifetime, landscape painting was unfashionable, and the artist was forced to struggle for recognition. He was 39 before he sold his first landscape. And although his magnificent paintings were acclaimed in France, the Royal Academy in London refused him full membership until 1829 – just eight years before his death.

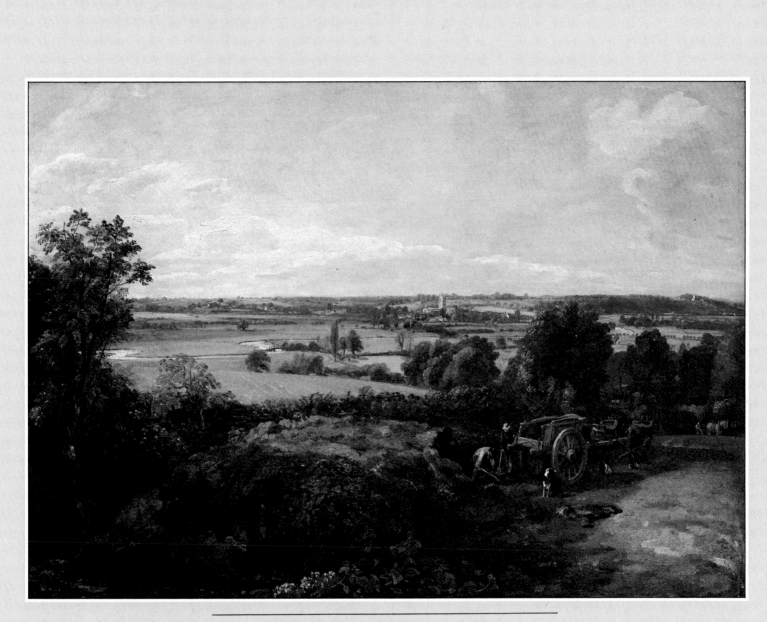

The Stour Valley and Dedham Church *1814*
21¾″ × 30¾″ Museum of Fine Arts, Boston

A Countryman in London

When he chose art as a profession, Constable left his Suffolk home to live permanently in London. But his bonds with East Anglia remained strong, and he returned each summer to sketch and paint.

John Constable was born in East Bergholt in Suffolk on 11 June 1776, the fourth of his parents' six children. His father Golding was a prosperous corn merchant who owned wind- and water-mills in East Bergholt and nearby Dedham, together with land in the village and his own small ship, *The Telegraph*, which he moored at Mistley on the Stour estuary and used to transport corn to London. Constable was brought up with all the advantages of a wealthy, happy home.

Most of his 'careless boyhood', as he called it, was spent in and around the Stour valley. After a brief period at boarding school in Lavenham, where the boys received more beatings than lessons, he was moved to a day school in Dedham. There the schoolmaster indulged Constable's interest in drawing, which was encouraged in a more practical way by the local plumber and glazier, John Dunthorne, who took him on sketching expeditions.

Golding Constable was not enthusiastic about his son's hobby, but gave up the idea of educating him for the church and decided instead to train him as a miller. John spent a year at this work and, though he never took to the family business, he did acquire a thorough knowledge of its technicalities. When his younger brother Abram eventually came to run the business, he often consulted John about repairs to the mill machinery.

FIRST SIGHT OF A MASTERPIECE

Constable's passion for art was decisively stimulated by Sir George Beaumont, an amateur painter and art fanatic, whom he met in 1795. Beaumont

East Bergholt Society

John Constable/East Bergholt House/The Tate Gallery

The family home
(left) Constable was born in East Bergholt House, near the centre of the small Suffolk village, and lived there until his departure for London at the age of 23. Set on a ridge, in several acres of grounds, it overlooked miles of open countryside. Constable's father had the house built in 1774, when the family moved up the hill from nearby Flatford Mill; it was pulled down in the 1840s.

The artist's mother
*Ann Constable, the
daughter of a London
cooper, moved to Suffolk
on marriage at the age of
19. A lively, sociable
woman, she helped run
the family business and
gave her son much-needed
encouragement in the
difficult early years.*

John Constable/The Tate Gallery

John Constable/The Tate Gallery

National Portrait Gallery, London

Constable at 24
*A pencil self-portrait
shows the artist soon after
he moved to London as a
student at the RA.*

The artist's father
*Golding Constable was a
wealthy corn merchant
with two water-mills
and some 90 acres of
farmland. He started
training John to be a
miller, but when a
younger son Abram
showed a flair for the
business, he gave the
artist an allowance to help
him live in London.*

Dedham, Suffolk.
*(above) An early photograph shows the village, three miles
from East Bergholt, where Constable's father ran a water-
mill. The artist himself went to school in Dedham and was
encouraged to draw by one of the teachers there. The
distinctive church tower, which dominates the local
landscape, appears in many of Constable's paintings: it
can be clearly seen in* Dedham Lock and Mill *(p.295).*

owned a French masterpiece, *Hagar and the Angel*,
by Claude Lorrain, which he took with him wher-
ever he went, packed in a specially-made travel-
ling box. The sight of this picture convinced Const-
able of his vocation as an artist. Soon afterwards,
on a trip to London, he began to take lessons from
the painter 'Antiquity Smith', an eccentric charac-
ter who gave him sound advice and introduced
him to the world of professional painting.

By 1799 Golding Constable's reluctance to allow
his son to pursue his unprofitable and scarcely re-
spectable career was tempered by the fact that a
younger brother, Abram, was showing promise as
a miller and businessman. So Constable was
admitted to the Royal Academy school and his
departure was blessed by his father with a small
allowance.

In London Constable was a hardworking and
committed student, who spent his evenings read-
ing and making drawings, but he was homesick
for his friends and family in Suffolk, and also for its
countryside. For a while he shared rooms with
another student, Ramsay Reinagle, who painted
his portrait (page 286), but Constable became dis-
gusted with his sly copying of Old Masters and his
doubtful dealings in the art market. His morale
was not improved by the discovery that landscape
and landscape painters were held in very low
esteem by the Academy, which only respected
history and portrait painting.

Letters and baskets of food transported by the
family ship kept him in constant contact with East
Bergholt, and he spent many of his summer holi-
days there, using a cottage near his parents' house
as a studio. He also did some travelling around
England. In 1801 he toured the Peak District in
Derbyshire and two years later made a short sea
voyage from London to Deal in Kent aboard an

Key Dates

1776 born at East Bergholt, Suffolk

1795 meets Sir George Beaumont, art collector

1799 enters RA school

1801 tours Peak District

1802 exhibits at RA for first time; buys cottage studio in East Bergholt

1806 visits Lake District

1809 falls in love with Maria Bicknell

1811 meets Revd John Fisher at Salisbury

1812-14 makes hundreds of sketches in Stour valley

1815 exhibits 8 pictures at RA, inc. *Boatbuilding*

1816 marries Maria after 7-year engagement

1817 birth of son John: first of seven children

1821 *The Hay Wain* shown at RA; moves to Hampstead

1823 *Salisbury Cathedral* shown at RA

1824 awarded gold medal by the King of France

1828 Maria dies of TB

1829 finally elected full member of RA

1832 Revd Fisher dies

1835 Last Suffolk picture

1837 dies in Hampstead

John Fisher of Salisbury

Constable's closest friend was the Revd John Fisher (inset) who bought several of his paintings, gave him moral support and even officiated at his wedding. Fisher's uncle was the Bishop of Salisbury, and over the years the two men spent several weeks as a guest in his house. Constable painted the Cathedral (left) on at least three occasions.

John Constable/Revd Fisher/Fitzwilliam Museum

East Indiaman. He visited the Lake District in 1806, but found the solitude oppressive.

By 1809, when Constable reached the age of 33, he had more or less mastered his craft, but had not as yet made a success of his career. He had not been elected an Associate of the Academy – let alone a full Member – and could not live independently on his meagre earnings from a few portrait and altar-piece commissions. However, it was at this unpromising point in his life that he fell in love with Maria Bicknell. She was 12 years younger than him and the daughter of a senior civil servant. More significantly, she was the granddaughter of Dr Rhudde, rector of East Bergholt and a formidable old man, who was believed by his family to be very rich. When Constable announced his desire to marry Maria, Dr Rhudde promptly threatened her with disinheritance.

A LONG, FRUSTRATING COURTSHIP

During the next seven years the unhappy couple were often parted and sometimes forbidden even to write, but throughout their long, frustrating courtship they remained loyal to each other. Constable, who felt badly isolated in London, was sustained by his family, all of whom wished to see him married to Maria, and by the Revd John Fisher, a nephew of the Bishop of Salisbury, one of his earliest patrons.

Without a strong vein of obstinacy in his character, Constable would not have survived these difficult years, though they also sharpened his tendency to suffer from depression and moodiness. He gained a reputation for being hostile, arrogant and sarcastic in his professional dealings, which did not help to sell his pictures. On the other hand,

with his family and close friends, he was unfailingly generous and affectionate. In fact, his makeup was in many ways contradictory. He was, for example, a die-hard reactionary in his politics, viewing the prospect of Reform with alarm, but in his art he was distinctly radical.

While courting Maria, he fell into a regular pattern of work. He would spend the late autumn, winter and early spring in London, working up his sketches from nature and preparing his paintings for the Royal Academy exhibition, which opened each May. Then he would go down to East Bergholt for the summer and early autumn, escaping the city with relief.

In 1815 Mrs Constable died, which was a great blow to him. Not long after, Maria's mother died too. These sad events seem to have strengthened the couple's resolve and by the February of 1816 they had made up their minds to marry in defiance of all opposition. Then in May, Constable's father died, sitting peacefully in his chair. According to

A Lifelong Romance

Constable's love for Maria Bicknell (right) was a guiding passion in his life. He had known her since childhood, and the sketch below is thought to be a portrait of Maria as a young girl. When they fell in love in 1809, Constable's income was meagre, and Maria's family opposed their engagement. The lovers were forced to wait seven years until he could afford to support them both. And while the marriage was happy, it was doomed to be short. At the age of 40, Maria died of TB, leaving a heartbroken husband to bring up their seven young children.

(right) Maria in 1816, just before their marriage.
(below) This 'Girl in a Fox Fur' may be Maria, aged 12.

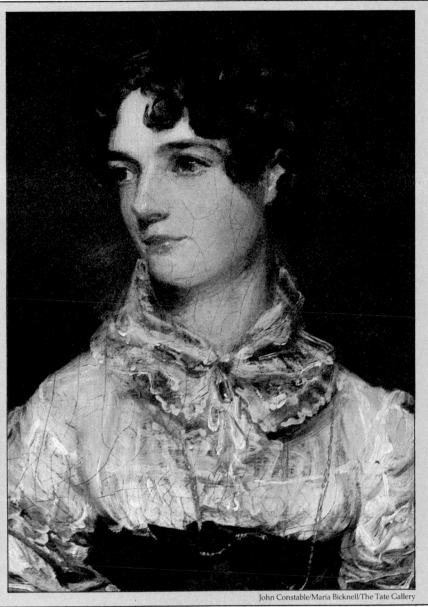

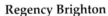
John Constable/Maria Bicknell/The Tate Gallery

Regency Brighton
The Constable family spent several summers in Brighton after Maria developed TB in 1824. The South Coast resort had been made fashionable by the Prince Regent, for whom Nash designed the exotic Pavilion. But Constable disliked the town intensely and described it as 'Piccadilly by the sea'.

his will, Abram was to take over the firm and pay John his share of some £200 a year. Added to his allowance and his earnings from painting, this made marriage possible at last.

Constable wrote to Dr Rhudde, seeking his consent for the final time. He did not reply, but confined himself to a frosty bow from his coach, which was reinforced by a huge grin of congratulation on the face of his coachman above. At the last moment, Constable astounded Maria by trying to delay the wedding, while he worked on a painting, but on 2 October they were married in St Martin-in-the-Fields by his friend Fisher, now an archdeacon. None of the Bicknell family attended.

They enjoyed a long and happy honeymoon, returning to London in December. By the spring of the next year Maria was pregnant, having already suffered a miscarriage, and Constable arranged for them to move into larger lodgings. He chose a house in Keppel Street in Bloomsbury, which ap-

pealed to him because it overlooked fields and ponds. There was even a pig farm near the British Museum to remind them of Suffolk. In these rustic surroundings their first son was born in 1817.

Marriage and fatherhood seemed to release in Constable new powers of creativity, and he was soon at work on his 'six-footers', the large scenes of the River Stour, which were to become his best-loved masterpieces. The family now enjoyed a settled way of life, dominated each spring by the exhibition of these big canvases, which slowly added to the growth of his reputation.

SKETCHES FOR THE HAY WAIN

In 1820 he began his oil sketch of the picture that was to be *The Hay Wain* (p.334). The wain itself gave him much trouble and he finally had to ask Johnny Dunthorne, the son of his old friend, to supply him with an accurate drawing. He finished

Joseph Turner – a rival at the RA

England's two greatest artists, Constable and Turner, were students together at the RA, but never close friends. Turner easily outpaced Constable in professional success: he was elected a full member of the Academy at 26, while Constable was denied the accolade until the age of 52 – just eight years before his death.

At that time, the RA had a virtual monopoly over the painting profession, and Constable's failure cost him dearly. He was 39 before he sold his first landscape, and in his entire life he sold less than 20 paintings in England.

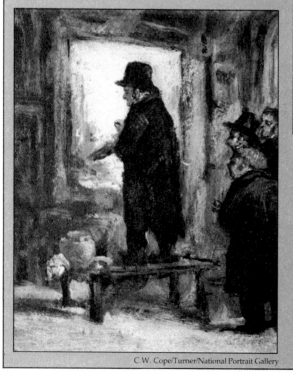
C.W. Cope/Turner/National Portrait Gallery

D. Maclise/Constable/National Portrait Gallery

Joseph Turner
Born the year before Constable, Turner was a boy prodigy whose dramatic seascapes and grand historical scenes won instant acclaim. His paintings commanded huge prices, and he dominated the art world. When Constable was finally elected to the RA, Turner brought him the news in person.

Constable teaching
Constable's election to the RA came too late to influence his career – his most creative years had already passed, and the death of his wife Maria had plunged him into melancholy. But he enjoyed teaching, and his new status as an Academician gave him the opportunity to champion landscape painting.

The summer exhibition
The Royal Academy exhibition was a society event which drew large crowds each year. It was the main showcase for artists to display their work, and they competed

it in the April of the following year soon after his second son was born. It has become his most famous picture, though it made little impact in England at the time of its original exhibition, and was eventually bought by a French dealer.

Maria's health had always been delicate and in 1821 Constable settled his family into a house in Hampstead where the air was cleaner. For his own use, he rented a room and a little shed from the village glazier. Standing some 400 feet above the smoke of London, Hampstead was at that time a farming area, with sand and gravel workings. Along with the Stour valley and Salisbury, it became one of the few landscapes Constable responded to creatively.

In 1824 the king of France awarded him, in his absence, a gold medal for *The Hay Wain*. And for the first time his six-footer of the season, *The Lock*, was bought for the asking price while on exhibition at the Royal Academy.

MARIA'S TRAGIC ILLNESS

Tragically, just as it looked as if he might be achieving professional independence, the first signs of his wife's fatal illness, pulmonary tuberculosis, showed themselves. To restore her health, he sent her and their young children, now four in number, to Brighton for the summer. Constable joined them for a few weeks and painted a number of marine scenes.

The next two years saw the birth of two more children, but no improvement in Maria's health. And the birth, in January 1828, of her seventh child weakened Maria badly. In March her father died, leaving her £20,000 and putting an end at last to their money worries. But Maria's coughing worsened, she grew feverish at nights and throughout the summer she wasted away. Maria died on 23 November and was buried in Hampstead.

Constable told his brother Golding, 'I shall never feel again as I have felt, the face of the world

is totally changed to me'. The marriage for which he had waited so long had lasted a mere 12 years.

He slowly picked up the threads of his professional life. Ironically, he was elected a full Academician the next February, though by only one vote. His great rival Turner brought the news, and stayed talking with him late into the night. In time, new projects began to interest him, notably the publication of engravings taken from his paintings and oil sketches. But the period of his greatest achievements was over.

In 1835 he painted *The Valley Farm*, another view of Willie Lott's cottage in Flatford, which appears in the *Hay Wain*. This was his last major picture of Suffolk. The buyer wanted to know if it had been painted for anyone in particular. 'Yes sir', Constable told him. 'It is painted for a very particular person – the person for whom I have all my life painted.' He died at night on 31 March 1837 and was buried beside Maria in Hampstead.

G. Cruikshank/ Tom & Jerry at the Exhibition

fiercely to have their pictures hung in prominent positions. Constable chose the large format of his 'six-foot' canvases to make his paintings stand out and catch the eye of potential purchasers.

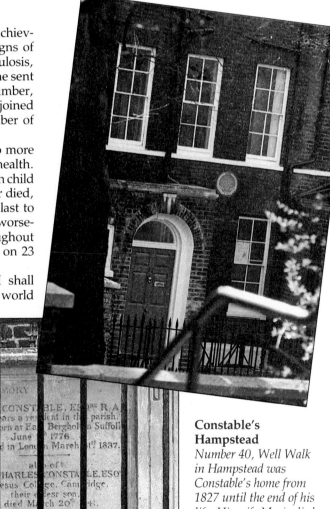

Constable's Hampstead
Number 40, Well Walk in Hampstead was Constable's home from 1827 until the end of his life. His wife Maria died there of TB in 1828, and they are buried together with their eldest son – also named John – in Hampstead Parish Churchyard.

Scenes of the Stour Valley

Constable's strongest inspiration came from the scenes of boyhood, which he said 'made me a painter'. The few square miles of Suffolk around are now known as 'Constable country'.

Constable is often described as the greatest painter of the English landscape, but it is truer to call him the painter of Suffolk, or rather the Stour valley – the 12 square miles around his birthplace in East Bergholt, which even in his own day became known as Constable country. He could never bring his extraordinary gifts to bear on a landscape which held no personal meaning for him. Apart from Suffolk, only Hampstead, Salisbury and to a lesser extent Brighton stimulated the intense observation and passionate feeling which is the hallmark of his best paintings.

Constable seems to have realised where his genius lay in 1802, while studying at the Royal Academy in London. He wrote to his old sketching companion John Dunthorne, the village glazier, that he was determined to come home and study nature, the source of all originality in art. His plan was to make a 'pure and unaffected representa-

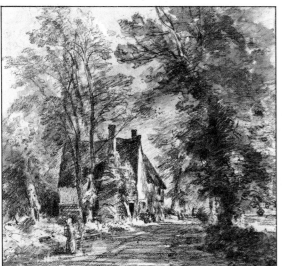

Victoria and Albert Museum

Constable on Suffolk

'Tis a most delightful country for a landscape painter; I fancy I see Gainsborough in every hedge and hollow tree.'

'The sound of water escaping from mill dams, willows, old rotten banks, slimy posts and brickwork – I shall never cease to paint such places.'

'I even love every stile and stump, and every lane in the village, so deeply rooted are early impressions.'

Victoria and Albert Museum

Stratford St Mary
(left) This pencil and wash sketch shows the house once known as Old Valley Farm, on the road towards Dedham from Stratford St Mary. Constable sketched the house twice in 1827.

Constable Country
Most of Constable's Suffolk pictures show scenes within walking distance of his home in the Stour valley.

East Bergholt
(right) A detail from Golding Constable's Flower Garden (1815) *shows a view from the back of the family house. Constable was the first English artist to paint barns and out-houses with such careful attention.*

tion' of the scenes of his childhood. With this end in mind, he not only spent that summer and autumn in East Bergholt, but also bought a cottage in the village to use as a permanent studio.

THE SUMMER SKETCHBOOKS

Almost every summer for more than 15 years he returned to the village to make detailed records in his sketchbooks of every object, activity or view that caught his interest. The summer of 1813 was particularly valuable. The weather was magnificent, and Constable walked daily in the Stour valley, sketching obsessively. 'I almost put my eyes out with that practice', he wrote later.

His sketchbook for that year has fortunately been preserved, and clearly shows his working methods. The tiny drawings measure no more than 3½″ × 4¾″, but cover an extraordinary range of subjects: the river and its barges, sheep sheltering from the heat under a tree, cottages, farms and

Dedham
(above) The graceful tower of Dedham Church overlooks the river in Dedham Lock and Mill *(1820), three miles from East Bergholt.*

Flatford Mill
(right) This oil sketch for The Mill Stream, *painted around 1812, shows the same scene as* The Hay Wain, *with Willie Lott's cottage on the left. Such sketches, made rapidly in the open air, served as notes for the full-size paintings.*

Farmland views
Two tiny pencil sketches show the fields near East Bergholt: the first looks north to his father's windmill; the second looks west beyond Stratford St Mary. Constable made hundreds of such sketches in the fine summers of 1812-3.

churches, mooring posts and water lilies, ploughmen and their horses, and dozens of little details, including the cuff of a jacket. Many amount to fully realised compositions and almost all the rural themes which he later illustrated in his paintings are seen here.

These scenes, Constable said, made him a painter, and his feeling for their visual beauty was enhanced by his understanding of the work being done in the locks and towpaths, boatyard and meadows. His apprenticeship in his father's mills had taught him not to look only at the buildings,

trees and people. He watched the sky too and the river with the professional eye of a miller, whose livelihood depended on understanding the weather and its ever-shifting moods.

Yet despite Constable's devotion to Suffolk and its countryside, the great majority of the finished works were painted not in East Bergholt, but in London with the sketchbooks and some small oil-studies serving as 'notes'. Just one early picture, *Boatbuilding*, was completed in the open air; the other major canvases were painted in his London studio during the winter months.

COMPARISONS

The Landscape Tradition

Few English artists of Constable's generation bothered with landscapes, which were generally regarded as a low form of art compared with historical or mythological scenes. But he learned much from earlier masters. His first sight of Claude Lorrain's *Hagar and the Angel* inspired him to take up painting as a vocation, and he greatly admired Thomas Gainsborough, another Suffolk artist who had lived nearby at Sudbury.

Claude Lorrain (1600-82) **Hagar and the Angel**
(right) Constable saw this picture at Dedham in 1795. The composition and the pure quality of light had a lasting influence on his work.

Thomas Gainsborough (1727-88) **Cornard Wood**
(below) Constable made a careful study of Gainsborough's technique, and even visited some of the scenes he painted. He adopted the earlier artist's custom of showing people and animals in the landscape.

Jacob van Ruisdael (1628-82) **Landscape with Ruin**
(below right) Ruisdael was one of the first artists to see how important the sky could be to the mood of a landscape. Constable also used heavy cloud formations to give a brooding atmosphere to many later works.

National Gallery, London

National Gallery, London

National Gallery, London

For the famous 'six-footers' exhibited at the Royal Academy, Constable went through one more stage of preparation which is probably unique amongst artists: he painted a full-size oil sketch, to work out the composition and blocks of colour he would finally use. These sketches have also been preserved and are much admired by modern critics for the freedom with which he used his palette knife to apply the paint, capturing the effects of the English weather with all its changes.

THE GREAT CANAL SCENES

But the finished versions of the great canal scenes show Constable's genius at its height. Here, as nowhere else, he captured the atmospheric effects of early summer in the open air, the movement of clouds across the broad Suffolk sky and the impact of sunlight on the waters of his beloved Stour.

To convey on canvas the sun's rays glittering on the river surface and dancing on the foliage of trees agitated by the wind, Constable abandoned the 'fiddle browns' of traditional landscape painting for the true colours and textures of nature. Restricted by the paints available to him, he used pure yellow and white for the flash of sunlight on dew, and captured the motion of clouds and the racing wind with rapid, nervous brushwork whose sensitivity has never been rivalled.

TRADEMARKS

Patches of Red and White

Two distinctive technical features appear in many of Constable's paintings: small areas of brilliant red, often against green; and blobs of white, mostly against brown. The red is a device he adopted to make the greens of the foliage seem more vivid; it also serves to focus the viewer's gaze. The white blobs are meant to create an illusion of the sun reflecting on damp wood. They were known to unfriendly critics as 'Constable's snow'. But as the artist said in a lecture, white was the only colour on his palette (right) which could achieve the desired effect.

The Leaping Horse (1825)
A detail (left) from this famous painting shows Constable's technique in action. The red bridle on the tow horse helps attract the eye to the key element in the picture; and the light shimmering on the wet wooden barrier is captured by the white paint of 'Constable's snow'.

The Hay Wain

Constable painted *The Hay Wain* (see pp.334-335) in his London studio during the winter of 1820-1, using his diary sketches and oil studies as reference material. He chose a landscape he knew well, and the shallow fording-place on the Stour between Flatford Mill and Willie Lott's cottage forms an attractive setting for a typical scene in the hay-making season (see map). As usual, Constable was anxious that the details should be accurate, and he even asked a local artist to send him an extra sketch of a hay wain. But there is far more in the painting than its picturesque cottage and waggon – Constable's true subject is the day itself, as he carefully studies the shifting summer clouds and the play of sunlight on the trees and meadows.

The Clouds
Constable observed the sky with unusual care and made detailed oil studies, often noting the exact time of day and the wind speed and direction.

Victoria and Albert Museum

Willie Lott's cottage (*above*) *was the home of a local farmer whom Constable knew well. A tradition in the village holds that he spent only four days away from the farm in the eighty years of his life.*

The missing rider
(*right*) *A detail from Constable's full-size oil study shows that he originally included a man on a horse – said to have been his father, Golding – next to the dog. In the finished painting, this space is filled with the shadow of a tree.*

Victoria and Albert Museum

The National Gallery, London

> 'Look at these English pictures – the very dew is on the ground.'
>
> Critic at Paris Salon 1824

The haymakers
In the distant meadow, a gang of farm hands are loading hay on to a second waggon. Their leader, 'the lord of the harvest' is distinguished by the red sash he wears around his waist.

An early drawing
(right) This tiny sketch of a man carrying a scythe is from Constable's 1813 sketchbook (actual size) and may have served as a model for the painting.

Victoria and Albert Museum

Luminous green
(left) Almost at the centre of the picture the sun streams through the leaves of a tree. Constable renders its liquid warmth by spreading several thick layers of green and yellow paint with a palette knife.

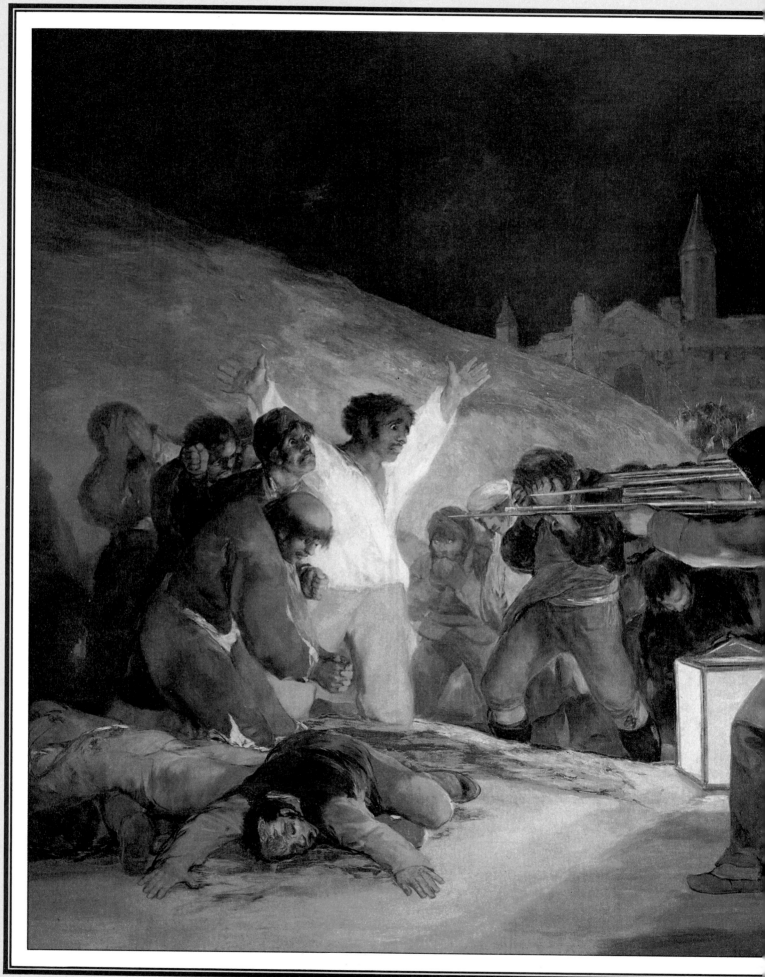

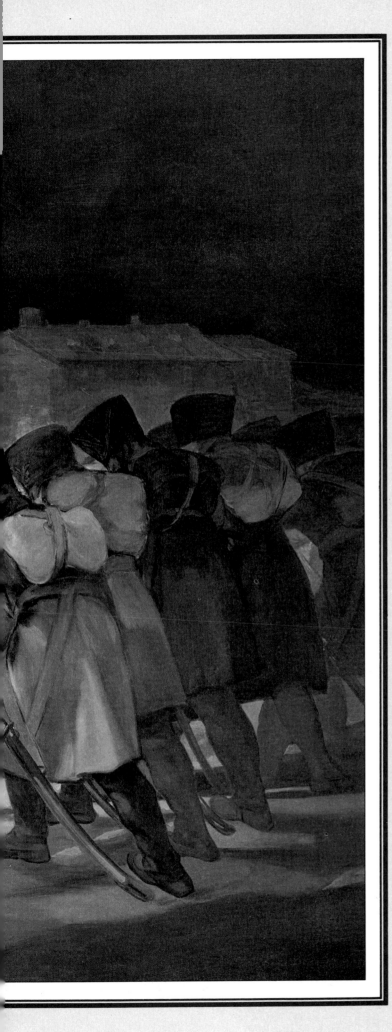

Background

The period of the Romantic artists coincided with a time of great change in European society. Living at such a time, they could not fail but be touched by the pervasive effects of this change. So, while each one's work represents an expression of his own personal feelings, it also expresses the way those feelings were shaped, both consciously and subconsciously, by the mood of the times. Examples of this are Blake's illustrated poem *Jerusalem*, an indictment of the evils of the industrialism of Britain's 'dark, satanic mills', and Friedrich's use in his art of the revived interest in the Gothic and all it symbolized.

The Third of May, 1808 *1814*
by Francisco de Goya
94¾" × 135¾" Prado Museum, Madrid

Dreaming of Jerusalem

Blake's 'fiery youth' was a time of hope for believers in Utopia. Revolutions in America and France gave grounds for optimism that liberty, equality and fraternity could exist in Britain too.

The revolutionary message of Blake's *Jerusalem* – one of the most famous poems in the English language – is easily missed now that it has become a church hymn, almost a patriotic anthem, with its moving evocation of 'England's green and pleasant land'. But in the 1780s, the image of Jerusalem as a city of innocence which could be reclaimed from the hell of industrial Britain's 'dark, satanic mills' was common currency among London's radicals.

Since the Gordon Riots of 1780, when Blake saw the mob march through the streets of Soho and the City to sack Newgate Prison, the government under William Pitt the Younger had taken stern measures to hold down discontent. But when the decade closed with the French Revolution of 1789 – signalled by another mob storming another prison, the Bastille in Paris – the news inspired hopes in London that justice could return to England too. In a land equally oppressed by its king and by the wealthy, swords could be beaten back to ploughshares, the wolf lie down with the lamb, and all men and women enjoy the fruits of their work in harmony with their neighbours.

TOM PAINE, THE REVOLUTIONARY

A well-known 'Liberty Boy' himself, Blake was involved that year with a group of radical authors and pamphleteers who met regularly in the home of Joseph Johnson, at 72 St Paul's Churchyard. Johnson was a publisher and printer who gave weekly dinners for his friends in a cramped upstairs room, and it was here the Blake met some of the most notorious activists of his era, including the revolutionary journalist Thomas Paine, the political philosopher William Godwin, and one of the earliest feminist writers, Mary Wollstonecraft.

Of the three, Paine was already by far the most influential. The son of a Norfolk tradesman who made women's corsets, he had worked as a customs man in Sussex – and organized a claim for better wages – before trying his luck in America. He arrived in Philadelphia in November 1774, just before the first shots were fired in the War of Independence, and made his name a year later with a pamphlet named *Common Sense*, which

Tom Paine
(right) Author of the famous treatise The Rights of Man, *Tom Paine was born in England but made his name as a journalist in America. His pamphlets urging the colonists to rebel against Britain were highly successful.*

Land of the free
(below) The American War of Independence, which broke out in 1775, was an inspiration to Europe's radicals. After eight years of bitter fighting, George Washington's citizen army won victory against overwhelming odds. Washington himself, shown here crossing the frozen Delaware River, became the first president of the new republic.

A. Milliere/National Portrait Gallery, London

Peter Newark's Western Americana

E. Leutze/Washington Crossing the Delaware/Metropolitan Museum, New York

And did those feet in ancient time,
Walk upon England's mountains green:
And was the holy Lamb of God
On England's pleasant pastures seen!

And did the Countenance Divine,
Shine forth upon our clouded hills?
And was Jerusalem builded here
Among these dark Satanic Mills?

Bring me my Bow of burning gold:
Bring me my Arrows of desire:
Bring me my Spear: O clouds unfold:
Bring me my Chariot of fire:

I will not cease from Mental Fight,
Nor shall my Sword sleep in my hand:
Till we have built Jerusalem,
On England's green & pleasant Land.

P.J. de Louterbourg/Coalbrookdale by Night/Science Museum, London

Dark satanic mills

Blake's rousing poem, written in 1804, expresses his passionate belief that social justice could exist on earth, not just in heaven. Attacking the ugliness and misery of the Industrial Revolution, he summons up a vision of Jerusalem – a city of beauty and freedom that could be built in Britain.

called on Americans everywhere to rise against the British and fight for liberty. The pamphlet sold more than 150,000 copies; it was read by every rank of the new American army, and brought Paine to the attention of Washington himself. In another pamphlet issued soon afterwards, he even coined the name for the new republic: the United States.

Paine returned to Europe in the 1780s, preoccupied with plans for his own invention, a wide-spanned iron bridge. But he was in Paris to witness the first, relatively orderly stages of the Revolution, and left the city with the key to the Bastille, to forward to George Washington as a comradely gift. When Paine reached London, he found the government vehemently attacking the 'savagery' of the Paris mob. In defence of their actions, he wrote his most famous pamphlet, *The Rights of Man*, which Johnson published in 1791.

Here he set out his vision of a just society, with the stirring declaration that 'All men are born equal.'

Among Paine's strongest supporters was Mary Wollstonecraft, a vigorous campaigner for women's rights. They met in 1791 at Johnson's house in St Paul's Churchyard: William Godwin was also present, and was dismayed when Mary talked Paine into silence, but her forceful arguments – published the following year in her *Vindication of the Rights of Women* – forced both men to adjust their own notions of equality. She condemned marriage, which at that time deprived women of all economic freedom, and insisted on women's right to participate in politics, while calling for sex education, state schools and better job prospects for women.

Outside radical circles, Wollstonecraft's pleas fell on deaf ears, but Paine's pamphlet shook the

BACKGROUND

Storming the Bastille

When the people of Paris destroyed the hated Bastille prison on 14 July 1789, radicals throughout Europe believed that freedom was at hand. But their hopes were soon dashed: horrific stories of the Reign of Terror drowned revolutionary ardour in a tide of blood.

The struggle for Reform

Alarmed by the French Revolution, the British government crushed all known radicals without mercy. But a campaign for parliamentary reform, led by Henry 'Orator' Hunt, won massive support – until stamped out by the brutal 'Peterloo Massacre' of 1819.

government. Alarmed by the success of *The Rights of Man*, which sold thousands of copies throughout Britain and Ireland, Pitt urged George III to action. On 21 May 1792 a royal proclamation banned 'wicked and seditious writings' and Pitt issued a writ against Paine for blasphemous libel – a charge carrying a long prison sentence.

According to one contemporary, Blake himself warned Paine to flee. Paine was at Johnson's house, delivering a rousing speech on liberty, when Blake put his hands on his shoulders and said 'You must not go home, or you are a dead man.' Paine fled that night to Dover, tracked all the way by Pitt's spies, and crossed to France.

A MASSACRE IN PARIS

That September, news reached London of a massacre of royalist prisoners and the start of the Reign of Terror. Lurid reports of a blood-soaked Paris soon dimmed the enthusiasm of numerous English radicals, including the Lake Poets, Wordsworth and Coleridge. Blake himself, who had once worn the red revolutionary bonnet on the streets of London, put his cap away forever. Government repression made such overt shows of support extremely dangerous, especially after 1793, when England joined an alliance of foreign powers pledged to destroy the new French state.

Pitt moved swiftly to silence the radical writers and their publishers. Johnson refused to publish the second edition of *The Rights of Man* for fear of prosecution, and Blake laid aside his own work on *The French Revolution* at the proof stage. William

Godwin's *Political Justice*, published in 1793, escaped solely because of its high price – at three guineas a copy it was unlikely to inflame the poor.

Yet while the flame of protest seemed to be dying, a new generation was being born to take up the radical torch. The poet Percy Bysshe Shelley was born in 1792, the same year *The Rights of Man* appeared; as a schoolboy at Eton he was entranced by Godwin's vision of *Political Justice*, and in 1814 he fell in love with a precocious 16-year-old – the daughter of Godwin and Mary Wollstonecraft, who had reluctantly overcome her own objections to marriage, only to die giving birth to her child.

Shelley's brief life overlapped with the later years of Blake, who had retreated into political silence. The younger poet was protected by his high birth and the prospect of an inheritance; he could speak out far more safely. In 1812 he wrote his own *Declaration of Rights* in support of the Irish, then launched into a fierce defence of the printer Daniel Eaton, who had been sentenced to 18 months' imprisonment – and a spell in the pillory each month – for publishing Paine's last great work, *The Age of Reason*.

SHELLEY'S CALL TO ARMS

Two years later, Shelley met Mary Godwin, and declared his love beside her mother's grave in Old St Pancras Churchyard. Throughout his own short life, he remained true to his radical heritage, despite leaving England for good in 1818. The Peterloo Massacre of the following year stirred him to insurrectionary fury, and in *The Mask of Anarchy* he called on the people of England to: 'Rise like lions after slumber/ In unvanquishable number,/ Shake your chains to earth like dew/ Which in sleep had fallen on you/·Ye are many – they are few.' Shelley died in 1822, when his ship sank in the Bay of Leghorn in Italy, five years before Blake's own death.

A radical alliance
(above) The marriage in 1797 of William Godwin and Mary Wollstonecraft united the leading theorist of the radical movement with one of Britain's first feminists. Mary Wollstonecraft died the same year, giving birth to their daughter – the future Mary Shelley, author of Frankenstein.

Shelley in Italy
The Romantic poet Percy Bysshe Shelley (1792-1822) was inspired by the writings of Godwin and Wollstonecraft, and even married their daughter Mary. A fervent supporter of radical causes, he moved to Italy in 1818, but continued to attack the government. After the Peterloo Massacre he called for revolution in Britain in his poem The Masque of Anarchy.

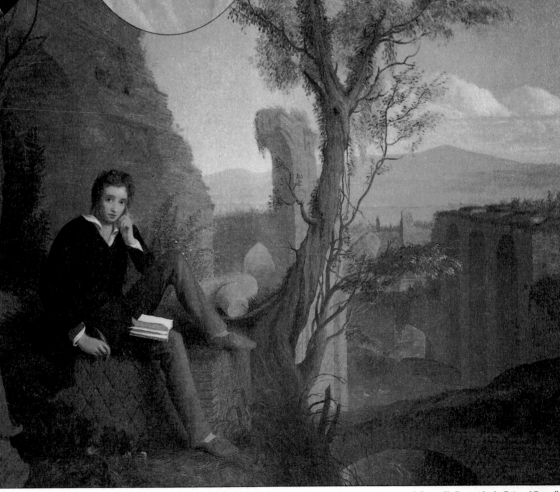

J. Severn/Shelley amidst the Ruins of Caracalla

The Thrill of the Gothic

**During Friedrich's lifetime, Gothic architecture was revived after
centuries of neglect. With it came a new literary movement, exploring
the imaginary Gothic world in tales of horror and suspense.**

J.G. Eccardt/Sir Horace Walpole/National Portrait Gallery

Friedrich's use of Gothic buildings in his paintings,
to create a mood of elevated spirituality, is a
striking feature of his art. The soaring arches and
delicate tracery of Gothic architecture (the style
that dominated most of Europe from the late 12th
to the early 16th century) suggest the otherwordly
aspirations of the Middle Ages. And the great
medieval cathedrals still evoke awe as master-
pieces of design, engineering and craftsmanship.

Such buildings, however, were not always
thought of as the supreme works they are
acknowledged to be today. During the 16th
century, the architectural style of the Italian
Renaissance – based on the buildings of ancient
Rome – spread all over Europe, and the Gothic
style went out of favour. Indeed the word 'Gothic'
was originally coined as a term of abuse, implying
– quite wrongly – that the style had something to
do with the barbarian Goths of the Dark Ages. But
in the mid-18th century the Gothic came back into
fashion, not only in Germany, but all over Europe.

Noble inspiration
*(above) Horace Walpole,
4th Earl of Orford (1717-
97), inspired the Gothic
Revival in England. A
pioneering figure in
both architecture and
literature, he was the son
of Prime Minister Robert
Walpole.*

Piranesi's prisons
*(right) The engravings of
Giambattista Piranesi
were eagerly bought by
English visitors to Rome
in the mid-18th century.
His macabre views of
'imaginary prisons' have
influenced the Gothic
vision into the 20th
century – inspiring sets
for horror movies.*

British Museum, London

The romance of ruins
*(above) Friedrich was one
of the first painters to
appreciate the emotional
and symbolic power of
ruined buildings. He used
crumbling Gothic abbeys
to evoke feelings of
mystery and melancholy,
inspiring a mood of
religious contemplation.*

Gothic grotesquery
The gargoyles and grotesque carvings that leer from the parapets of medieval churches sum up the cruder aspects of the Gothic spirit – in marked contrast to the sublimity of soaring arches and delicate tracery.

Strawberry Hill
(below) Horace Walpole's famous country house was built for show, with many plaster and papier-mâché adornments inspired by decorations in medieval churches. Atmosphere rather than authenticity was Walpole's aim, and he succeeded so triumphantly that a visiting French aristocrat removed his hat in one of the rooms, mistakenly assuming he was in a chapel.

C.D. Friedrich/Ruin at Eldena/Nationalgalerie, Staatliche Museen Preussischer Kulturbesitz, Berlin

It was appropriate that the Gothic Revival should originate in England, for there Gothic architecture had never entirely died out. Sir Christopher Wren, England's most famous architect, designed several buildings in the Gothic style. However, this Gothic survival was very different in spirit from Gothic Revival, which had new and diverse influences.

GHASTLY PRISONS

One of the most important came, somewhat surprisingly, from Italy, where the original Gothic had never taken root. The pioneer there of the Gothic vision was Giambattista Piranesi, whose engravings were immensely popular with English tourists. He was famous for his views of Roman remains, but also made an extraordinarily original series of engravings called *Carceri d'Invenzione* (Imaginary Prisons), depicting huge ghastly interiors in which tiny figures toil up endless staircases towards dark caverns suggestive of torture and unnamed horrors. Piranesi directly inspired two of the leading figures of the Gothic

In the early days of the 'Gothic Revival', literature played just as important a role as architecture, for the taste for the Gothic embraced not only the grandeur of medieval buildings, but also the sense of mystery they evoked. In Thomas Gray's *Elegy Written in a Country Churchyard* (1751), the poet ruminated on death with all the panoply of 'ivy-mantled tower' and 'mopeing owl'. This first Gothic poem touched a responsive nerve, a romantic yearning for sensation, which proved a fertile legacy for his successors.

Charles Wild/Fonthill Abbey/Victoria and Albert Museum

Fonthill Abbey
The English eccentric William Beckford built this strange Gothic country house, at great speed. The gigantic tower, 280 feet high, collapsed one night in 1825.

Revival in England: Horace Walpole, a writer, connoisseur and amateur architect; and William Beckford, a decadent and eccentric man of letters.

In 1750, Walpole began alterations to his 'cottage', Strawberry Hill in Twickenham. The alterations turned into a major building project that took 20 years to complete – the first great monument of the Gothic Revival. The house still exists today, with its long, delicately-vaulted corridors, a monastic hall with tall, pointed windows and statues of saints lining the walls, and a baronial staircase peopled with suits of armour.

THE FIRST GOTHIC NOVEL

As well as being a landmark in architectural history, Strawberry Hill inspired a new literary genre – the 'Gothic novel', in which mystery and horror were essential ingredients. Walpole himself wrote the first Gothic novel, *The Castle of Otranto* (1764), as a result of a nightmare in which 'I thought myself in an ancient castle . . . and that on the uppermost bannister of a great staircase I saw a gigantic hand in armour'. The hand becomes that of an avenging angel known as the Knight of the Gigantic Sabre, and the story is as labyrinthine as the castle it describes.

Some 20 years after *Otranto*, William Beckford published *Vathek: An Arabian Tale* (1786), which like

François Gérard/Ossian/Musée du Château, Rueil-Malmaison

its predecessor owed a debt to Piranesi. 'I drew chasms, and subterranean hollows, the domain of fear and torture, with chains, racks, wheels, and dreadful engines in the style of Piranesi,' Beckford related. Vathek is a sadistic young caliph who sells his soul to Eblis, the devil, for illusory powers. It marks the beginning, in literary terms, of the Gothic of gargoyles – exotic, rather than medieval – a tradition culminating in Mary Shelley's *Frankenstein* (1818).

Beckford's architectural taste was equally bizarre. For his own private delectation, he had built one of the great architectural extravaganzas of the age – Fonthill Abbey in Wiltshire, a huge country house done up in ecclesiastical garb. At Beckford's insistence the vast structure was completed at insane speed, with up to 600 workmen toiling day and night by the light of huge bonfires, no matter how inclement the weather. But the great endeavour was doomed. On his deathbed the clerk of works confessed to Beckford that the specified foundations to the tower had not been provided, and one night in 1825 the tower collapsed. Beckford, who was informed of this in his London club, simply regretted that he had not been a witness to this spectacular event.

Among the other bizarre products of the Gothic Revival in England were two famous literary forgeries. Thomas Chatterton was a child genius

The Mysteries of Udolpho
Ann Radcliffe's novel (1794) was an early Gothic tale, with handsome villains and ghosts in armour.

The death of Chatterton

(above) Thomas Chatterton, a leading poet of the Gothic movement, poisoned himself in 1770, aged 17. This picture was painted in the attic where he died and shows some of his forgeries of medieval poems – torn into shreds.

Frankenstein

(right) Mary Shelley's novel (1818) was an archetypal Gothic horror story. It was the outcome of a friendly competition in which she and several friends – including Byron – each agreed to write a supernatural tale.

The songs of Ossian

(left) A series of poems allegedly written by a Gaelic bard named Ossian – but actually forged by James MacPherson – were acclaimed throughout Europe. This painting of the dreaming bard is a variant of one commissioned by Napoleon Bonaparte.

who fabricated medieval poetry under the pseudonym of Thomas Rowley, a 15th century monk from Bristol. In 1768 he began publishing his forged documents, but poverty and lack of recognition drove him to suicide two years later.

And while Chatterton was living his tragically short life, a young Scottish writer called James Macpherson had published several volumes purporting to be translations from a 3rd century Gaelic bard called Ossian. The authenticity of the poems was challenged in Macpherson's lifetime

and convincingly refuted after his death, but the fictitious Ossian nevertheless became a European cult figure, a kind of Homer of the North, and Macpherson's 'translations' were praised by figures as diverse as the Emperor Napoleon and Friedrich's own friend and admirer, Johann Wolfgang von Goethe.

THE GRAVEYARD PAINTER

Germany's most famous poet and playwright, Goethe was also a scientist and a talented amateur artist. His astonishingly broad interests and talents embraced architecture too, and in 1772 he wrote one of the most important books of the Gothic Revival, *Von Deutscher Baukunst* ('Concerning German Architecture'), in which he passionately extolled Strasbourg Cathedral. He even claimed that Gothic was German in origin (in fact it was French) and wrote of 'the deepest sense of truth and beauty in its proportion, growing out of the powerful, rugged German spirit'.

Friedrich himself was less concerned with nationalistic claims than with reviving the spiritual associations of Gothic. Although many of the literary and architectural expressions of the Gothic Revival were thoroughly secular, Friedrich realized that the original Gothic was the greatest visible expression of an age of faith. His paintings capture the sense of sublimity that fired his imagination and Gothic ruins become an exquisite metaphor for the transience of human life. If Gray is the great graveyard poet, Friedrich is the great graveyard painter.

The Body of Abel Found by Adam and Eve *c.1826*
12¾″ × 17″ Tate Gallery, London

Goya

By 1800, despite the crippling illness that left him deaf, Goya was one of Spain's most successful painters. He moved freely among royalty and the aristocracy, and painted numerous portraits of the court.

The Clothed Maja, which may be a portrait of the Duchess of Alba, was owned by the royal favourite, Manuel de Godoy.

The Clothed Maja *c.1800-1805*
37¼" × 74" Prado Museum, Madrid

The Clothed Maja *was painted as a companion to* The Naked Maja *(p.235) and is, perhaps surprisingly, the more seductive of the two images. The model is shown in the same provocative pose, propped up on plump silk cushions. But here she is dressed in a flimsy pyjama costume which clings to the generous contours of her form. The brushstrokes are bolder and the colours more brazen, stressing the redness of the lips and the pink glow on the cheeks. Goya's striking model has often been thought to be the Duchess of Alba, one of the greatest beauties of her day.*

Like the portraits of Dona Isabel de Porcel and the Two Majas on a Balcony, it reveals Goya's interest in costume as well as the subtleties of character.

During the Napoleonic Wars, Goya became obsessed with the endless cruelty and utter futility of the fighting. The Colossus and the famous Third of May, 1808, (p.300-301) are both powerful evocations of the catastrophes of warfare and they are amongst his most striking works.

Towards the end of his life, Goya's works acquired a nightmarish intensity and he painted what came to be known as his 'black paintings': the gory Saturn Devouring One of His Sons is his most disturbing vision.

Doña Isabel de Porcel *c.1804-5*
32¼″ × 21¼″ National Gallery, London

*Goya painted this splendid portrait of Isabel de Porcel in return for
the hospitality he had received when he stayed with her and her
husband in Granada. She is dressed in the coquettish costume of the
'majas' – then all the rage among the aristocracy – resplendent in a
pink satin gown and black lace mantilla.*

Two Majas on a Balcony *c.1811*
76½″ × 49½″ Metropolitan Museum of Art, New York

The 'majas' were girls from the lower social classes who were renowned for their beauty, their alluring costumes and their flighty lifestyles. Goya shows these two seated on a balcony with their protectors, the 'majos', lurking in the shadows behind. Majas and majos were notorious for their stormy and often violent love affairs.

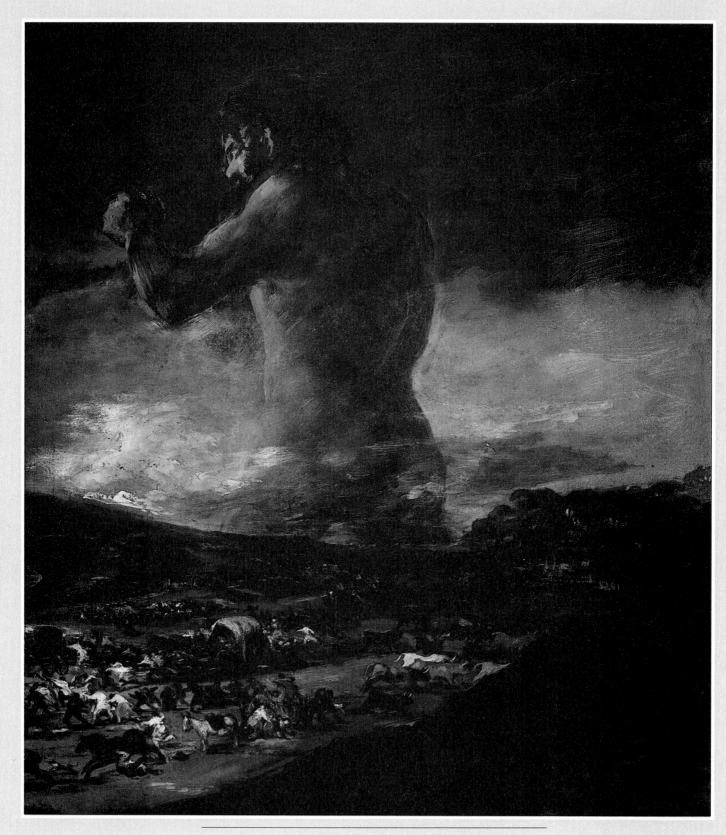

The Colossus *c.1808-12*
45½″ × 41¼″ Prado Museum, Madrid

In the midst of war, a grim giant looms over fleeing crowds. Goya's terrifying vision was probably inspired by some lines written by a Spanish poet about the Napoleonic wars: 'On a height above yonder cavernous amphitheatre, a pale Colossus rises, caught by the fiery light of the setting sun.'

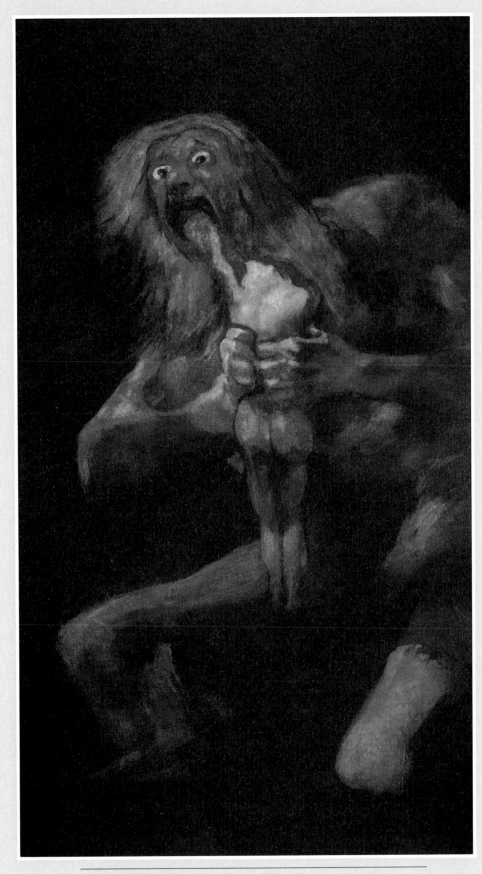

Saturn Devouring One of His Sons *1820-23*
57½″ × 32¾″ Prado Museum, Madrid

This gruesome image is one of the famous 'black paintings' that decorated Goya's house, the Quinta del Sordo – it hung in his dining room. The god Saturn ate his sons because he was afraid that they might grow up to usurp him. The cruelty of the myth appealed to Goya, who loathed the irrationality of old age.

Blake's output as a painter, engraver and draughtsman was enormous. He often worked on projects over a number of years, gradually bringing them to fruition, and he frequently returned to favourite subjects. Sometimes he would colour a print that he had engraved many years earlier, as with The Ancient of Days.

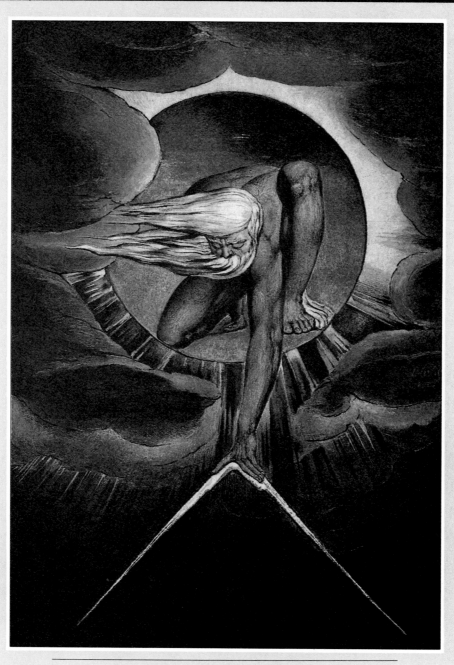

The Ancient of Days 1794
9¼″ × 6½″ Whitworth Art Gallery, Manchester

Blake used this design as an illustration to his poem Europe, *and it proved one of his most popular prints – he handcoloured this particular impression for a customer 30 years later. The image was inspired 'by a vision which he declared hovered over his head at the top of the staircase'.*

The Bible was Blake's most frequent source of inspiration, and he recreated its awesome stories – God Judging Adam, The Body of Abel Found by Adam and Eve (p.310-311) – with an intensity few artists have matched. Just as impressive are the products of his own imagination, such as Glad Day and Newton. No other artist has created such a rich personal mythology, or made spiritual beings seem so real.

A mystic, Blake was an outstanding example of the artist feeling free to put his private vision on paper as only the poets had done up until that time. It was the outstanding effect of the break which was brought about in artistic tradition.

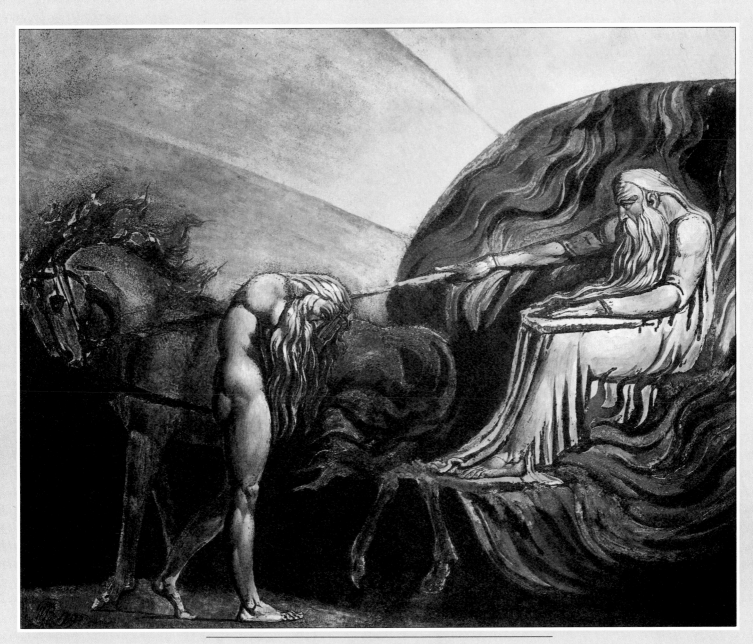

God Judging Adam *1795*
17" × 21" Tate Gallery, London

This print was known for many years as Elijah in the Fiery Chariot, *but a faint pencil inscription discovered in 1965 revealed its true subject. Blake may have adapted an earlier design on the subject of Elijah, transforming the prophet's fiery chariot into God's blazing throne.*

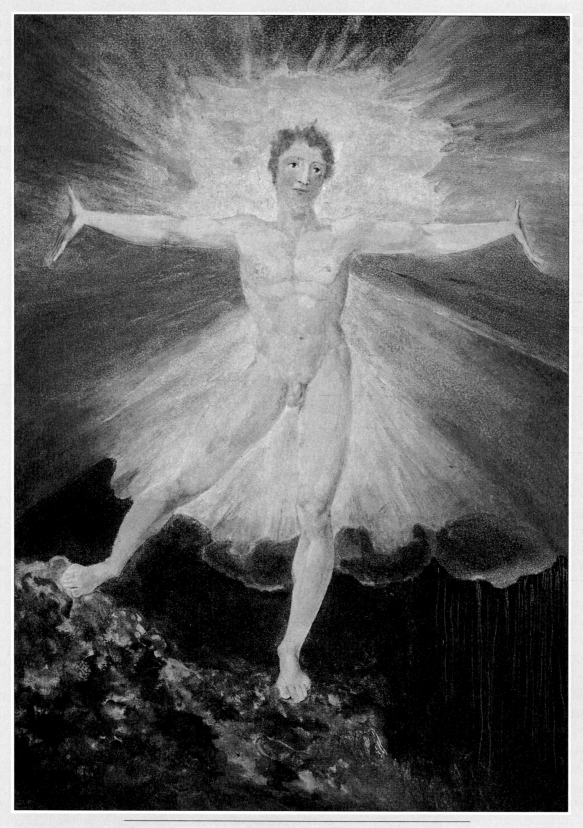

Glad Day *c.1795*
10¾″ × 8″ British Museum, London

The inspiration for this work is uncertain. Blake may have had in mind a passage in Shakespeare's Romeo and Juliet *in which 'jocund day stands tiptoe on the misty mountain tops'. But the print is also known as* The Dance of Albion, *a symbolic figure embodying the personality of England.*

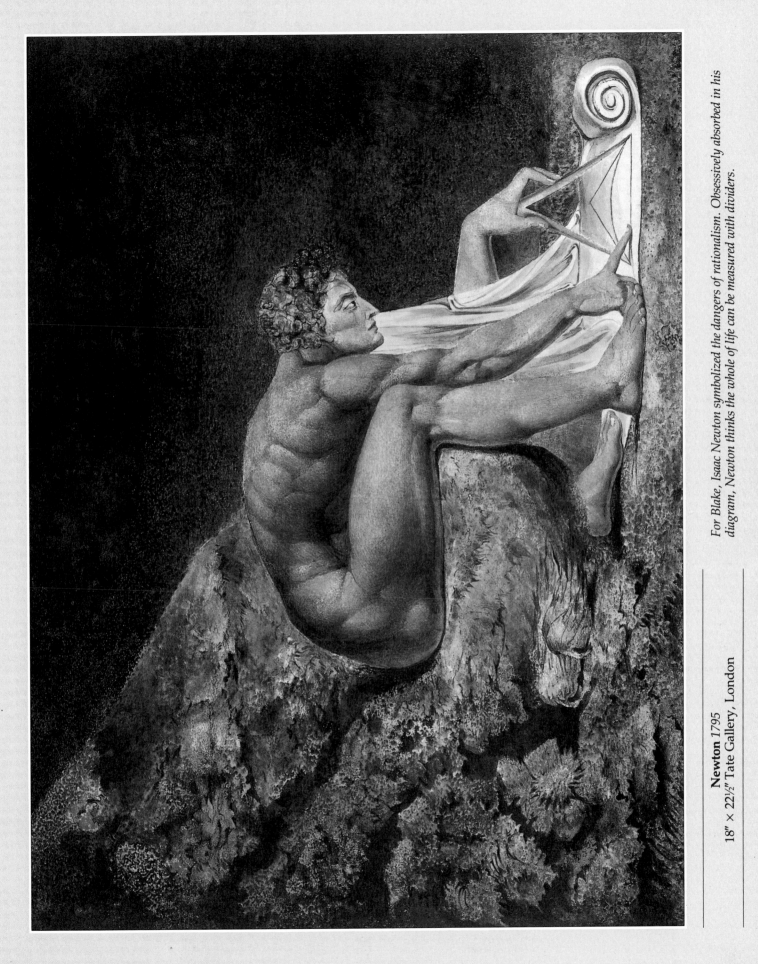

Newton 1795
18″ × 22½″ Tate Gallery, London

For Blake, Isaac Newton symbolized the dangers of rationalism. Obsessively absorbed in his diagram, Newton thinks the whole of life can be measured with dividers.

Friedrich

Friedrich's landscapes are distinguished by their powerful mood and atmosphere, which give them a brooding significance. The early Abbey in the Oakwoods is a striking image of death, filled with religious allusions. Together with paintings like The Wanderer, it confirmed Friedrich's reputation for romantic, melancholy scenes.

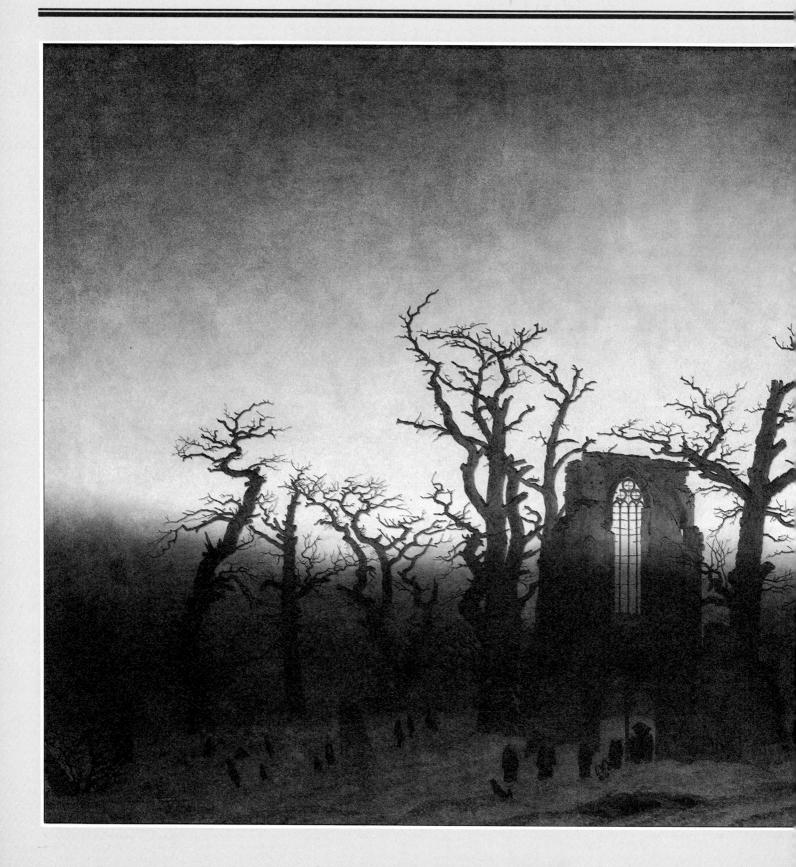

Following his marriage, however, Friedrich's work acquired a new tenderness. Chalk Cliffs on Rugen is one of his happier pictures, perhaps a honeymoon momento.

In his later works, Friedrich's style became richer and more atmospheric. The Stages of Life (pp.226-227) – one of his most mysterious images – reveals a lasting preoccupation with the theme of mortality. It has been interpreted as a premonition of death. The artist appears in the painting walking slowly towards the seashore. His figure is echoed by a ghostly ship. Now nearing the end of its voyage, the ship is a poignant symbol of man's passage from birth to death.

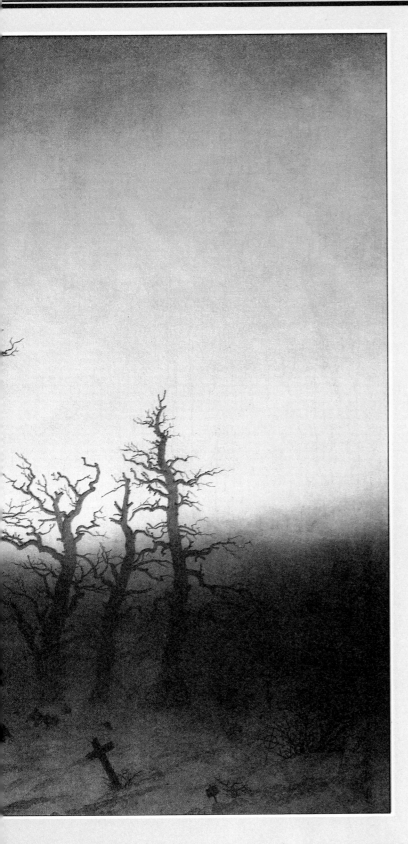

Abbey in the Oakwoods *1810*
43″ × 67½″ Schloss Charlottenburg, West Berlin

Throughout his life, Friedrich was obsessed with 'death, transience and the grave', as he put it. In this chill, sombre work, he shows a procession of monks carrying a coffin towards a desolate Gothic ruin, surrounded by barren oak trees. For Friedrich, the ruined structure symbolized the incompleteness of earthly existence, while the portal stood as a gateway to the spiritual life beyond.

Wanderer Looking over a Sea of Fog *c.1815*
38¾″ × 29½″ Kunsthalle, Hamburg

*Standing on a rocky cliff, Friedrich's 'wanderer' looks out over a
landscape shrouded in thick mists. Absorbed in thought, he
personifies Friedrich's overwhelming desire for solitude: 'I have to
stay alone in order to fully contemplate and feel nature', he wrote.*

Chalk Cliffs on Rügen *c.1819*
35¾″ × 28¼″ Oskar Reinhart Foundation, Winterthur

*In 1818, shortly after his marriage, Friedrich took his young wife on a
tour of his homeland and together with his favourite brother,
Christian, they visited the spectacular white cliffs of Rügen. Friedrich
painted this picture later, probably as a honeymoon memento.*

J M W Turner RA

Turner first built his reputation with dramatic sea-pictures like Calais Pier: an English Packet Arriving, and the violence of the elements held a life-long fascination for him, inspiring such masterpieces as Snow Storm: Hannibal and his Army Crossing the Alps. This also embodies other themes common to Turner's work – a preference for the melodramatic and catastrophic, and an interest in the heroic.

The theme of the heroic is used again in

Calais Pier: an English Packet Arriving *1803*
67¾″ × 94½″ National Gallery, London

This picture of the cross-channel ferry arriving at Calais was based on Turner's own experience of a hair-raising landing on his journey to the continent in 1802 – his first visit abroad. He recorded the whole episode in the sketchbook, with an inscription reading: 'Our landing at Calais. Nearly Swampt.'

the patriotic Fighting Temeraire, painted for exhibition at the Royal Academy. It was universally admired although the critics noticed that Turner's colour was becoming more dramatic and symbolic.

From 1840, light and colour became the real subject-matter of Turner's paintings. His atmospheric views of Venice show why the city had been called 'the birthplace and theatre of colour'. His painting Venice from the Canale della Guidecca has a mass of architectural detail and makes an interesting contrast with Rain, Steam and Speed, one of Turner's late masterpieces.

Here, Turner has transformed a personal experience into an imaginative vision. It is also an example of the exciting creative discoveries which the artist made about light and its relationship to colour, discoveries which preceded the Impressionists by thirty years. The Impressionists held their first exhibition in 1874.

Snow Storm: Hannibal and his Army Crossing the Alps *1812*
57½″ × 93½″ Tate Gallery, London

The legendary exploits of Hannibal, the Carthaginian general who marched across the Alps to attack ancient Rome, were a popular theme for Romantic painters. But for this picture Turner's inspiration came from nature, not history – he had witnessed a violent snow storm in Yorkshire a year or two before.

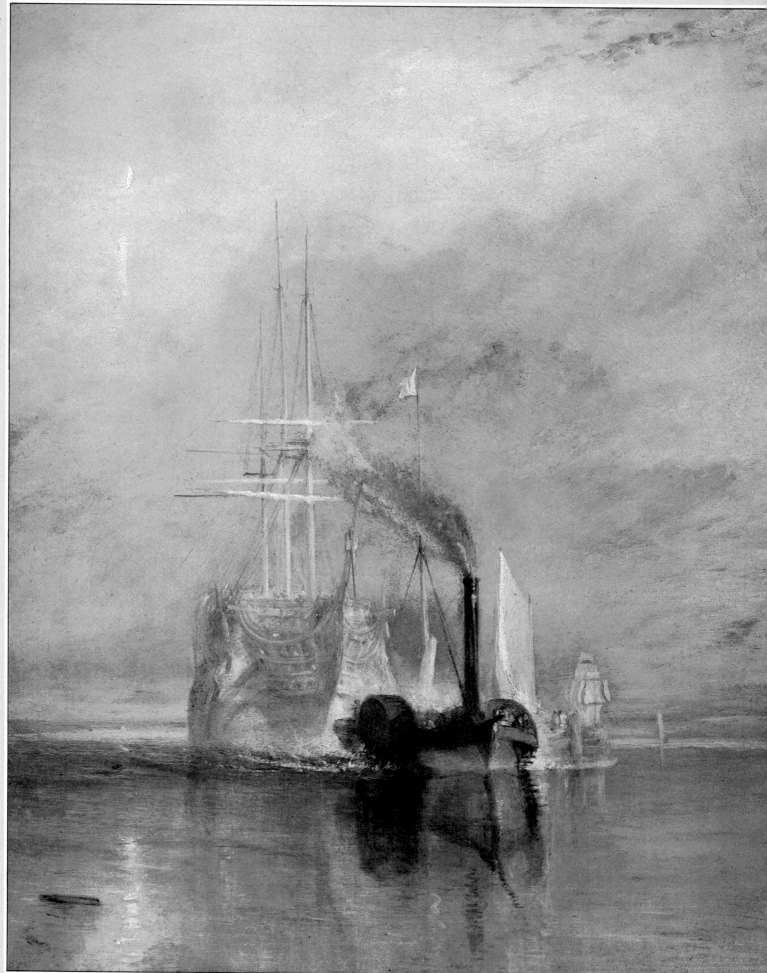

The Fighting Temeraire *1838*
35¼" × 48" National Gallery, London

From the day of its first exhibition, this has been one of Turner's most popular paintings, as much for its patriotic sentiments as for its blazing pictorial splendour. The picture shows the Temeraire – a famous warship – being towed up the Thames to a breaker's yard. The ship in full sail in the background recalls the Temeraire's own days of glory, and the black buoy looming in the foreground suggests the finality of this last, melancholy journey.

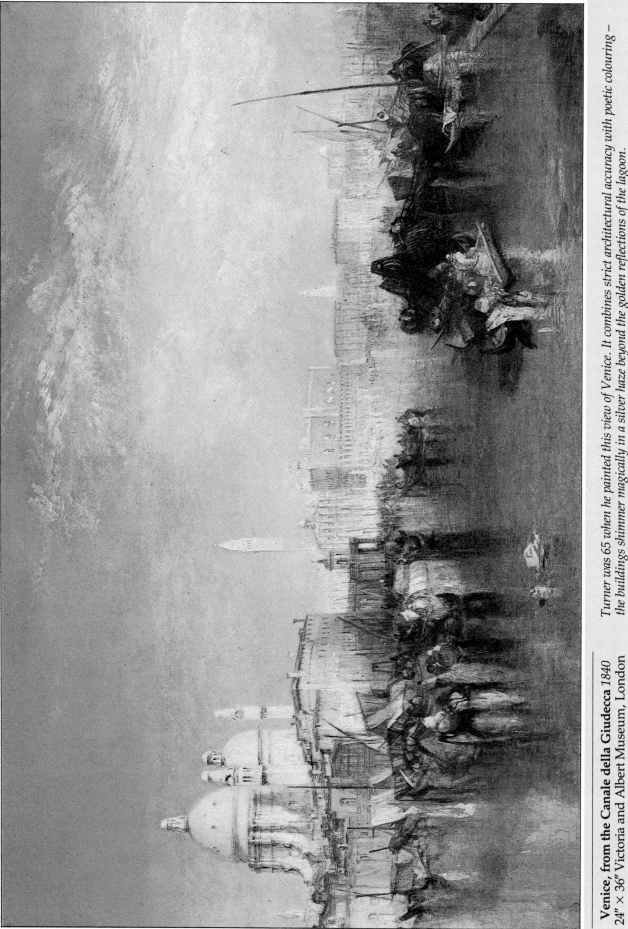

Venice, from the Canale della Giudecca 1840
24″ × 36″ Victoria and Albert Museum, London

Turner was 65 when he painted this view of Venice. It combines strict architectural accuracy with poetic colouring – the buildings shimmer magically in a silver haze beyond the golden reflections of the lagoon.

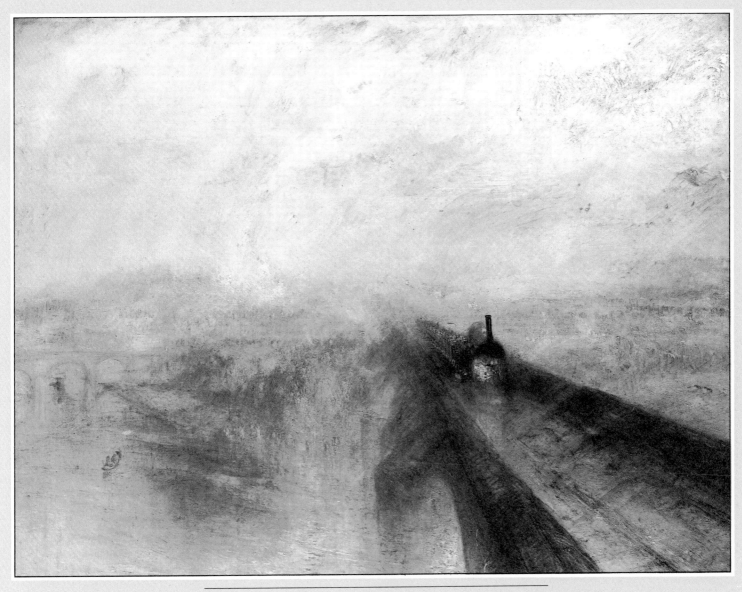

Rain, Steam and Speed *1844*
35¾″ × 48″ National Gallery, London

Turner prepared for this picture of an early steam train on the Great Western Railway in a typically thorough way: he stuck his head out of a train window for ten minutes during a storm. They were crossing a bridge, and a boat can be seen on the river below.

Constable's art matured into greatness after 1815 – the year of Waterloo – when he exhibited Boatbuilding at the Royal Academy and abandoned the small canvases of his youth for the imposing 'six-footers' which made his reputation.

Flatford Mill was the first in a series of large canal scenes painted near the family

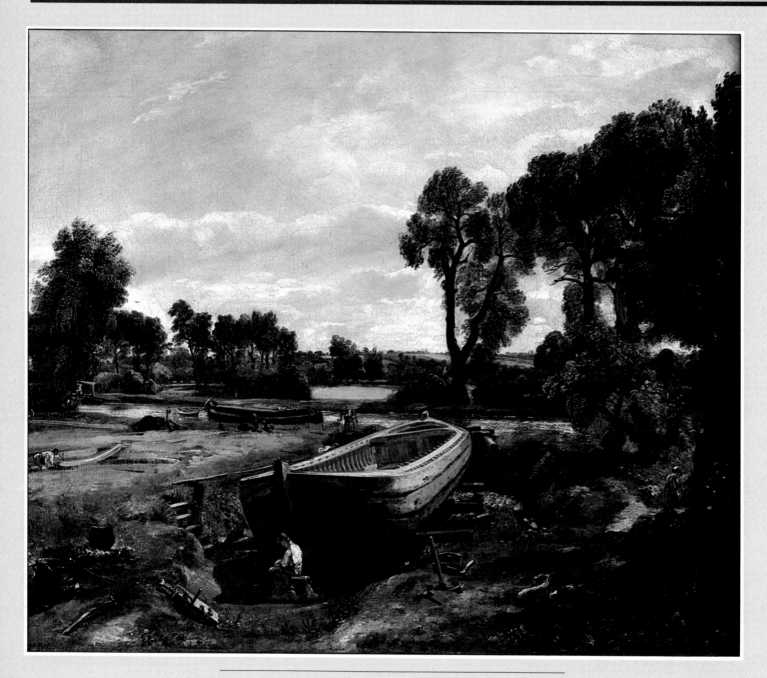

Boatbuilding *1815*
20″ × 24¼″ Victoria and Albert Museum

The only canvas Constable painted entirely out of doors shows his father's boatyard beside the River Stour, near Flatford Mill. The barges built here carried flour from the mill downstream to Mistley, on the coast.

home, which included The Hay Wain, Constable's most famous painting. These Suffolk scenes were ones with which Constable was personally familiar. He paid particular attention to the mood of the sky, and the pattern of sunlight on the fields, foliage of the trees and the surface of the water of the River Stour. In the Hay Wain, he captures the sun's rays by using pure yellow and white paint. His technique of painting a small patch brilliant red to focus the viewer's gaze is also utilised in this picture – notice that the saddles of the dray-horses are painted scarlet, bringing the eye to the centre of the canvas. The red also makes the green of the foliage appear more vivid.

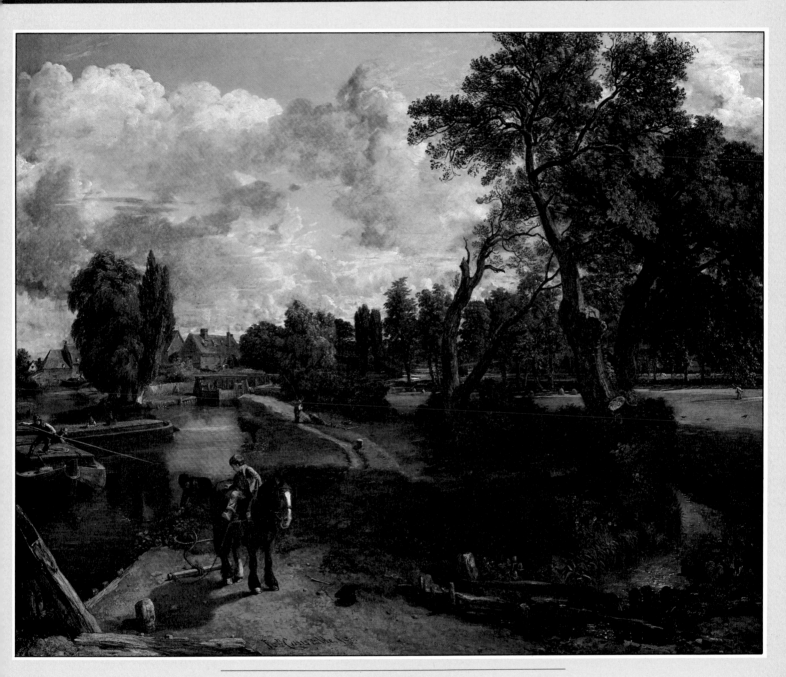

Flatford Mill *1817*
40″ × 50″ Tate Gallery

On a warm, summer's day a boy unties his tow-horse from the barge before it passes under Flatford footbridge. It is late afternoon; in the meadow on the right a haymaker casts a long shadow as he finishes work for the day.

The Hay Wain *1821*
51¼″ × 73″
National Gallery

*Constable's most famous
painting shows the
tranquil scene at Flatford
Mill in early summer:
only the dog looks up as
an empty hay waggon
crosses the Stour by Willie
Lott's cottage on its way
to the meadow beyond.
The artist's own name for
his picture – which took
five months to paint – was*
Landscape: Noon. *The
sun is out of the picture,
high and slightly in front
of us; scudding clouds
throw patches of shadow
across the green fields.*

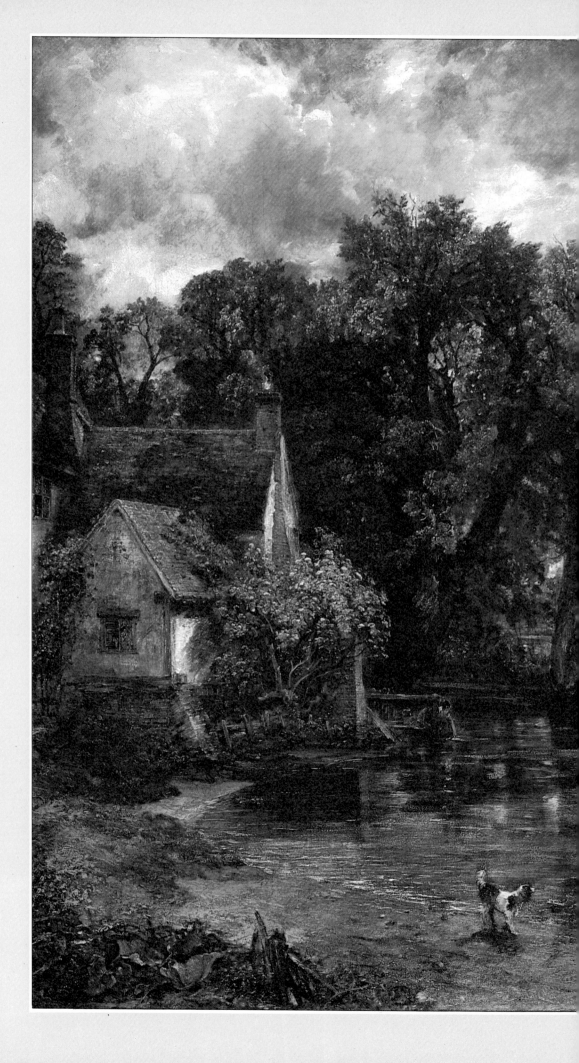

Wild Poppies *1835 by Claude Monet*
19⅝″ × 25⅝″ Jeu de Paume, Paris

Manet

1832 – 1883

Edouard Manet was one of the most original and influential painters of the 19th century. His unconventional scenes from modern life and his breathtakingly bold brushwork brought new life to French painting and were an inspiration to the Impressionists. But Manet did not see himself as a revolutionary; indeed, he always thought of himself as following in the footsteps of the Old Masters.

The critics thought otherwise, and subjected Manet to unprecedented abuse, condemning his work as incompetent and, in the case of his nudes, obscene. Although he had no need to earn his living by painting, because he came from a wealthy family, the harsh criticism hurt him deeply. Manet longed for recognition, but he was denied all public honours until late in life, when he was crippled by illness.

considered the most typical of the Impressionists, remained committed to this idea throughout his working life. His fascination with the changeability of light can be seen in his series of pictures *The Haystacks* (p.379) and of Rouen Cathedral (pp.382-383) where he painted the same view over and over again but in different light.

That the artists were able to make such a drastic break with tradition was brought about in part by new developments in the 19th century which helped people to see their world with new eyes. One of these developments was the research done into colour harmonies by the French chemist Eugène Chevreul. His thesis was that colours in proximity influence and modify one another. It was his findings that led the Impressionists to juxtapose colours on the canvas and leave the eye to fuse them at a distance – if only the critics at that exhibition in 1874 had taken a few paces back! It also encouraged them to use complementary colours in shadows and to use colours to intensify and neutralize one another. This influence can be seen in Renoir and Monet's work and also in that of Seurat, a contemporary of the Impressionists, who developed pointillism, a novel technique of painting in tiny dots of colour (see pp.404-409).

The other influence on Impressionism was that of photography which encouraged techniques of composition based on the snapshot. Degas was particularly fond of this and used it in *The Rehearsal* (p.357). By cutting off figures at the edges of the picture, he suggests that the scene is changing, or will move out of focus in a moment or two. It also adds a real feeling of movement to the picture.

The last Impressionist exhibition was held in 1886, after which the group broke up. Having begun only in the 1860s, Impressionism was apparently short-lived. It effects, though, were far reaching and have helped to shape the art of the 20th century. Indeed, it would be true to say that Impressionism was not only the best-known (and most popular) movement in French painting, but also the most important phenomenon in 19th century art, such was its resounding impact. It made painters everywhere look with open eyes and to see afresh the inexhaustible beauty of the world around them.

Manet

1832 – 1883

Edouard Manet was one of the most original and influential painters of the 19th century. His unconventional scenes from modern life and his breathtakingly bold brushwork brought new life to French painting and were an inspiration to the Impressionists. But Manet did not see himself as a revolutionary; indeed, he always thought of himself as following in the footsteps of the Old Masters.

The critics thought otherwise, and subjected Manet to unprecedented abuse, condemning his work as incompetent and, in the case of his nudes, obscene. Although he had no need to earn his living by painting, because he came from a wealthy family, the harsh criticism hurt him deeply. Manet longed for recognition, but he was denied all public honours until late in life, when he was crippled by illness.

Wild Poppies *1835 by Claude Monet*
19⅝″ × 25⅝″ Jeu de Paume, Paris

Introduction

In 1874 a number of French artists who had found it increasingly difficult to show their unorthodox work through the usual channel of the Paris Salon took matters into their own hands and set up their own exhibition. It contained a picture by Monet – *Impression: Sunrise* (p.375) – which was attacked by a journalist in an article called 'Exhibition of the Impressionists'. The name, at that time completely derogatory, was eventually accepted by the artists themselves, and it is as such that they have been known ever since.

To say they were received unfavourably is an understatement. Critics and public alike did not feel that conveying the impression of a moment was 'art'. They looked and saw only a confusion of brush strokes and bright colours and something – but what? – that looked decidedly unfinished. And where was the dignified subject-matter they were used to seeing?

So the Impressionists and their circle offended on two counts – not only was their style unacceptable, but so too was their content. The scenes of everyday life favoured by the artists may seem quite normal to us today, but at that time they were a radical choice. In this they were given a lead by Manet, sympathetic to the Impressionists, although he never exhibited with them. His painting *The Absinthe Drinker* (p.350) was rejected by the Salon jury for its uncompromising naturalism.

What, then, were the Impressionists and their contemporaries doing? In very simple terms, they were trusting their eyes. They were trying to represent what they *saw* at one particular moment in time rather than what the mind knows *ought* to be there, which was the approach of academic art. Such an approach called for speed and spontaneity in technique. On-the-spot scenes from contemporary life made perfect sense as subjects, be they Renoir's working women or a rural winter landscape such as Monet's *The Cart: Road under Snow* (p.371).

They also wanted to capture the fleeting effects of light and atmosphere. One of the best ways of doing this was by painting in the open air, another departure from established tradition. Monet,

Argenteuil *1874*
58″ × 52″ Musée des Beaux-Arts, Tournai

The Unlikely Revolutionary

A gentleman artist, always impeccably turned-out, Manet was completely unprepared for the scandal his paintings provoked. And he was continually surprised by his own lack of success.

Edouard Manet was born in Paris on 23 January 1832, the eldest son of a senior civil servant in the Ministry of Justice. With this comfortable, upper middle-class background, Edouard was destined – in his father's eyes, at least – for a safe legal career.

Edouard, however, had neither the temperament nor the inclination to follow in his father's footsteps. From the beginning he found school dull and was consistently inattentive – he much preferred his home life, where he could be with his mother, Eugénie, whom he adored. A woman of artistic inclinations, she loved music and arranged for Edouard and his two younger brothers to take piano lessons. In the evenings, Edouard also learned to draw, under the guidance of his uncle, Edmond Fournier, who had a passion for art.

By 1848, when Edouard was 16, matters between himself and his father came to a head. Edouard was expected to go to law school, but by now he was determined to become a painter. M. Manet was outraged by this suggestion, but eventually father and son reached a compromise:

Edouard agreed to enter the Navy rather than become a lawyer or a painter. He promptly failed his entrance exams, but was given the chance to retake them if he spent six months as an apprentice on a transport ship. On 9 December 1848, Manet set sail for Rio de Janeiro.

A CAREER AS A PAINTER

On his return, Manet resat his exams and failed yet again. He had learned that the hardships of life at sea were not for him and begged his father to allow him to become a painter. Recognizing his son's seriousness, M. Manet relented, and in January, 1850, Manet enrolled at the Paris studio of the respected figure painter Thomas Couture.

Manet's talent as a painter was instinctive and he very quickly showed greater promise than any of his fellow students. But at 18, he already had decided ideas about painting, and for the most part these were not his master's. The outworn traditions and the artificiality of academic art

A fashionable gathering
(below) Manet adored Parisian society, and his painting of a Concert in the Tuileries Gardens (1862) *shows the world he moved in. Mingling with the dandies and fashionable ladies are some of his gifted contemporaries – the composer, Jacques Offenbach, the writer, Théophile Gautier, and the poet, Charles Baudelaire. Manet's brother, Eugène, is prominent in the centre of the composition and Manet himself appears on the extreme left.*

Key Dates

1832 born in Paris

1848 joins the navy

1850 enrols at Couture's studio

1860 rents studio in Batignolles quarter

1862 father dies; large inheritance

1863 marries Suzanne Leenhoff. Exhibits *The Luncheon on the Grass* at the Salon des Refusés.

1865 *Olympia* provokes a scandal

1868 meets Berthe Morisot

1869 frequents the Café Guerbois

1874 paints with Monet at Argenteuil

1879 onset of fatal illness

1881 awarded the Légion d'Honneur

1883 dies in Paris

The perfect gentleman
Manet was elegant, cultured and urbane. Described by Zola as a man of 'exquisite politeness' and 'extreme amiability', he was a rebel only in his art.

M. and Mme Auguste Manet
(left) Manet's parents were wealthy and highly respected. His father was a stern and self-righteous man, who expected his son to pursue a career in the civil service, similar to his own. His mother, on the other hand, was an artistic woman who loved music. Manet was always extremely close to her.

Manet/Jeu de Paume, Paris

Wife and 'godson'
(left and below) When he was 18, Manet fell in love with his 20-year-old piano teacher, Suzanne Leenhoff. They married in 1863, and an 11-year-old boy, Léon-Edouard Koëlla, was a special guest at their wedding. Léon was introduced as Suzanne's younger brother and Manet's godson. But it seems certain that he was the couple's son – born on 29 January 1852.

exasperated him. When he was given a plaster cast of an antique statue to copy, he drew it upside down – because it was 'more interesting' that way. 'You've got to belong to your own period', he said, 'and paint what you see'.

During these years at Couture's studio, Manet presented an image that was to change little as he grew older. He was an attractive man, of medium height and strong physique. His mouth, turned up at the corners, was ironic. His glance was keen; his eyes were deepset but very mobile and he walked with an elegant swagger. Manet was urbane and charming – in fact, an unlikely revolutionary. In spite of his unconventional ideas on painting, he wanted above all to be accepted by the Salon, the established centre of the French artistic world.

In 1850, while still a student, Manet began an affair with his 20-year-old piano teacher, Suzanne Leenhoff, a pretty Dutch girl. Two years later, she gave birth to Manet's son. To reveal this was unthinkable, given Manet's background and character; besides, his father would never give his blessing to such a 'bad' marriage. So with his mother's help, Manet set up Suzanne in lodgings. In years to come, even after they married, Suzanne was to pass off their child, Léon-Edouard Koëlla, as her brother, and Manet always kept up the official pretence of being Léon's godfather.

Manet studied under Couture for six years, a period broken only by a visit to Italy in 1853, where

National Gallery, London

Art Institute of Chicago

he copied the Old Masters in Venice, Florence and Rome. Then in 1856, he left Couture and began to work on his own. But before settling down, he travelled to Holland, Germany, Austria and again to Italy, visiting galleries and making sketches.

Manet worked hard, but still found time for pleasure, and above all the evening parties and café discussions where he met the cream of artistic society. With his ease of manner and irresistible charm, Manet always attracted friends, including the brilliant poet Charles Baudelaire whom he met in 1858. The two were to remain loyal companions until Baudelaire's death from syphilis, nine years later. Manet was a generous friend, often lending Baudelaire money, just as he helped Claude Monet financially.

DISAPPOINTMENT AND SCANDAL

In 1859 Manet submitted his first canvas to the Salon – *The Absinthe Drinker* (p.350). He expected success, but the painting was rejected almost unanimously. Bitterly disappointed, but still courting official favour, Manet set to work on the *Concert in the Tuileries Gardens* (p.344), which shows a fashionable Paris crowd, in all the finery of their contemporary dress, sitting out under the trees. Because of its lukewarm reception among his friends, Manet decided not to submit the picture to the 1862 Salon. But the two paintings he did submit were both accepted – and this in spite of a severe jury. Manet's confidence increased and at last he felt he had proved himself to his parents. The success was fortunately timed, for his father died later that year.

At a private exhibition early in 1863, Manet was shocked and wounded by the hostile reception to his *Concert in the Tuileries Gardens*. Nevertheless, he

The Salon des Refusés

Every year thousands of paintings were rejected by the jury for exhibition at the Salon. In 1863, over half of the 5,000 paintings submitted were thrown out. The artists complained so loudly and bitterly that the Emperor, Napoleon III, decided to take notice. On 24 April the official newspaper carried the announcement that a special exhibition would be held of the rejected pictures – the notorious Salon des Refusés. At last the public could make up its own mind whether the jury had been correct or the artists' complaints were justified.

Rejected masterpieces
Among the stacks of canvases rejected from the 1863 Salon was Manet's Luncheon on the Grass *(p.422). The pictures were kept in the Palais d'Industrie, each marked with an 'R' (for Refusé) on the back.*

Leader of a 'school'
(right) During the 1860s Manet was hailed as the leader of a new, anti-Establishment school, and later as the 'Father of Impressionism'. Henri Fantin-Latour's painting Studio in the Batignolles Quarter (1870) *shows him surrounded by his 'disciples'. Monet, peering out of the right-hand corner, and Renoir, his head framed by the picture on the wall, are among them.*

346

Jeu de Paume, Paris

Napoleon III
When Napoleon III authorized the Salon des Refusés, he no doubt wanted to demonstrate that the Salon jury had been justified in its selections. He himself was not a good judge of painting.

Manet/Battle of the Kearsarge and the Alabama (1864)/Private Collection

An eye-witness report
In 1864, at the height of the American Civil War, a battle between two American ships took place just outside Cherbourg. Manet witnessed and painted the encounter.

decided to submit a new painting, *The Luncheon on the Grass* (p.422), to the Salon of 1863. The picture was rejected, then exhibited instead at the newly established Salon des Refusés.

Here, the works that had been excluded from the Salon could all be hung – and Manet found himself in the distinguished company of artists like Cézanne and Whistler. The Salon des Refusés drew enormous crowds. They came mainly to ridicule, but Manet's contribution provoked outright fury. The public, from whom Manet in his ingenuous way had expected approval, jeered and scoffed at the 'indecency' of a nude woman sitting casually on the grass with clothed men – clothed moreover, in modern suits!

In spite of himself, and his desire to be recognized officially, Manet was soon acquiring a reputation as the leader of a school of non-conformist artists. And when in 1865 the Salon accepted and exhibited the nude *Olympia* (p.424), an even greater storm broke out. Critics and public alike were scandalized by what they saw. Here was a naked prostitute – a 'female gorilla' – gazing candidly and unashamedly from the picture, masquerading as a classical Venus. Morals were

outraged; surely the artist had deliberately chosen to sneer at tradition. Manet was thrown into a deep depression by the extraordinary violence of the public's reaction and for a time was unable to paint. He took himself off to Spain for a break, and was bowled over by the paintings of Velázquez.

MAN-ABOUT-TOWN

Although these were years of struggle in terms of his work, Manet had the comfort of no longer being in need of money. His father's death had left him comfortably off – and free to marry Suzanne. Together, he and Suzanne led a busy social life, entertaining and holding musical evenings. In addition, Manet still frequented the fashionable cafés, in particular the Café Guerbois, where every Thursday tables were set aside for Manet's 'court', which included Whistler, the photographer Nadar, Renoir, Degas and Monet. Here he met the novelist Emile Zola, who became a champion of Manet's art.

Now 35, Manet was far from making a living from his paintings. Still hoping to convert the public, he mounted an expensive private

Manet/Country House at Rueil (1882)/National Gallery of Victoria, Melbourne

art dealer Paul Durand-Ruel bought some 30 canvases from Manet and when, in addition, his canvases were accepted by the Salon for two years running, success seemed assured.

Manet was now 40. Under the influence of the younger painters he mingled with, he had begun experimenting with open-air painting and his palette was becoming lighter. At Argenteuil, he painted side by side with Monet and Renoir in a brighter, more spontaneous style. However, he still felt the right approach was through the official channel of the Salon, and so he refused to take part in the 1874 exhibition mounted by the group of Impressionists. Yet Manet was sympathetic to their aims and a loyal defender of their work.

A TERRIBLE ILLNESS

Throughout the 1870s, Manet's fortunes at the Salon continued to be uneven. With the critics, however, his work was slowly gaining ground and his technique was more virtuoso than ever before. But in the late 1870s, Manet became aware for the first time of his ill-health. His left foot was hurting and he experienced bouts of extreme tiredness and lightning pains throughout his body. For a while he was content to believe it was rheumatism and nervous exhaustion. But soon it was diagnosed as *locomotor ataxia*, a disease sometimes associated with the later stages of syphilis.

Manet took a course of treatment at Bellevue, just outside Paris. He continued painting, although he increasingly used pastels, which he found less physically taxing than oils. In 1880 he rented a villa near the Park of Versailles where he went to convalesce. A true city man, Manet was never very happy when not in Paris and with his symptoms temporarily relieved, he flung himself once more into his work and his social life.

exhibition at the Paris World Fair of 1867. The result was depressingly predictable: people came in droves to see Manet's work, but to mock rather than to admire. He had unexpected success at the Salons of 1868 and 1869, but the critics and public maintained their hostility. Manet's nerves were so strained by the years of criticism that he even challenged a journalist acquaintance, Edmond Duranty, to a duel on account of an adverse newspaper article. Fortunately, the fight was quickly stopped and Manet offered his opponent his boots, as a token of friendship.

In July 1870, Manet's work was interrupted by the outbreak of the Franco-Prussian War. Serving as a lieutenant in the National Guard, he remained in Paris for the duration of the fighting, while sending his family to Oloron in the Pyrenees. After months of some hardship in besieged Paris, Manet joined his mother, wife and 'godson' early in 1871. By May they were back in Paris, where they lived through the end of the Commune. As the events of the past year took their toll, Manet had a nervous collapse and was sent to Boulogne to recover.

But that same year, his fortunes changed. The

The last summer
(above) In the summer of 1882, Manet rented a charming villa at Rueil, outside Paris. By this time he was desperately ill, crippled by a terrible disease of the nervous system. Just before he returned to Paris, he drew up his will.

Unrequited love
In his last years, Manet conceived a passion for a young woman called Isabelle Lemonnier. He painted her, sketched her and sent her letters and poems: 'I would kiss you, had I the courage', he wrote. Isabelle, however, was unimpressed by her middle-aged admirer.

Manet/Woman in a Large Hat/Sterling and Francine Clark Art Institute, Mass.

A late honour

(left) Throughout his career Manet craved official recognition, but it was only in 1881 that he was awarded the coveted Légion d'Honneur. And this was largely through his friend, Antonin Proust – the newly-appointed Arts Minister – pulling strings. For Manet, however, it had come 'too late to repair 20 years' lack of success'.

Manet's tomb

(above) On 20 April 1883 Manet had his leg amputated and soon afterwards fell into a fever. He died 10 days later and was buried in the Passy Cemetery in Paris.

Manet's work now seemed much less revolutionary than in the 1860s, and in 1881 he was awarded a second-class medal by the Salon. At the end of this year, he was even named a Chevalier of the Légion d'Honneur, largely through the efforts of his lifelong friend Antonin Proust, the Minister of Arts. But for Manet, acceptance had come too late to be properly enjoyed. Crippled by pain and increasingly irritable, he underwent further medical treatment, but his condition deteriorated. He spent the summer of 1882 in the country, where he drew up his will, and returned to Paris a dying man.

In March 1883, gangrene set in and Manet's left leg was amputated on 20 April. On 30 April he died, in terrible pain, aged 51. 'An appalling death!' lamented his sister-in-law Berthe Morisot 'Death in one of its most horrible aspects.' The next day, the 1883 Salon opened its doors to the public.

Lessons with Berthe Morisot

In 1868 Manet was introduced to Berthe Morisot and her sister during a copying session at the Louvre. 'The demoiselles Morisot are charming', he wrote afterwards. 'Too bad they are not men.' Berthe was a very talented painter, who had studied under the influential artist, Camille Corot. She was a great admirer of Manet's work and eagerly sought his friendship and advice. Manet also learned some valuable lessons from her: it was Berthe, it seems, who persuaded him to paint in the open air. A beautiful young woman, she often posed for Manet, appearing in masterpieces like *The Balcony*. However, after her marriage to Manet's brother Eugène in 1874, she never sat for him again, although they remained good friends.

A striking subject

(left) From their first meeting, Manet was captivated by Berthe Morisot's ravishing good-looks. This portrait of Berthe Morisot with a Bunch of Violets *(1872) was painted when she was 31 years old.*

An intimate art

As an artist, Berthe Morisot specialized in gentle domestic scenes painted in a delicate Impressionist style.

Private Collection

Berthe Morisot/Pasie Sewing in the Garden (1881)/Musée des Beaux-Arts, Pau

A Painter of Modern Life

An elegant man-about-town, Manet was above all the painter of contemporary Parisian life. He took his subjects from low life as well as high society, and was never really happy away from the capital.

The Cats' Rendezvous (1868)

(below) Manet was a brilliant printmaker, excelling at both etching and lithography. This lithograph was used as a poster to advertise a book on cats by Manet's friend Champfleury (both men were cat-lovers). Many contemporaries found the sexual explicitness of the poster shocking.

Of all the great artists of the 19th century, Manet is perhaps the hardest to categorize. He was seen as a revolutionary, but he craved conventional academic success and honours; he was part of the circle of the Impressionists, but he never exhibited with them; he was above all a painter of modern life, but his reverence for the Old Masters was profounder than that of almost any of his contemporaries. Some critics have accused him of lack of imagination, saying that he could paint only what he saw in front of him, while for others his paintings are among the most complex and subtle of his age.

These contradictions reflect the enormous variety of Manet's art and his undogmatic approach to everything connected with it. He painted landscapes, everyday scenes, still-lifes, portraits, traditional religious subjects, incidents from modern history and some subjects, such as

The Absinthe Drinker (1859)

(above) One of Manet's most ambitious early works, this was rejected by the Salon jury and criticized for its uncompromising naturalism – subjects from the seamy side of life were considered suitable only if they were comic or picturesque. Manet's model was a drunken rag and bone man.

Pinks and Clematis (1882)
(above) The last pictures Manet produced were flower paintings. This exquisitely simple group was one of a series of flower paintings he did in the last year of his life, when his crippling illness forced him to confine himself to working on a small scale.

The Dead Toreador (1864)
(below) In 1864 Manet exhibited a Bull-Fighting Episode, *which was severely criticized. Manet himself was not happy with the composition, so he cut it up to make two separate paintings (of which this is one) and destroyed the parts left over.*

The Luncheon on the Grass (p.422), that defy all categorization. Unlike most of his contemporaries, he rarely repeated favourite themes.

His paintings range from intimate sketches to ambitious large-scale canvases meant to impress on the walls of the Salon, and he was also a superb draughtsman and pastellist, as well as a masterful printmaker. In all these fields he showed an intuitive feeling for the characteristics of his materials, and like many great artists he was reluctant to theorize: he was once prompted to publish his views on art, but he replied 'No, I would put it badly, since it is not my business and everyone ought to stick to his own trade.'

SPONTANEOUS SKETCHES

Although Manet's work is so varied, it was based largely on his skill in drawing – in capturing spontaneously the life he saw around him in the boulevards and cafés of Paris. He carried notebooks with him everywhere, sketching constantly. A contemporary described his tireless observation: 'The least object or detail of an object that caught his attention was immediately fixed on paper. These sketches, these brief drawings that one might call instantaneous, show with what certainty he seized on the characteristic trait and the decisive moment.'

The sense of spontaneity that Manet captured

Young Woman with Blue Eyes (1878)
Manet loved painting beautiful young women and he found pastel the perfect medium to capture the softness of their skin. Here Manet's touch is so delicate that the colour seems almost to have been breathed on to the paper.

The Impressionists banished black from their palettes, endeavouring to make their paintings bright and full of light. Manet, however, saw black as a positive, not a negative force in his painting and used it so skilfully in contrast with lighter tones that it takes on a sparkle of its own.

Unlike most of the Impressionists, Manet was a skilful printmaker, so he was used to thinking in terms of bold contrasts of black of white.

in his drawings was crucial to his art, and his working method was geared to retaining it. His friendship with the Impressionists led him to enjoy painting out-of-doors, but it was not so easy to keep a feeling of freshness when he was in the studio, where most of his work was done.

FAMILY MODELS

Manet overcame the conventionality and the formality that could come from working with professional models by relying mainly on his family and friends to pose for him. His brothers and brothers-in-law, his sister-in-law · Berthe Morisot, and various painter and critic friends appear regularly in his paintings. But Manet had no fixed rules: for his two most famous works, *The Luncheon on the Grass* and *Olympia* (p.424), he employed the same professional model, Victorine Meurent. Both these paintings were carefully planned, but more often, as his friend Emile Zola remarked, 'In beginning a picture, he could never say how it would come out.'

Manet's paintings do indeed often look anything but planned, as if everything had come right for him in the heat of inspiration. Often, however, he endured a long struggle to get the effects he wanted. He was ruthlessly self-critical and would repaint passages again and again, or even destroy the canvas and start afresh, until he was satisfied. The novelist George Moore had his portrait painted by Manet (the picture has unfortunately been destroyed), and described the exhilarating way in which the artist worked: 'I saw him scrape off the rough paint and prepare to start afresh. Half an hour after he had entirely repainted the hair; every time it came out brighter and fresher and the painting never seemed to lose anything in quality.'

Although his subject matter was usually firmly of the present, Manet often looked to the art of the past for inspiration. He made numerous copies of the Old Masters, studying assiduously in the Louvre, and also on his journeys to Holland, Italy and Spain. In Spain he was overwhelmed by the work of Velázquez, and Manet's liking for clean, bold forms against plain backgrounds, as in *The Fifer*, reflects the influence of the great 17th century master.

Manet was also influenced by Japanese prints – their strong colours and flat patterning appealed greatly to him. In his *Portrait of Emile Zola*,

he included a Japanese print on the wall behind the sitter, together with an engraving after a painting by Velázquez and a print of his own *Olympia*, the whole forming a kind of artistic manifesto.

The distinctive boldness of Manet's work depends not only on his composition and colouring, but also on his handling of paint, particularly the way he treated light and shade. The normal academic practice was to produce very fine gradations, so that dark blended imperceptibly into light, but Manet liked stark contrasts of light and shadow. The effect that this produces in his paintings is similar to that seen in photographs taken by flash, where forms seem clear but rather flattened. This lack of traditional modelling enraged contemporary critics, one of whom wrote of *Olympia*: 'The shadows are indicated by more or less large smears of blacking . . . The least beautiful woman has bones, muscles, skin, and some sort of colour. Here there is nothing.'

A FOUNDER OF MODERN ART

Manet no longer enrages the critics, but he continues to perplex. Although he is universally recognized as one of the giants of 19th-century art and his luscious brushwork as one of its chief glories, there is still much about his work that resists explanation. Often, as in his last great masterpiece, *A Bar at the Folies-Bergère* (p.345), his characterization is enigmatic or non-committal, indeed his paintings often seem to be about painting rather than about the ostensible subject. In this concern with purely visual phenomena, free of all literary, anecdotal or moralistic connections, he stands as one of the founding figures of modern art.

Boating (1874)

This delightful painting is one of the boldest of Manet's open-air scenes, done at a time when he was in close contact with Monet and other Impressionists. The way in which the river fills the background without a horizon perhaps shows the influence of Japanese prints, but the breathtaking fluency of the brushwork (detail above) is completely Manet's own.

COMPARISONS

The Reclining Nude

Manet's *Olympia* is one of the most celebrated examples of the reclining female nude, a subject that became popular in painting in the early 16th century. At first the nude was usually shown as Venus, but soon it became fashionable to portray courtesans in this way, as in Titian's *Venus of Urbino*. The pose continued its popularity into the 20th century, when Modigliani, Italian by birth but French by adoption, became perhaps the supreme exponent.

Titian (c.1490-1576) Venus of Urbino

(above) Titian's famous nude won its popular name because it was owned by a nobleman who became Duke of Urbino. The model may have been the Duke's mistress.

Amedeo Modigliani (1884-1920) Reclining Nude

(left) Modigliani led a dissolute life and his work often has a strong erotic charge. This wonderfully graceful and harmonious figure is often considered to be his finest nude.

THE MAKING OF A MASTERPIECE

Olympia

After the scandal caused by his *Luncheon on the Grass* in 1863, Manet was cautious about showing another potentially inflammatory picture in public. *Olympia* was also completed in 1863, but Manet held it back for exhibition until 1865, perhaps hoping that the critical climate would have become more liberal by then. He was disappointed, and the furore was greater than ever. Although *Olympia* was part of a great tradition including works by the most revered artists, the blatant, even aggressive sexuality of Manet's model, with her direct, imperturbable gaze, made the picture seem shocking – a threat to public morals and the social order. 'Insults are pouring down on me as thick as hail', Manet wrote to his friend Baudelaire, before taking temporary refuge in Spain.

Flowers from an admirer
(above) The bouquet Olympia's maid brings to her is presumably a gift from one of her admirers or 'clients'. Flowers have traditionally been given as tokens of love.

Flattened forms
(right) Olympia's hand is bold in outline but rather flat; and Manet's critics objected to the lack of traditional modelling through light and shade. His direct frontal lighting gives the effect of a photograph taken by flash.

'A woman who embodies the habits of a city'
Gustave Geffroy 1892

Museum of Fine Arts, Boston

Louvre, Paris

Louvre, Paris

Beauty's Adornments

Olympia's eroticism is enhanced by her luxurious adornments, which are rich in symbolic meaning. The orchid in her hair was supposed to have aphrodisiac powers, and pearls were traditional attributes of Venus – the goddess of love.

Careful preparations
(above) Manet often threw himself into his work, almost in a kind of fury, but he took unusual care over the planning of Olympia. *Several preparatory studies are known, including this figure, drawn in red chalk.*

Inspiration from the Old Masters

Manet was humble enough never to stop learning from the great masters. He made this copy of Titian's *Venus of Urbino* when he was in Italy in 1853, and 10 years later its influence can clearly be seen in the composition of *Olympia*.

Manet's model
(left) Victorine-Louise Meurent was a professional model, aged about 30 when she posed for Olympia. *Manet painted this portrait of her a year earlier in 1862. Victorine later became a painter herself and had a self-portrait accepted at the 1876 Salon, where Manet's entries were rejected. Her career was unsuccessful, however, and she ended her life as a drunkard.*

Private Collection, Paris

Degas

1834-1917

The most brilliant draughtsman of his generation, Edgar Degas abandoned his law studies at the age of 18 to take up his career as an artist. He always respected the tradition of the Old Masters, but drew his inspiration from the lively scenes of modern Paris. He is best known for his charmingly evocative pictures of the ballet dancers at the Paris Opera, rehearsing in the practise rooms, or transformed on stage.

A shy, awkward man, with a fetish for privacy, Degas was renowned for his aloof manner and sharp-tongued wit. He had only a few close friends, and apparently no love affairs, preferring to devote his life to art. In later years, as the daylight hurt his failing eyes, and he grew even more anti-social, he withdrew into his dimly-lit studio in Montmartre, where he worked obsessively. He died a lonely old man at the age of 83.

The Rehearsal *1877*
26¾″ × 40½″ Burrell Collection, Glasgow Art Gallery and
Museum

The Elegant Outsider

The haughty Degas was often seen in the streets and cafés of Paris – always smartly dressed in his top hat – but his reserved manner and acid wit kept him aloof from many of his contemporaries.

Edgar Degas was born in Paris on 19 July 1834. He was baptized Hilaire-Germain-Edgar de Gas, but adopted the less pretentious 'Degas' early in his career as an artist. His father, Auguste de Gas, was a successful banker, while his mother, Célestine Musson, came from a wealthy colonial family. Her death when Degas was 13 seems to have been the most painful event of his early years.

As the child of well-off parents, Degas received a sound classical education at the Lycée Louis-le-Grand and then went on to study law. However, by his own account he spent most of his time copying the masterpieces in the Louvre. Eventually he told his father that he could not go on with law, and Auguste de Gas agreed to let the 18-year-old Edgar take up a career as a painter. A room in the de Gas house was converted into a studio, and Edgar was set to study under two now-forgotten masters – first Félix-Joseph Barrias, and later Louis Lamothe.

Lamothe had been a pupil of Jean Dominique Ingres, and taught Degas according to Ingres' principles, stressing the importance of drawing from memory and the Old Masters. In 1855 Degas met the master himself. He had intervened on Ingres' behalf when Edouard Valpinçon, the owner of one of Ingres' paintings, had refused to release it for an exhibition. As it happened, Valpinçon was a family friend, and young Edgar argued with him so forcefully that Valpinçon changed his mind. He also took Degas to see the 75-year-old Ingres, who gave the aspiring artist weighty advice: 'Draw lines, young man, many lines, from memory or from nature; in this way you will become a good artist.' No doubt this was what Degas wanted to hear, since his skill as a draughtsman gave him a natural preference for a painting style that employed strong outlines.

VISITS TO ITALY

During the 1850s, Degas made several trips to Italy studying in Rome and staying with relatives in Florence and Naples. But he soon got bored with looking at the landscape, and devoted all his attention to people and works of art. During these years and on his return home, he painted some fine portraits, occasionally – as in the portrait of his Italian cousins *The Bellelli Family* (p.428) – anticipating the casual, modern look of his later work. But as a disciple of Ingres, he was still committed to the orthodox doctrine of the period – that history was the proper subject-matter for any serious artist. In such works as *Young Spartans*

The young artist
(left) This self-portrait was painted about four years after Degas abandoned his law studies for painting. A sensitive, shy young man, with few close friends, he was supported by a private income and not dependent on the sale of his work.

Fashionable Paris
(right) Brought up in a wealthy family, Degas preferred to spend his time with the fashionable society of the Right Bank district, where he lived for most of his life. He had a deep dislike of the bohemian Left Bank, which he considered a hotbed of anarchy.

Sterling and Francine Clark Art Institute, Williamstown, Mass.

Louvre, Paris

A sympathetic father
(above) A prosperous banker, Auguste de Gas was devoted to the arts and encouraged his son's artistic ambitions. Degas shows him listening to the Spanish tenor and guitarist Lorenzo Pagans.

Portrait of a hero
(below) The Neo-Classical artist Jean Dominique Ingres had a profound influence on Degas, who met his hero on several occasions, and never forgot his advice to 'draw lines, many lines'.

An Italian connection
In the late 1850s Degas made several visits to Italy to study art. He spent much of his time in Naples, where his father was born and Degas himself owned a share of the family villa.

Uffizi, Florence

(p.364), he was making his own bid for fame as a painter in the approved 'grand style'.

At the very time when he was working in this style, Degas was also absorbing new influences, such as the art of Ingres' rival Eugène Delacroix. And while staying with his friends the Valpinçons at their estate in Normandy, he became interested in painting horses. By about 1860, he was already making pictures of horse races, going out to Longchamp racecourse to sketch the jockeys and their mounts.

FRIENDSHIP WITH MANET

In the year 1862 he met Edouard Manet, an artist who was just two years older than Degas and who came from the same upper-middle-class background. Manet was already establishing himself as an audacious painter of modern life and the hero of younger artists. His subsequent friendship with Degas involved a great deal of mutual influence, mutual respect, and an intermittent antagonism based on rivalry.

During the 1860s, Degas painted many portraits, including several of musicians who performed at his father's Monday evening entertainments. Among these were the guitarist Pagans and the bassoonist Desiré Dihau, who became a close friend and who appears in *The Opera Orchestra* (p.429). Degas also became interested in the theatre as a subject, and embarked on his famous pictures of dancers.

He was already an obsessive worker. 'When I have not worked for a few hours', he remarked, 'I feel guilty, stupid, unworthy.' There was room in

The Cotton Exchange, New Orleans (1873)
(left) In October 1872 Degas and his brother René travelled to New Orleans – their mother's family home. Degas soon grew bored: 'One lives for cotton and from cotton', he complained. The Cotton Exchange is a group portrait, showing Degas' uncle Michel Musson (seated in the foreground), René (reading a newspaper), and his other brother Achille (leaning against a window sill).

his life for friends, but not for love-affairs; as far as is known, he never became seriously involved with a woman. Indeed, he once observed in a typically clipped manner that 'there is love and there is work, and we have only one heart'.

In 1870, France went to war with Prussia and suffered a disastrous defeat. Degas was called up and served his time safely in the artillery. But during the Siege of Paris in 1871, his eyesight was seriously injured in some way – Degas himself believed that exposure to cold air was to blame – and for the rest of his life he worked with increasing difficulty and had to endure the terrifying threat of total blindness.

In 1872-73, Degas spent six months in New Orleans, where his mother's family was living. Though fascinated by Mississippi life, Degas insisted that – quite apart from the fact that the bright light hurt his eyes – he could only work properly in surroundings that he knew through and through. Without such knowledge, which enabled an artist to organize and select his material, a painting was no better than a snapshot.

A FAMILY CRISIS

Degas' unwavering sense of family pride had consequences that were to affect his life deeply. In 1874 his father died and it was discovered that the family bank had accrued vast debts. Worse was to come. Degas' brother René had borrowed 40,000 francs to start his New Orleans business, and by 1876 the creditors were threatening to sue. To uphold the family name, Degas and his brother-in-law settled the debts from their own pockets, sacrificing much of their personal fortunes in the process. Degas sold his house and his art

The New Paris Opera

The new Paris Opera House, designed by Jean Louis Charles Garnier, opened in January 1875 – some 13 years after the foundation stone was laid. Degas was a frequent visitor. He had held a season ticket to the old Opera in Rue le Peletier from the age of 20, and it was there that he made his early studies of the ballet and dance classes until the building was destroyed by fire in October 1873. With the opening of the new Opera, his interest in ballet grew and the life and training of the dancers became the major subject of his work in the late 1870s.

collection, and for the first time was compelled to earn a living by selling his own art. He later complained bitterly of his need to produce something every day.

Degas' difficulties with money may have been partly self-induced, since he was such a perfectionist that he often failed to deliver commissions, and sometimes even bought back his own works in the belief that they were still in need of improvement. Stacked away, such items often lay forgotten in his studio for years; in some instances they were only brought to light again after the artist's death.

Meanwhile, Degas had emerged in an unfamiliar role, as an exhibition organizer. Together with Pissarro, Monet, Renoir and others, he formed an association to mount an exhibition independently of the official system which controlled French artistic life. Degas threw himself into the venture enthusiastically. The exhibition, held at the photographer Nadar's studio in the Boulevard de Capucines in 1874, was labelled 'Impressionist' by a hostile critic – and the name stuck, much to the annoyance of Degas.

His work, laboriously created in the studio, had little in common with the Impressionist landscapes of an artist such as Monet, who painted rapidly in the open air. To Degas, the exhibition was a 'realist Salon' in which modern subjects and the modern spirit might at last receive their due.

The abuse showered on the Impressionists left Degas unmoved. As always, he was defiantly independent and disdainful. He dismissed one critic, the extremely ugly Albert Wolff, with the remark 'How could he understand? He came to Paris by way of the trees!' This contemptuous streak impressed the Irish novelist George Moore, who spent some years in Paris as an art student. He remembered evenings passed with Degas and Manet in the later 1870s, when they frequented a café called the Nouvelle Athènes in the Place Pigalle. 'Manet', he wrote, 'sits next to Degas, that round-shouldered man in a pepper-and-salt suit . . . his eyes are small, and his words are sharp, ironical, cynical.'

A DAUNTING FIGURE

Degas had now earned a reputation as a 'bear', whom it was dangerous to approach – at his fiercest where his working life was concerned. His studio was sacrosanct, a dusty, dimly-lit place, filled with folders, boxes and equipment in an apparent disorder which no one but the artist was allowed to disturb. Few people were even allowed in except models and dealers.

But Degas could be sociable enough when his art required it. He took part in seven of the eight Impressionist exhibitions held between 1874 and 1886. He haunted the new Paris Opera, sketching dances in rehearsal and performance, just as he later entered the worlds of milliners and laundresses. And in the late 1870s, as well as exchanging asperities with Manet at the Café Nouvelle Athènes, he became a close friend of the American painter Mary Cassatt.

Many of Degas' contemporaries believed that the two were lovers, but if so they displayed a

Degas in his 40s
(above) In this etching, the top-hatted Degas adopts an apparently haughty stance – but one which may also reflect the backache from which he suffered.

Carriage at the races
(below) Degas' lifelong friend Paul Valpinçon, his wife and baby are seen in the foreground of this Normandy racing scene.

Architectural splendour
(left and above) The elaborate facade of the Opera is topped by an elegant dome and triangular pediment. The interior is equally ornate: marble of every hue was used to decorate the magnificent foyer, dominated by an impressive staircase and lit by chandeliers.

Degas' Beautiful Protégée

Mary Cassatt (1844-1926) was one of the few women painters involved in the Impressionist movement. The daughter of a Pittsburgh banker, she came to Paris in 1866 to study art and exhibited her gentle portraits at the official Salon (1872-76). It was here that she was first noticed by Degas in 1874: 'There is someone who thinks like me', he remarked. The admiration was mutual and in 1877, when he asked her to exhibit her work at the fourth Impressionist exhibition of 1879, she accepted eagerly. A warm friendship grew between the two artists, with Degas assuming the role of teacher.

Mary Cassatt
This self-portrait was painted when Mary was in her early thirties. It was at this time that she first met Degas – 10 years her senior.

Woman sewing (c.1880-82)
(right) Images of women and children are the central theme in Cassatt's work. The delicate colour and lighting of this portrait give the painting its immediate appeal, and are characteristic of all her pictures.

Metropolitan Museum, New York

Jeu de Paume, Paris

The studio in Rue Victor-Massé
(above) Degas spent most of his working life in Montmartre. In 1889 he moved to 37 Rue Victor-Massé, which was to be his studio for 23 years.

heroic discretion, leaving behind not a scrap of sentimental evidence for the benefit of posterity. Degas did, however, once make a revealing comment about Cassatt: 'I would have married her, but I could never have made love to her'.

During the 1880s, Degas' eyesight deteriorated further, despite his use of dark glasses and the attention of specialists. This was probably one of the reasons why he began to paint less, turning to more easily manageable media such as sculpture – in which touch played a controlling part – and pastel, which could be executed relatively quickly and without laborious definition of detail.

Failing eyesight was probably also responsible for his increasingly unsociable and eccentric behaviour. After the last Impressionist exhibition in 1886 he showed his work only rarely and shunned all publicity, while still complaining that he was short of money. Any reference to him in newspapers or magazines, however well-meaning and favourable, threw Degas into a rage and shut his door for good to the author. 'What a fate!' he complained, 'To be handed over to writers!'

Having withdrawn from public life, Degas relied more than ever on a small band of old, close friends to provide refuge from solitude and shadows. In Paris he had two 'homes'. On Thursday evenings he dined at the house of the librettist Ludovic Halévy, whose wife Degas had known since childhood, and he spent Fridays with an old school friend, the engineer Henri Rouart, and his family. Outside Paris, there were the Valpinçons in Normandy and others with whom he could escape from the studio, assured of

Souvenir of a journey
(left) One of the happier periods in Degas' later life was his journey through Burgundy with Paul Bartholomé in September 1890. Like schoolboys, the two artists ate huge meals at every stop, and were received by their friends with mock-civic honours.

Degas in 1915
(below) This photograph taken by Bartholomé – one of Degas' few remaining friends – shows a solitary man two years before his death in September 1917.

tolerance and sympathy for his bursts of temper and sudden depressions.

But Degas could still be good company on occasions, devising entertaining photographic tableaux which he recorded with the camera he carried about with him. And in 1890 there was one unusually sustained period of jollity in Degas' existence when he persuaded the sculptor Paul Bartholomé to embark with him on a jaunt through Burgundy in a horse and trap.

THE DREYFUS CASE

Degas' last years were gloomy, and his life was further embittered from 1897 by the Dreyfus case. In 1894 Dreyfus, a Jewish army officer, had been convicted of espionage and sent to Devil's Island; but as it became clear that an injustice had probably been committed, the reopening of the case divided the French people into two camps. Degas, right-wing and anti-Semitic, broke with Jewish and liberal-minded friends of long standing such as Pissarro and the Halévys; and the eventual exoneration of Dreyfus only served to embitter him further.

In 1912, Degas was forced to move from his studio in the Rue Victor-Massé. This – combined with failing health and eyesight – brought his art to a halt. Deprived of his only consolation, he took to wandering the streets of Paris in his long, ancient Inverness cape, at risk from the growing motorized traffic and being helped across streets by gendarmes. He survived into the Great War, dying at last on 27 September 1917.

Paris Behind the Scenes

Degas made a number of on-the-spot studies of Parisians at work. But unlike his Impressionist friends Monet and Renoir, he composed his finished works behind the closed doors of his studio.

'They call me the painter of dancers. They don't understand that the dancer has been for me a pretext for painting pretty fabrics and for rendering movement.' In this outburst against the critics, Degas sums up the intention of his paintings: their significance lies not just in the subject-matter, no matter how descriptive or provocative that might be. For when Degas painted a dancer, it was not the dance that attracted him, but the spectacle of a body in space, and the challenge of transforming it into art.

Throughout his career, Degas felt the pull of two rival forces – on the one hand the need to make art modern, just as his friends Manet and the Impressionists were doing; and on the other, his desire to respect and continue the great achievements of the Old Masters. He always saw himself as an artist in the great Európean tradition, whose achievements were based on disciplined drawing, composition and expressive colour.

ADVICE FROM A HERO

Drawing was one of Degas' greatest delights. During his youth he copied many pictures in the Louvre, and became a superb draughtsman. He never forgot the advice of his hero Ingres, to 'Draw lines, young man, many lines', and he realized that the discipline of drawing gave him an important link with the past that some of his contemporaries lacked. All through his career, Degas drew obsessively, whether he was scribbling down a face seen in a café or labouring for months over a carefully posed nude. Drawing was a way of sharpening his observation and of preparing for the paintings he wanted to create.

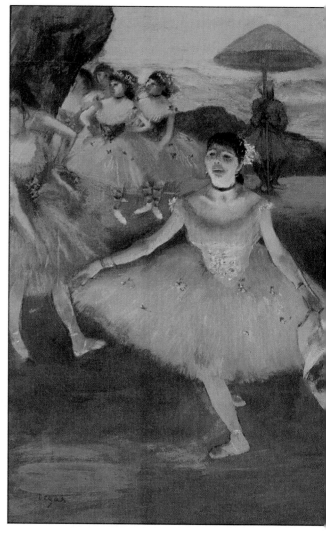

Lefevre Gallery

Little Dancer aged 14
This is a cast of the only sculpture that Degas ever exhibited – when first seen in 1881, it stunned artists and critics alike with its unprecedented realism. The adolescent girl with her scraggy arms was dressed in real clothes, and the original wax model even wore a wig. Degas may have been inspired by the wax-works which he had recently seen at Madame Tussaud's in London.

364

Ballerina with a Bouquet, Curtseying (1877)
(above) Degas was fascinated by the ballerinas of the Opera, depicting them both in rehearsal, and – as here – in their moments of glory on stage.

The Young Spartans (1860)
(left) Degas was proud of this early painting of boys and girls in ancient Greece. But he soon rejected classical subjects.

National Gallery, London

Lefevre Gallery, London

In the 1870s Degas' fascination with new pictorial effects led him to investigate different techniques and media, such as pastel, distemper and print-making. Pastel suited his purpose best and became his favourite means of expression: with pastel, he could draw and colour at the same time, building up rich effects of texture and modelling without the tedious delays of traditional oil-painting. To achieve the effect he wanted, Degas would dampen his pastels with steam from a kettle, rub them with his fingers and build up crusts of colour with scribbles and hatchings.

Degas was an obsessional artist, capable of being swept off his feet by whatever novelty or discovery had caught his imagination, whether it be photography, sculpture or some new etching technique. He tried both etching and lithography, and more or less invented a new printing process called monotype, which he used to produce scores of sparkling, inventive and surprisingly intimate scenes, including witty glimpses of brothel life.

In his own time, the sexuality of Degas' art was highly controversial. Even the ruthlessly honest ballet pictures were considered distasteful by

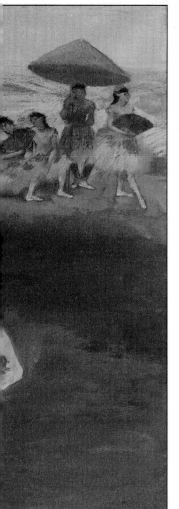

Four Dancers (c.1902)
In this late work, created when his sight had almost failed, Degas comes close up to his figures using brilliantly coloured pastels in boldly hatched lines.

Jockeys before the Start, with Flag-pole (c.1881)
In his paintings of the Paris race tracks, Degas ignored the races themselves to concentrate on the quiet moments before the start. In this dramatic 'snapshot' composition, the flag-pole cuts right through the horse's head.

Jeu de Paume, Paris

As a young artist, Degas concentrated on traditional subjects producing large and ambitious canvases, laboriously prepared through a series of sketches and preliminary studies. But in the 1860s, modern subjects began to exert their appeal – the bright lights and fashionable high-life, as well as more mundane scenes, of contemporary Paris. Degas turned his attention to the race-track, the concert hall and the back-street laundry.

These new subjects demanded a radical change in technique. Degas started to work on smaller canvases, sacrificing the fine detail of his earlier work in favour of bold, eye-catching effects. He began experimenting with off-centre compositions, and figures cut in half by the picture frame – as if the viewer were glimpsing an unexpected slice of Parisian life as he hurried past.

Barber Institute of Fine Arts, University of Birmingham

COMPARISONS

Women in the Bathroom

Women bathing have always been favourite subjects for painters, but Degas' nudes seem modern by comparison with those of the Old Masters, because he paints ordinary women, stripped naked for the bath – not nymphs or goddesses posing by a stream. His intimate 'key hole' pictures did have some forerunners, such as Ingres' famous *Bather* – who seems unaware of the artist's presence as she sits waiting for her bath to fill. And Pierre Bonnard's *Nude in the Bath*, painted more than a century later, looks equally unselfconscious.

Jean Ingres (1780-1867) **The Valpinçon Bather**
(left) Degas knew this painting well, for it was owned by his friends the Valpinçons. The woman is seen from the back – a viewpoint which Degas often adopted – but it is not immediately obvious that she is about to take a bath. The water spout is almost hidden between her feet and the curtain.

Pierre Bonnard (1867-1947) **Nude in the Bath**
(below) Unlike the clear lines of Ingres' nude, the contours of Bonnard's bather are dissolved beneath the water. But, like Ingres, Bonnard has chosen an unusual viewpoint – high above the bathing woman.

Louvre, Paris

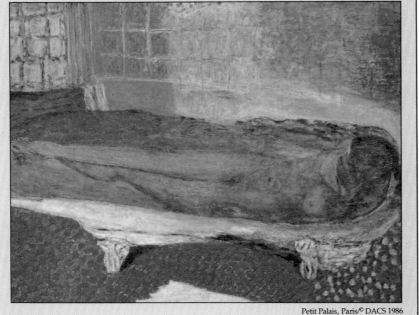

Petit Palais, Paris/© DACS 1986

Ballet Dancers in Butterfly Costumes (c.1880)
(right and below) Degas' use of an off-centre, cut-off composition gives a suitably informal feel to this picture of two young ballet dancers waiting in the wings. Colour and incident are concentrated in one half of the image: the geometric simplicity and neutral greens of the left heighten the impact of this busy, brightly coloured right side. The detail shows clearly how Degas used layer upon scribbled layer of brightly coloured pastel to imitate the diaphanous material of the young ballerinas' dresses.

many of his own contemporaries. Laundresses, dancers and cabaret singers – all of whom Degas loved to paint and draw – had a reputation for loose morals, so his pictures were found shocking by both the general public and his staunchly bourgeois family. And the studies of nudes, now greatly admired and apparently innocent, caused a scandal when Degas' own suggestion that we were viewing them 'through a keyhole' was interpreted as voyeuristic.

By the middle of his career, Degas' subject-matter was clearly established: portraits of friends, nudes, dancers and singers, laundresses and jockeys provided the basis for thousands of his drawings, pastels, paintings, prints and sculptures. He was an immensely hard-working, prolific artist, who gradually retreated into the world of his own studio, relying less and less on direct observation, and working increasingly from memory and his stockpile of drawings.

Degas would very often repeat his own compositions, adding a figure or inventing a new,

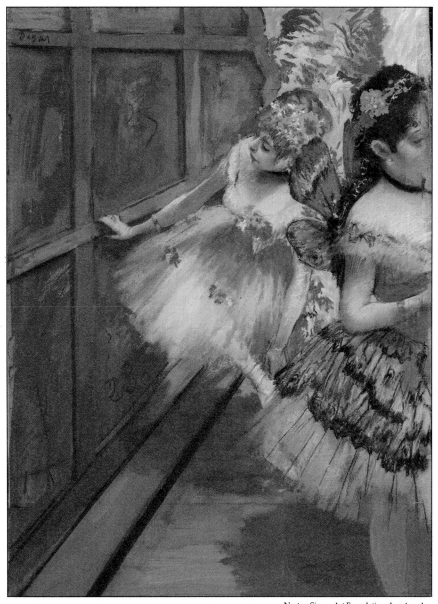

Norton Simon Art Foundation, Los Angeles

quite imaginary combination of colours in his search for an image that satisfied him. Figures or horses from one painting crop up again in a different picture, years or even decades later. We are reminded of Degas' early years of study and his reverence for tradition: 'No art was ever less spontaneous than mine,' he wrote. 'What I do is the result of reflection and study of the great masters; of inspiration, spontaneity, temperament I knew nothing.'

REPEATED THEMES

Degas' tendency endlessly to repeat particular themes, such as nudes washing themselves or dancers in rehearsal, with no apparent regard for the psychological predicament of his models, has given him a reputation as a harsh, cruel observer of humanity. It is true that Degas often conceals the faces of his models, but at the same time he pays them the ultimate compliment by recording, with unflinching honesty, the weariness of their limbs and the awkward dignity of their bodies. A committed professional himself, Degas always admired professionalism in others.

Towards the end of his career, Degas became a virtual recluse, working as hard as his failing health and eyesight allowed him, still drawing, modelling in wax and retouching the pictures of his youth. He continued working even in his 70s, building up vibrant charcoal contours and blazes of pastel colours. All detail had long since gone, but he could still create extraordinarily powerful images, which stand comparison with the Old Masters he loved so much.

The Tub (1886)
The theme of women washing occupied Degas throughout the 1880s. His intention was to show 'the human animal preoccupied with herself, as if you were looking at her through a keyhole'.

TRADEMARKS

Cut-off Figures

The recent development of the camera had a dramatic effect on Degas' composition. His figures are often deliberately cut off by the edge of the picture – like a badly composed snapshot. The resulting sense of casualness belies the laboriously considered process of Degas' art.

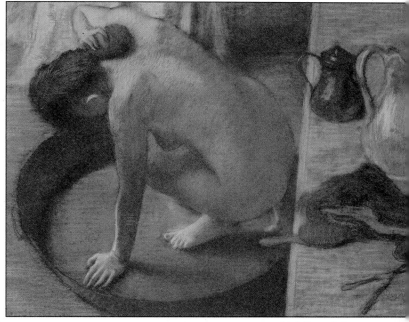

Jeu de Paume, Paris
367

THE MAKING OF A MASTERPIECE

The Dancing Class

In this delightful painting (see p.431), Degas captures a moment in the arduous training routine of the young ballerinas at the Paris Opéra. The viewer's impression is of an inadvertent glance into the rehearsal room as most of the *corps de ballet* take a break, while the ballet-master Jules Perrot concentrates on the little dancer framed in the doorway. To achieve this sense of immediacy, Degas spent countless hours behind stage at the old Opéra in the Rue le Peletier, studying the ballerinas at work, and building up a vast stockpile of drawings, which he later put together in his final compositions.

Every detail is lovingly observed – from the tired dancer stretching in the far corner, to the watering can used to dampen down the dusty floorboards. But the picture as it stands today is very different from Degas' original composition. X-rays have shown that Jules Perrot originally stood facing the back wall, while two of the foreground figures looked towards the spectator. One of these now has her back to us, while the other has been almost hidden by the addition of the girl sitting on the piano, scratching her back.

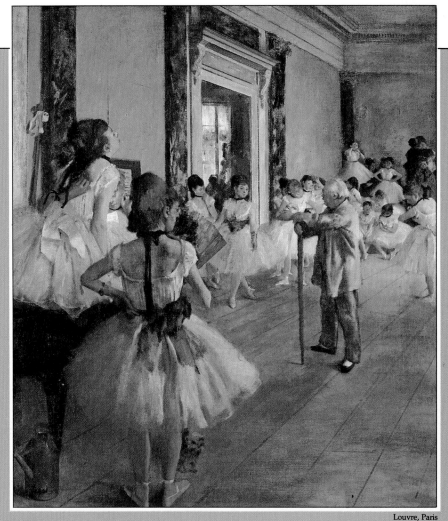

Louvre, Paris

Incidental details
(above and right) Degas' details often add a touch of informal humour: between two foreground figures, we catch a glimpse of a dancer twiddling her earring, while a little dog peeps out from behind a ballerina's leg.

The Paris Opera

(right) The setting of The Dancing Class *is the Opera in the Rue le Peletier. Degas was a frequent visitor there from 1872 until a disastrous fire destroyed the building the following year. When the huge new Opera was opened in 1875, that in turn became the focus of his attention.*

A new perspective

(left) When Degas added the girl on the piano, he strengthened the illusion of depth in the painting. The figures now form a funnel-like triangle that runs across the picture, enclosed by the dramatic perspective lines created by the floorboards and cornice. Accents of red run through the group, from the flower in the foreground dancer's hair, to the hat of one of the lovers by the far wall.

A dated sketch

This thinned-oil study of Jules Perrot is dated 1875 – probably the year in which Degas altered his composition. Perrot is leaning on the long stick he used for pointing and tapping rhythm for his pupils.

Collection of Henry P. McIlhenny, Philadelphia

> ## 'One must paint the same subject 10 times, 100 times'
> Edgar Degas

Bulloz

Fogg Art Museum, Cambridge, Mass.

Jeu de Paume, Paris

Reappearing figures

(left and above) Degas made repeated use of individual figures. This study, carefully drawn on squared paper, is the basis for the central figure in The Dancing Class. *She appears again in* Ballet Rehearsal on Stage *(1874).*

Claude Monet

1840-1926

Claude Monet was the most dedicated and single-minded of the French Impressionists. He was brought up on the Normandy coast, and the beautiful scenery there inspired him to devote his life to landscape painting. Fired with a desire to capture nature's most fleeting effects, he painted out-of-doors in all weathers. When he moved to Paris he worked with the other great artists of his circle – Renoir, Manet and Pissarro.

Today Monet is almost universally admired, but at first he was misunderstood and mocked. Estranged from his wealthy family, he endured misery and poverty in his early career, and was in his forties before his work began to sell. By the end of Monet's long life he was a wealthy man and a revered artist, but success never spoiled him. Even in his 80s he still worked tirelessly, despite his failing eyesight.

370

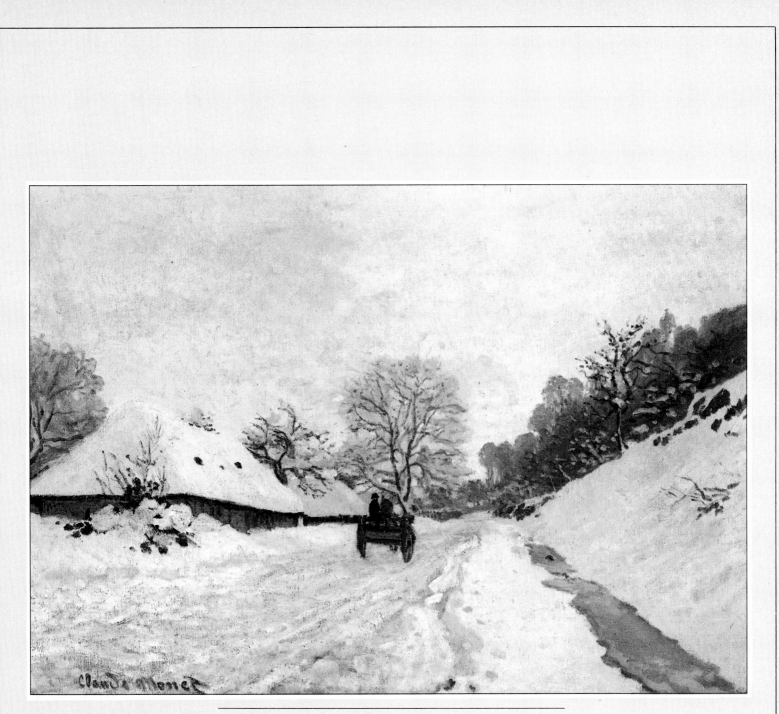

The Cart: Road under Snow *1865*
25½″ × 36¼″ Louvre, Paris

The Pioneer from Normandy

At the age of 18, Monet left a prosperous family home in Le Havre for a bohemian life in Paris. His willingness to sacrifice everything for his art had set the pattern for his career.

Claude-Oscar Monet was born in Paris on 14 November 1840, the elder son of a grocer and former sailor, Adolphe Monet. In 1845 Adolphe took over his family's flourishing grocery and ship-chandlering business in Le Havre, and it was in this busy port at the mouth of the River Seine that Claude (or Oscar, as his family called him) spent most of his happy childhood and youth.

His aunt, Sophie Lecadre, was an amateur painter and she no doubt encouraged the talent for drawing he showed as a boy. When he should have been attending to his lessons, Monet was often filling his books with caricatures, and by the time he was 15 such drawings had won him a local reputation and his first earnings as an artist.

Monet's drawings were displayed in the window of a local picture-framer's shop, and this led to the great turning point in his life. The landscape painter Eugène Boudin, a native of nearby Honfleur, also showed his work there, and when he met Monet he took the young man (16 years his junior) under his wing and encouraged him to paint alongside him. At this time most landscape paintings were produced in the studio, but Boudin, a specialist in sea and beach scenes, liked to paint in the open air, saying 'Everything that is painted directly and on the spot always has a force, a power, a vivacity of touch that is not to be found in studio work.'

Monet at first found Boudin's painting 'distasteful', but he was soon converted to his friend's way of thinking, and in the summer of

The struggling artist
At the age of 28, a year after he painted the scene on the right, Monet was still struggling to make his living as an artist. He had a young son by his mistress Camille, but remained dependent on his father, who prevented their marriage until 1870.

A prosperous background
Monet's father was a successful grocer with a seaside property at Sainte-Adresse, near Le Havre. He is seen there in The Terrace at Saint-Adresse (1866), *sitting in a basket chair. Monet's mother had died in 1856.*

The capital of art
(*left*) *In 1859, when Monet moved to Paris, the city dominated the international art world – painters flocked there from all over Europe. The population at the time was about 1½ million.*

Wife and son
(*below*) *Monet's lifelong friend Auguste Renoir painted this picture of Madame Monet and her son Jean in their garden at Argenteuil in 1874. This was one of the happiest periods of Monet's life.*

Renoir/Madame Monet and her Son/National Gallery, Washington

1858, at the age of 17, he found that landscape painting from nature was his true vocation. 'Suddenly a veil was torn away. I had understood – I had realized what painting could be. By the single example of this painter devoted to his art with such independence, my destiny as a painter opened out to me.'

A STUDENT IN PARIS

The superb scenery of his Normandy home and the rapidly changing weather typical of coastal areas provided ideal material for Monet's new-found love. But Paris – the artistic capital not just of France but of the whole world – was a lure for all aspiring artists, and in 1859 Monet went there to pursue his studies, armed with letters of introduction from Boudin and his aunt. His father wanted him to study at the Ecole des Beaux-Arts, the official state school of art, but Monet was always strong-minded and self-confident and preferred to study at the Atelier Suisse. Named after its founder Charles Suisse, this was an independent academy where models were provided but there were no examinations and no formal tuition. Monet's father cut off his allowance because of his disobedience.

At the Atelier Suisse, Monet met Camille Pissarro, who was to become one of the central figures of the Impressionist movement, and he frequented the Brasserie des Martyrs in Montmartre, a favourite meeting place of Gustave Courbet, Edouard Manet and other avant-garde artists. Monet's growing involvement in the cultural life of Paris was halted when he was conscripted into the army, and in 1861-62 he

Key Dates

1840 born in Paris

1845 family moves to Le Havre

1858 meets Eugène Boudin who encourages him to paint in the open air

1859 moves to Paris

1863 meets Renoir, Sisley and Bazille

1867 his son Jean born to Camille Doncieux

1870 marries Camille. Visits England

1871 moves to Argenteuil

1874 first Impressionist exhibition in Paris

1879 Camille dies

1883 settles at Giverny

1892 begins *Rouen Cathedral* series. Marries Alice Hoschedé

1900 enlarges waterlily pond in his garden

1908 begins to suffer from cataracts on eye

1911 Alice dies

1914 builds studio for series of *Waterlilies*

1926 dies at Giverny

Scala

A floating studio

When Monet moved to Argenteuil on the Seine in 1871 he built a special floating studio so he could work on the river. This painting, made by . Edouard Manet in 1874, shows Monet on the boat with his wife Camille.

Manet/Monet in his Floating Studio/Neue Pinakothek, Munich

served in Algeria. He developed anaemia and went to convalesce at home, where his family offered to buy him out of the army if he would undertake to study with an established painter.

Monet agreed, but before returning to Paris he met the Dutch painter Johan Barthold Jongkind, who was working at Le Havre and who with Boudin was to be the great mentor of Monet's early career. The novelist and critic Emile Zola wrote in 1868 of the 'astonishing breadth' and 'masterly simplifications' of Jongkind's paintings, 'rapidly brushed for fear of losing the first impression', and in 1900 Monet said that he owed to him 'the definitive education of my eye'.

FINANCIAL PROBLEMS

In 1862 Monet began to study at the Paris studio of Charles Gleyre, a successful painter of conventional portraits and figure compositions. Monet was not happy following the normal academic training of painting from the nude model, but as his fellow-student Pierre-Auguste Renoir remarked, if Gleyre was 'of no help to his pupils', he at least had the merit 'of leaving them pretty much to their own devices'. Other students included Frédéric Bazille and Alfred Sisley, who with Monet and Renoir, would evolve the Impressionist style of painting. They painted together

The Birth of Impressionism

The term Impressionism was coined in 1874 when Monet and several of his associates, including Cézanne, Degas and Renoir, held a group exhibition. A journalist called Louis Leroy made a sarcastic attack on Monet's *Impression: Sunrise* (opposite) in a review in the satirical magazine *Le Charivari*, heading his article 'Exhibition of the Impressionists'. The name stuck. Seven more group exhibitions followed, the last in 1886. Monet showed his work at five of the eight exhibitions.

Impression: Sunrise (1872)

(right) This view of the harbour at Le Havre gave Impressionism its name. 'What freedom, what ease of workmanship!' wrote the critic Louis Leroy in his mocking review.

Jean-Loup Charmet

Impressionism mocked

Critics and cartoonists found the Impressionists an easy target. Their bright colours and bold brushwork made their paintings seem crude and unfinished compared with the more traditional and sober works to which the public was accustomed.

in the Forest of Fontainebleau, and Bazille, who came from a wealthy family, helped Monet financially until his death in 1870.

Gleyre was forced to close his studio in 1864 because of an eye ailment and Monet's family, dismayed at his bohemian lifestyle, again cut off his allowance. His financial problems continued to be acute throughout the 1860s and even led to a half-hearted attempt at suicide. In 1867 his mistress Camille, of whom his family disapproved, gave birth to his son, and Monet, who was staying at Sainte-Adresse near Le Havre, was so abjectly poor that he could not even raise the money to go to Paris to see them.

In 1870 Monet married Camille, but when war broke out between France and Prussia in the same year, he left her with his son and went to England to avoid having to fight. In London, where his family joined him later, Monet studied the work of Constable and Turner and painted some views of parks and the River Thames, but the most important aspect of his stay was meeting the French picture-dealer Paul Durand-Ruel, who was the first dealer consistently to support the Impressionists. Although Monet would still know poverty after Durand-Ruel began buying his pictures, his life was no longer the tale of unremitting destitution it had been through so much of the 1860s.

In 1871 Monet returned to France via Holland and rented a house at Argenteuil, a village on the Seine a few miles from Paris. This was one of the most fruitful periods in Monet's life: he was happily married and comparatively prosperous (Camille inherited some money in 1873), and the pleasures of life on the river and along its banks provided him with an abundance of subjects. His friends often visited him, and the bridges and boats of Argenteuil appear again and again in the Impressionist paintings of Renoir and Sisley.

CAMILLE'S DEATH

It was at this period that the Impressionists were most united and in 1874 they held their first exhibition as a group. The show was a commercial failure, as was a group sale in the following year, and when debts began to mount, Monet's idyllic Argenteuil period drew to a close. In 1878 he moved to Vétheuil, still on the Seine, but farther from Paris, and in 1879 Camille died after a long illness. Monet's burden of grief and responsibility (by now he had a second son) was eased by a woman called Alice Hoschedé, the wife of a collector of Impressionist paintings, with whom Monet had begun an affair in 1876. She nursed Camille, looked after the children and assumed Monet's debts. Monet eventually married her in 1892 after she had become a widow.

In the next few years Monet moved to various places, including Dieppe, Pourville and Varengéville, all on the Normandy coast. Then in 1883 he finally settled at Giverny, about 40 miles from Paris, on the River Epte, with Madame Hoschedé, his children and her children. By this time the original Impressionist group had virtually broken up, and only Monet continued to pursue the Impressionist ideal – the acute scrutiny of nature.

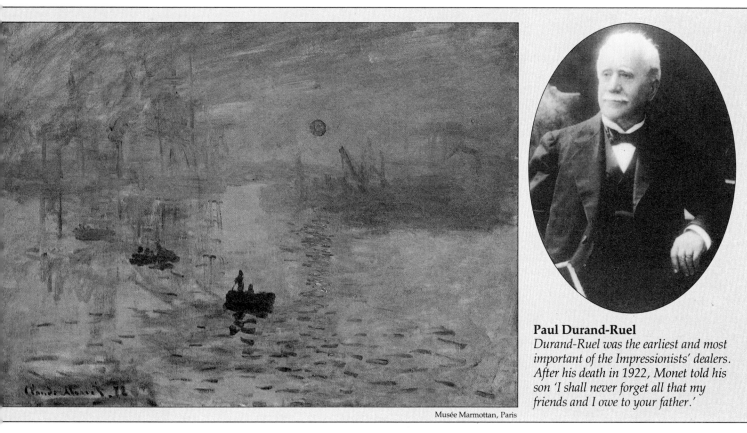

Musée Marmottan, Paris

Paul Durand-Ruel
Durand-Ruel was the earliest and most important of the Impressionists' dealers. After his death in 1922, Monet told his son 'I shall never forget all that my friends and I owe to your father.'

Monet first went to London in 1870-71 to avoid the Franco-Prussian War, during which his friend Frédéric Bazille was killed in action. There he met the picture-dealer Paul Durand-Ruel, who had transferred his stock of pictures from Paris when the war began and would later play a key role in establishing Monet's reputation.

Monet did not return to London for almost 30 years, but he then made three visits between 1899 and 1904. On these trips he produced dozens of paintings, concentrating on certain favourite themes, notably the Houses of Parliament and the bridges over the Thames.

Visits to Venice
Monet visited Venice in 1908 with his second wife Alice and they returned the following year. He worked hard during these visits, but is seen here with Alice in lighter mood, feeding the pigeons in St Mark's Square.

Monet now had a settled home, but his tremendous energy led him to travel widely in search of subjects, and in the 1880s he worked extensively on the Mediterranean coast as well as in Brittany and Normandy; he also visited Holland and Italy. In the same decade his reputation began to grow and his fortunes to prosper, thanks in great measure to the efforts of Durand-Ruel, who in 1883 alone organized exhibitions of Impressionist paintings in Berlin, Boston, London and Rotterdam. By 1890 Monet was secure enough financially to buy the house at Giverny he had previously rented, and in 1891 an exhibition of his paintings at Durand-Ruel's gallery in Paris sold out only three days after opening.

All the paintings at this exhibition were of haystacks, and this marked the beginning of the most original feature of Monet's later career – the production of several series of paintings in which he represented the same subject at different times of the day under different lighting conditions. Monet spent much of his time in his studio developing these series for although he still loved painting out of doors, he now realized that he

could more easily obtain the effects he wanted when he had time to reflect away from the subject.

MONET THE GARDENER

As he advanced in years, Monet continued to travel; he visited Norway in 1895 as the guest of Queen Christiana, London three times between 1899 and 1904, Madrid in 1904 and Venice in 1908 and 1909. However, his attention was focused mainly on Giverny, and particularly on one part of his home – the water garden that he had developed during the 1890s on a strip of marshland next to his house. Monet had diverted a stream through it and created an exotic world of weeping willows, bamboo and floating lilies.

He began painting the garden in about 1899, and from about 1906 it became the centre of his artistic life, for in the waterlilies, with their ever-changing patterns of colour and light, he had found an inexhaustible subject: 'my pond had become enchanted'. The first paintings of the garden were about three feet square, but they became larger as Monet's absorption increased,

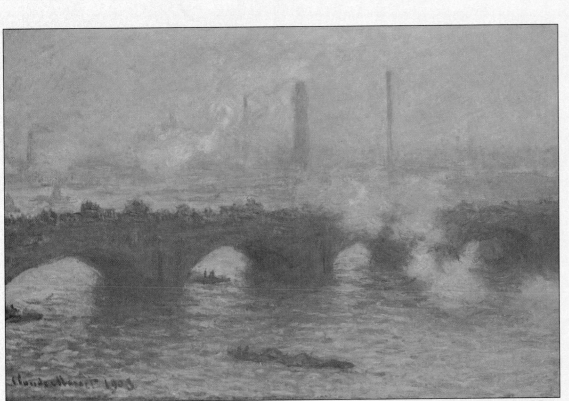

The Savoy Hotel
(left) On his later visits to London, Monet stayed at the Savoy, one of the grandest hotels in the capital, from which he had a good view of the river. When the American painter John Singer Sargent visited Monet there, he found him 'surrounded by some 90 canvases'. Monet did not have time to finish the paintings in London, but shipped them back to France and completed them in his Giverny studio.

Waterloo Bridge (1903)
Waterloo Bridge was among Monet's favourite subjects in London. In 1904 he exhibited 37 views of the Thames at Durand-Ruel's gallery in Paris – 18 were of this bridge. The exhibition catalogue said the paintings were the result of 'four years of reflective observation, strenuous effort, prodigious labour'. Monet obtained the high viewpoint from a balcony (no longer in existence) at the Savoy Hotel.

Monet's final home
In 1883, Monet moved into this splendid house at Giverny, some 40 miles from Paris, where he lived until his death 43 years later. He made numerous paintings of the house and the magnificent garden he created there.

and in 1914 he had a special studio built so he could work on a huge scale. His wife had died three years earlier, but he had the love of his devoted step-daughter, Blanche Hoschedé-Monet, herself a painter, to support him, and he worked with un-flagging energy.

By this time Monet was the grand old man of French painting, and it was at the suggestion of the Prime Minister, Georges Clemenceau, one of the many distinguished visitors to Giverny, that he decided to present several of his waterlily paintings to the nation in the form of an enormous decorative scheme. Monet's sight was failing, his work on the paintings was delayed while he had a cataract operation, and he did not live to see their unveiling in the Orangerie in Paris (part of the Louvre complex) on 17 May 1927. He died aged 86, on 5 December 1926 at Giverny and was buried beside the small village church. In the last year of his life, Monet described his aim as being 'to render my impressions in front of the most fleeting effects', words he could equally have used at any stage during more than half a century of ceaseless creativity.

The Fleeting Impression

Monet painted in the open air with a speed and fervour no earlier artist had approached. But as he grew older, he saw the need to work more in his studio, to refine and perfect his paintings.

Monet is often considered the greatest and most typical of the Impressionists. This judgement reflects not only the quality of his work, but also his wholehearted dedication to the ideals of Impressionism throughout his mature life. In particular, he was committed to the Impressionist practice of painting out of doors. This in itself was not new, but Monet made it an article of faith.

None of his predecessors had worked out-of-doors to the same ambitious scale. In the early 19th century, for example, John Constable had often made sketches in oils outdoors, but only as preparatory studies for larger paintings. And Boudin and Jongkind, the two artists who had the most important influence on Monet's early work,

also worked on a fairly small scale. Monet differed from these painters both in his conviction and in his ambitions. He made outdoor painting not just a basis for further elaboration, but the central feature of his huge output.

Monet's declared aim was to catch the passing impressions of light and atmosphere, 'the most fleeting effects', as he called them, and in his dedication to this goal he took measures that often had an element of farce about them. In 1866-7 he painted one of his most famous works, *Women in the Garden*, a canvas more than eight feet high, and to enable him to paint all the picture out-of-doors, he had a trench dug so the canvas could be raised or lowered by pulleys to the required height.

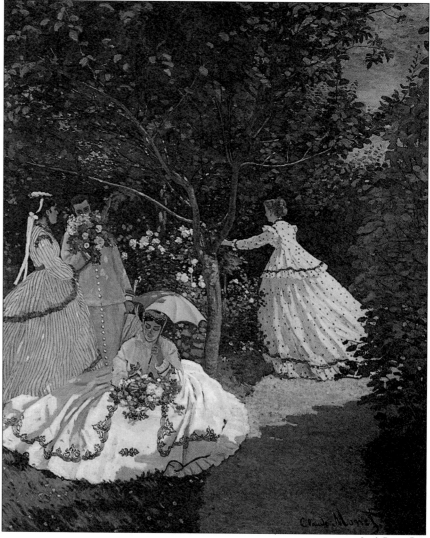

Monet at work
Under a huge white parasol, Monet works on one of his waterlily paintings in the garden at Giverny. Beside him stands his step-daughter Blanche Hoschedé-Monet, ready to change the canvas on his easel.

Women in the Garden
Monet painted this eight-foot high canvas entirely out-of-doors in 1866-7. According to the painter Gustave Courbet, who visited him, Monet would not paint even the leaves in the background unless the light was just right.

Jeu de Paume, Paris

Much later in his career, when he was working on a series of paintings such as his *Haystacks*, his step-daughter Blanche Hoschedé-Monet used a wheelbarrow to carry his unfinished paintings around the fields with him; when the light changed perceptibly, Monet would switch to another canvas that matched the new conditions.

BRAVING THE ELEMENTS

Bad weather did not weaken his determination to capture the effects he wanted. One observer described him working on the Normandy coast in 1885: 'With water streaming under his cape, he painted the storm amid the swirl of the salt water. He had between his knees two or three canvases, which took their place on his easel one after another, each for a few minutes at a time. On the stormy sea different light effects appeared. The painter watched for each of these effects, a slave to the comings and goings of the light, laying down his brush when the effect was gone, placing at his feet the unfinished canvas, ready to resume work upon the return of a vanished impression.'

Such accounts of Monet at work – part-heroic, part-absurd – illustrate what he and the other

Lady with a Parasol
This brisk and vigorous painting, dating from 1886, conveys the atmosphere of a blustery day – the rough brushstrokes of the sky suggest the scudding motion of the clouds. Monet had to work quickly to capture such fast-changing conditions in the weather.

Jeu de Paume, Paris

Pictures in series
In 1891, Monet exhibited his first major series of paintings – The Haystacks. *These two, from the series of 15, illustrate his fascination with the varied colours produced by natural sunlight.*

Camille on her Deathbed
Monet's first wife died in 1879. Despite his grief, he still looked at her with the eye of a painter, noticing 'the arrangement of coloured gradations that death was imposing on her motionless face'.

Jeu de Paume, Paris

Art Institute of Chicago

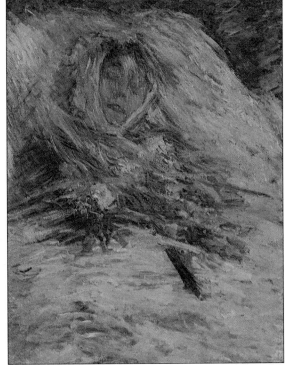

Jeu de Paume, Paris

COMPARISONS

COMPARISONS

The Streets of Paris

Before Monet arrived in Paris in 1859, few artists had bothered to paint the city's streets. To academic painters, everyday scenes seemed dirty, drab and vulgar. But when the Impressionists began working out-of-doors in the 1860s, Paris was not just a new subject for painters, it had literally been transformed: by Baron Haussmann, civil servant and town planner to the Emperor Napoleon III.

From 1853 onwards, Haussmann had been in charge of rebuilding the capital, tearing down old shops and houses to create the wide boulevards that lead to the Arc de Triomphe and other focal points. And the Paris we see today, remains very much the city we see in the paintings of Monet, Renoir and Pissarro.

Camille Pissarro (1830-1903) **The Boulevard Montmartre** *(below) Pissarro's evocative canvas, painted in 1897, shows carriages parked along this fashionable street. Rows of gas-lights recede into the distance, emphasizing the formal layout of the city.*

Pierre-Auguste Renoir (1841-1919) **Pont Neuf** *(below) Horse-drawn carriages and buses — all driving on the right — cross the wide 'new bridge' at the heart of Paris. Painting in 1872, soon after the Franco-Prussian War, Renoir shows soldiers in uniform mingling with street-vendors and ladies with their children.*

National Gallery, London

National Gallery, Washington

Impressionists found was the greatest drawback to their new approach to painting: the effects in nature change so quickly that the more sensitive an artist is to them, the less time he can spend on a picture before any particular effect has gone. Referring to his haystack series in October 1890, Monet wrote: 'I really am working terribly hard, struggling with a series of different effects, but at this time of year the sun sets so quickly that I can't keep up with it.' To overcome this problem Monet began to work more and more in the studio to re-touch or revise his paintings. But publicly he liked to maintain his image as an outdoor painter.

PAINTING AT SPEED

Monet developed a free and spontaneous painting technique which enabled him to work at speed. His brushwork is remarkably flexible and varied, sometimes broad and sweeping, sometimes fragmented and sparkling. Occasionally he used the handle of the brush to scratch through the paint surface and create a more broken, textured effect. His last paintings, the great series representing the waterlilies in his garden at Giverny, were executed more slowly than his earlier works and many of them have a richly encrusted surface, the paint dragged and superimposed, layer upon shimmering layer.

Jeu de Paume, Paris

TRADEMARKS

Slabs of Colour

Monet's treatment of water is both original and distinctive. He makes no attempt to show the exact forms of waves or ripples, but uses firm individual strokes – sometimes almost slabs – of colour to suggest reflections in the water.

This is a prime example of the Impressionist approach to painting. In essence Monet represents what his eye actually sees, rather than what his mind knows is there. In the hands of a master, this can produce stunningly vivid effects.

Regatta at Argenteuil (1872)

(above and right) In the reflection of boat-sails on the River Seine, Monet reveals his skill at painting water. He conveys the flickering movement of the ripples with just a few brushstrokes so bold that when enlarged (detail) they seem almost abstract. Monet's love for water – first developed during his childhood by the sea – never left him. He once said jokingly that he would like to be buried in a buoy.

Paul Cézanne, a landscape painter of equal stature, declared that Monet was 'only an eye, but, my God, what an eye!' Many of Monet's own observations seem to bear out that this was the way he thought of himself. He told a pupil that 'he wished he had been born blind and then suddenly regained his sight, so that he would have begun to paint without knowing what the objects were that he saw before him'. And he advised 'When you go out to paint, try to forget what objects you have in front of you, a tree, a field . . . Merely think, here is a little square of blue, here an oblong of pink, here a streak of yellow, and paint it just as it looks to you, the exact colour and shape, until it gives your own naïve impression of the scene.'

But no artist simply reproduces what he sees in front of him, and although Monet might strive to be objective, he was never impersonal. His increasing reliance on studio work shows that he realized that his art consisted not merely in observing and recording, but in finding a pictorial equivalent – in opaque paint on a two-dimensional surface – for the infinitely varied effects of light. And as with all great art, there is a dimension to Monet's work that ultimately evades analysis or explanation. His great series of waterlily paintings, in particular, are the product not simply of an exceptionally keen eye and an unerring hand, but also of a poetic spirit.

THE MAKING OF A MASTERPIECE

Rouen Cathedral

Monet painted his famous series of Rouen Cathedral scenes following the success of the Haystacks series, exhibited in 1891. The unusual choice of a cathedral for his subject was probably influenced by the severe rheumatism Monet had suffered since 1890. This made it arduous to work in the open air ('I endure torment in rain and snow'), so a view he could paint from a window, protected from the weather, had an advantage over outdoor subjects. The series took three years to complete. Monet spent several weeks in Rouen in 1892 and 1893, then finished the paintings in his Giverny studio during the winter of 1894-5.

Jeu de Paume, Paris

Rouen Cathedral in Full Sunlight

(above) As the 19th century photograph makes clear, Monet radically simplified the intricate lace-like forms of the Gothic cathedral, preferring to capture the haze created by full sunlight. To achieve such luminous effects, he mixed his colours with white, rather than using them straight from the tube.

Monet's studio

(left) Monet rented a first floor room over a milliner's shop to serve as his studio. The building no longer exists, for the area around the cathedral was almost completely rebuilt after being bombed in World War II. This plan of the old layout shows how Monet's viewpoint was restricted by the narrow streets.

'Everything changes, even stone'
Claude Monet

View from a window
His makeshift studio above a milliner's shop gave Monet an oblique view of the west front of the cathedral. He was so close to the huge building (less than 30 yards away) that the sky was almost entirely blotted out by the pinnacled façade.

Jeu de Paume, Paris

Jeu de Paume, Paris

Jeu de Paume, Paris

Three variations
Although Monet viewed the cathedral mainly from a single window, he seems also to have used photographs and engravings of the cathedral as aids to composition. The three paintings above indicate some of the different viewpoints he adopted; the one on the right is very close in angle of view to the photograph on the opposite page. Monet's lighting is subtly varied, but the cool tones seen in all the paintings reflect the time of year – he worked in Rouen mainly during the winter months of February and March.

Melting the stone
A detail from Rouen Cathedral in Full Sunlight *(opposite) shows how the richly clotted, shimmering quality of Monet's paint dissolves the solid stone into a translucent haze.*

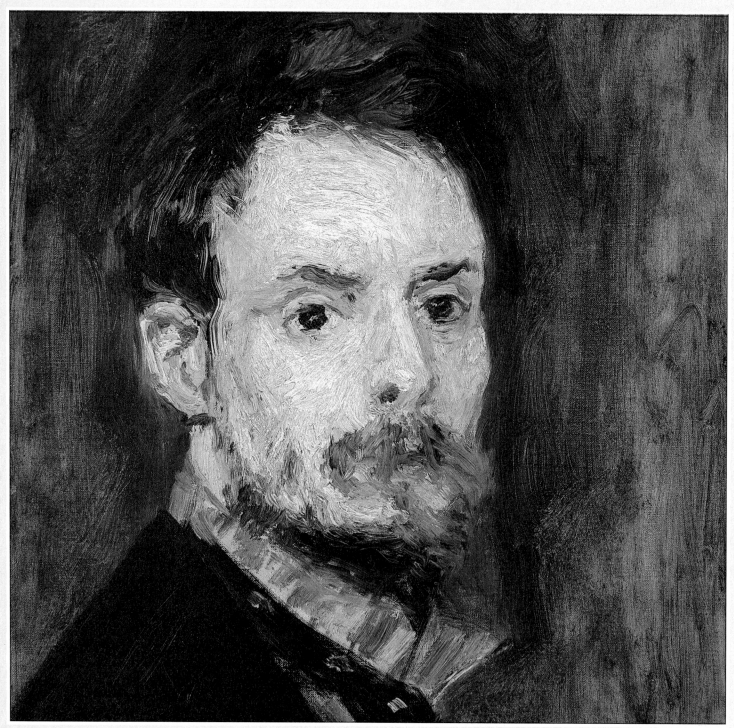

1841-1919

Pierre-Auguste Renoir created some of the most charming paintings of Impressionist art. Trained as a porcelain painter in a small Paris factory, he made the transition from artisan to artist at the age of 19. Throughout his long career, and despite many changes of style, his paintings always remained joyful. They evoke a dreamy, carefree world full of light and colour where beautiful women dance with their lovers.

After struggling for more than 15 years – his Impressionist canvases were derided by the critics – Renoir made his name as a society portrait painter when he was nearly 40. Around this time he married and settled into a happy family life. Later he became crippled by rheumatism and moved south to the Riviera, where he spent his final years painting every day until his death at the age of 78.

Girl Reading *1875/6*
18″ × 15″ Jeu de Paume, Paris

The Friendly Impressionist

During his long life, Renoir made many loyal friends, from Claude Monet – the leader of the Impressionists – to his patrons Victor Chocquet and the Charpentier family.

Pierre-Auguste Renoir was born at Limoges in mid-France on 25 February 1841, the fourth of his parents' five children. His father Léonard was a tailor; his mother, Marguerite, a seamstress. The family moved to Paris when Renoir was aged four so he grew up in the capital – at first in a run-down apartment in the courtyard of the Louvre, which was then still a royal palace.

The Renoir household was crowded and hardworking, but the boy had a happy childhood distinguished by the discovery that he had a beautiful voice. The composer Gounod proposed to arrange a complete musical education for him, with a place in the chorus of the Paris Opera. But even at 13, Renoir somehow felt that he was not 'made for that sort of thing'. Instead, he took up another offer – he became an apprentice decorative painter in a small porcelain factory.

Aspiring painter
The young Renoir worked for several years as a decorative painter in a Paris porcelain factory. But at the age of 19 he made the decision to become an artist.

The forest of Fontainebleau
Renoir's art teacher encouraged his students to make trips to the Forest of Fontainebleau, 40 miles south of Paris, and paint in the open air. Renoir stayed there for weeks at a time, spending the days painting the effects of dappled light beneath the great beeches and oaks.

Key Dates

1841 born in Limoges

1844 moves to Paris

1854 apprenticed as porcelain painter

1862 enrols in Charles Gleyre's studio; meets Bazille, Monet and Sisley

1863 paints in Forest of Fontainebleau

1865 meets Lise Tréhot

1870 Franco-Prussian war; Bazille killed

1874 takes part in first Impressionist exhibition

1879 exhibits *Madame Charpentier and her Children;* launched as a society portrait painter

1880 meets Aline Charigot

1881 paints *Luncheon of the Boating Party;* visits Algeria, Spain and Italy

1882 returns to Paris

1885 birth of Pierre, first of three sons

1890 marries Aline

1894 Gabrielle Renard arrives to help Aline

1897 first attack of crippling rheumatism

1903 moves to Riviera

1907 buys last home, Les Collettes

1915 Aline dies

1919 dies at Cagnes

Renoir/The Inn of Mother Anthony/National Museum, Stockholm

Auguste proved so skilful at the job that he was nick-named Mr Rubens and was soon given the task of painting profiles of Marie-Antoinette on the fine white cups. He earned a good living at his craft for five years, before the job of hand-painting was made obsolete by the invention of a mechanical stamping process. It was his first real contact with 'the machine', and turned him against mass-production and standardization for life.

VISITS TO THE LOUVRE

During his time at the factory, Renoir would visit the art galleries of the Louvre during his lunch hours. His great loves were the exquisite 18th century pictures of courtly gaiety painted by Watteau, Boucher and Fragonard, and the dramatic, colourful canvases of Delacroix. But as he told his son Jean, he was most inspired by a superb 16th-century sculpture, the Fountain of the Innocents. And after a year spent painting blinds and a series of murals for cafés, he decided to become an artist.

In 1862, at the age of 21, Renoir became a student at the studio of Charles Gleyre, a very well-known private art school in Paris. Though academic and traditional in character, it gave him an excellent training with plenty of time to go to the Louvre and study the Old Masters. But Gleyre also stressed the importance of sketching out-of-doors, and encouraged him to visit the Forest of Fontainebleau. This feature of Gleyre's teaching and his remarkable group of young art students had a profound effect on Renoir's career.

Among the students were Claude Monet, Alfred Sisley and Frédéric Bazille, through whom

Mother Anthony's Inn
During his visits to Fontainebleau, Renoir often stayed at this inn in the tiny village of Marlotte. In 1866, he painted his friends there: Monet (reaching for his tobacco), Sisley (in a hat) and Jules LeCoeur.

Renoir met Edgar Degas and Edouard Manet, as well as many leading writers and critics. Together they gradually forged a close-knit group that met regularly in the Paris cafés to discuss their theories, and the ideas of Impressionism emerged.

Working closely with Monet in the Forest of Fontainebleau (a two-day walk from Paris), Renoir gradually developed his own style. But their collaboration reached a climax in the summer of 1869 when, working together at the popular river-

Renoir's Model Mistress

Renoir met Lise Tréhot when he was in his early twenties and she was just 16: her sister lived with Renoir's friend and fellow-artist Jules LeCoeur in Marlotte village.

The artist was attracted by the young girl's dark, pretty features and rounded figure. She soon became his favourite model – and mistress. He painted her more than 20 times between 1865 and 1872: in that year, the couple parted and Lise married. She never saw Renoir again.

Teenage girlfriend
(left) This photograph of Lise was taken around the time that she and Renoir met.

Oriental temptress
Renoir delighted in painting Lise in different guises. In The Odalisque (below) he painted her as an Algerian harem-girl with an inviting look in her eye. Her exotic, sumptuous dress and openly seductive pose are a far cry from the demure post-master's daughter in the photograph.

Renoir/Odalisque/National Gallery, Washington

side restaurant known as La Grenouillère, the two men produced the canvases which are now regarded as the first Impressionist paintings.

These were days of financial hardship for both men. Renoir at least had some help from his family, and took bread and scraps for Monet from his table. But neither had cash to spare for paint or canvas. It was only money from Bazille, who had a small private income, which kept them going.

RENOIR IN THE CAVALRY

In 1870, this period of intense creativity was brought to an abrupt halt by the Franco-Prussian War. Renoir was called up, and found himself training horses for the cavalry in the Pyrenees, far from the fighting. He returned to Paris in the middle of the bitter Commune battle of 1871, but was lucky enough to have influential friends on both sides who made it possible for him to travel in and out of the city.

Renoir continued to paint and the group slowly reformed, though without Bazille, who had been killed in the war. Through Monet, Renoir now met Paul Durand-Ruel, the first art-dealer to support the Impressionists, who agreed to take his work. Soon he was selling enough to move into a large studio in the Rue St Georges. After a sequence of garret studios over the years, he now laughingly declared he had 'arrived'.

This studio, which he occupied for over ten years, became an important meeting place for the Impressionist group and its associates. Renoir's younger brother Edmond, who had emerged as a leading writer and art critic, lived downstairs and made the studio almost too much of a meeting

Influential friends and patrons
(left) This painting of Madame Charpentier and her Children *made Renoir's name as a society portrait painter when it was exhibited at the 1879 Salon. The woman in the picture was the wife of the publisher Georges Charpentier, and it was through her husband's influence that the painting was exhibited.*

After the exhibition, a band of enthusiastic collectors grew up among the Parisian élite. The most important was the diplomat Paul Bérard. He owned over 30 Renoirs, many of which were painted during the artist's visits to the Bérard's country house at Wargemont, near Dieppe (above).

Renoir/Madame Charpentier and her Children/Metropolitan Museum of Art, New York

place. Renoir was forced at times to seek small studios for the peace he needed to work.

Skinny, bearded and immensely charming, with a nervous, modest manner, Renoir inspired extraordinary affection among his friends. Although not demonstrative – he hated any public show of emotion – he showed intense loyalty and love with acts of quiet generosity. One of his life-long friends, the artist Paul Cézanne, was the complete opposite. Where Cézanne was suspicious of people, Renoir would not waste his energy worrying about being exploited. 'People love to be nice,' he said, 'but you must give them the chance.'

Even with the new studio, Renoir's money problems were far from over. During the 1870s Renoir's work, like that of other Impressionist

Journey to Algeria

(below) Renoir travelled to Algeria in 1881, and then went on to study the Old Masters in Spain and Italy. It was a pivotal year for him both personally and artistically: on his return to Paris, he married, and adopted a new 'harsh' style of painting.

A city in revolt

(above) After France's defeat by the Prussians, angry Parisians rebelled against their Republican government and formed a Commune. These were bloody days, and Renoir was once arrested as a spy, only to be saved from the firing squad by one of the Commune leaders whom he had once protected. He also had influential friends on the Republican side: while others were kept in or out of the city, Renoir passed freely between Communist Paris and Republican France.

Pretty young mistress

(right) This detail from Dancing in the Country (1883) shows Renoir's future wife Aline around the time they set up home.

Renoir/Country Dance/Jeu de Paume, Paris

painters, was ignored or ridiculed by the academic critics – one of his nudes was once compared to a 'mass of rotting flesh'. But gradually, a small and devoted band of enthusiasts developed.

One of them, Victor Chocquet, became a particular admirer and proceeded to form a considerable collection of Renoir's work. This gave the painter enormous confidence at a difficult time, but on its own it was not enough to support him. He was still dependent on portrait commissions gained via the Salon, until enlightened middle-class families like the Charpentiers and the Bérards became his patrons, enabling him to continue with the more experimental Parisian scenes.

Through all these years Renoir had remained a bachelor. There had been romances, probably including one with Lise Tréhot whom he painted so often in the 1860s, but Renoir seems always to have regarded the idea of marriage and children as a distraction from the focus of his life – painting.

But around the age of 40, he met Aline Charigot, a pretty girl some 20 years younger than himself, who had occasionally modelled for him. Their relationship developed during the summer of 1881, while he was working on the great masterpiece of his Impressionist period, *The Luncheon of the Boating Party*, for which she was one of the

Renoir and his family
Renoir enjoyed a settled family life with his wife Aline and their three sons. Aline's cousin Gabrielle (on the right) helped with the children and became Renoir's favourite model.

models. He taught her to swim, and they danced and went boating together. The gentle Aline had almond eyes and 'she walked on the grass without hurting it', but though they loved each other, their affair was not to be straightforward.

Renoir was at a crisis in his painting. Despite Aline's suggestion that they should go and stay in her small home village in Burgundy, he was reluctant to leave Paris and equally reluctant to have children. Aline called things off. Renoir started to travel intensively: first to Normandy, then Algeria, a country he associated with Delacroix, then to Spain and Italy to see the works of the Old Masters – Velázquez in Madrid, Titian in Venice, and Raphael in Rome – and the murals at Pompeii.

A WIFE AND CHILDREN

But Renoir did not forget Aline, and returned to Paris to be with her. It was to be a relationship of harmony and happiness. She brought him peace of mind as well as children to paint and, as he put it, 'Time to think. She kept an atmosphere of activity around me exactly suited to my needs and concerns.'

Back in his old Rue St Georges studio, Renoir absorbed the visual impressions of his travels into a new way of painting. The so-called 'harsh' style he developed first created further difficulties for his dealer, and it was only the huge enthusiasm of Americans for his work from 1885 that enabled Renoir to support Aline and their newly-born son in reasonable comfort. In 1890 the couple married.

Though not yet rich, he was able to move with his family to a larger house in Montmartre and to take on help for Aline. Gabrielle Renard, a distant cousin of Aline's, arrived in 1894. Aged just 15, she had never before left the village of Essones in Burgundy where she and Aline were born. The rosy-skinned, dark-haired young girl soon became part of the family, helping to bring up the younger sons Jean and Claude, and frequently posed as a model.

Renoir enjoyed family life, working hard – and by now selling well – seeing friends every Saturday night, when Aline would hold 'open-house', and visiting his mother on Sundays. But disaster was soon to strike in the form of a serious illness. In 1897, he broke his arm falling off a bicycle, and this brought on the first attack of the muscular rheumatism that slowly started to cripple him and

The final years
(above) Renoir, aged about 64 and suffering from rheumatism, sits painting in his garden in the south of France. He moved there for his health, but although the beauty of the place inspired a flood of creativity, his illness crippled him.

Renoir/Wagner/Jeu de Paume, Paris

Portrait of a Composer

Towards the end of his months of travel in Spain and Italy, Renoir visited Richard Wagner at his home in Sicily in January 1882. He was not a fan of Wagner, whose music he found boring, but his friend Judge Lascoux had commissioned him to paint the composer. Granted only a brief interview, Renoir completed Wagner's portrait in just over half an hour. The two men did not take to each other. Renoir continued to prefer the light opera and easy company of his neighbour, Jacques Offenbach.

Richard Wagner
Renoir painted this portrait in just 35 minutes on January 15 1882 – the date appears on the left. The composer thought the picture made him look like a protestant minister.

he continued to paint virtually non-stop, only halting briefly at Aline's death in 1915.

In his last years, Renoir took up sculpture – with two young sculptors acting as his hands, since his own were too crippled to use. The fact that these sculptures are unmistakably Renoir's bears witness to his exceptional ability to communicate.

Renoir painted to the end, working in a special glass studio in his garden. He was carried there daily in his sedan chair, always wearing his white out-of-doors hat, and placed in his wheelchair. Gabrielle would push the paintbrush between his twisted fingers. One day, after Renoir had painted some anemones a maid had brought him, he asked a friend to take his brush, saying 'I think I am beginning to understand something about it.' He died later that night, on 3 December 1919.

The French Riviera
Renoir built his last home, Les Collettes, on a piece of land outside Cagnes on the French Riviera.

Renoir's famous son
Renoir's second son Jean became famous as the director of numerous films. His biography Renoir, My Father *is full of fascinating anecdotes which bring to life the painter's charming personality.*

never left him free from pain for the rest of his life. By enormous force of will, aided by the devotions of Aline, Gabrielle and their friends, he somehow continued to paint.

To relieve the pain, Renoir spent increasingly long periods in the warmth of the South of France. In 1907, he built a beautiful house in Cagnes on the Riviera. With its many olive trees and orange blossom, and its views over the Mediterranean, 'Les Collettes' became his base for painting. The brilliant light and relaxed atmosphere helped ease his muscular pain and released a flood of creativity in a colourful, classical style.

However, the beauty of the place could not cure rheumatism. By 1908 Renoir could only walk with sticks. By 1912, his arms and legs were crippled and he was confined to a wheelchair. Nonetheless

Painting for Pleasure

**For Renoir, painting was a way of expressing his pleasure in life.
He always enjoyed portraying his friends and lovers, and was never
ashamed of making pretty pictures.**

'Why shouldn't art be pretty?' Renoir asked once. 'There are enough unpleasant things in the world.' This simple statement sums up his attitude to both life and painting – he had a tremendous capacity for enjoyment, and his art was an expression of his pleasure in life. Renoir only worked when he felt happy, and he deliberately chose subjects that he considered attractive: lush landscapes, fruit and flowers, people enjoying themselves, children playing and, above all, beautiful women.

Nothing gave him greater pleasure than painting women, and although our idea of fashionable beauty may have changed considerably since Renoir's time, the young women we see in his paintings still evoke an era when living in Paris was fun. He was brought up the son of a tailor in the centre of the city, and his models are invariably working girls – seamstresses, milliners, actresses – who, he once said, had the precious gift of living for the moment.

Natural as it seems now, Renoir's choice of subject matter was radical and daring when he decided at the age of 21 to enrol as an art student at the studio of Charles Gleyre. The Paris art world was still dominated by the official Salon, which preferred to exhibit works on historical and literary themes, painted in a realistic style. Only in the past few years had younger artists, notably Gustave Courbet, turned to everyday subjects which were more expressive of a fast-changing France.

Renoir quickly found that he was more interested in life on the street corner than in the usual studio practice of copying plaster casts of antique sculpture. His teacher could not persuade him that the big toe of a Roman consul should be any more majestic than the toe of a local coal man. One day, exasperated with his pupil, Gleyre said, 'No doubt you took up painting just to amuse yourself. And Renoir replied, 'Certainly. If it didn't amuse me I wouldn't be doing it.'

THE IMPRESSIONIST YEARS

While studying at Gleyre's studio, Renoir became friendly with a group of fellow students, dominated by the dynamic personality of Claude Monet, who were later to become famous as the Impressionists. Together they went on painting trips to the Forest of Fontainebleau, 40 miles south of Paris, where they worked out in the open air. Renoir, very impressed by Courbet, used subdued browns and blacks in his work. But one day the artist Narcisse Diaz chanced upon him in the forest and, examining Renoir's canvas, asked 'Why the devil do you paint in such dark colours?'

Le Moulin de la Galette (1876)
This painting of a café shows a favourite Renoir subject – his own friends enjoying themselves.

The Bathers (1884-87)
Renoir always loved painting nudes. This picture, with its hard outlines, illustrates his 'harsh' style.

Success as a portrait painter
(below) Renoir earned much of his money by painting portraits on commission. In 1876 he painted his patron, the customs official Victor Chocquet.

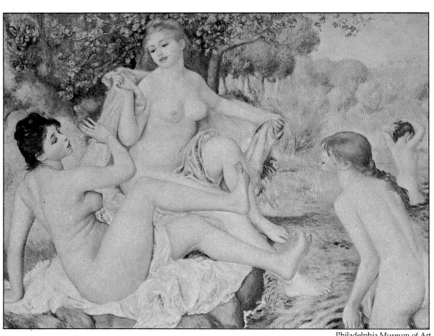

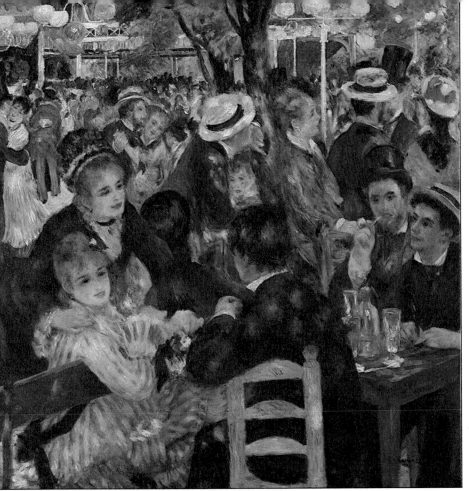

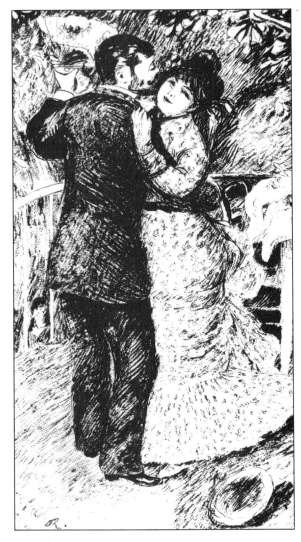

This encouraged Renoir to use the lighter, rainbow colours he instinctively preferred and which he had learned to handle during his early years as a porcelain painter.

During the late 1860s, Monet and Renoir worked very closely together, for they were both attracted by sparkling river scenes and views of bustling Paris. Several of their pictures at this time are of almost identical scenes, but Renoir's style is softer and more delicate than Monet's. Working out of doors, where the light could not be controlled as in a studio, they had to paint quickly to capture the colours in nature before they changed – for

Flower paintings
(above) In paintings like Moss Roses *(c. 1880) Renoir discovered a wonderful form of relaxation: 'I just let my brain rest when I paint flowers', he said. In the 1890s, he painted many still-lifes of roses, experimenting with the same flesh tints he used for his nudes.*

Preparatory drawings
Precise drawings, like this sketch for Dance in the Country *(1883), are rare in Renoir's work before the 1880s.*

The heat of Algeria
(above) Following two trips to Algeria, where he painted The Steps *(1882) Renoir's colours became noticeably 'hotter'.*

Venus Victrix
In his last years, although crippled by rheumatism, Renoir created many sculptures with the help of assistants.

393

Jeu de Paume, Paris

example, when clouds covered the sun. So they made no attempt to blend their brushstrokes in the traditional way. Instead they placed different colours side by side, in the manner soon to be generally described as Impressionist.

Renoir enjoyed painting landscapes, but he was always more interested in people. Throughout his life he included his friends and lovers in his pictures – initially, as a penniless artist, they were the only models available to him. Some of their faces are distinctively 'Renoir', with almond-shaped eyes and luxuriant hair, but what he looked for especially in a model was 'an air of serenity' and a good skin that 'took the light'. Some of Renoir's most successful early works are portraits, and his graceful, gentle style was particularly suited to painting children.

During his Impressionist years, Renoir developed a fascination with the effect of light passing through foliage to fall as dappled shadows on the ground, and on human forms. In his painting *Le Moulin de la Galette*, a large, complex composition, Renoir used the light passing through the trees to unite his figures with their surroundings. Although Renoir painted this work in his studio, he visited its location – a Montmartre dance-hall –

The Swing (1876)
(above) Renoir painted this picture out-of-doors, in the shady garden of his studio in Montmartre. He used bright blue for the shadows and yellow and pink for the pools of dappled sunlight. By contrasting cool with warm colours, he was able to suggest the brilliance of a sunny day. Renoir also used blue for the bows on the woman's pink dress (detail right), across which blue shadows dance. Behind, dots of light break up the blue shadow on the path into a rich pattern.

Favourite colours
Renoir's hand-written list of the colours he used shows that he favoured two kinds of blue – Cobalt Blue and Ultramarine.

COMPARISONS

Pictures of Women

Painters have always enjoyed painting women, whether nude or fully clothed, but different generations have had different ideas about how they should be portrayed. Boucher's sensual nudes, painted in the 18th century, were admired because they were 'ideal' women masquerading as classical nymphs and goddesses. But Courbet's 'real' women, with their commonplace features and contemporary dress, were considered vulgar by the 19th-century critics. Renoir admired Courbet's realism but he also loved what he termed the 'racy and dignified' women who inhabited Boucher's artificial world.

Petit Palais, Paris

The Louvre, Paris

François Boucher (1703-70) Diana Bathing
This painting was one of Renoir's favourites – he copied the design for a porcelain service. He shared Boucher's delight in painting soft skin. In later years, Renoir painted numerous pictures of nudes bathing.

Gustave Courbet (1819-77) Young Women on the Banks of the Seine
Courbet's straightforward and simple treatment of a scene from everyday life had a special appeal for Renoir. He admired the robustness of the figures, the extravagance of their dress and the brilliant summer landscape.

every day, immersing himself in the life of the area and making sketches on the spot.

Throughout the 1870s Renoir exhibited regularly with the Impressionists, but he also submitted paintings to the Salon. He was always more traditional than the other Impressionists and never for a moment considered himself a revolutionary. While his anarchist friend, the painter Camille Pissarro, wanted to burn down the Louvre, Renoir was a frequent visitor to the gallery.

A CHANGE OF STYLE

At first he saw no contradiction between his Impressionist insistence on painting directly from nature and his reverent study of Old Masters. But in 1883, following a trip to Italy, Renoir was no longer able to reconcile the two. He told a friend: 'I had travelled as far as Impressionism could take me and I realized that I could neither paint nor draw.' Subsequently, Renoir dramatically changed his style, and developed a 'harsh' technique, surrounding his figures with hard,

sinuous outlines. In *The Bathers* (1884) he adopted the Old Masters' method of making detailed preparatory drawings. The resulting work is as flat and decorative as a mural at Pompeii.

By the 1890s, these harsh outlines had melted again as Renoir returned to a style more in harmony with his instincts. He began to use warmer colours, especially reds – possibly as a result of two earlier trips to Algeria where he had been most impressed by the hot, sultry light. He painted his children, their beautiful, robust nurse Gabrielle, and a variety of large, sensual nudes, all glowing with radiant colour.

Renoir also did a number of flower paintings, in which he experimented with the same rosy flesh tints he used for his nudes. And at the end of his life, when his hands were increasingly crippled by rheumatism, Renoir began to execute small bronze sculptures with the help of studio assistants. These solid, rounded figures were yet another expression of his endless delight in the human form. 'I never think,' he said, 'that I have finished a nude, until I feel that I could pinch it.'

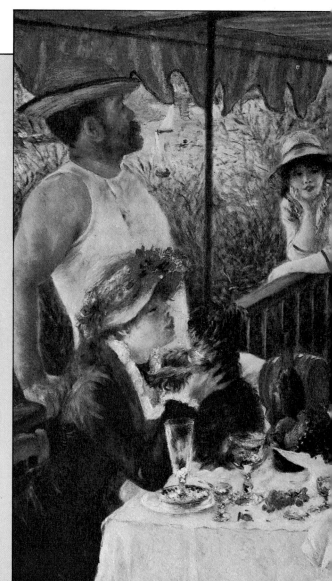

THE MAKING OF A MASTERPIECE

THE MAKING OF A MASTERPIECE
The Luncheon of the Boating Party

Renoir began work on the *Luncheon of the Boating Party* (see pp.410-411) in the summer of 1881. It was a subject that he had been 'itching' to paint for sometime – a merry group of friends lunching on the terrace of the Restaurant Fournaise at the Isle of Chatou on the River Seine. A friend named Baron Barbier, a good-natured regimental captain who much preferred horses to paintings, volunteered to stage-manage the affair – rounding up all Renoir's friends and even making sure the boats were properly positioned for the background. Then Renoir began to make studies and sketches on the spot. The result is an Impressionist masterpiece, filled with a spirit of 'joie de vivre'. But the picture marked the end of an era. Shortly afterwards Renoir changed his style.

Boats on the Seine
(right) The boats glimpsed in the background remind us that the friends relaxing over lunch have just returned from the river.

Renoir's future wife
(below) This young woman, shown in a remarkably natural pose, is Aline Charigot, Renoir's wife-to-be. The Restaurant Fournaise was their favourite meeting place at the time.

The Restaurant Fournaise
(above) Sunday-trippers flocked to this restaurant near Chatou. They ate out on the first-floor terrace overlooking the Seine.

Still-life
(right) Renoir's skill as a painter is shown in this sparkling still-life. The bottles and glasses take on all the colours of the objects around them.

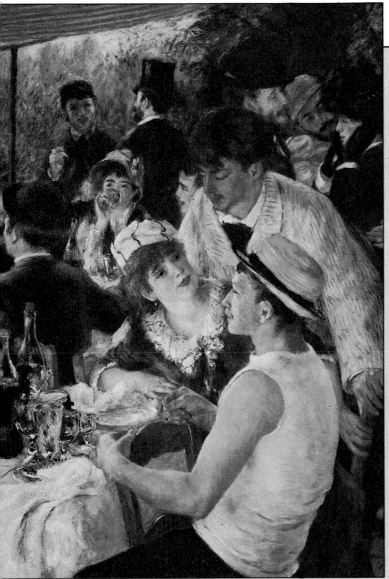

Phillips Collection, Washington

'The Impressionists reach the summit of their art when they paint our French Sundays.'

French critic

Friends Around the Table

The proprietor
M. Fournaise, the landlord, and his daughter, 'the lovely Alphonsine'.

The organizer
(right) Baron Barbier, in the top hat, helped Renoir round up all the friends who appear in the painting. He chats with the proprietor's son. The girl drinking is one of Renoir's favourite models, Angèle, who talked non-stop while she posed.

The hypnotist
(left) Lestringuez, in the bowler hat – a friend fascinated by the occult and a demon hypnotist – stands with Paul Lhote. Despite being 'as near-sighted as a mole', Lhote had a reputation as a ladies' man Here he flirts with the actress Jeanne Samary.

The boating enthusiast
(right) Gustave Caillebotte, in the straw hat, was a talented artist and boating enthusiast. He is listening to the actress Ellen Andrée. Behind them stands the journalist Maggiolo.

1859-1891

Georges Seurat is best known for his novel technique of painting in tiny dots of colour – the method known as 'pointillism', which he devised according to rigid scientific principles. A proud man, but extremely shy by nature, he spent most of his time reading books or painting in the isolation of his studio. He was intensely secretive, jealously guarding his latest discoveries from even his closest friends.

Seurat was attracted by much the same subjects as his Impressionist contemporaries – seascapes, summer by the River Seine, the entertainers of the Parisian night-clubs. But instead of recording fleeting impressions, he imposed a sense of stillness and order on his world. Seurat's whole career was compressed into 12 years of patient activity. He died tragically young, probably from meningitis, at the age of 31.

Sunday, Port-en-Bressin *1888*
25½″ × 32″ Kröller-Müller Museum, Otterlo

The Quiet Experimenter

A man of independent means, Seurat devoted his short life entirely to art. He worked alone, and was so secretive that even his close friends were unaware that he had a wife and son.

Georges-Pierre Seurat was born in Paris on 2 December 1859, the son of comfortably-off parents. His father, a legal official, was a solitary man with a taciturn and withdrawn manner which his son also inherited. At every available opportunity, Antoine-Chrisostôme took leave of his family and disappeared to his villa in the suburbs to grow flowers and say mass in the company of his gardener; he was only at home on Tuesdays. Seurat's mother was quiet and unassuming, but it was she who gave some warmth and continuity to his childhood.

Hidden depths
Seurat's personality was reserved but strong. A contemporary wrote of him: 'Imagine a tall young man, extremely shy, yet of great physical energy He is one of those peaceable yet stubborn men who may appear afraid of everything, but who actually do not flinch at any challenge.'

The family apartment was on the Boulevard de Magenta, close to the landscaped pleasure garden the Parc des Buttes-Chaumont, where young Georges and his mother spent much of their spare time. Such places, and the people who frequented them, were to become the subject of some of his greatest paintings.

THE HANDSOME STUDENT

As a young man, Seurat was tall and handsome with 'velvety eyes' and a quiet, gentle voice. Reserved and dignified in dress as well as manner, he was always neatly and correctly turned out: one friend described him as looking like a floor-walker in a department store, while the sophisticated and sharp-tongued Edgar Degas nicknamed him 'the notary'. He was serious and intense – preferring to spend his money on books rather than on food or drink – but his most pronounced characteristic was his secretiveness.

Despite many of the qualities of the perfect student, Seurat did not particularly shine at school or at the Ecole des Beaux-Arts, the official Paris art school, which he entered in 1878. But thanks to a regular allowance, he never had any need to sell his work for a living – nor to produce work that was saleable. In 1879, a year of military service

La Grande Jatte
In Seurat's day the island of La Grande Jatte – in the River Seine, on the outskirts of Paris – was a popular weekend pleasure resort. Seurat visited the island frequently, and chose it as the setting for his largest painting.

Seurat's champion
(below) The writer Félix Fénéon vigorously defended Seurat and his avant-garde friends at a time when they were subjected to much critical abuse. This extraordinary portrait of Fénéon was painted in 1890 by Paul Signac. It shows him sporting his distinctive 'Uncle Sam' beard.

Friend and disciple
(right) Paul Signac was a valuable friend who introduced Seurat to other artists. An accomplished painter himself, he also wrote a book explaining Seurat's scientific theories of painting, and adopted many of his friend's ideas. Seurat drew this portrait in about 1889.

Key Dates

1859 born in Paris

1875 takes drawing lessons at a local art school

1878 becomes a student at the official Ecole des Beaux-Arts

1879 does military service at Brest, where he draws marine subjects

1880 returns to Paris; devotes himself to black and white drawing

1883 works on *Bathing at Asnières*

1884 meets Paul Signac; helps to found the Société des Artistes Indépendants

1886 exhibits *La Grande Jatte* at the final Impressionist exhibition

1887 visits Brussels, where his work is exhibited with the avant-garde Belgian group, 'The Twenty'

1890 his mistress Madeleine Knobloch gives birth to his son

1891 dies suddenly in Paris

David Rockefeller Collection, New York

broke into his artistic studies. Seurat was sent to the great military port of Brest on the western coast of Brittany, where he fitted in easily to barracks discipline and used his spare time to begin sketching figures and ships.

Returning to Paris in 1880, the young artist initially shared a cramped studio on the Left Bank with two student friends before moving to a studio of his own, closer to his parents' home on the Right Bank. For the next two years, he devoted himself to mastering the art of black and white drawing.

The year 1883 was spent working on a huge canvas, *Bathing at Asnières* (p.444), his first major painting. In 1884, the Salon jury rejected it and Seurat changed the direction of his career. From this year on, instead of pursuing a conventional academic course, he scorned the Salon and allied himself with the young independent painters.

An instinctively gifted painter, Seurat also had extraordinary powers of concentration and perseverance, and took a dogged and single-minded approach to work. He was convinced of the rightness of his own opinions, and of the importance of the 'pointillist' method he was

developing. Although other painters turned to him as a leader, he seems to have inspired admiration rather than affection. He in turn looked upon this admiration as naturally befitting his superior intellect, hard work and achievement.

MEMBER OF THE COMMITTEE

In May and June 1884, Seurat's *Bathing at Asnières* hung at the first exhibition of the new group of Artistes Indépendants, mounted in a temporary hut near the ruined Tuileries Palace. The show ended in financial muddle, but out of the ensuing arguments a properly constituted Société des Artistes Indépendants emerged, committed to holding an annual show with no jury. Seurat attended its committee meetings regularly, always sitting in the same seat, quietly smoking his pipe.

At one such meeting, Seurat struck up a friendship with Paul Signac. Signac was four years younger, a largely self-taught painter who was influenced by the Impressionists and very receptive to Seurat's theoretical ideas. The extrovert and enthusiastic Signac provided Seurat

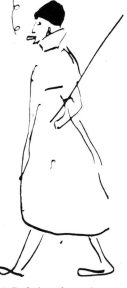

J. Toorop/The Three Brides/Kröller-Müller Museum, Otterlo © ADAGP 1986

A Belgian friend
*Theo van Rysselberghe –
here caricatured by himself
– was a Belgian artist who
admired Seurat's work.*

with contacts and moral support as he set about making his mark within the avant-garde.

In the summer of 1884, Seurat embarked on another major canvas, again depicting the popular boating place of Asnières, but this time focusing on the island of La Grande Jatte in the Seine. With characteristic single-mindedness, he devoted his time entirely to the composition. Every day for months he travelled to his chosen spot, where he would work all morning. Each afternoon, he continued painting the giant canvas in his studio.

After two years of concentrated, systematic work, Seurat completed the painting in 1886, and exhibited it with the Impressionist group in May of that year. *La Grande Jatte* (p.420) proved to be the main talking point of the exhibition, and he was hailed by the critics as offering the most significant way forward from Impressionism. Félix Fénéon, a sensitive and sympathetic young critic, was particularly impressed. He christened Seurat and his associates the Neo-Impressionists, and became an enthusiastic spokesman for them. In a series of articles on contemporary art in the newly-launched *Vogue* magazine, Fénéon paid special attention to Seurat's work, and expounded his new method in scientific detail.

A fashion for decadence
Through Signac, Seurat came into contact with many contemporary artists, including the Dutchman Jan Toorop, who painted The Three Brides *(1893), a famous example of the fashionable taste for 'decadence'. Like Toorop, Seurat exhibited with the avant-garde Belgian group Les Vingt (The Twenty) – and in fact Seurat was better received in Brussels than in Paris.*

CENTRE OF CONTROVERSY

Suddenly, Seurat found that he was the most controversial figure on the artistic scene in Paris. He was now occupying a studio next to Signac's on the Boulevard de Clichy in Montmartre. Here he was surrounded by artists ranging from the conservative decorator Puvis de Chavannes, whom he greatly admired, to more progressive contemporaries – including Degas, Gauguin, Van Gogh and Toulouse-Lautrec. He was at the centre

Summers in Honfleur
(right) Seurat often spent the summer at this port, and other resorts on the Normandy coast. Seascapes and harbour views formed a major part of his output as a painter.

of artistic debates, but he kept aloof from them.

Seurat's relative financial ease meant that he was unused to dealing with potential clients, and his demands remained modest despite his new fame. Once, when pressed to name his price for the painting he was showing at 'The Twenty' exhibition in Brussels, Seurat replied, 'I compute my expenses on the basis of one year at seven francs a day'. His attitude to his work was similarly down-to-earth and unromantic – he had no pretensions to the status of genius. When some critics tried to describe his work as poetic he contradicted them: 'No, I apply my method and that is all.' He was, however, very concerned not to lose any credit for the originality of his technique and guarded the details obsessively.

Seurat's life had begun to assume a regular pattern. During the winter months, he would lock himself away in his studio working on a big figure picture to exhibit in the spring, then he would spend the summer months in one of the Normandy ports such as Honfleur, working on smaller, less complex, marine paintings. Whether in Paris or at the coast, Seurat was never a great socializer and in the last year of his life he virtually cut himself off from friends. He could warm up in a one-to-one situation, but by all accounts his conversation centred on his own artistic concerns.

A SECRET FAMILY

Late in 1889, when Seurat was approaching 30, he moved away from the bustling Boulevard de Clichy to a studio in a quieter street nearby, where – unbeknown to his family and friends – he lived with a young model, Madeleine Knobloch. In February 1890 she gave birth, in the studio, to his son. Seurat legally acknowledged the child and gave him his own Christian names in reverse. But it was not until two days before his death that he introduced his young family to his mother.

Seurat died in March 1891, totally unexpectedly: he seems to have contracted a form of meningitis. One week he was helping to hang the paintings at the Indépendants exhibition and worrying about the fact that his hero Puvis de Chavannes had walked past *The Circus* (p.405) without so much as a glance; the following week he was dead, at the age of 31. Signac sadly concluded 'our poor friend killed himself by overwork.'

Wife and Heiress

Seurat was so secretive that few people knew he had a common-law wife named Madeleine Knobloch, and after his early death even his close friends were surprised to learn that he also had a son. Seurat's parents allotted her a half-share of the paintings he left behind in his studio, but Madeleine was not content with this. She claimed that Seurat's friends were trying to 'despoil' her of his works, and these repeated accusations eventually turned everyone against her.

Seurat's tomb
(below) Seurat is buried in an imposing family vault – the third from the left – in Père Lachaise Cemetery in Paris.

Woman Powdering Herself (1890)
Seurat's wife Madeleine – model for this painting – was described as 'a poor scatterbrain'.

Courtauld Institute Galleries, London

A Pattern of Dots

With the aid of scientific treatises on colour – and his own acute powers of observation – Seurat developed a highly original technique of painting, using tiny multicoloured dots.

Seurat is best known today as the artist who devised a painstaking method of painting in tiny dots. His works as a whole, paintings and drawings alike, are characterized by their precise and deliberate quality. He left nothing to chance, never starting a picture unless he knew exactly where he was going. As one friend remarked later, 'the sensation of being carried away meant nothing to him'.

Every day, Seurat shut himself in his little studio, surrounded by his books. There he could be found perched on a step-ladder in front of one of his canvases – some of them up to ten feet long – working in silence, his eyes half closed, a little wooden pipe held tightly between his teeth. He often worked late into the night, undeterred by the poor artificial light. When he wanted a breath of air he went for long walks around Paris.

A MYRIAD OF DOTS

To begin with, he covered the canvas with a layer of paint. Over this, he painted a layer of local colours in broad textured strokes. Then he began to build up the painting using multi-coloured dots, taking small sections of the canvas at a time and working with incredible concentration. And because he had mapped out every detail in advance, he rarely needed to step back from the canvas to see the whole effect.

The Stone Breaker (c.1883)
Seurat's earliest subjects were peasants at work, toiling in the fields or at the roadside. They were painted on small wooden panels in a bold Impressionist style.

When friends came to visit Seurat, they found him reserved and uncommunicative. He only became animated when they touched upon his ideas or theories. Then he would climb down from his ladder and, taking up a piece of chalk, eagerly draw diagrams on the studio floor.

Seurat did not invent these theories. Rather he studied the aesthetic and scientific treatises of the day with a view to finding logical explanations for the colouristic qualities he had already admired in paintings. One of the key notions Seurat took up was the idea of 'optical mixture'. Instead of mixing his colours on the palette before placing them on

The Models (1888) *(below) In this 'small version', three models pose in front of Seurat's huge canvas* La Grande Jatte. *Seurat probably wanted to prove that his vibrant 'dot' technique could be applied with equal effect to a studio interior or a sunny outdoor scene.*

The Phillips Collection, Washington D.C.

A master draughtsman
(left) Early in his career, Seurat devoted two years to mastering the art of drawing in black and white. At the 'Concert Européen' (1887/8) shows the beautiful subtlety of his technique.

The Eiffel Tower
(1889)
Seurat painted the Eiffel Tower a year before it was opened to the public, when it was highly unfashionable to like it. At that time, the tower was covered in enamel paint in various colours, so that Seurat's colourful technique was strangely suited to it.

the canvas, which made them lose their brilliance, he tried placing separate dabs of unmixed colour side by side on the canvas. He believed that they would then merge in the eye of the spectator, without any loss of vibrancy. The Impressionists had worked like this instinctively, but Seurat was able to justify the practice in logical terms.

Seurat first experimented with this novel technique in a seascape of 1885, painting in regular dots or dashes to capture more subtle changes in light effects. It was this technique that was dubbed 'pointillism'. The actual colours of the dots depended on a number of considerations: the natural colour of the scene before him, the effect of sunlight or shadow, and the reaction of one colour to another. By a logical extension of his desire to control the viewer's response, Seurat began, in 1887, to give his works painted borders.

Lines of emotion
(above) Having evolved his own theory of colour, Seurat began to ponder the significance of line. From aesthetic treatises, he learned that the directions of lines could express different emotions: upward-slanting lines are happy, horizontal lines are calm and downward-sloping lines are sad.

The theory in practice
In a working sketch for his final painting, The Circus. Seurat has blocked in the main lines of the composition in blue. The lady bare-back rider sets the emotional tone of the picture – she is sketched in 'happy' lines, leaping upwards.

COMPARISONS

The Coast of Normandy

Many French artists painted views of the Normandy coastline, attracted by the bustling harbours, the majestic chalk cliffs, the fishing-craft and the many moods of the sea.

But each painter catches a different mood. Seurat himself liked to evoke the 'feeling the sea inspires on calm days'. Pissarro was more interested in the appearance of the ocean under different weather conditions. And Courbet responded most strongly to the rugged character of the cliffs along the seashore.

Louvre, Paris

Gustave Courbet (1819-77) The Cliffs at Etretat
(above) Courbet's vigorous seascape shows a gusty day at Etretat – famous for its natural rock arch, formed by the relentless beating of wind and sea.

Camille Pissarro (1830-1903) The Pilot's Jetty, Le Havre
Pissarro gave this busy harbour scene the detailed subtitle 'Morning, grey weather, misty'. The bleak, overcast sky is reflected in the greyish green sea.

Tate Gallery, London

The pointillist nude
(below) Seurat's Study for The Models (1887), *shows how successfully his technique could be applied to painting a nude. The regular dots are used to convey the roundness of the model's simplified form.*

What Seurat hoped to achieve through the pointillist technique was not just greater accuracy, but also the vibration of light itself. He was hampered, unfortunately, by faulty materials. By the 1890s, his artist friend Paul Signac could already see serious discolouration and darkening in some of the colours Seurat had used.

HAPPY AND SAD LINES

From 1887 onwards, Seurat turned his restless intelligence to the problem of line. He was intrigued by contemporary theories on the directions of lines and the belief that in a painting lines could be used to convey different emotions. Upward-tending lines were thought to express gaiety, horizontal lines serenity, and downward lines sadness. He applied these theories in some of his later works, especially those depicting the artificially high-spirited world of the circus.

For his subject matter, Seurat turned his analytical eye on the contemporary world. At first he deliberately set out to explore Impressionist subjects – suburban scenes, summer landscapes and seascapes. But unlike the Impressionists,

who had tried to capture the passing moment, Seurat was fascinated by the eternal moment – the timeless grandeur of everyday life. Later he favoured themes in which people were performing: circus parades, cancan dancers, singers and clowns. In his early drawings Seurat had made studies of individual figures, which he re-used in his later compositions, but they remain isolated. Even his crowds are strangely silent.

Seurat's drawings form an important part of his output – described by Signac as 'the most beautiful painter's drawings that ever existed'. As in his paintings, Seurat organized and simplified his subject-matter to convey a fixed and lasting image. He patiently built up tones in small criss-cross strokes, using velvety conté crayon on heavy, rough-textured paper. Often he would isolate a dark silhouetted figure against a lighter background, or capture the fall of lamplight on the softened features of a face.

If Seurat can be criticised for a certain dryness and impersonality, he was nevertheless one of the most acute observers of contemporary life. The perfect balance of harmony and luminosity he achieved has never been equalled.

Jeu de Paume, Paris

Painting in Dots

Seurat's paintings are made up of thousands of tiny, coloured dots, in which the natural colours of objects mingle with contrasting colours – red with green, orange with blue. This is known as pointillism.

Port-en-Bessin (1888) *(above and left) In this carefully composed painting of the quay at Port-en-Bessin, Seurat makes meticulous use of his pointillist technique. The dots vibrate on the canvas, suggesting the harshness of the midday sun. Stiff little figures cast short shadows, made up of red, blue and orange dots. The detail of the pavilion in the background shows just how many colours Seurat used. From a distance, these dots blend together in the eye of the onlooker.*

THE MAKING OF A MASTERPIECE

La Grande Jatte

Seurat began work on *La Grande Jatte* (p.420-421) in 1884, and spent nearly two years on the immense canvas. For months on end he visited the little island on the Seine, making studies of the Sunday strollers and the sunny landscape. He worked with complete concentration, moulding the real scene into the picture of his imagination – when the grass grew too long at the river's edge, he even asked his friends to cut it. Eventually Seurat began to build up the final picture in his studio, skilfully distributing his calm, static figures across the canvas. The finished work was exhibited in 1886 at the last Impressionist exhibition, where it provoked an outcry. Seurat's admirers hailed him the 'Messiah of a new art'.

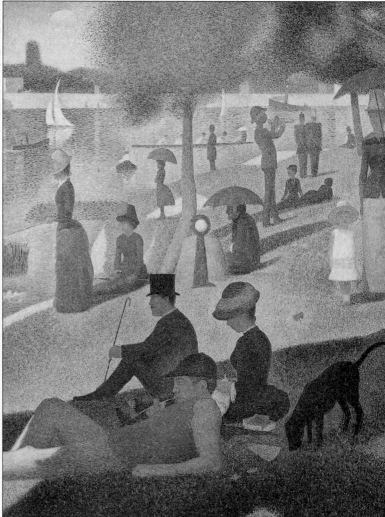

The emerging picture
(*above*) *Seurat set up the ten-foot canvas in his small studio in the Boulevard de Clichy. Working from a step-ladder he painted over a speckled base, and patiently built up small areas of the picture at a time. The blobs of colour on his palette were laid out in the exact order of the spectrum.*

Oil studies
(*right*) *Seurat's loosely painted oil sketches, made on the spot, record the slow development of the picture.*

Private Collection

> 'La Grande Jatte unrolls before you like some myriad-speckled tapestry.'
>
> Félix Fénéon

Solemn silence
(left) In reality, the Sunday crowds were often rowdy and boisterous, but the people in Seurat's painting are dignified and restrained. He delights in showing the details of their clothes, their hats and canes, dainty fans and genteel reading-matter.

An empty landscape
Seurat made a detailed study of the landscape without any people in it.

Whitney Collection, New York

Art Institute of Chicago

The fashionable bustle
(above right) Seurat probably drew his elegant costumes from contemporary fashion-plates. The bustle was at the very height of fashion.

Sketches of monkeys
Seurat made four sheets of drawings for the monkey in the right foreground. In the painting he is spotted with yellow, purple and ultramarine.

Cabinet des Dessins/Louvre, Paris

Background

One of the changes which happened in the second half of the 19th century in France was the growth of leisure pursuits. The reasons for this growth were varied and had to do with the changes brought about by the industrial age. It created an urban, affluent middle class eager to parade its prosperity. In Paris, whether on the boulevards, in the cafés, the parks and gardens or at the races, theatre and opera, the smart set – those with time and money to spare – were set on conspicuous consumption.

For others, leisure took a simpler form, often that of the Sunday outing. As their own surroundings became more built up, a day trip to the country became attractive, made possible by the easy transport of the new railways. It gave them the opportunity to picnic and stroll under the trees, to boat and bathe, to dance and drink in the open-air cafés.

Luncheon of the Boating Party *1881*
by Pierre-Auguste Renoir
50″ × 69″ The Phillips Collection, Washington DC

Fashionable Paris

The society of the Impressionists' time was essentially outward-looking, materialistic and pleasure-loving, lax in morals but with certain 'rules' that had to be followed for appearance sake.

For the well-to-do Parisian, life in the second half of the 19th century provided abundant pleasures. The French court set the style, with extravagant fashions, modish leisure pursuits, glittering balls and receptions. But the industrial age had also created an affluent middle class, as keen as the upper classes to parade its prosperity.

The social day began at noon for the fashionable 'boulevardiers' of the city. The wide pavements would be crowded with strollers like Manet, who might stop for a drink or for lunch at one of the fashionable cafés – Tortoni's, for instance, or the Café Riche, which was open from 11 am until well after midnight. The Café Riche attracted 'men-about-town, actors and artists, all the Parisians who live with elegance, comfort and money,' according to a contemporary. The composer Jacques Offenbach was a regular customer, along with Baudelaire and Manet.

OPEN-AIR CONCERTS

During the afternoon, the fashionable upper middle classes might stroll in the garden of the Tuileries, or attend one of the regular open-air music concerts staged there. Situated right in the heart of the city, the palace of the Tuileries had been the Paris home of the French monarchs for three centuries. It offered beautifully landscaped grounds, and avenues bordered by orange trees, terraces and classical statues.

Another favourite haunt of Parisian society was the Bois de Boulogne, transformed in the 1850s from a near wilderness to a landscaped park in the style of London's Hyde Park. For the fashionable lady, a carriage drive in the Bois de Boulogne each afternoon was a social necessity. In the summer, gondolas took visitors across to an island on the lake; in winter, there was ice-skating and sledging, the latter a favourite pastime for the well-to-do, in spite of its lack of sophistication.

The Bois de Boulogne
(right) The Bois de Boulogne, newly landscaped with a splendid lake, quickly became popular with the Parisian leisured classes, who toured the park in open carriages.

Lady riders
(left) Elegant society ladies followed the Empress's lead and rode regularly in the Bois de Boulogne. They were dubbed 'the Amazons', since riding was still considered to be a masculine pursuit.

Fogg Art Museum, Harvard University, Massachusetts

Days at the races

(left) *The thrill of horse-racing and the bright social spectacle attracted many well-to-do Parisians, including Manet. During the 1860s he made frequent visits with his friend Edgar Degas to the new racecourse at Longchamp, on the outskirts of the city.*

Tortoni's restaurant

(below) *At Tortoni's, on the Boulevard des Italiens, elegantly dressed gentlemen would sit on the terrace or – in the evening – gather in the salon of the restaurant. Manet and his friends met here regularly during the 1860s – a table was reserved on Friday evenings.*

Musée Carnavalent, Paris

Musée Carnavalet, Paris

During the 1860s a new craze, horse racing, swept Paris and was taken up enthusiastically by the smart set – those with leisure and money to spare. In 1857 a racecourse was opened at Longchamp, just outside Paris, and the season began each year on the first Sunday in March. Longchamp, together with the racecourse which was established in the Bois de Boulogne, gave Parisians easy access to the sport.

PARIS BY NIGHT

Evening entertainment took various forms. There were, of course, the pleasures of dining out at such prestigious restaurants as the Café Anglais, which featured regularly in newspaper gossip columns on account of its aristocratic clientèle and exquisite food. Customers dined in the café's vast cellar, which also held 200,000 bottles of wine. Private banquets were held in other suites in the restaurant, and for more intimate occasions – perhaps a meal between a well-respected man and his mistress – one of the *cabinets particuliers*, small rooms with separate staircases, would be hired.

An assignation

(right) *Parisian cafés were convenient meeting places for well-to-do gentlemen and women from the demi-monde – actresses, singers and prostitutes.*

Victoria and Albert Museum, London

Musée Carnavalet, Paris

On particular evenings during the season, the Tuileries gardens would be transformed with coloured lanterns and Bengal lights into a fairytale setting for grand balls and fancy-dress balls held by the Court. These reached new heights of splendour as fashions grew more and more opulent: clothes had become an important means of displaying wealth and status.

During the early 1860s crinolines had been all the rage, but under the influence of an English designer, Charles Worth, the crinoline lost favour by about 1868. Worth, who had come to Paris as a shop assistant, became the most influential designer of the century, and it was largely due to him that Paris became the mecca of the fashion world – a position it holds to this day.

Although Worth was responsible for banishing the absurdities of the crinoline, his creations were sumptuous and extreme in their own way. He made use of new and different materials such as brocade, tulle, crushed velvet and Lyons silk, and

The Winter Garden
(above) Not far from the Champs Elysées, the Winter Garden was open to everyone for dancing and concerts, and had a lively family atmosphere.

A Court banquet
(below) Under Napoleon III, the Court set the style for fashionable society throughout France. This magnificent banquet was held at the theatre in the palace of the Tuileries to celebrate the Universal Exhibition of 1867.

trimmed his dresses with garlands of artificial flowers, flounces, ruches, ribbons, lace and jewels, often hiding completely the sumptuous silk, satin or velvet of the dress itself.

COURT FASHIONS

Extravagant fashions on this scale demanded great wealth – and as a result, Court invitations were not always joyfully received. One lady guest at a Court ball in the 1860s was reported as saying that she had been invited to a house-party held by the Court and 'had to sell a flour mill to meet the expense'. This is perhaps less surprising in the context – for a few days' stay, it was considered necessary to take about twenty dresses, eight day costumes, seven ball dresses, five gowns for tea and a hunting outfit.

As women's fashions became increasingly fussy, men's clothing underwent a revolution in favour of sobriety. Towards the middle of the century, black or dark suits began to be worn by men of all ranks, until they became almost an obligatory everyday uniform.

Originally copied from the clothes worn by English country gentlemen, the dark, sober tail coat became a hallmark of respectability that, on the surface at least, gave the appearance of equality between different ranks. The less wealthy were helped considerably by the boom in ready-made suits, but men of wealth would still have their clothes made for them.

Decoration, strong colours and luxurious materials disappeared almost entirely from the male wardrobe as neckcloths or cravats became the only permissible outlet for individuality or frivolity. The overall effect was grave, even sombre, as can be seen in Manet's *The Concert at the Tuileries*, in which – almost without exception – the men are dressed in black frock coats and top hats.

Hats were important for both sexes; indeed, it was considered almost indecent to appear in public without one. The 1860s man-about-town favoured top hats: the taller these were, the more elegant the wearer. For women, simple bonnets were fast being replaced by hats richly decorated with feathers, flowers and artificial fruit.

LAVISH SPECTACLE

At the theatre and opera, extravagance and flamboyance were again the order of the day. Lavish spectacle was highly prized: one production of Cinderella in the 1860s demanded no less than 30 different full-scale sets. The newly built Paris Opera staged equally grand productions, with the light operas of Offenbach achieving immense popularity.

Private salons were important for cultured Parisians. At these evening gatherings, sparkling conversation was highly valued, and new artistic and literary ideas were circulated and discussed as avidly as the latest gossip.

The society of the time was essentially outward-looking, materialistic and pleasure-loving, lax in morals but with certain 'rules' that had to be followed for appearance's sake. So although it was commonplace for the well-to-do to keep mistresses or lovers (and the liaison might be universally known), publicly they could not be linked in any way without creating a scandal.

Frequently the mistresses of the affluent came from the *demi-monde*, the enticing world of actresses, singers and beautiful courtesans, known as *grande cocottes*, immortalized in stories such as Dumas' *The Lady of the Camellias* (which later became the subject of Verdi's opera *La Traviata*) and Zola's novel *Nana*. Some of these ladies became very wealthy – and very famous – as a result of their affairs, but they were not openly admitted into respectable social circles until later in the century.

Musée Carnavalet, Paris

A ball at the Tuileries
(*above*) *The magnificent palace of the Tuileries, with its beautiful gardens, made a perfect setting for grand Court balls. Manet moved with ease in high society and was used to the glitter and formality of such occasions.*

Musée Carnavalet, Paris

Women's fashions
(*above*) *Women's fashions grew more elaborate in the 1860s and 1870s as clothing became a symbol of status and wealth amongst the middle and upper-middle classes.*

The Paris Opera
(*left*) *The sumptuous auditorium of the Paris Opera – completed in 1875 – made an extravagant setting for fancy dress balls, which were popular amusements amongst fashionable Paris society.*

Musée Carnavalet, Paris

415

Sundays in the Country

Every Sunday, thousands of day-trippers took the train out of Paris for pleasure spots on the banks of the Seine. Renoir's famous paintings of his friends at play – dancing, boating, eating, chatting – are a celebration of such French summer outings.

For Parisians in the second half of the 19th century, Sunday was the one day that they could forget about work and enjoy themselves. The fresh, unspoilt beauty of the countryside had become increasingly attractive to city-dwellers as their own surroundings became more built-up, and with the coming of the railways, destinations that had previously involved long, arduous journeys were now within easy reach of everyone.

DRESSING UP FOR SUNDAY

'Of course you may have a little recreation on Sunday . . .' wrote one preacher to his readers. And they certainly took him at his word. Sunday outings, especially for the working community, soon became the social highlight of the week. Men and women dressed up in their 'Sunday best', the women wearing their prettiest crinolines and carrying sunshades, and headed for the country.

One of the favourite haunts of day-trippers from

The age of the train
Pleasure-bent Parisians wearing their best clothes board the crowded 'Sunday' train for a trip into the country. The railways – newly built in Renoir's time – gave everyone a chance to escape from the city on their day off.

Musée Carnavalet, Paris

Etang des Carpes

Cavalière des Brigands

COUR D

TOUR DENECOURT
ancien fort l'Empereur

la Roche

A 1 HEURE DE PAR

AFFICHES CAMIS, 59 Bd Richard-Lenoir PARIS (Deposée)

Day trips from Paris

The railways carried passengers out of Paris in two directions: northwest to the riverside villages around Argenteuil and southeast to Fontainebleau – 62,000 acres of woodland, with spectacular crags and gorges.

Fontainebleau Palace

The French court took up residence at Fontainebleau for six weeks every spring. The sight of aristocrats picnicking in the forest was an added attraction for the Sunday trippers.

Paris was the Forest of Fontainebleau, lying some 40 miles south of the capital. Before 1849, access to Fontainebleau had been difficult, requiring a day-long journey by stage-coach which had to be booked several days in advance. But in August of that year a new railway line opened. Now it took just 90 minutes to reach Melun, at the edge of the woods, and Parisians flocked there to take advantage of the various attractions of the region.

The rugged scenery of the place, with its outcrop of craggy rocks and still untamed woodland, had nurtured a whole generation of landscape painters, succeeded now by younger artists – among them Renoir and Monet – who delighted in open-air painting. The little villages of Barbizon and Chailly, situated on the north-east borders of the forest, were particular favourites with artists, being just a short walk from some spectacular scenery: centuries-old beeches and oaks lining the road at Chailly and the rocky gorges of Apremont. The grotesque shapes of some of the rocks had given rise to stories that the forest was inhabited by fantastic monsters. Its woodland had also acquired a romantic reputation as the hideout of escaped convicts and brigands.

Sunday trippers would trek the five miles to Barbizon from Melun Station, or take a gig if they were lucky enough to get one. Shop-assistants,

Delights of Fontainebleau

(left) A poster advertises the palace and forest at Fontainebleau – a 90-minute ride from the Gare de Lyon station in Paris. The line, built in 1849, went to Melun, from where visitors could walk or take a gig to Chailly, Barbizon, Fontainebleau and other villages.

A family picnic

A photograph dated 1888 shows a family enjoying a game of whist after their picnic lunch – washed down with liberal quantities of wine.

417

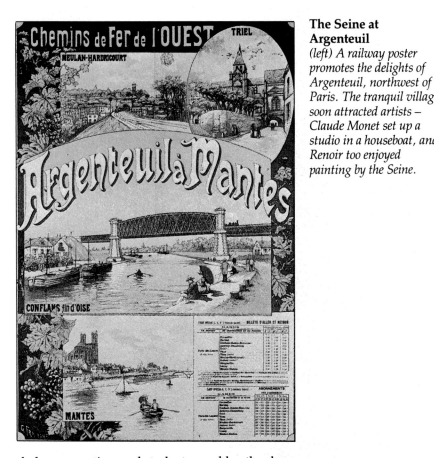

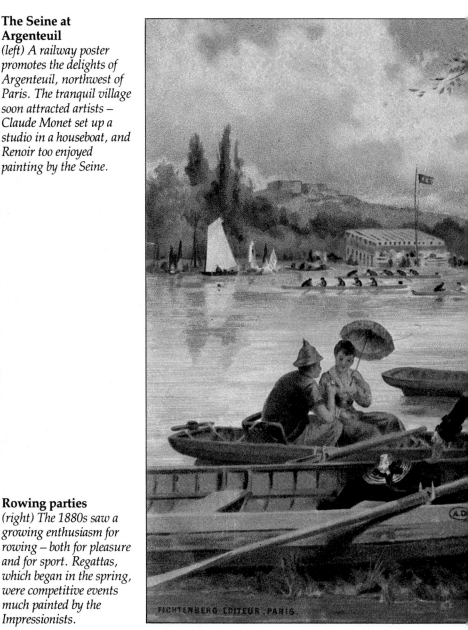

The Seine at Argenteuil
(left) A railway poster promotes the delights of Argenteuil, northwest of Paris. The tranquil village soon attracted artists – Claude Monet set up a studio in a houseboat, and Renoir too enjoyed painting by the Seine.

clerks, apprentices and students would gather here – some to sketch; most, out of curiosity, to watch the painters at work; others to picnic and stroll under the trees. On one occasion Renoir was spied by a group of Parisian rowdies who were greatly amused by his old-fashioned artist's smock. They kicked his palette out of his hand, while the girls laughingly poked at him with their parasols. Most of the trippers, however, were interested in more harmless amusements. One Belgian artist noted: 'At present there are crowds of people gathered here, and everywhere exclamations of joy can be heard throughout the forest.'

INNS OF THE FOREST

With their reputation for lively, hospitable inns, home to many an artist, Barbizon and Chailly could also provide food, drink and plenty of entertaining conversation. One such inn, the Auberge Ganne at Chailly, had become renowned as an artistic centre. It was not so famous for its culinary delights. The Goncourt brothers, watercolour artists who also kept detailed notebooks, were dismayed by the 'monotony of omelettes' and the 'pewter forks that stained the fingers'. The tiny village of Marlotte, to the south of the forest, was also popular with young painters.

The Fontainebleau region retained its popularity as a sight-seeing spot until the very end of the century. The French court, which took up residence at the Chateau of Fontainebleau for six weeks every spring, would sometimes travel down by coach to picnic in a select corner of the

Rowing parties
(right) The 1880s saw a growing enthusiasm for rowing – both for pleasure and for sport. Regattas, which began in the spring, were competitive events much painted by the Impressionists.

Bathing at Bougival
(left) For young men, the great attraction of bathing resorts like Bougival was the chance to enjoy wine, women and song. Respectable young ladies were kept well away from such carefree scenes.

Drinks on the terrace
(right) Cafés overlooking the water gave the more restrained visitors a good viewpoint for watching the antics on the river.

418

woods, providing an added twist of excitement for the Parisian weekenders.

Easier communications between Paris and its surrounding countryside also opened up areas to the north of the city. The River Seine, on its winding course towards the Normandy coast, was dotted with villages and islands which were popular with boating enthusiasts.

In places made famous for us through their association with painters and paintings – Argenteuil, Bougival, Chatou and its island and La Grenouillère (the 'frog pond') – Sunday trippers could indulge in a variety of amusements, from boating and bathing to the sophisticated joys of dancing and drinking in the many *guingettes*, or open-air cafés that lined the river banks.

Situated within 25 minutes by train from Paris's Gare St Lazare, Argenteuil was understandably popular. Today it is a drab suburb of Paris, but in the 1860s and 70s it was still a village, noted for its market gardens and its vineyards.

BOATING ON THE SEINE

The town itself might show the first signs of encroaching industrialization – factory chimneys were already visible – but the riverside at Argenteuil boasted lively *guingettes* from which the sound of the dance music of the day could be heard mingled with the animated chatter of customers, and was a meeting place for sail-boat enthusiasts. 'The taste for boating has developed remarkably in the last 15 years,' wrote an observer of the French scene in 1867. Regattas were a regular event.

Bougival, too, a little further to the west along the river, together with Chatou on the opposite bank, attracted a real mixture of Sunday visitors. The outdoor restaurants and pleasure-boat companies flourished with the trade from boatmen and their ladies, journalists, office workers and the coquettish young women, nicknamed *grenouilles* ('frogs') who thronged there. At Chatou, the Restaurant Fournaise enjoyed years of popularity.

Between these two resorts lay a string of islands running up the middle of the river. Crowds would wait for the ferry to take them across to their favourite islands of La Loge or Croissy, and after a picnic and rest they might perhaps bathe at La Grenouillère nearby. These charming pockets of woodland and water on the Seine were the meeting places of writers and artists as well. The author Guy de Maupassant, who knew and loved the area, has left us a colourful description of the *grenouilles*, 'yellow-haired girls with heavily rouged faces, made-up eyes and excessively red lips . . . in extravagant dresses that trail on the fresh turf.'

These Sunday outings were precious days, when the very real hardships of daily life could briefly be forgotten. For Renoir, they offered a feast of vibrant life – 'a never-ending party, and what a jumble of social sets!' 'How one laughed in those days!' the artist reminisced later. 'Machinery didn't take up the whole of life; there was time for living, and we made the most of it.'

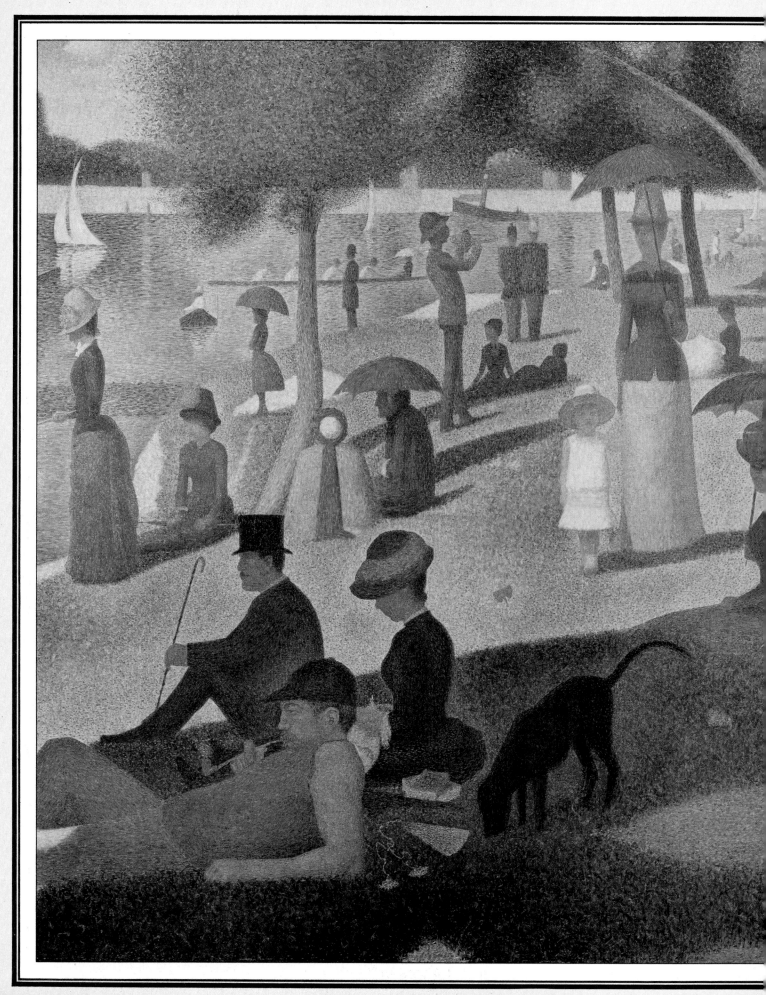

Le Grande Jatte *1884-86 by Georges Seurat*
81″ × 120″ The Art Institute of Chicago

Manet

Manet was in his early thirties when he outraged Parisian society with his modern-day nudes in The Luncheon on the Grass and Olympia. The bold brushwork was almost as offensive to some eyes as the shocking subject matter. For the next two decades, until his death at 51, Manet continued to paint highly original scenes of contemporary society – the fashionable Parisian world he knew so well.

Both as an artist and a gentleman of leisure, Manet frequented the smartest places on the boulevards. His work At Père Lathuille's took as its setting a Parisian restaurant much in vogue at that time. It was near the Café Guerbois where every Thursday tables were set aside for Manet's 'court', which included Renoir, Degas and Monet.

Illness clouded Manet's final years, but he continued to paint in spite of acute pain, and at last won the academic honours and critical respectability he had always craved. A Bar at the Folies-Bergère was acclaimed at the 1882 Salon, and with this final masterpiece Manet surpassed any of his earlier achievements in splendour of colour and richness of brushwork.

The Luncheon on the Grass *1863*
84½″ × 106¼″ Jeu de Paume, Paris

A landmark in the history of art, this painting shocked the Paris critics. Nudes were considered acceptable only if they were suitably idealized – the more like Greek statues, the better. Manet's earthy figure, with her obviously modern companions, was too close to the real world and seemed a deliberate insult to conventional taste.

Olympia *1863*
51¼″ × 74¾″ Jeu de Paume, Paris

Manet himself considered Olympia *to be his greatest work, but it evoked unprecedented abuse when it was first exhibited at the Salon of 1865. One critic wrote that 'Art sunk so low does not even deserve reproach.' What appalled the public was the picture's forthright sexuality: in contemporary French literature, 'Olympia' was a stock name for a prostitute, and the model's erotic adornments and challenging, impertinent gaze left no doubt as to her profession.*

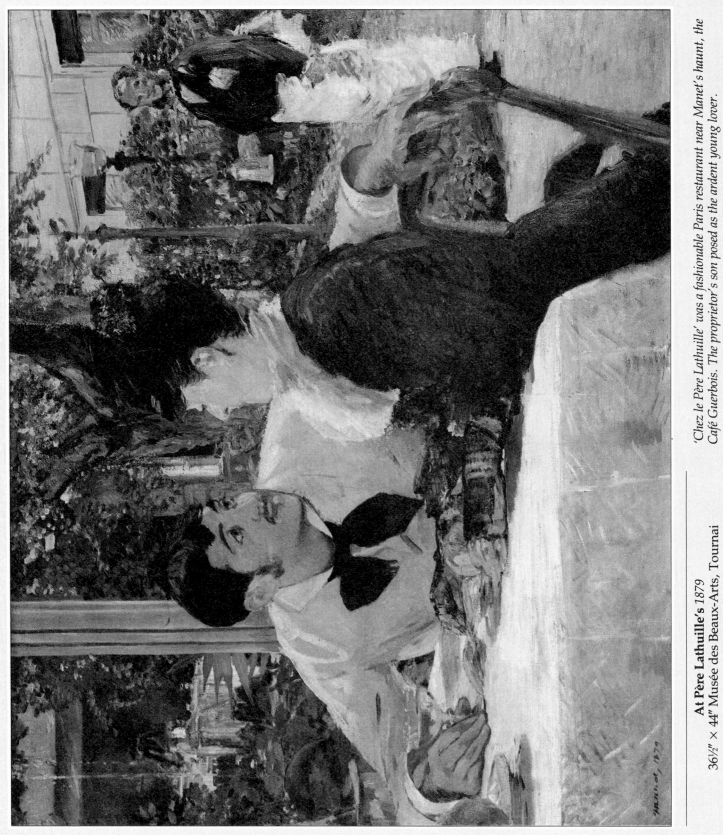

At Père Lathuille's 1879
36½" × 44" Musée des Beaux-Arts, Tournai

'Chez le Père Lathuille' was a fashionable Paris restaurant near Manet's haunt, the Café Guerbois. The proprietor's son posed as the ardent young lover.

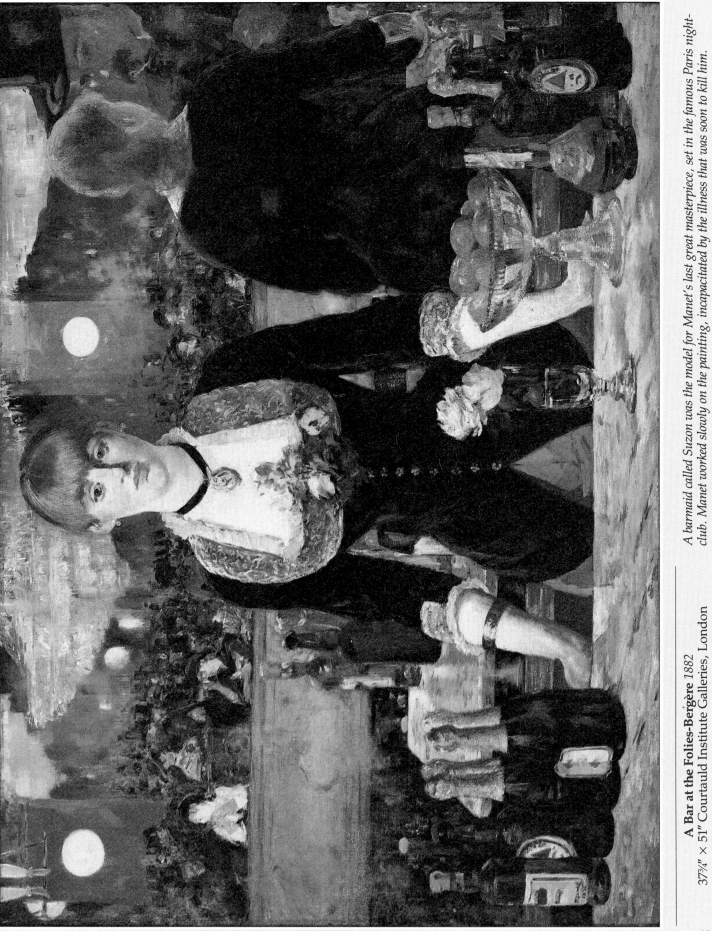

A Bar at the Folies-Bergère 1882
37¾" × 51" Courtauld Institute Galleries, London

A barmaid called Suzon was the model for Manet's last great masterpiece, set in the famous Paris nightclub. Manet worked slowly on the painting, incapacitated by the illness that was soon to kill him.

The masterpiece of Degas' early years is the life-sized portrait of The Bellelli Family. Painted in the tradition of the Old Masters he so admired, it achieved a new sense of immediacy, which is still more striking in The Opéra Orchestra painted 10 years later. This time the theme was modern Paris – to which he devoted the rest of his life.

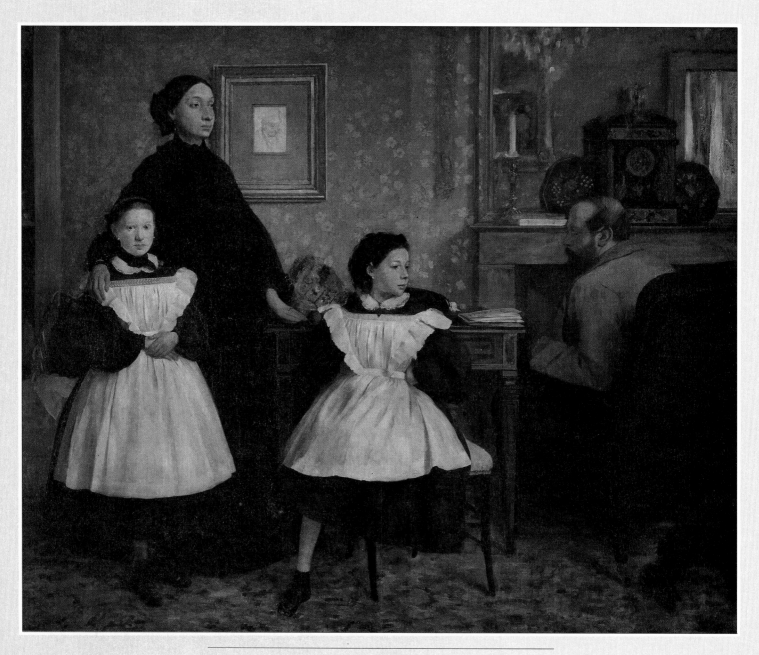

The Bellelli Family *1858-60*
78¾" × 98⅜" Jeu de Paume, Paris

Degas began this magnificent portrait of his aunt Laura and her family when he visited them in Florence when he was in his mid-20s. Composed from a number of studies, it evokes the tension between the unhappily married couple. Laura – haughty and detached – is pregnant, but dressed in mourning for her father, whose portrait hangs behind her. Her husband sits in isolation, in his armchair.

Degas focused on a limited number of themes, and explored them obsessively. Dancers were among his favourite topics and he was fascinated by the young ballerinas of the Paris Opera, both on stage and in the rehearsal rooms, as in Two Dancers on Stage and The Dancing Class. Even though fixed on canvas, his figures seem to be moving.

He captured this by using techniques of composition based on the camera snapshot.

Dancers had a reputation for loose morals so his pictures were found to be shocking by the general public. So too were Degas' nudes, like After the Bath. He returned to this 'grooming' theme in the less risqué – but equally powerful – Combing the Hair.

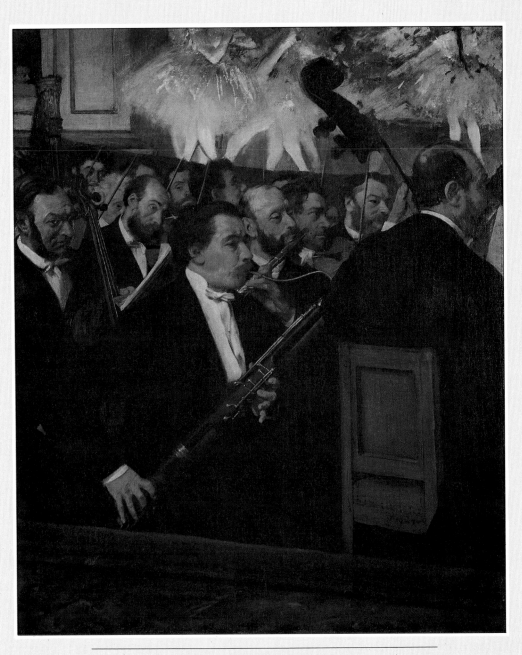

The Opéra Orchestra *c.1868-9*
22¼" × 18⅛" Jeu de Paume, Paris

The bassoonist in the centre of this group is Désiré Dihau, a friend of Degas who had commissioned his own portrait from the artist. Degas chose to paint him among his fellow-musicians during a performance at the Paris Opera, and adopted a viewpoint in the stalls, close to the orchestra pit. As a result, the floodlit dancers on the stage are dramatically cut off by the top edge of the picture.

Two Dancers on Stage *1874*
24½″ × 18″ Courtauld Institute Galleries, London

These two young dancers performing in the limelight are viewed from above, as if seen from a box to the left of the stage. The off-centre composition adds a delicate precariousness to the dancer balancing on points, and the impression of sideways movement is accentuated by the lines of the scenery tracks behind her.

The Dancing Class *c.1873-5*
33½″ × 29½″ Jeu de Paume, Paris

With this informal picture of a lesson in a rehearsal room at the Opera, Degas made a complete break from the conventional ballet paintings of his day. Instead of depicting a famous ballerina in the costume for her best-loved role, he turned his attention to the day-to-day training of the anonymous young dancers in the chorus.

After the Bath *1888-92*
41″ × 39″ National Gallery, London

Degas returned time and again to the theme of women washing or drying themselves – it allowed him to represent nudes in natural poses, without artificial gestures. The back view he adopted in this pastel serves to emphasize its informal quality. Yet despite the modesty provided by the towel, such 'keyhole' nudes were considered obscene by many of Degas' contemporaries.

Combing the Hair *1892-5*
45″ × 57½″ National Gallery, London

The bright colour and lack of detail in this unfinished picture are characteristic of Degas' late work. As his eyesight worsened, his painting became looser, yet the subtlety and acuteness of vision somehow remain. The tension is finely balanced as the girl tips back in her chair, clutching the roots of her long hair while it is combed through by the maid.

Claude Monet

From the start of his long career Monet worked mostly in the open air, concentrating on scenes that he knew well. Wild Poppies (frontispiece) was painted at Argenteuil, a pretty riverside village just outside Paris, where the artist and his family settled in 1871. The painting was shown at the first Impressionist exhibition in 1874 and Monet's wife Camille and son Jean appear twice, a

The Bridge at Argenteuil *1874*
23⅝″ × 31½″ Jeu de Paume, Paris

Monet lived at Argenteuil, near Paris, for seven years and made several paintings of sailing boats on the Seine. In this tranquil scene, the impression of broken reflections on the shimmering water is conveyed by well-defined brushstrokes of pure colour.

device which draws the eye repeatedly to the triangular hillside of bright red poppies.

Monet loved to paint the boats on the Seine with their sails reflected in the river's rippling waters – like those in The Bridge at Argenteuil. The effects of light and atmosphere gradually became more important to Monet than the objects in his paintings. In Gare St-Lazare, for example, it was the smoke – not the train – which most fascinated the artist.

In later life, Monet developed unique pictorial series – numerous versions of the same view under different lighting conditions which captured the passing of time. Poplars, Rouen Cathedral in Full Sunlight and Waterlilies (the latter painted from his own garden pond) are examples.

Gare St-Lazare *1877*
29½″ × 39½″ Jeu de Paume, Paris

This railway station was the Paris terminus of the line from Argenteuil and Monet painted it several times. He captured its atmosphere – with clouds of steam and smoke rising from the engine, and shadows thrown by the glass roof – rather than a precise, detailed likeness.

Poplars *1891*
32¼″ × 32⅛″ Metropolitan Museum of Art, New York

A row of tall poplars lining the River Epte near Monet's home in Giverny fascinated the artist, and he painted them many times from his boat. In this late stage of his career Monet's Impressionist style grew increasingly abstract and decorative.

Rouen Cathedral in Full Sunlight *1894*
42⅛″ × 28¾″ Jeu de Paume, Paris

Like Poplars, *this painting formed part of a series; Monet painted the same view over and over again, under changing light conditions. The year after this version was completed, 20 different canvases were exhibited together, covering the whole day from dawn to dusk.*

Waterlilies *1916-1926*
78¾" × 167¾" St Louis Art Museum, Missouri

Monet painted the waterlily pond at the bottom of his garden hundreds of times; it became virtually his only 'model' for the last 20 years of his life. He focused increasingly on this small area, painting ever larger pictures. This 14-foot long canvas was originally the central panel of three, forming a massive 40-foot painting. The lilies themselves are not immediately recognizable – they dissolve into a magical mixture of delicate colours.

Renoir's sparkling picture of La Grenouillère was one of his first pictures in the new Impressionist style. He went on to exhibit La Loge at the first Impressionist Exhibition in 1874.

Throughout the 1870's Renoir exhibited regularly with the Impressionists but he

La Grenouillère *1869*
26″ × 32″ Nationalmuseum, Stockholm

Renoir and his friend Claude Monet both painted views of La Grenouillère, the popular bathing place on the Seine. Working in the open air, they set up their easels side by side, to paint the lively crowds and the reflections on the water.

also submitted paintings to the Salon. He was always more traditional than the others, never considered himself a revolutionary and liked to study the Old Masters. He saw no contradiction in this but a point came in his life when he was no longer able to reconcile the differences. He changed his style and developed a 'harsh' technique, which can be seen in such pictures as the famous Umbrellas.

Towards the end of his life, Renoir painted mainly nudes. After the Bath, with its warm, melting colours, is a fine example of the 'hot' style of his last years.

La Loge *1874*
31½" × 25" Courtauld Institute Galleries, London

Renoir's younger brother Edmond and a model called Nini posed for this picture in Renoir's studio. Nini was dressed up to look like a wealthy woman at the opera. The painting was bought by a dealer for 425 francs, which Renoir already owed in rent.

The Umbrellas *c.1881-6*
71″ × 45″ National Gallery, London

In this famous picture, a Paris crowd braves the showers under a canopy of open umbrellas.

After the Bath *c.1888*
25½″ × 21¼″ Private Collection, Japan

In his later years, Renoir's favourite subject was the nude. He painted hundreds in rich, glowing colours, revelling in their roundness and fullness of form. 'My concern, he said, 'has always been to paint nudes as if they were some splendid fruit.'

Seurat

Seurat made over 20 outdoor studies for his first major painting, Bathing at Asnières, creating the finished picture in his studio. This exhaustive approach was typical of his working method, yet Seurat had not yet developed an individual technique. When he returned to the banks of the Seine to begin work on La Grande Jatte (p.420), he was in

Bathing at Asnières *1883-84*
79″ × 118½″ National Gallery, London

This timeless image of working people relaxing at the weekend is set in the vicinity of the industrial suburb of Asnières. The air is heavy with the midsummer heat and the inhabitants have come to the island of La Grande Jatte to cool off by the banks of the Seine. In the background we see the railway bridge and the factory chimneys.

Men and boys in various stages of undress are spread out carefully through the landscape. Their simplified, static poses give the painting an air of silence and repose. Only the boy in the water, frozen in the act of cupping his hands to his mouth, seems to make any sound.

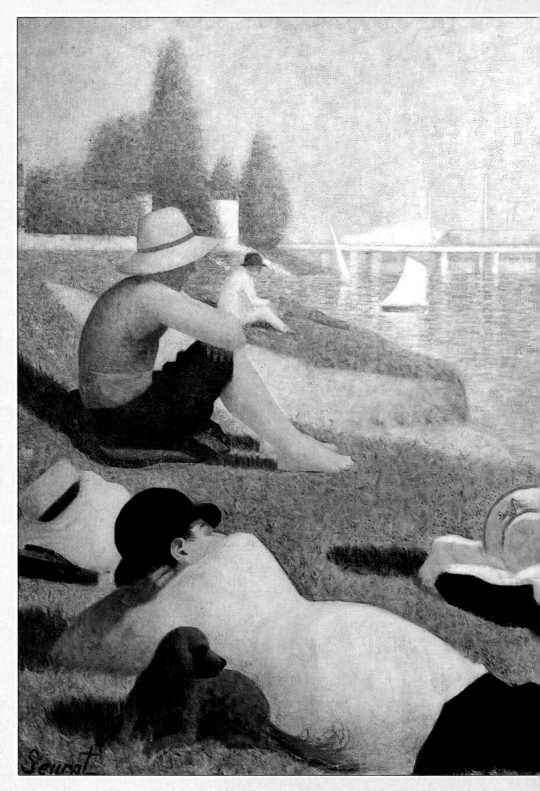

the process of inventing a new style of painting in tiny, brilliantly coloured dots.

During the summers, Seurat left Paris to paint many calm seascapes and quiet harbour views in his new style. He stayed in resorts like Grandcamp, which is situated on the Normandy coast, hoping to 'freshen his eyes' after long bouts in the studio.

Back in the capital, Seurat found another rich source of subject matter in the lively night-life of Montmartre. His late masterpieces all show entertainers of one kind or another – musicians, high-kicking dancers, graceful acrobats and clowns. The Circus (p.405), which he did not live to complete, is an example of this.

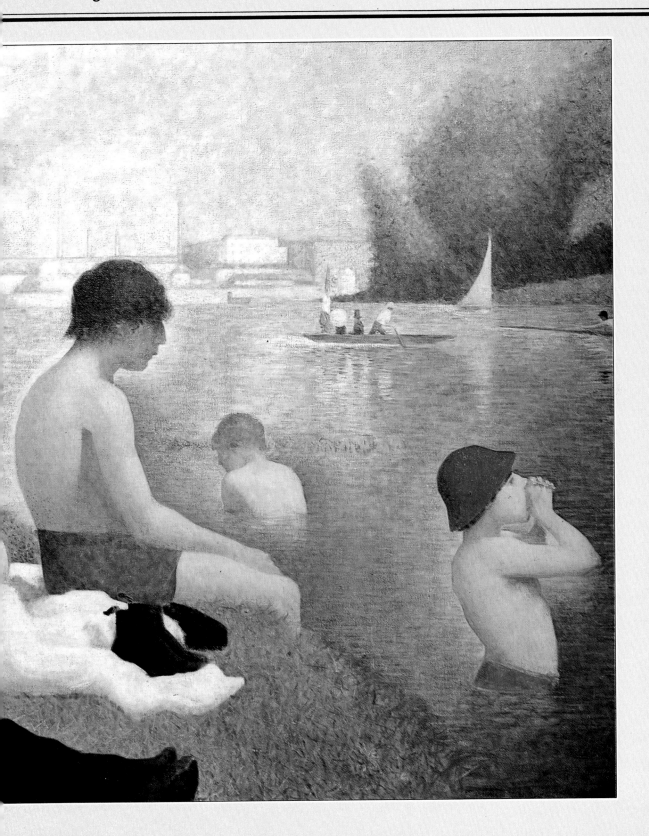

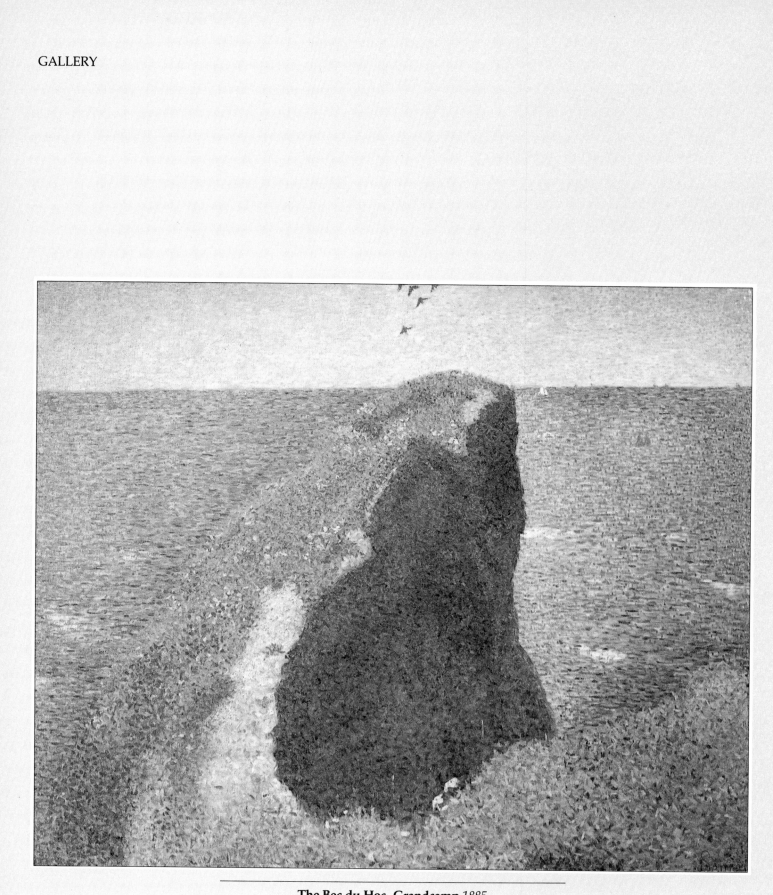

The Bec du Hoc, Grandcamp *1885*
26" × 32½" Tate Gallery, London

*'Seurat's seascapes', wrote his friend Félix Fénéon, 'give off calm and
melancholy. They ripple monotonously as far as the distant point
where the sky comes down. One rock rules them tyrannically – the
Bec du Hoc.' Here, the huge outcrop of rock juts across the canvas,
dwarfing the distant sailing boats.*

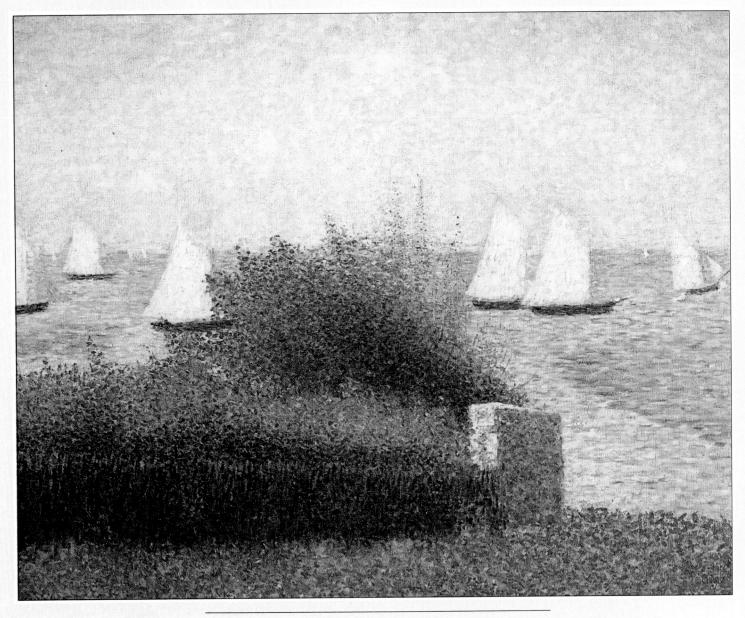

Boats at Grandcamp *1885*
25½″ × 32″ Private Collection, New York

*This tranquil seascape concentrates on the slim dark hulls and broad
white sails of boats passing along the seashore. A clump of intensely
coloured shrubbery – dotted with red, orange, purple and blue – fills
the centre of the composition. The sea itself is painted in Seurat's early
style, with small, controlled brushstrokes.*

INDEX

AISA: 180(b) J. Novak, 233, 234, 235(tl & tr), 239(tl & cr), 242(bl), 312/3, 388/9, Endpiece (3)

Jorg P. Anders: 166(1), 264(tr & bl), 266(b), 267(tl), 268/9

Archiv Für Kunst und Geschichte: 70(t), 73(b), 83(bl), 170(t), 195(tr), 231, 262(t), 263(c), 268(b), 269(t), 270(b), 434

Artothek: 72(bl) Joachim Blauel, 72/3 Josef S. Martin, 111 Josef S. Martin, 121(b) Josef S. Martin, 124/5 Joachim Blauel, 126(b) Meyer, 127(b) Joachim Blauel, 128(b), Joachim Blauel, 154(r) Blauel Gnamm, 169(br), 179(b) Bayerische Staatsgemaldesamm Lungen/Joachim Blauel, 189(t), 213 Joachim Blauel, 266(t)

Arxiu Mas: 128(t), 232, 232/3(b), 235(bl & br), 237(t & b), 238(l)

Atlas Van Stolk, Rotterdam: 199(b)

BBC Hulton Picture Library: 279(t), 390(t)

Nick Bantock: 397(r)

Chris Barker: 308(t)

Barnabys Picture Library: 247(r), 248/9

Bibliotheque Nationale: 345(c)

Bildagentur Mauritius: 120(b)

Bildarchiv Jurgens/Ost & Europa Photo: 261(t & b), 263(b), 264/5

Bildarchiv Preussischer Kulturbesitz: 13(r), 143(r), 144(l), 184(tl), 208, 220, 263(t), 265

Bodleian Library Film Strip/Picturepoint: 256(bl)

Bridgeman Art Library: 30(b), 44(t), 80/1(b), 124(br), 130(bl), 142(t), 156(tr), 157, 157/8, 174, 193(b) Christies, 226/7, 230, 240(tl & b), 248, 253(tr), 254(br), 270/1, 277(t), 281(cr), 320, 347, 348(t), 349(br), 352/3, 353(t), 392, 395(l), 396(tl & bl), 396/7, 397, 402(t), 404/5, 405, 406(c), 408, 408/9, 409(t & cr), 413(br), 420/1, 426, 432

British Tourist Authority: 251

Bulloz: 29(b), 264(tl), 358/9, 369(br), 380/1, 389(b), 412/3, 413(tl), 414, 414/5, 416 Carnavalet

P. J. Cates: 364(t)

Jean-Loup Charmet: 236(b), 344, 346(t), 349(tl), 372/3, 374(b), 417(b), 418(b), 418/9, 419

Christies: 393(bc)

Colorific!: 34(cr & br), Enrico Ferorelli/Dot, 276(l) Carl Purcell

Courtauld Institute of Art: 136(tl)

Corvina Archives, Budapest: 30(t) Kàroly Szelényi

Mirco Decet: 66

Deutsche Fotothek, Dresden: 127(t), 183(b), 262(b)

Edimages: 401(t), 409(bl)

Edimedia: 370, 377(b) Jacqueline Guillot, 379(t)

Edistudio: 232/3(t), 238/9, 240/1, 241, 242(br), 242/3, 243, 300/1

Mary Evans Picture Library: 277(b), 291(b), 304(b), 309(c & t)

Explorer: 25(tl) Prado, 29(t) Jose Dupont, 40/1, 66/7 P. Gleizes, 123(t) Louis-Yves Loirat, 132(br) Louis Yves Loirat, 135 Louis Yves Loirat, 153(c) Ch. Errath

Fotobank: 298(bl)

The Fotomas Index: 120(t), 126(t), 131(bl), 156(tl), 196/7, 237(r), 239(tr & br), 249(b), 274/5, 281(t), 285(br)

John Gaisford: 293(t)

Giraudon: 52(t), 52(br) Lauros, 54(b), 68(br), 86(c), 149(b) Lauros, 190(tl), 192(tl), 204 Lauros, 205 Lauros, 242 Lauros, 269(b), 304(t) Lauros, 343 Lauros, 345, 349(cr) Lauros, 351(t) Lauros, 353(br), 359(b) Lauros, 360(t), 366(tl), 366(b) Lauros, 368, 390(b) Lauros, 392/3 Lauros, 393(t) Lauros, 393(br), 394, 395(r), 413(tr) Lauros, 415(tr) Lauros, 416/7 Lauros, 418(t), 431

Susan Griggs Agency: 9(b) John G. Ross, 50(b), 194 Adam Woolfitt

Robert Harding Associates: 250(t)

John Heseltine: 22/3, 307(t)

Michael Holford: 197(bl)

Angelo Hornak: 307(r)

Hutchison Library: 55(b) T. E. Clark, 349(bl) Bernard Regent, 362(b) Carlos Freire, 400/1 Bernard Regent, 402(b) Bernard Regent, 403(l)

The Image Bank: 8/9 J. Bryson, 82(b) Juergen Schmitt, 84/5, 179/80 Bullaty Lomeo, 264/7, 359(tr) Amedeo Vergani

Colin Jeffrey: 297(cr)

By permission of the executors of the late Sir Geoffrey Keynes: 253(tl)

Ralph Kleinhempel: 260(b), 324

Kobal Collection: 391(b)

Jacques Lathion: 271

Mike McGuinness: 35(r), 47(br), 49, 383(t), 408(t)

The Mansell Collection: 275, 369(t)

The Map House: 285(t)

National Portrait Gallery, London: 81(tl & tr), 305(tl)

Peter Newark's Western Americana: 302(b)

Office National des Forets: 386(r) J. P. Chasseau

Collection Phillippe Piguet: 376(tl), 378(t)

By courtesy of the Port of London Authority: 278/9

Mauro Pucciarelli: 69(r), 82(t), 83(t)

Reproduced by Gracious Permission of Her Majesty The Queen: 282(t)

Rapho: 150(c) Bernard G. Silberstein, 163(l) R. G. Everts

Réunion des Musées Nationaux: 28(t), 33(cl), 53(b), 56(b), 96, 97, 167/8, 346(b), 351(b), 354/5, 355(t), 356, 362 (tr), 364/5, 367, 378(r), 379(cl & br), 382(tr), 383(c), 405(bl), 406(t & b), 422/3, 424/5, 428, 435, 437

Ann Ronan Picture Library: 186(br), 254(t)

Scala: 9(tl & tr), 10(l), 11, 12, 12/3, 13(1), 14(br), 16, 17(l), 18 (tl & bl), 18/9, 19(tr), 20, 22, 23(l & tr), 24, 25(tr & b), 26(tl), 31 (t & r), 32, 34/5, 35(t & c), 36, 38, 40, 41, 42(tr), 43, 44(bl), 45, 46, 46/7, 51(bl & br), 54(tl), 56(t), 57(t), 58(tr), 59(tl), 60, 60/1(t), 61(t), 61(cr), 62(t & cl), 62(cr), 63, 67(t & br), 71(t & bl), 73(t), 76, 77, 80(1), 81(b), 83(br), 84, 85, 86(tl), 87(t), 90/1, 98, 102, 103, 104, 106/7, 110, 122(tl & b), 124(bl), 127/8, 129, 131/2, 147, 164(b), 171, 184(tr), 193(t), 197(c), 202/3, 212, 353(bl), 371, 374(t), Endpiece (1)

Tom Scott: 183(t)

John Sims: 68(tl)

The Society of Antiquaries of London: 247(1)

Sothebys: 443

Spectrum Colour Library: 39(br), 165(tr), 278(t), 290(tl), 391(t), 417(tc)

Agence TOP: 360(b & l) Rosine Mazin

Topham Picture Library: 376(cr)

Roger Viollet: 363(t), 373(tl), 382(tl), 390/1

Vision International: 254(bl) Scala

Wallace Collection, London: Endpiece (2)

Zefa Picture Library: 23(br), 389(r) Havlicek